マンガ：マスターズ オブ アート

MANGA
Masters of the Art

MANGA
Masters of the Art

Timothy R. Lehmann

COLLINS | DESIGN

An Imprint of HarperCollins*Publishers*

The First Edition

First Japanese edition published in 2005 by
BIjutsu Shuppan-sha Co., Ltd.
8F Inaoka Building
2-38 Kanda Jimbo-cho
Chiyoda-ku Tokyo
101-8417 Japan
phone; +81 3 3234 2151 Fax; ;81 3 3234 9451
http://www.bijutsu.co.jp/bss

First published in English in 2005 by:
Collins Design
An Imprint of HarperCollins*Publishers*
10 East 53rd Street
New York, NY 10022
Tel: (212) 207-7000
Fax: (212) 207-7654
collinsdesign@harpercollins.com
www.harpercollins.com
with the rights and production arrangement by
Rico Komanoya, ricorico, Tokyo, Japan

Distributed throughout the world except Japan by:
HarperCollins*Publishers*
10 East 53rd Street
New York, NY 10022
Fax: (212) 207-7654

Staff
Editing: Keiko Yamamoto, Yuri Okamoto, Rico Komanoya
Typesetting: Far, Inc.
Book Design: Yoyo Suzuki
Cover Design: Yoyo Suzuki and Powergraphixx
Production: Rico Komanoya (ricorico)

Library of Congress Control Number: 2005930652

ISBN10-06-083331-9
ISBN13: 978-0-06-083331-2

Printed in China

First Printing, 2005

To Mom and Dad

Contents

MANGA
Masters of the Art

How to use this book

The pages of Manga shown in this book are usually in the original Japanese format, and should be read from right to left, the reverse of Western comics.

Japanese names have not been westernized but preserve the Japanese custom of putting the family name first. Japanese titles are shown in romanji (English alphabet), with the translation following in parentheses.

Since this book is primarily for artists rather than readers, a Japanese version of a work will sometime be recommended over an English translation if the printing quality is deemed significantly better.

INTRODUCTION

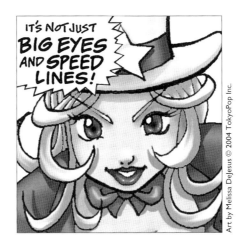

Art by Melissa DeJesus © 2004 TokyoPop Inc.

"I'll teach you differences."

– Ludwig Wittgenstein

Ten years ago, I was on Christmas vacation in Quebec City, searching for books by my favorite European comics artists. By chance, I came across a special edition of the anthology *A Suivre*, edited by the French comics surrealist Jean Giraud, aka Moebius. Titled *Silence, On Reve*, the collection was devoted to dream-inspired art. Most of the contributors were European, but there were two Japanese contribution—Maruo Suehiro and Takayama Kazumasa. Their work was intense and disturbing, but exquisitely crafted. In his introduction, Moebius described them as "the hidden face of Manga." By this time, I knew that "Manga" meant comics from Japan. But, ironically, this was the beginning of a period of Manga revelations for me. For this was 1995, and back in the U.S., English translations of Manga were about to kick into high gear . . .

The following summer, at the Comic-Con International in San Diego, I picked up a copy of *Dreamland Japan*, Frederik L. Schodt's just-released sequel to *Manga! Manga!*, his masterful 1983 overview of the Japanese comics phenomenon. In one section of new book, Schodt had profiled a group of Manga artists, among them Maruo Suehiro, one of the artists I had discovered the preceding December, and Okano Reiko, a woman who had written a light comedy with metaphysical overtones involving a Buddhist monk.

In 1998 I attended three anime (Japanese animation) conventions, two in the U.S. and one in Canada. I was immediately in touch with a network that made Manga more

available to me. Through these new contacts, I became aware of Egawa Tatsuya, a superb stylist and a stylistic genius of comics storytelling. I found the stunning *Mr. Arashi's Amazing Freak Show,* the Blast Books English translation of Maruo Suehiro's masterpiece. I discovered *Comickers* magazine, a lavishly-produced Japanese quarterly of comics journalism, criticism, and art technique analysis. I also found comic art tutorials by the same publisher, such as *Manga Supa Tekunikku Koza (Manga Super Technique Seminar).* Several of these contained interviews (albeit in Japanese) with some of the artists I had come to know. And there was one who was new to me: Hiroki Mafuyu, an accomplished graphic realist in the tradition of Neal Adams.

In early 1999, I came across a book of science fiction short stories by a Manga artist with a very European look to his work—Taniguchi Jiro. I detected unmistakable influences from the Frenchman Moebius and the Belgian comics fantasy artist François Schuiten. That same year, in Chicago, I found the French translation of another of his books, *L'Homme Qui Marche (The Walking Man).* The two works could not have

been more different in tone and subject. While the first was an action-fantasy-adventure, the second was more like a meditation. It followed the home life of an ordinary modern Japanese man as he walked through his neighborhood and observed life and nature around him.

In 2000, I found Takaya Miou's delicate pen-and-ink work in *Comickers* magazine and discovered two giants of Manga—Tsuno Yuko and Furuya Usamaru—thanks to Cadence Books' *Secret Comics Japan.* And I discovered one other book . . .

In the local comics shop I found Mark Salisbury's *Artists on Comic Art,* a collection of interviews with American and British comics artists. As an artist myself, I've always been fascinated by the way other artists' minds work. Just as interesting is peering into the nuts and bolts of their techniques, tools, and resources. Salisbury's conversations with artists like Brian Bolland, J. Scott Campbell and Bryan Hitch made for fascinating reading.

And, I thought, why not do this with the Japanese comics artists I had come to know and admire? Schodt had had a section of artists' profiles in *Dreamland Japan,* but they were not as in the depth as Salisbury's interviews. I got out the *Comickers* magazines and art books I had collected. If I combined Salisbury and *Comickers* and threw in a little Schodt, I would have the right mix—And a perfect foil for the rash of how-to-draw-Manga books that had sprung up in the 1990s, reducing all the diversity I was finding in contemporary Japanese comics art to "big eyes and speed lines."

This is a book for artists and those who love art, not just comics. There is no attempt to cover every story genre or every art style in Japan today. Indeed, given the breathtaking scope of Manga at the beginning of the twenty-first century, it would be impossible to do this in a book a hundred times this size. In the following conversations with creative visionaries, however, you will get a sense of context. Each has traversed a unique path to the craft of comics storytelling, beginning with her or his first inspirations, shaped through training and experience, and driven by their individual personalities.

One of the most exhilarating things about being in an art class is looking over the shoulders of those next to you, learning the little secrets that each artist discovers by chance and from the unique interplay of background and personality.

Even if you're not an artist but are interested in cross-cultural studies or eavesdropping on colorful personalities, you are likely to find something of interest here.

Come along. Let's meet the masters . . .

Asamiya Kia, the animator/manga artist inspired by American films, who has become a kind of ambassador of "World Comics."

CLAMP, the creative team whose characters have struck a responsive chord in both male and female readers around the world, making them among the most famous women in the history of comics.

Egawa Tatsuya, whose obsession with sex is an honest exploration of life and relationships and who has created some of the most memorable characters and brilliant storytelling devices you'll ever come across.

Furuya Usamaru, the postmodern deconstructionist who, with a plethora of styles, turns the comics art form upside down and devours it from the inside.

Inoue Takehiko, a master of pacing and action, whether he is telling a story about basketball or creating a period drama about a wandering sword-saint.

Maruo Suehiro, who records nightmares and atrocities, but with a sensitivity and beauty of line that redeems his subject matter, although viewred through an ironic prism.

Okano Reiko, who explores fantasy, folklore, and contemporary stories with meticulous attention to detail, sensitive ink-wash art, and an uninhibited sense of humor.

Sakurazawa Erica, who combines elements of fantasy with frank depictions of sex from a woman's point of view, in a disarmingly honest and autobiographical fashion.

Takaya Miou, the philosophy school dropout, who creates pen-and-ink poetry and surrealistic picture-fables.

Taniguchi Jiro, who has worked in every imaginable genre of Manga for over 30 years, from hard-boiled detective stories to a Buddhist meditation on the quiet wonder of everyday life.

Tsuno Yuko, the recluse who turned her back on fame and creates delicate stories with a sure, elegant line . . . only for herself.

Hiroki Mafuyu, the illustrator/Manga artist, whose sophisticated rendering and elegant graphic design create an erotic cyber-tech surrealism.

On the following pages, note how they compare in terms of subject matter and artistic style, see where they fit into the half-century history of the modern Japanese story Manga phenomenon, and enjoy a portfolio of their color work. Then visit to their creative spaces and gain insight into their art, influences, and methods—in their own words.

Timothy R. Lehmann
Kalamazoo, Michigan USA
2005

The artists chosen for this book represent a great diversity of artistic styles. But they are even more diverse when the subject matter of their stories is considered. These charts attempt to depict those differences. The categories are subjective, but I have tried to be as consistent as possible in indicating my impressions of each creator's oeuvre. Surrealism figures highly in the works of Takaya, Tsuno, Hiroki, Furuya, and Maruo. Humor and satire are most developed in Egawa and Furuya. Violence is most extreme in the works of Maruo. The

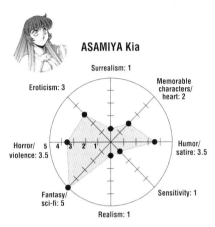

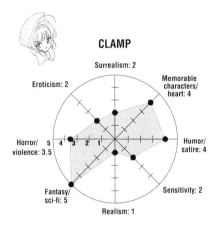

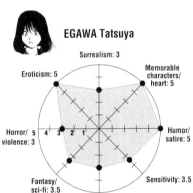

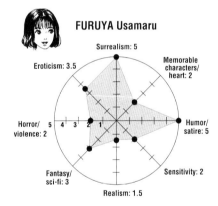

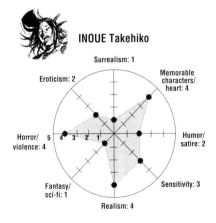

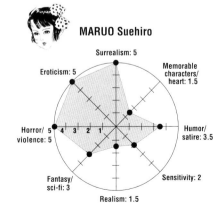

fantastic or science fiction element is strongest in Asamiya, CLAMP, and Hiroki. Sensitivity is most pronounced in Okano, Sakurazawa, Taniguchi, and Tsuno. Eroticism, while present to some degree in all of the artists, is greatest in Egawa, Sakurazawa, Takaya, Furuya, and Maruo. Memorable protagonists or stories that touch the heart characterize the work of Inoue, Egawa, CLAMP, Sakurazawa, Taniguchi, and Tsuno. Realism rings truest in Inoue, Sakurazawa, and Taniguchi.

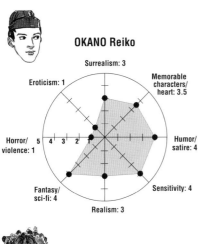

OKANO Reiko

Surrealism: 3
Memorable characters/ heart: 3.5
Eroticism: 1
Humor/ satire: 4
Horror/ violence: 1
Sensitivity: 4
Fantasy/ sci-fi: 4
Realism: 3

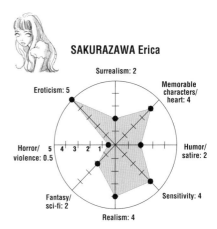

SAKURAZAWA Erica

Surrealism: 2
Memorable characters/ heart: 4
Eroticism: 5
Humor/ satire: 2
Horror/ violence: 0.5
Sensitivity: 4
Fantasy/ sci-fi: 2
Realism: 4

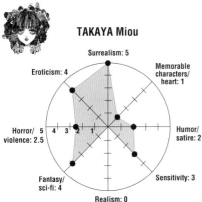

TAKAYA Miou

Surrealism: 5
Memorable characters/ heart: 1
Eroticism: 4
Humor/ satire: 2
Horror/ violence: 2.5
Sensitivity: 3
Fantasy/ sci-fi: 4
Realism: 0

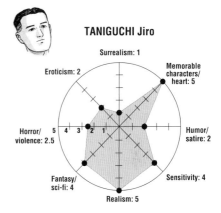

TANIGUCHI Jiro

Surrealism: 1
Memorable characters/ heart: 5
Eroticism: 2
Humor/ satire: 2
Horror/ violence: 2.5
Sensitivity: 4
Fantasy/ sci-fi: 4
Realism: 5

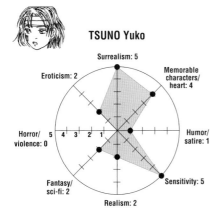

TSUNO Yuko

Surrealism: 5
Memorable characters/ heart: 4
Eroticism: 2
Humor/ satire: 1
Horror/ violence: 0
Sensitivity: 5
Fantasy/ sci-fi: 2
Realism: 2

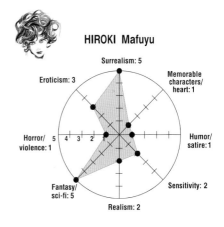

HIROKI Mafuyu

Surrealism: 5
Memorable characters/ heart: 1
Eroticism: 3
Humor/ satire: 1
Horror/ violence: 1
Sensitivity: 2
Fantasy/ sci-fi: 5
Realism: 2

Scott McCloud, in *Understanding Comics: The Invisible Art*, created this chart for visualizing comics styles. The chart has been adapted here to include the artists interviewed in this book.

How to read the chart: Detailed realism is in the lower left-hand corner. As you go up, you go toward greater abstraction. As you go to the right, you go toward greater simplification. Most comics creators use more than one style, but stylistic fluidity is more common in Japanese comics than in their American counterparts. Please refer to McCloud's book for more detaile about analyzing comics styles and the nature of the art form itself. This chart is copyright © Scott McCloud and Harper Perennial. For all other copyrights, please see pages 254–255.

1. Mary Fleener at her most abstract.
2. Mariscal's Piker.
3. Dave McKean employing one of the many styles found in his series *Cages*.
4. Mark Hempel's *Gregory*.
5. Mark Beyer.
6. Larry Marder's Beanish from *Tales of the Beanworld*. "Resembling" nothing ever seen (hence all the way to the right), Marder's beans walk the line from design to meaning.
7. Saul Steinberg.
8. Penny Moran Vanhorn from *The Librarian*.
9. Lorenzo Mattoti in *Fires* combines deeply impressionistic lighting with iconic forms and strong design-oriented compositions. In other words, he's a hard one to place.
10. Aline Kominsky-Crumb.
11. **Furuya Usamaru employing one of the myriad styles found in his series *Palepoli*. (Compare to 27, 79 and 80, which are from the same series.)**
12. Kristine Kryttre.
13. Rea Irvin.
14. Steve Willis's *Morty*.
15. Phil Yeh's *Frank the Unicorn*.
16. Jerry Moriarty's *Jack Survives*. Based closely on real-world light and shadow, but decomposed into rough shapes. Similar effects are found in 8, 18,19, and 20.
17. Jeff Wong's art for Scott Russo's *Jizz*.
18. Rolf Stark's *Expressionistic Rain*.
19. Spain's *Trashman*.
20. Frank Miller's *The Dark Knight Returns*.
21. William Messner-Loebs's Wolverine MacAlistar from *Journey*.
22. Don Simpson's *Megaton Man*. Beginning from a realistic anatomical base, Simpson distorts and exaggerates M.M.'s features to the brink of abstraction.
23. Michael Cherkas from *Silent Invasion*.
24. Rick Geary.
25. Peter Kuper.

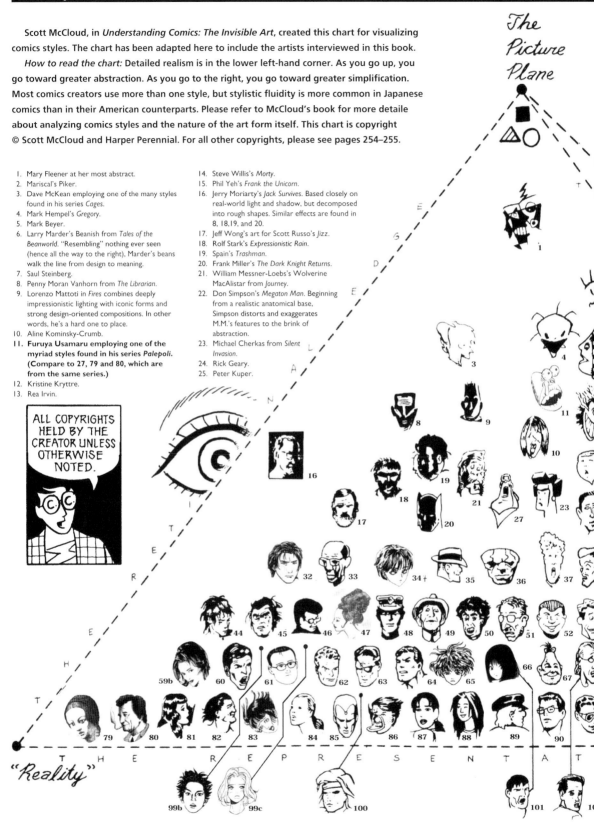

ALL COPYRIGHTS HELD BY THE CREATOR UNLESS OTHERWISE NOTED.

26. Gary Trudeau's *Doonesbury*.
27. Furuya Usamaru, again from *Palepoli*.
28. Shirato Sanpei
29. Charles Burns's *Big Baby*.
29½. Cliff Sterrett. The character pictured here (from *Polly and Her Pals*) might belong a bit lower, but Sterrett's art, like Fleener's often heads upward toward the wildly abstract.
30. Sergio Aragones's *Groo the Wanderer*. Simple, straightforward, but with a strong gestural quality that always reminds us of the hand that holds the pen (also true of 14, 28, 31, 41).
31. Roberta Gregory's Bitchy Bitch from *Naughty Bits*.
32. Asamiya Kia from *Junk: Record of the Last Hero*.
33. Jose Munoz from *Mister Conrad, Mister Wilcox*.
34. Takaya Miou.
35. Chester Gould's *Dick Tracy*.
36. Jack Kirby's *Darkseid*.
37. Bob Burden.
38. Daniel Torres's Rocco Vargas from *Triton*.
39. Peter Bagge's Buddy Bradley from *Hate*.
40. Seth.
41. Mark Martin.

42. Julie Doucet.
43. Edward Gorey.
44. Craig Russell's Mowgli from Kipling's *The Jungle Book*. Russell's characters are as finely observed and realistically based as Hal Foster's or Dave Stevens' but with an unparalleled sense of design that draws them toward the upper vertex.
45. Kojima Goseki from *Kozure Okami (Wolf and Cub)*.
46. Eddie Campbell's *Alec*. Realistic in tone, but also gestural and spontaneous. The process of drawing isn't hidden from view.
47. Okano Reiko's *Yomi Henjo Yawa*.
48. Hugo Pratt's *Corto Maltese*.
49. Will Eisner from *To the Heart of the Storm*.
50. Dori Seda.
51. R. Crumb swings between realistic and cartoony characters, usually staying about this high but occasionally venturing upward.
52. Steve Ditko.
53. Norman Dog.
54. Valentino's *Normalman*.
55. Ron Chast.
56. Joost Swarte's *Anton Makassar*.
57. Elzie Segar's *Popeye*.
58. George Herriman's Offissa Pupp from *Krazy Kat*.
59. Jim Woodring's *Frank*.
59b. Hiorki Mafuyu.
60. Neal Adams from *X-Men*.
61. Taniguchi Jiro's *The Walkingman*.
62. Milton Caniff's *Steve Canyon*.
63. Jim Lee, Nick Fury appearing in *X-Men*.
64. John Byrney, *Superman*.
65. Tsuno Yuko's *Yuko's Swing Shell*.
66. Egawa Tatsuya's *Tokyo Daigaku Monogatari*.

67. Bill Griffith's *Zippy the Pinhead*.
68. Joe Matt.
69. Kyle Baker from *Why I Hate Saturn*.
70. CLAMP's *Cardcaptor Sakura*. This is CLAMP's most intentionally "cute" style, aimed at teen-age girls, and comes closest to the so-called "manga style" stereotype.
71. Ikeda Riyoko's Oscar from *The Rose of Versailles*.
72. George McManus, *Bringing Up Father*.
73. Charles Schulz's Charlie Brown from *Peanuts*.
74. Art Spiegelman from *Maus*.
75. Matt Feazell's *Cynicalman*.
76. The Company Logo. The picture as symbol.
77. Title Logo. The word as object.
78. Sound Effect. The word as sound.
79 and 80. Furuya Usamaru, again from *Palepoli*.
81. Dave Stevens.
82. Hal Foster, Tarzan created by Edgar Rice Burroughs.
83. Maruo Suehiro's *Shojo Tsubaki*.
84. Milo Manara.
85. John Buscema, The Vision.
86. Carol Lay's Irene Van de Kamp from *Good Girls*.
87. Gilbert Hernandez.
88. Jamie Hernandez.
89. Colin Upton.
90. Kurt Schaffenberger, *Superboy*.
91. Jack Cole's *Plastic Man*.
92. Reed Waller's *Omaha the Cat Dancer*.
93. Wendy Pini's Skywise from *Elfquest*.
94. Dan de Carlo, *Veronica*.
95. Harold Gray's *Little Orphan Annie*.
96. Herge's *Tintin*.
97. Floyd Gottfredson, *Mickey Mouse*.
98. Jeff Smith's *Bone*.
99. Smile Dammit.
99b. Inoue Takehiko's *Riaru*.
99c. Sakurazawa Erica.
100. Coleen Doran's *A Distant Soil*.
101. Roy Crane's *Captain Easy*.
102. Dan Clowes.
103. Wayno.
104. V.T. Hamlin's *Alley Cop*.
105. Chester Brown.
106. Stan Sakai's *Usagi Yojimbo*.
107. Dave Sim's Cerebus the Aardvark.
108. Walt Kelly's *Pogo*.
109. Rudolph Dirk's Hans and Fritz.
110. H.C. "Bud" Fisher's Jeff from *Mutt and Jeff*.
111. Mort Walker's *Hi And Lois*.
112. Tezuka Osamu's *Astroboy*.
113. Carl Barks, *Scrooge McDuck*.
114. Crockett Johnson's Mister O'Malley from *Barnaby*.
115. Pat Sullivan's *Felix the Cat*.
116. *Uderzo*. Asterix by Goscinny and Uderzo.

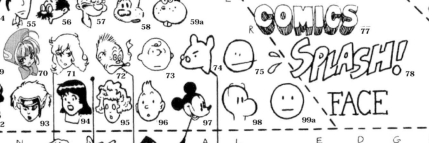

	Garo and its sub stream	Gekiga	Ero, moe manga	Seinen manga
1950s				
1960s	Tsuge Yoshiharu/Nejishiki	Mizuki Shigeru/GeGeGe-no-Kitaro; Hirata Hiroshi/Onore ra ni Tsugu; Saito Takao/Golgo 13		Monkey Punch/Lupin III
1970s	Moroboshi Daijiro/Yokai Hunter (category crossed over to gekiga)	Kamimura Kazuo/Dosei Jidai	Azuma Hideo/Futari to 5nin	Yokoyama Mitsuteru/Sangokushi; Yokoyama Mitsuteru/Sangoku; Terasawa Buichi/Cobra
1980s	**Maruo Suehiro/Shojo Tsubaki**; Hoshino Yukinobu/Yamataika	Kano Seisaku/Jikken Ningyo Dummy Oscar; **Taniguchi Jiro/Botchan no Jidai**; Ikegami Ryoichi/Crying Freeman	Azuma Hideo/Futari to 5nin; Yamamoto Naoki/Asatte Dance (Dance Till Tomorrow); U-Jin/Angel	Otomo Katsuhiro/AKIRA; HirokaneKenshi/Kacho Shima Kosaku; Watase Seizo/Heart Cocktail; Eguchi Hisashi/Stop!! Hibari-kun; Kamijo Atsushii/TO-Y; **Asamiya Kia/Silent Mobius**; Fujishima Kosuke/Oh My Goddess!; Shirow Masamune/Ghost in the Shell; Katsura Masakazu/Video Girl Ai
1990s	**Tsuno Yuko/Ame Miya Yuki Kohri**; **Hiroki Mafuyu/Louise**		**Egawa Tatsuya/Tokyo Daigaku Monogatari**; Fujiko Fujio Ⓐ /The Laughing Salesman; Oh! great/Tenjho Tenge	Kawaguchi Kaiji/Silent Service; Matsumoto Taiyo/Ping Pong; Urasawa Naoki/Monster
2000s			Azuma Kiyohiko/Azumanga Daihoh	**Furuya Usamaru/π**

Shonen manga	Shojo manga	Boys' Love and its sub stream	Josei manga
Tezuka Osamu/Tetsuwan Atom (Astro Boy)			
	Mizuno Hideko/Hoshi no Tategoto		
Akatsuka Fujio/ The Genius Bakabon — Ishinomori Shotaro/ Cyborg 009			
...asaki Noboru/ ...r of the Giants — Chiba Tetsuya/Ashita no Joe (Tomorrow's Joe)			
Umezu Kazuo/ The Drifting Classroom — Fujiko F Fujio/ Doraemon	Ikeda Riyoko/Berusaiyu no Bara (The Rose of Versailles) — Hagio Moto/The Poe Clan		
Tsunoda Jiro/ Horror Paper — Mizushima Shinji/ Dokaben	Igarashi Yumiko/ Candy, Candy! — Mihara Jun/ Hamidashikko		
	Hosokawa Chieko/ Oke no Monsho (Pharaoh's Seal) — Satonaka Machiko/ Maidens of Aries		
Matsumoto Reiji/Galaxy Express 999	Ichijo Yukari/ The Sand Castle — Miuchi Suzue/ Garasu no Kamen (Mask of Glass) — Kihara Toshie/ Mari and Shingo		
Shintani Kaoru/Area 88	Wada Shinji/ Sukeban Deka (Bad Girl Cop) — Yamato Waki/ Here Comes a Modern Girl!		
		Takemiya Keiko/Kaze to Ki no Uta (The Song of the Wind and Trees)	
	Oshima Yumiko/ Wata no Kuniboshi (Planet of the Cotton Country) — Maya Mineo/Pataliro!		
	Makimura Satoru/Aranfes of Love		
Adachi Mitsuru/Touch	Kuramochi Fusako/ Chopin, Always Inside my Pocket — Narita Minako/ Alien Street	Yamagishi Ryoko/ Emperor of the Land of the Rising Sun	
Takahashi Yoichi/Captain Tsubasa	Mutsu A-ko/Konpei Sou no Francois		
Hara Tetsuo/Fist of the North Star			
Kurumada Masami/Saint Seiya			
Takahashi Rumiko/Ranma 1/2	Tsumugi Taku/Hot Road — Takaguchi Satosumi/ The Magnificent Asuka Gang!		
Araki Hirohiko/ JoJo's Bizarre Adventure	Yoshida Akimi/Banana Fish		Anno Moyoko/Happy Mania
Hojo Tsukasa/ City Hunter — Toriyama Akira/ Dragon Ball	Kawahara Izumi/Warau Michael		Uchida Shungiku/ Minami's Sweetheart
	Sasaki Noriko/Mr. Veterinarian	Ozaki Minami/ Zetsuai (Desperate Love)	Nishimura Shinobu/ Miku & Maiko — Okazaki Kyoko/ Pink
Yudetamago/Kinnikuman (Muscleman)"	Nishi Keiko/ I Wish I Was a Bird		
...Takehiko/Slam Dunk — Togashi Yoshihiro/ YuYu Hakusho	Shibata Ami/ Papuwa, Boy from the Southern Countries		Saimon Fumi/Tokyo Love Story
	Shimizu Reiko/Princess Kaguya	Kouga Yun/ Earthian	
	Tamura Yumi/BASARA		Morizono Milk/Kiala
	CLAMP/Cardcaptor Sakura	Yoshinaga Fumi/ Antique Bakery	
Aoyama Gosho/Detective Conan			
Oda Eiichiro/One Piece	Minekura Kazuya/Saiyuki		Okano Reiko/Onmyo-ji
	Yazawa Ai/NANA — Takaya Miou/ Kikaijikake no Ousama		Sakurazawa Erica/ Body & Soul

Shonen manga Shojo manga Boys' Love and its sub stream Josei manga

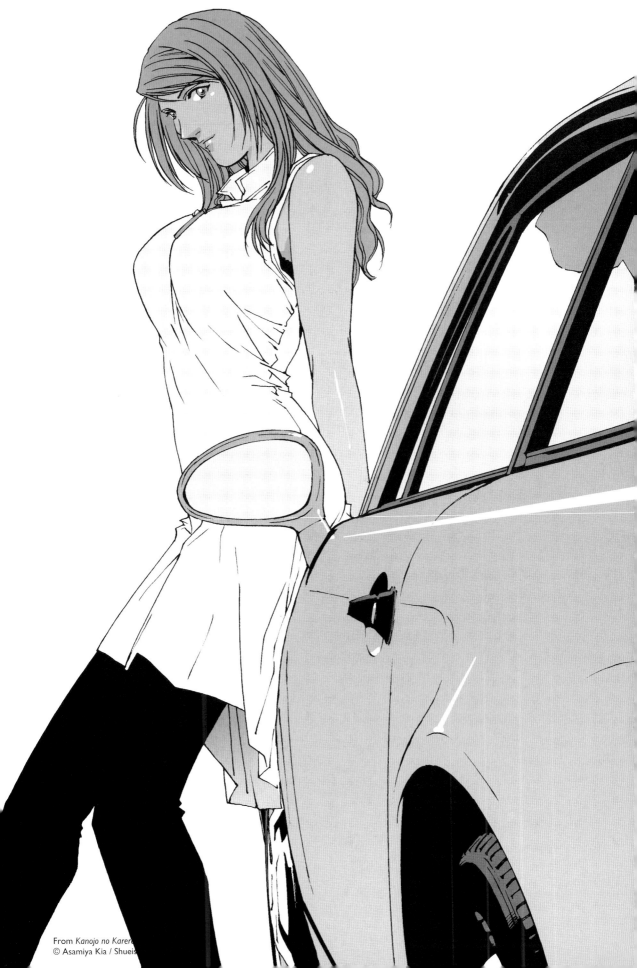

From *Kanojo no Karera*
© Asamiya Kia / Shueisha

ASAMIYA KIA

麻宮騎亜

His first manga was done at the request of a friend who needed help with a *doujinshi* (amateur fanzine). Asamiya remains a bridge between the two fields, bringing animation techniques to manga and sometimes acting as a "director" of manga projects, utilizing the skills of fellow artists. A longtime devotee of American comics and movies, from which he has frequently drawn inspiration, Asamiya has become a fan favorite in the U.S. and around the world. Many of his manga have been adapted into animated television series and/or movies. An avid collector of *Batman* and *Star Wars* souvenirs, his studio is a pop culture museum.

PROFILE

Place of birth: Japan

Date of birth: March 9, 1963

Home base: Tokyo, Japan

First published work:
Shinseiki Vagrants (Kadokawa Shoten), 1986

Education:
Tokyo Designer School, degree in animation

Career highlights:

1988 *Sairento Mebiusu* (*Silent Möbius*) (Kadokawa Shoten)

1990 *Dark Angel* (Kadokawa Shoten)

1991 *Sairento Mebiusu* animated movie released

1994 *Steam Detectives* (Shueisha)

1996 *Yuugeki Uchuu Senkan Nadeshiko* (*Nadesico*) (Kadokawa Shoten)

2000 *Batman: Child of Dreams* (Kodansha)

2003 *Uncanny X-Men: Dominant Species*, (Marvel Comics)

2003 *Junk* (Akita Shoten)

2004 *Kanojyo no Karera* (Shueisha)

2005 *Silent Möbius·neos* series will start

Welcome to the BatCave, I thought. I was in Asamiya Kia's Studio Tron in west Tokyo, marveling at his collection of *Batman* and *Star Wars* movie memorabilia. In the display case behind us was a full Batman costume; in a corner to our right models, of the Batplane and Batmobile. The dim light and slight chill added to the effect. The studio was in the midst of remodeling and Asamiya had graciously made time to meet with us despite of a hectic schedule.

Asamiya Kia is a private man in a public business, but he has a ready smile and a wealth of knowledge and experience from his parallel careers as an animator and a manga artist.

It's no surprise that he did a Batman manga story in 2000, the first Batman story to be drawn and published outside the U.S. Clearly the work of someone who loves the character and mythos surrounding him, Asamiya's story is set half in Gotham City and half in Tokyo—an idea that was at first opposed by editors at DC Comics. But it is a fitting metaphor for Asamiya himself, who has had numerous projects on both sides of the Pacific.

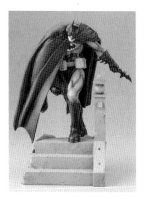

Asamiya attended the Tokyo Designer School and became a professional animator in 1984. Though uncredited, he is reported to have worked on Hayao Miyazaki's *Nausicaa of the Valley of the Wind*. He started drawing manga as a way of strengthening his skills in animation. He is still a bridge between the two fields, recently enlisting a fellow animator

The figure above was based on Asamiya's 2000 manga interpretation of Batman in the graphic novel *Child of Dreams* and was produced by Yamato (www.yamato-toys.com).

to design the costume for the protagonist of *Junk: Record of the Last Hero,* one of Asamiya's three current manga series.

A longtime devotee of American movies as well as comics, Asamiya has appropriated some of his most important manga storytelling lessons from the art of moviemaking. "When I was still an amateur there was an exhibition of special effects at Shinjuku that displayed both Japanese and Hollywood film props. Those of Japan's *Sayonara Jupiter* were really well made, but for the props of *2001: A Space Odyssey,* they had drawn in the details with a pencil!" He realized that lighting and the selective use of detail were important devices that he could apply to manga stories.

Although one of the pioneers of computer art, Asamiya has taken a step away from digital-only creation. He prefers drawing by hand through the inking stage, then scanning the art to do toning and other finishing work in pixels. "I've seen a lot of art done on a computer, and . . . there's no depth to the art. But when it's drawn by hand, no matter how rough, I can keep looking at it for an hour or more."

Asamiya has created numerous popular manga series, almost all of which have spawned anime. In recent years he has worked on several comics projects in the U.S., using characters such as the X-Men, Iron Man, and the Fantastic Four, and produced a manga adaptation of *Star Wars: The Phantom Menace.*

There is an added touch of realism in his current manga *Junk.* Yuki Hino, the protagonist, is a victim of bullying—a major problem in Japanese schools. Yuki has become a recluse, never leaving his home. While surfing the Internet, he comes across a mysterious Web site that changes his life with a one-hour power suit. Asamiya's art for this manga is his most highly rendered to date.

Asamiya Kia is an artist without borders, a true ambassador of "World Comics."

ASAMIYA's interview

— How did you become a manga artist?

When I was an amateur, I was asked to do four pages for a friend's *doujinshi.* An editor saw them and contacted me, asking if I had an interest in doing manga. By then, I had become an animator, but I thought drawing a manga would be good practice for my [anime] layouts, so I started.

— How is working on animation different than manga? And which do you prefer?

To put it simply, animation is a group activity and manga is an individual activity. Working on manga is calm and quiet, but working on anime is dynamic and active. Both have good and bad

aspects. In its final form, I like anime better. A completed manga is just a book. But anime moves, has music, sound, and talks. It's more exciting to see the completed work for the first time.

— Did you ever work at another job?

I did part-time work as a student, but since I became a pro, I haven't done anything besides anime and manga. I did package illustration for games, but that's related. I've even been a DJ for a radio show, but that's also related to anime and manga. I've produced a voice actress's essay book, and I've done photography—I took most of the photos for the book *Ultraman in the Real.*

— What was your education?

I graduated from high school, and then entered the animation program of Tokyo Designer School. Right after I graduated, I got a job at an animation studio. To put it bluntly, the things you learn in a professional school are basically meaningless. After you become a pro—when you get into a real studio—you start gaining skills by osmosis, and that's best. The reason I went to school was because I wasn't raised in Tokyo, and—compared to kids who lived there—I got limited information. By going to that school, I thought I could make friends and get information. I didn't have any contacts, and I didn't know anything, so that was the only place for me . . .

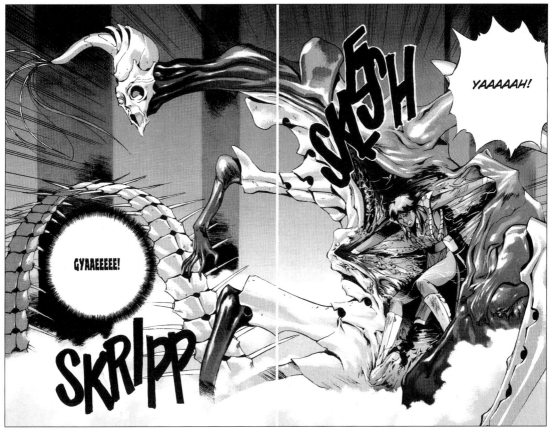

Silent Möbius is one of Asamiya Kia's most representative works. The manga series, which began in 1988, was a unique combination of *Blade Runner*esque future dystopia and sorcery. It also featured an all-female team of strong heroes, the "Attacked Mystification Police," who Asamiya claims were based on *Charlie's Angels* and *CHIPS*.

Above, Kiddy Phenil, who is 80 percent cyborg, battles one of the "Lucifer Hawks," supernatural terrors from the dimension Nemesis. The manga series spawned two movies and a TV series, all animated. © Asamiya Kia / Kadokawa Shoten

and I didn't have to take an [entrance] exam! [Laughs.]

— How did you learn to tell a manga story, as opposed to animation?

I just read manga and observed how to draw it. It was the late '80s when I debuted, and it was popular to have animators draw manga in a magazine called *Motion Comic.* To be honest, there were many who questioned animators drawing manga . . . if it would truly be manga. For instance, they didn't use much Screen-Tone, or, since they couldn't use a pen, they would just draw in pencil. But, if I was to work as a manga-ka, I wanted to take it seriously. So I put aside my true name, Kikuchi Michitaka, and made a totally different pen name, Asamiya Kia, and started working.

— So you learned manga by yourself?

Well, it was like that for my debut manga, but when I started *Silent Möbius,* I called some professional assistants, some people I knew who had become manga-kas. So, actually, there were things that they taught me.

— Your first published manga was . . .?

Shinseiki Vagrants, in *Comptique* magazine, in 1986.

— Was there a low point in your career?

Well, I'm a type that gets affected by rumors. [Laughs.] When I see someone bad-mouthing me on the internet, I get depressed and can't draw.

— How do you get over that?

Time is the only solution.

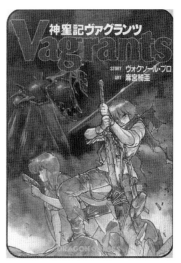

1986's *Shinseiki Vagrants* is the story of heroes who pass between multiple universes to solve problems. In this collaborative work, Asamiya supplied only the art. The script, written by Vauxhall Pro, is generally regarded as incomprehensible.

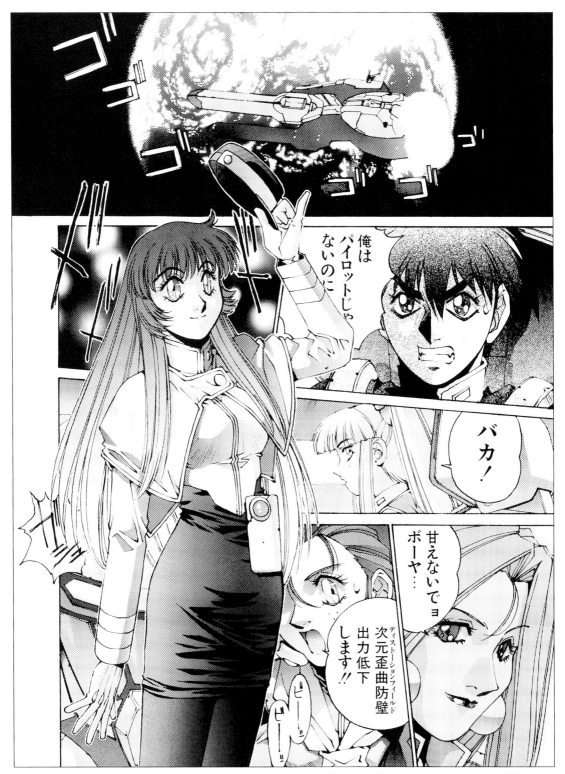

A metaparody of science fiction manga: Asamiya's *Yuugeki Uchuu Senkan Nadeshiko* (*Nadesico*) began in 1996, during a "space boom" in manga and anime. Asamiya described the series as "the character Ataru from *Urusai Yatsura* [Takahashi Rumiko's comedic alien story] on the Space Battleship *Yamato* [better known as *Star Blazers* in the U.S.], fighting with Gundams [the giant-robot fighting machines]." The sci-fi comedy-romance campy adventure, full of fan-pleasing homages to earlier stories, proved extremely popular, inspiring a television series and movie.
© Asamiya Kia / Kadokawa Shoten

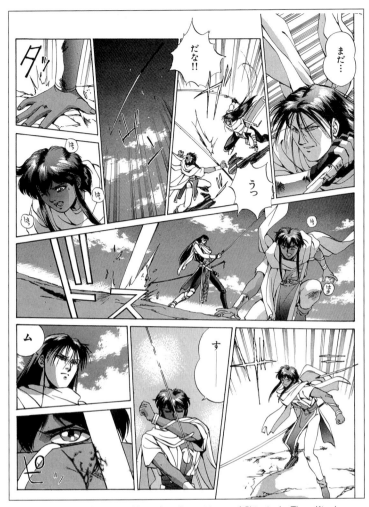

Dark Angel is set in a fantasy world very loosely reminiscent of China in the Three Kingdoms era. The characters include the protagonist, an impetuous young boy named Dark; his tiny assistant angel; and the mad, spoiled lord who's on the verge of stumbling into a major war in his attempts to kill Dark. The series began in 1990 and filled five volumes in its collected form. A sequel, *Phoenix Resurrection*, was published in the U.S., in color, by Image Comics in 2001.
© Asamiya Kia / Kadokawa Shoten

big. And perhaps the environment I've grown and cultivated.

— Describe how you create a story.

Before beginning, I have a meeting with the editor and discuss the type of story. After that, I write a simple plot and send it to the editor. If that's okayed, I start making a *name* (thumbnail outline) to fit the plot.

— How detailed is your *name*?

It's a simple storyboard, with the panels, dialogue, and layouts.

— You show the *name* to the editor?

Of course. When I show the *name* and get an okay, I go to the actual work, but sometimes I get rejected [and do revisions]. [Laughs.] I transfer the layout from the *name* to the manuscript and do the pencilling and inking. Since my work is published in foreign countries, I make it a standard practice to make the word balloons circular, so they can handle both Japanese and English.

— Do you use a computer?

I do all the finishing with the computer and submit the pages as [computer] data. "Finishing" includes the betas (spot blacks) and toning.

— So, up to the inking stage you do by hand?

Yes. Up to inking is just done the normal way; after I've finished inking, I scan it and continue on the computer.

— Do you put in the word balloons with the computer?

No, the word balloons are hand-drawn.

— What do you like best about using the computer?

The best thing, I think, is speed. And the cost! [Laughs.] I don't have to use Screen-Tone at all, and that helps a lot. In the past, I used to use 90,000 yen [about $820 U.S.] worth of Screen-Tone a month. But now I don't spend a single yen. It's very economical. [Laughs.]

— You do how many pages a month?

I'm doing three [manga series], so about 70 pages.

— What would you call your manga?

I think you have to be able to draw any genre in manga. When I think about my manga's genre, all I can say is that it's manga. I've done *shonen* (boys'), *seinen* (young men's), and *shojo* (girls'); I even drew a *gekiga* (gritty, realistic) type.

— Who are your fans?

I guess it's males in their late teens to 30s. I don't have a lot of female fans.

— In creating a manga story, do you begin with a script?

Before I start a manga, when it is only an idea, I make a proposal first. But

there are other times that I start the manga directly. I always fix the ending in my head before it starts. So, the beginning and the end are already determined, and I just keep the story moving while it's going into the magazine. This was the case with *Silent Möbius, Steam Detectives,* and *Junk,* the [super]hero manga that I'm currently doing for Champion Red.

— At the drawing stage, do you start with a *name* [thumbnail]?

Usually, but not always.

— Where do get your story ideas?

I do get influences from other media ouside of manga. For me, movies are

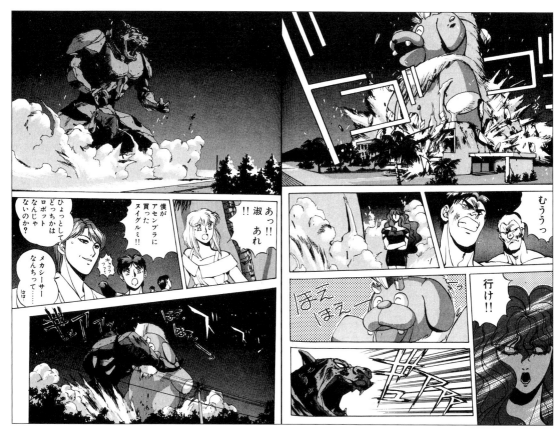

Two alien women, Konpaira (Compiler) and Asenbura (Assembler), strive to use their computer-derived supernatural powers to take over Earth on behalf of their home world, the Electro-Dimension. However, they soon become so entranced by the pleasures of life in three dimensions that they decide to protect our world instead of helping to invade it. This concept became the basis of two manga series in 1990 and 1993, and four animated episodes in 1994 and 1995. Although not translated into English, plot synopses of the manga are available at www.flowerstorm.net/disa/Site-Nemesis/guides/comp-plot-01.html
© Asamiya Kia / Kadokawa Shoten

— What do you hate about computers?

Oh, I hate it the most when it freezes. [Laughs.] When I'm in a good rhythm, I forget to save the data. And at those times, when it's almost done, I hear that "ping" sound. [Laughs.]

— Was the transition to using a computer smooth or difficult?

It's been 10 years since I started using a Mac, so I've seen a lot of downside as well as good. Especially for color, it's not good. The monitor and reflective manuscripts [art done on a reflective surface, such as a page] are completely different, so I was never satisfied with the color it produced. I've seen a lot of art done on a computer, and—this sounds critical, but I include my own work in this—I can't look at it for more than three minutes. There's no depth in the art. But when it's drawn by hand, no matter how rough, I can keep on looking at it for an hour or more. So, lately I stopped coloring with the computer. I do it all by hand. I just use the computer to do the layout. I scan it into the computer at the penciling stage and then do things such as changing the angles, or bringing in a photo to compare a "feel" that might be better. Then I print that out and draw it again. I copy that onto a French paper I always use with a toner, and use Liquitex to paint it. For the finished work, I use pastel pencils. I guess the final touch—using my hands, using paint—is what I am attracted to the most, so I'm kind of rewinding [going back to earlier] things.

— Do you have assistants?

I usually have about three. They mainly draw backgrounds and, besides that, I have them erase [pencil lines on] the pages or have them draw the panel borders. I do all the finishes myself. So, at the end, it's like a detention. [Laughs.] After the backgrounds are done, the assistants go home.

— What did you think of the alternative manga magazine *Garo*?

I did read *Garo* sometimes when I was a student. But its image is basically underground. [Laughs.] I haven't read it lately. It's a very unique magazine.

— Do you ever feel restricted working in mainstream manga?

Hmm, no, not really. A certain publisher was awful, and I will never work there again. It all depends on the publisher, since there are various types. It depends on whether you fit that type or not. So, the faster you can find out if the publisher is bad or not, the better, I guess. This particular publisher didn't think about the fans or the authors. They only thought about their employees, and I disliked that, so I quit. The things you need to think about the most are the fans, the work, the meaning of that work, and the writer or artist. After some things happened and and I talked with his

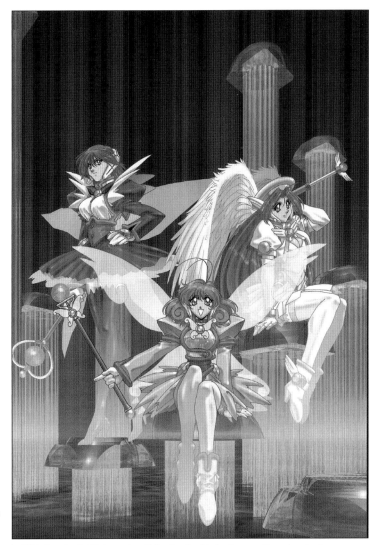

In 1996, Asamiya decided to make a TV series that his daughter could watch and enjoy. Asamiya's only *shojo* (girls') series, *Corrector Yui* is about a 14-year-old girl who is sucked into a computer world where she gains magical powers à la *Sailor Moon*. The manga appeared at roughly the same time that the animated series began airing on educational channel NHK (the equivalent of America's PBS). The whimsical story is more *Tron* than *The Matrix*, and has none of the sexy comedy of Asamiya's earlier *Konpaira* and *Asenbura*.
© Asamiya Kia / Shogakukan

actually had the chance to meet him, and, I was very impressed. He can draw nongenre, diverse manga, and every manga he works on is wonderful. I hope to be that kind of manga-ka. Besides that, my greatest influnce is movies. The light, shadow, and air in Hollywood movies are things I refer to. For me, the biggest shock was when I saw Ridley Scott's *Alien*. And *Blade Runner*, which came after, was also a big shock. In those days, Japanese movies tried to light everything. But if you do that, the realism disappears. But in those special-effects movies from Hollywood, they forget about the details—you can see from the props that they think about how it will look when it's filmed. When I was still an amateur, there was an exhibition of SFX at Shinjuku that displayed both Japanese and Hollywood film props. Those of Japan's *Sayonara Jupiter* were really well made, but for the props from *2001: A Space Odyssey*, they had drawn in the details with a pencil! [Laughs.] But when you see the completed film, like *2001* or *Escape from New York*, they look so real. So I thought, it's the lighting and rendering of space [that's important]. Showing everything isn't the best way.

— **Are you trying to do that in manga and anime?**

Yes, it's always in my mind. There's no necessity to draw everything—you need to have places where not much is drawn, and others where you do draw in detail and make things sharp.

— **Were you also influenced by American comics?**

Oh, yes. I'm certainly influenced by American comics. Back then, it was *Vampirella* and *Moebius*. And, of course, *Batman*.

— ***Moebius . . . that means you've been influenced by Europeans, too?***

Yes, but just the *Heavy Metal* kind.

— **Do you think American comics were influenced by manga during the '90s?**

Yes, especially the artists of *X-Men* . . . Joe Madureira was one of them.

— **When you designed the character Jokioh, the Emperor of Steam for *Steam Detectives*, were you inspired by the American comic *Iron Man*?**

Yes, Iron Man was another character that I liked, and so, without realizing it,

boss, I said it was the editor's fault. But the board member said, "He's one of our precious children." And I said, "Isn't that wrong? Shouldn't a publisher's important children be the work and the fans?" They didn't answer. There are two important things in doing manga: One is the fans, and the other is the editor. You might even say that everything about manga depends on the editor. If there's a good editor, you should even pay him to be your editor. [Laughs.] Now, thankfully, I'm able to work with the best editor I can think of, so

it's a very wonderful and happy thing.

— **Who were your artistic influences when you first started?**

Nagai Go, Ishinomori Shotaro, Matsumoto Reiji. After I got a little older, Otomo Katsuhiro, and ultimately, Takahashi Rumiko.

— **Have your influences or inspirations changed? Are there others now?**

It may not be an inspiration, but there's a manga artist I want to be like. It's Motoka Murakami sensei. I

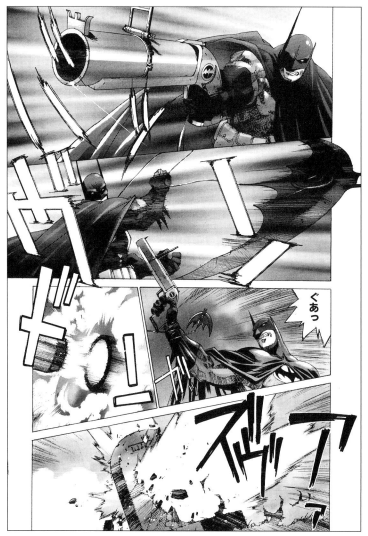

they ended up looking similar—but I didn't actually imitate it. When I went to the U.S., I met [Keron Grant] who designed Iron Man, and he said "I referred to Jokioh." [Laughs.] Well, Jokioh is the essence of Iron Man!

— Is this exchange of ideas and art inspirations beneficial to both American and Japanese artists?

I've always thought that, with art, there are no borders. There are influences that go back and forth—but the histories of how manga evolved in Japan and comics in the U.S. are very different. There are aspects that are unique, but if you just look at the art, you can see aspects that have affected each other. In Japan, there are a lot of people—well me, too—who were influenced by Mike Mignola. There are some who just imitate, but others who put a new twist on it.

— Was it a thrill for you to do a _Batman_ story, or was there a lot of pressure to "get it right"?

I had a lot of trouble before beginning the actual drawing. _Batman_ is the biggest merchandise for DC Comics, and it was kind of a risk to let an artist from another country draw it. We had a lot of arguments. In the first plot that I pitched, it was a story where you take a medicine, and it turns you into some kind of monster. But DC said, "You can't become a monster by taking a medicine. That's fantastic. Fantasy doesn't fit into the 'Batman world,'" so I was asked not to do it. Then, after that,

Asamiya's Batman: Child of Dreams takes place in Tokyo as well as Gotham City. The story features a battle between an imposter and the real Batman [above]. The graphic novel was published in Japan in 2000 and in the U.S. in 2003. While distinctly his own, Asamiya's art shows influences of his favorite Batman artists: Frank Miller, Todd McFarlane, and Mike Mignola.
© Asamiya Kia / Kodansha

In 2003, Asamiya produced an _Uncanny X-Men_ graphic novel, _Dominant Species_ [left] for Marvel Comics. Asamiya's work in the U.S. also included numerous cover paintings, such as one for _Iron Man_ [right]. Ironically, Asamiya had been inspired by an earlier incarnation of this very character when he designed the Emperor of Steam in 1994 [see pages 26–27].

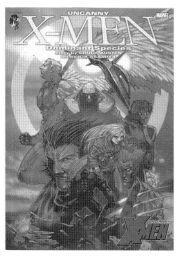

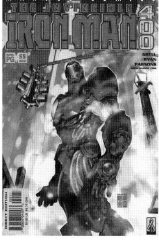

In *Junk: Record of the Last Hero,* Asamiya is spinning a superhero action yarn. The protagonist, a high school student, finds an Internet site called "Junk." Soon after, a package arrives containing a strange clock, a manual, and a CD-ROM, which together transform him into a kind of Robo cop action hero. The clock measures the one-hour limit of his power each time it is used.
© Asamiya Kia / Akita Shoten

we were trying to decide who should be the villain. The editor says, "There once was a Batman impostor with a fake outfit that went wild, so use that character." I didn't know there was such a character, so they showed me the comic—but the character died at the end, shot by a cop. I told the editor, "He's dead!" Then they said, "He's invulnerable." [Laughs.] Isn't that more fantastic?! But the good thing about them is that, even if we argued, after we finished a meeting, they would say, "Let's go to dinner."

— In terms of storytelling and design, do you have any dos and don'ts?

I try not to be the same as other artists. Since I came from a background as an animator, I'll ask other artists to do designs. When it comes from another mind, something really fresh comes out. For example, for *Junk,* I asked Izubuchi [Yutaka]-san [director of *Rahxephon,* and designer of many mechs] to do the costume design.

Images from Junk:
Asamiya's art style for this series features high-contrast graphics and the greatest realism of any of his work to date, including that on *Batman* and *X-Men.*
© Asamiya Kia / Akita Shoten

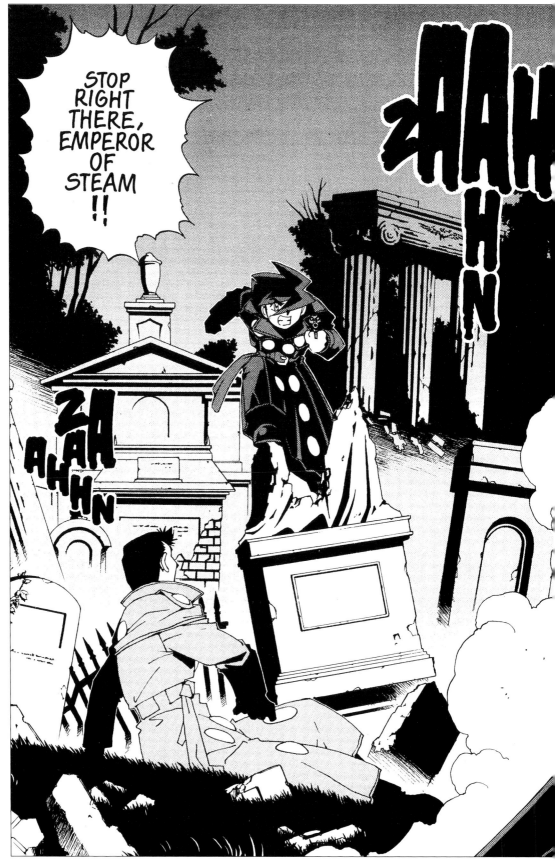

For 1994's *Kaiketsu Jouki Tanteidan (Steam Detectives)*, Asamiya intentionally simplified his style, aiming at a younger audience than that for his previous works.

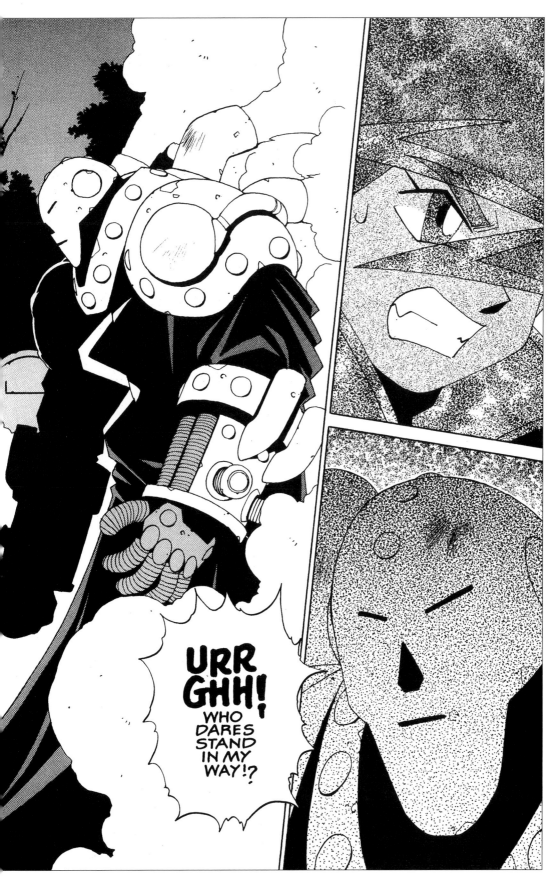

Steam Detectives was animated in 1998. Asamiya served as art director on the project.
© Asamiya Kia / Shueisha

!Karapuri! (Color-Pri) is a lighthearted sci-fi romantic comedy, similar to the *Konpaira* and *Asenbura* sagas. An unsuspecting design student is befriended by two beings from a color-based dimension, one wielding white, the other black, as weapons. Asamiya's art is clever and concise.
© Asamiya Kia / Kodansha

— This is your studio, but you have a separate home, correct?

But now I kind of live here. [Laughs.] I go back to see my kids' faces once a month, though.

— You work how many hours a day?

When I'm doing manga, I just do manga. So I sleep, then do manga, eat, then manga, eat, then manga, and then go to sleep. And after I'm done with the manga, I go out to play.

— How many days a month?

I spend a week on one manga story. I have two [current monthly series], so about two weeks for manga. But on top of that, I have a lot of meetings.

— How many pages a day do you do?

It averages about eight pages a day.

— Are there any of your works that you are unhappy with?

If a title was canceled or ended in the middle, I'm not satisfied. Or the magazine itself ceased publication.

— What are your favorite works?

I like them all. But when it comes to popularity, I guess it's *Silent Möbius* and *Steam Detectives.* And for now, *Junk.* I'd like many people to read this.

— What are your favorite manga or comics by other artists?

For Japanese manga, Ishinomori Shotaro's *Kamen Rider,* Nagai Go's *Mazinger Z,* Takahashi Rumiko's *Urusei Yatsura.* I don't read much manga nowadays. There are a lot of American and European comics artists that I like: Mike Mignola, Moebius, Bill Sienkiewicz, Alex Ross, and Travis Charest. I also like Adam Hughes and Chris Bachalo. I see lot of good artists outside of the U.S. There have been some good covers on *Ultimate X-Men.* The *Secret War* art by the Italian Gabriele Del'Otto. And there was someone from Singapore [Tan Eng Huat, from Malaysia] who's amazing. For *Ultimate X-Men,* the star artist is David Finch.

— What advice would you give to any aspiring artists?

The most important thing is to draw. It won't mean a thing if you don't complete something. The art doesn't have to be perfect; you should just show a completed manuscript. If you're a designer, it's different, but if you want to do manga, you should show completed pages, so keep on drawing and drawing and drawing. You shouldn't get hung up on the approach or the way you do it. If there's a hundred manga artists, there are a hundred ways to do it.

— Is there anything you would like to say to your fans?

Please read more of my manga . . . it comes down to that. It doesn't mean anything unless people read it!

LIST OF WORKS

List of works:
- *Shinseiki Vagrants*, Kadokawa Shoten, 1986, 2 volumes
- *Gunhed*, Kadokawa Shoten, 1989, 3 volumes
- *Dark Angel*, Kadokawa Shoten, 1990–1997, 5 volumes
- *Konpaira (Compiler)*, Kodansha, 1991–992, 3 volumes
- *Asenbura 0X (Assembler 0X)*, Kodansha, 1992–1995, 4 volumes
- *Moebius Klein*, Shufunotomo-Sha, 1993
- *Yuugeki Uchuu Senkan Nadeshiko (Nadesico)*, Kadokawa Shoten, 1996–1999, 4 volumes
- *Star Wars Episode 1: The Phantom Menace*, Shogakukan, 1999
- *Korekutaa Yui (Corrector Yui)*, Shogakukan, 1999, 2 volumes
- *Batman: Child of Dreams*, Kodansha, 2000, 2 volumes
- *!Karapuri! (Color-Pri)*, Kodansha, 2004– , 1 volume to date

Art books:
- *The Art of Asamiya Kia, Vol. 1: Gaia*, Media Works, 1996 (ISBN 4-07-304600-4)
- *The Art of Asamiya Kia, Vol. 2: Venus*, Media Works, 2000 (ISBN 4-8402-1522-7)
- *Dark Angel Illustration Book*, Kadokawa Shoten, 1997 (ISBN 3-89921-223-1)

In English:
- *Silent Möbius*, Viz LLC, 1999
- *Dark Angel*, CPM Manga, 2003
- *Steam Detectives*, Viz LLC, 2004
- *Nadesico*, CPM Manga, 2003
- *Star Wars Episode 1: The Phantom Menace*, Dark Horse Comics Inc., 1999
- *Batman: Child of Dreams*, DC Comics, 2003
- *Dark Angel: Phoenix Resurrection*, Image Comics, 2001
- *Uncanny X-Men: Dominant Species*, Marvel Comics, 2003

(Viz LLC: http://www.viz.com/)
(CPM Manga: http://www.centralparkmedia.com/cpmcomics/cpmcomic.htm)
(Dark Horse Comics Inc.: http://www.darkhorse.com/)

Major works:
- *Sairento Mebiusu (Silent Möbius)*, Kadokawa Shoten, 1988–1999, 12 volumes
- *Kaiketsu Jouki Tanteidan (Steam Detectives)*, Shueisha, 1995–2000, 8 volumes
- *Junk: Record of the Last Hero*, Akita Shoten, 2004– , 1 volume to date

 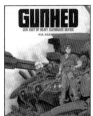

 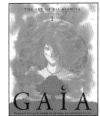 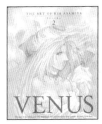

CHECK OUT

Top three:
- *Silent Möbius* (Vol. 1 ISBN 1569313644)
- *Steam Detectives* (Vol. 1 ISBN 1591163218)
- *Junk: Record of the Last Hero* (Vol. 1 ISBN 4253230954)

Web site:
- Asamiya Kia's official Web site: http://www.tron.co.jp
- Unofficial information on Asamiya Kia can be found at: Prisms, the Ultimate Manga Guide http://users.skynet.be/mangaguide/au168.html

Japanese manga artists you might like, if you like Asamiya Kia:
- Fujima Takuya
- Kumakura Yuichi
- Nagano Mamoru
- Shirow Masamune
- Sonoda Kenichi

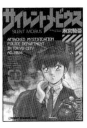 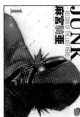

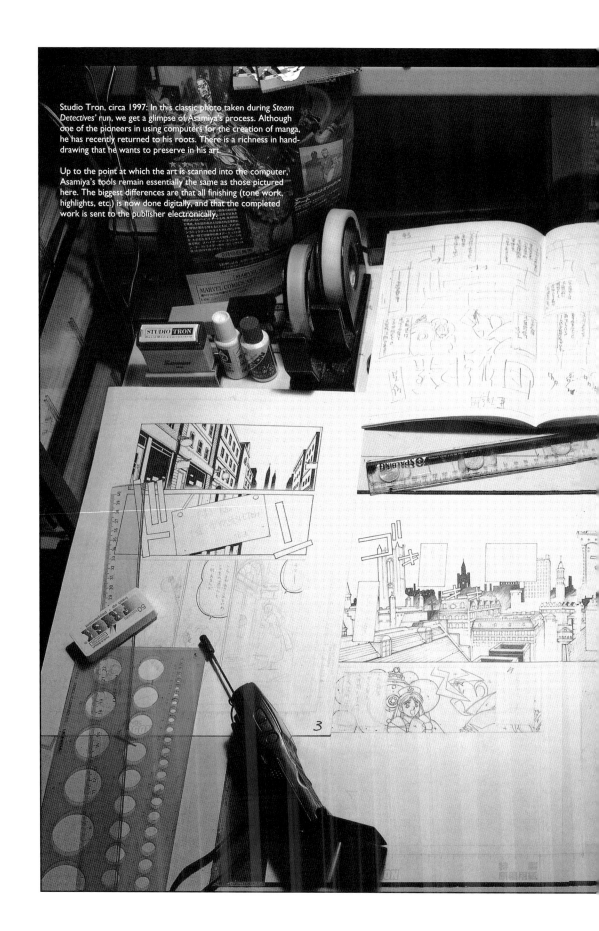

Studio Tron, circa 1997: In this classic photo taken during *Steam Detectives'* run, we get a glimpse of Asamiya's process. Although one of the pioneers in using computers for the creation of manga, he has recently returned to his roots. There is a richness in hand-drawing that he wants to preserve in his art.

Up to the point at which the art is scanned into the computer, Asamiya's tools remain essentially the same as those pictured here. The biggest differences are that all finishing (tone work, highlights, etc.) is now done digitally, and that the completed work is sent to the publisher electronically.

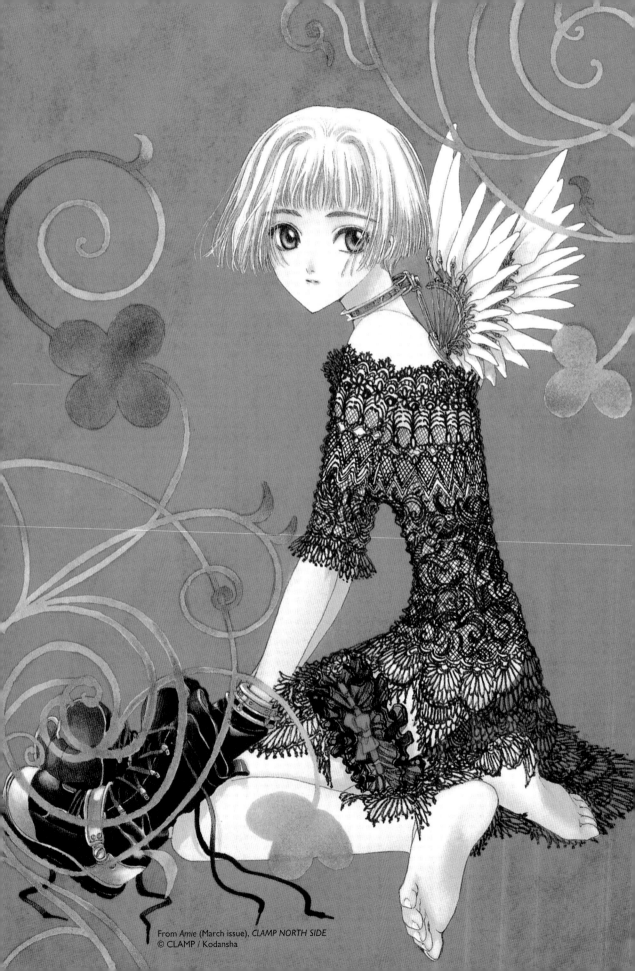

From Amie (March issue), CLAMP NORTH SIDE
© CLAMP / Kodansha

CLAMP

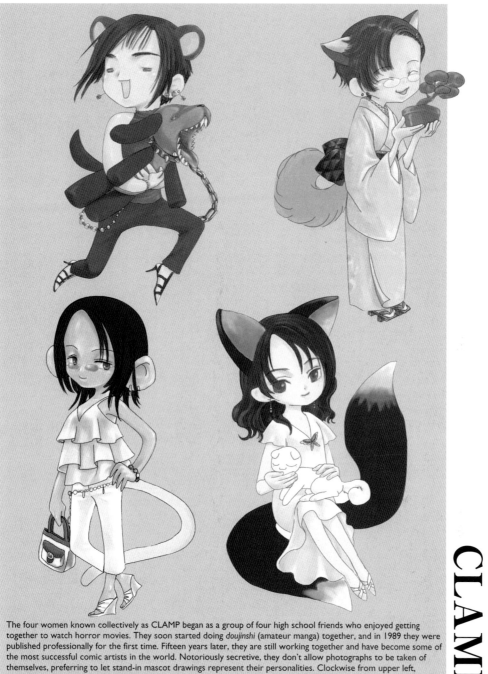

The four women known collectively as CLAMP began as a group of four high school friends who enjoyed getting together to watch horror movies. They soon started doing *doujinshi* (amateur manga) together, and in 1989 they were published professionally for the first time. Fifteen years later, they are still working together and have become some of the most successful comic artists in the world. Notoriously secretive, they don't allow photographs to be taken of themselves, preferring to let stand-in mascot drawings represent their personalities. Clockwise from upper left, CLAMP consists of Mokona, Igarashi Satsuki, Nekoi Tsubaki, and Ohkawa Ageha. CLAMP lives and works together somewhere in Tokyo, dividing their creative tasks among the four of them—they have no assistants.

CLAMP

PROFILE

I: Igarashi Satsuki	M: Mokona
N: Nekoi Tsubaki	O: Ohkawa Ageha

Places of birth: I, M, N: Kyoto, Japan O: Osaka, Japan

Dates of birth: I: February 8 M: June 16
N: January 21 O: May 2

Home base: Tokyo, Japan

First published work: *RG Veda* (Shinshokan), 1989

Career highlights:

1992	*X* begins (Kadokawa Shoten)
1994	*Mahou Kishi Reiassu* (Kodansha)
1996	*X* animated movie released
1997	*Kaado Kyaputa Sakura* (Kodansha)
2001	*Chobitsu* (Kodansha)
2003	*Tsubasa* (Kodansha)
2005	Exhibition "CLAMP FOUR" at Kawasaki Citizen Museum

Hokkaido

JAPAN
Honshu
TOKYO

Kyoto
Osaka

Shikoku

Kyushu

I felt like I was at a slumber party for teenage girls. The four women across the table giggled every time I called them "CLAMP sensei." They clearly were not taking themselves seriously. No matter that they are millionaires many times over. No matter that they are probably among the most famous women in comics in the world. At the heart of it, they are simply four friends doing what they love more than anything else. And still having a wonderful time after 15 years of it.

I was looking into the faces of CLAMP, the legendary female collective of manga artists. CLAMP allow no photographs of themselves and permit only their most trusted friends to visit their home/studio located somewhere in Tokyo. So I had rented a room at a Shinjuku hotel for a meeting with them and two of their editors.

Nekoi Tsubaki, Ohkawa Ageha, Mokona, and Igarashi Satsuki sat across from me. Female energy was thick in the air. I was impressed by their purity and single-mindedness. Ohkawa is their spokesperson and anchor, as she describes her role. But they deny that there is a boss or leader of the group. Their story-writing process is pure brainstorming and their artistic and production roles vary depending on the manga story they are working on. They are a tightly knit professional team who started as amateurs over 15 years ago in the Kansai area of Japan.

CLAMP began with a larger group when they were still high school students. They were discovered selling their *doujinshi* (self-published manga) at Comic Market, a huge Tokyo gathering of manga fans, and debuted professionally with *Seiden RG Veda* in 1990. An apocalyptic fantasy based loosely on Hindu mythology, the series was notable for two things. It had a propensity for killing off its heroes in an unpredictable way, and the art was lush, layered and amazingly detailed.

Still within the bounds of *shojo* (girls') manga, though with a decidedly darker air, CLAMP followed up with a string of popular titles, among them *Tokyo Babylon* and *X*. The latter proved to be one of their defining opuses. Still unfinished as of 2004, *X* is perhaps CLAMP's most intense work, dealing with themes of fate and freedom. Filled with tragedy and violence, this epic was made into a similarly dark and gorgeous theatrical animation in 1996.

CLAMP proved their versatility with 1996's *Cardcaptor Sakura*, an ultracute series aimed at teenage girls, 1997's *Clover*, a steam-punk science fiction tale short on plot but breathtakingly designed, and 2001's *Chobitsu*, their first foray into *seinen* (young men's) manga, with a wish-fulfillment magical love-slave story.

All the while, CLAMP have proven themselves to be exceedingly savvy businesswomen as well as pop culture geniuses, managing merchandise, video game, and other tie-ins with their creations.

I looked again across the table. There they were: Nekoi, with her pouty Mick Jagger-ish lips and confident air; Ohkawa, with her matronly, almost housemother-ish demeanor; Mokona, the cuddly teddy bear; and Igarashi, the petite and very feminine quiet presence. True individuals who had formed a hugely successful partnership as manga creators and managers of a multimedia empire. But most of all, still four friends who are doing what they love together.

The view from our window at the Hyatt . . . reminded me of the scenes of destruction in the animated version of *X*, the apocalyptic tale of two brothers whose "destiny was foreordained." The only thing spookier than meeting CLAMP in the shadow of this landmark would have been meeting on top of Tokyo Tower.
© CLAMP / Kadokawa Shoten

CLAMP's interview

— How did each of you become manga artists, and how was the group CLAMP formed?

Nekoi: I was drawing *doujinshi* when I was in college. Then, right before my graduation, CLAMP debuted in a magazine.

— Had you been drawing with CLAMP while you were at school?

Nekoi: Yes, we had been working together in high school.

Ohkawa: At the time of our debut, we already had too much work to deal with in Kansai, where we had grown up. So we moved to Tokyo, where our publisher was, and became artists. These three [Nekoi, Igarashi, Mokona] came from a different high school than me.

— Did you all go to different universities?

Mokona: Nekoi and I were studying at the same university.

Igarashi: I went to a technical college. Even though we went to different schools, we had still been doing *doujinshi* together.

— So you debuted right before graduating from the university?

Mokona: Yes.

— Did you ever work at another job?

Nekoi: I became a manga artist right after graduation, so I guess not.

Mokona: For a career, I've never done anything else.

— How did you learn to tell a manga story?

Ohkawa: None of us ever studied at schools for manga—the so-called manga technical schools.

— Did you study art in school?

Igarashi: Mokona, Nekoi, and I studied art in high school. It was a three-year high school and we had several courses to choose from.

— Did you ever work as assistants?

All: No.

Ohkawa: I helped my friend as an assistant, but it was not professional work.

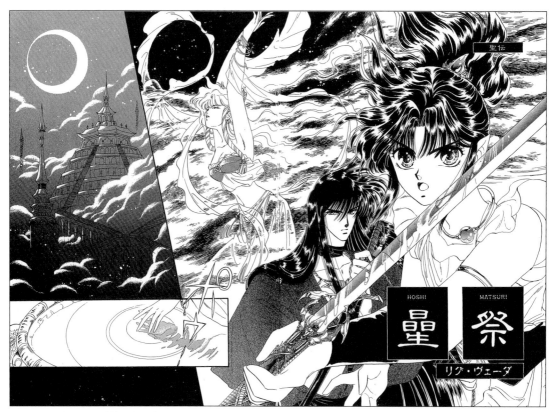

Beginning serialization in 1989 as CLAMP's first professional work, *Seiden RG Veda* refined the concepts of *shojo* (girls') manga. Based loosely on Hindu mythology, *Veda*'s lush fantasy world, morally ambiguous characters, and propensity for killing off its heroes to further the plot challenged the accepted conventions of a genre usually devoted to romance. The dark elements pioneered here would come to fruition in CLAMP's masterwork, *X. RG Veda* ran for seven years and filled 10 volumes. The work has yet to be translated into English.
© CLAMP / Shinshokan

— **What was your first published work, and when did it appear?**

Ohkawa: It was *Seiden RG Veda,* in 1989.

— **Was there ever a low point in your career?**

Ohkawa: Not really. We've occasionally been in bad moods, but we've never been unable to write.

— **What's the secret of being able to work together for 15 years?**

Ohkawa: Maybe because, when we work, we are not friends. Doing manga is our job. We are able to forgive things that we would not be able to . . . if we were friends, because we are professionals. But sometimes there are things we can't forgive since we work as professionals.

Igarashi: We are professionals while we are working, and we are friends when we hang out together. We change our mind-set depending on the situation.

Nekoi: Sometimes, there are things you can't stand if you are just friends.

— **What genre would you call your manga?**

Ohkawa: We've never thought about our genre particularly.

Mokona: We draw many different kinds of manga.

— **Most artists specialize in one type or genre, but CLAMP has drawn for *shonen* (boys'), *shojo* (girls'), and *seinen* (young men's) manga. How do you differentiate between them?**

Ohkawa: We don't really distinguish one genre from another. All are the same. If a girl reads a manga, that's a *shojo* manga for her; if a boy reads a manga, that's a *shonen* manga for him. It's up to the readers. However, there are different restrictions and guidelines from one publisher to another.

Igarashi: Yeah, guidelines differ greatly depending on the publisher.

— **Who are your readers?**

Ohkawa: I think the readers differ depending on the work. If we do a work for children, the readers are children, and if we draw one for older people, those are the readers.

Mokona: Different works have different readers.

— **How do you go about creating a manga story?**

Ohkawa: We basically have two processes. One is creating a manga upon a request from a publisher. The other is when we decide the story first, and then think about which magazine to write it for. Basically, we talk about the rough story and how we should do it, depending on the publisher. Nowadays, we all suggest ideas in a meeting, just like a business one. However, we still have to come up with the outline of the story first. So that's my role. After I create the outline, we discuss who's going to draw pictures, or if we'll all draw together, since several of us can draw. We decide who is going to make *contes* (storyboards), and then we start drawing. We sometimes have a work in which one person designs the characters and another person draws

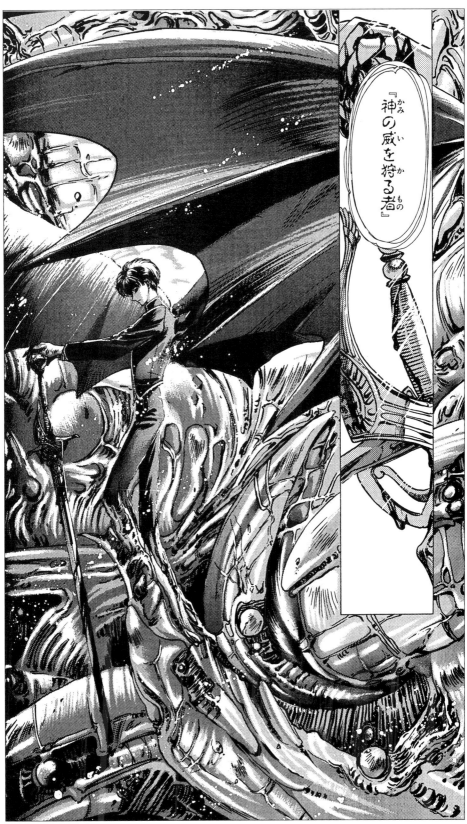

『神の威を狩る者』

Gothic and Giger-esque, *X* deals with the themes of fate and freedom. A supernatural thriller done in an opulent and elegant art style, the story follows a reluctant hero, Kamui, upon whom the fate of the world rests. The apocalyptic tale was made into a visually stunning theatrical anime in 1996.

The manga version, shocking for its violence, was begun in 1992 and is still running 12 years later—although it is currently drawing to a close.
© CLAMP / Kadokawa Shoten

Shirahime-Syo (Snow Goddess Tales) is CLAMP's tribute to traditional Japanese form and storytelling. Done in uncharacteristic ink-wash art, this single-volume manga is a collection of folktales surrounding the legend that snowflakes are the tears of a white goddess. This manga, first published in Japan in 1992, was translated into English in 2003 by TokyoPop.
© CLAMP / Kadokawa Shoten

the actually story, so we divide up the works depending on the situation.

— Who does most of the drawing in your works?

Ohkawa: Everyone.

— Do you have specialties, like character design, coloring, etc.?

Ohkawa: It depends on the time and the work.

— Ohkawa-sensei, it sounds like you're in charge of creating story outlines and running the meetings. When it gets to the drawing stage, do you take a step back?

Ohkawa: Our process of creating works is similar to that of animation and movies. We do assign each person's responsibility, though.

Igarashi: Ohkawa is still the one who makes final decisions . . . so she's our manager.

— When you bring a story idea to a publisher, do you show them a finished rough draft of the story, or maybe just the names of the characters?

Ohkawa: We decided all the names of the characters when we started work on *Chobits*. We brought a rough story and characters to the publisher.

— Tell me how you presented *Chobits* to the publisher. Did you actually draw a rough draft, or did you just explain the characters and the story verbally?

Ohkawa: We first turned in something like a project plan of a movie, which tells how the story goes, who's the main character, the number of episodes, etc. We usually do that among ourselves.

— Does that include sketches of the characters?

Ohkawa: There's a *kyara hyou* (character setting) for an animation, right? It would be a costume setting for a movie. We attach something like that to our project plan and turn it in.

— Is that just a rough description of the characters?

Ohkawa: No, we actually draw them the way they will appear in the manga. It is same as the *kyara hyou* (character setting) for an animation.

— Do you explain the story in words, or with pictures?

Ohkawa: It's done in words.

— Does the drawing include the clothes the characters wear?

Mokona: Yes.

— Do you follow the same process even when a publisher approaches you?

Ohkawa: Yes, we go through the same steps. However, in that case, we have to ask them what they want us to do. For example, if we are to work for a *shojo* magazine, we need to ask them if they want us to do something girly, or if we don't have to worry about it.

— Do publishers ever give you detailed directions, such as "Make the characters look like this" or "We want this kind of main character"?

Ohkawa: For us, that almost never happens.

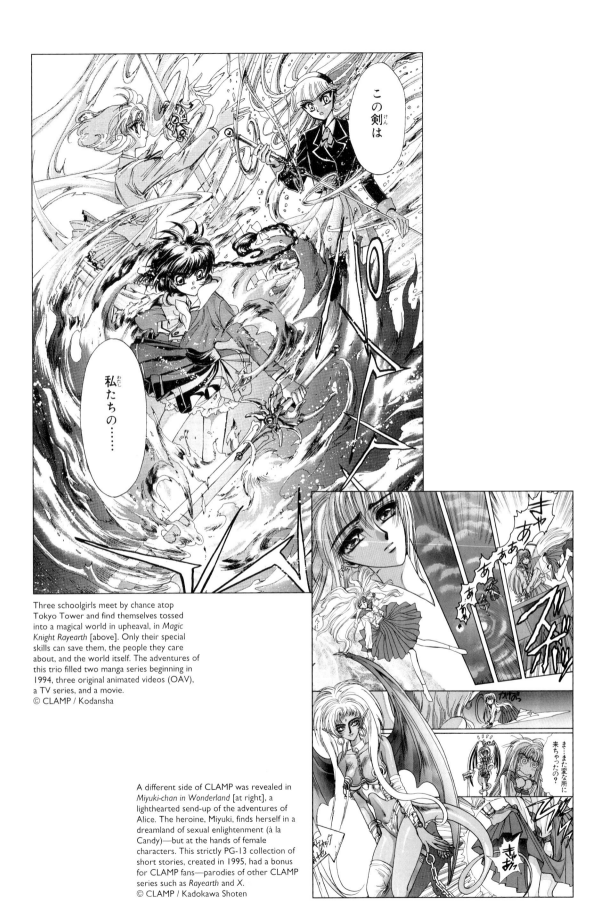

Three schoolgirls meet by chance atop
Tokyo Tower and find themselves tossed
into a magical world in upheaval, in *Magic
Knight Rayearth* [above]. Only their special
skills can save them, the people they care
about, and the world itself. The adventures of
this trio filled two manga series beginning in
1994, three original animated videos (OAV),
a TV series, and a movie.
© CLAMP / Kodansha

A different side of CLAMP was revealed in
Miyuki-chan in Wonderland [at right], a
lighthearted send-up of the adventures of
Alice. The heroine, Miyuki, finds herself in a
dreamland of sexual enlightenment (à la
Candy)—but at the hands of female
characters. This strictly PG-13 collection of
short stories, created in 1995, had a bonus
for CLAMP fans—parodies of other CLAMP
series such as *Rayearth* and *X*.
© CLAMP / Kadokawa Shoten

— Is it more like advice?

Ohkawa: No, that doesn't happen either. We basically only ask what their objectives are. For example, they might say, "We would like to target slightly older readers because that readership is too low now" or "Our readers are mostly girls, but it would be nice if boys could read our magazine." We ask these objectives in the first meeting with the publishers, but we have never been asked, "Please draw cute girls."

— So, even when you are collaborating with a publisher, you are the main decision makers?

Ohkawa: Yes.

— How do you go about creating a new story for a weekly magazine? Where do you begin?

Ohkawa: First, I decide on the rough story, from the beginning to the end. Actually, I often work backward from the ending. In order to have an ending like this, the story should be like that —something along those lines. Next, we decide who is going to design the characters. Sometimes I ask both of them [Nekoi and Mokona] to design characters and pick one of them. After that's decided, we will make a *kyara hyou* (character setting chart) and decide the characters' height, where they live, etc. Height is especially important because it would cause chaos later if we don't determine it at this point. Sometimes we decide the colors of the characters, but it depends on the situation. There are some characters we decide not to color. So, after that, we get the approval of the publisher and start working on the *conte*.

— What's the format of the conte?

Mokona: You know the *conte* (storyboard) for movies? We divide [the story] into frames.

Nekoi: For manga, some people call it a *name*.

— Do you draw it on a small piece of paper?

Igarashi: Sometimes, but most of the time we use same-sized paper as the manuscript (artboard). After we create the characters and script, the project goes to whoever is in charge of the *conte*. After the *conte* is done, we can start drawing in more details.

— Which of you does the conte?

Igarashi: It depends on the work.

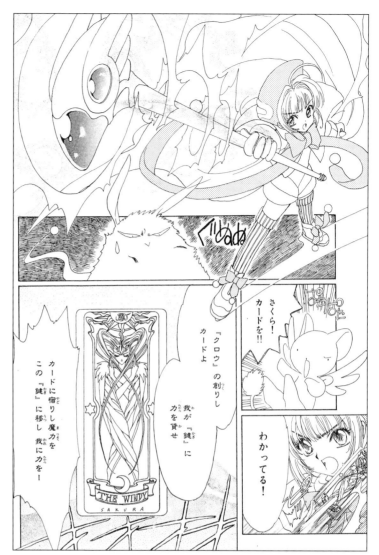

Liminal girl supreme: *Cardcaptor Sakura,* CLAMP's 1997 entry into the magical girl genre, spun off two TV anime seasons and two feature films. The story of a fourth-grader empowered to collect enchanted morphing cards before they can wreak havoc proved immensely popular, both in Japan and abroad. With art nouveau touches, the drawing style was light and airy, in stark contrast to the denser, darker tone of earlier series.
© CLAMP / Kodansha

— Do you use a small notebook?

Mokona: No. Some artists do draw them small, we usually draw them the same size as the manuscripts.

— What size is your manuscript?

Nekoi: B4 size, so-called Genkou size.

— Where do your story ideas come from? Dreams, reading, movies?

Ohkawa: Sometimes I get ideas from my dreams, but never from books.

— Do you ever make notes?

Ohkawa: I know I should take notes, but I don't, so I forget ideas. Tons of ideas have been lost because of that. It's a bad habit. I don't carry around something for jotting down notes.

— Do the four of you get together for a meeting and brainstorm ideas?

Ohkawa: No, actually I am the one who has determined the rough story. In the meeting, we talk about the ideas for specific scenes. For example, "I would like to do something like this; how can we make that cool?" And the others come up with ideas. There are some cases when we design the characters

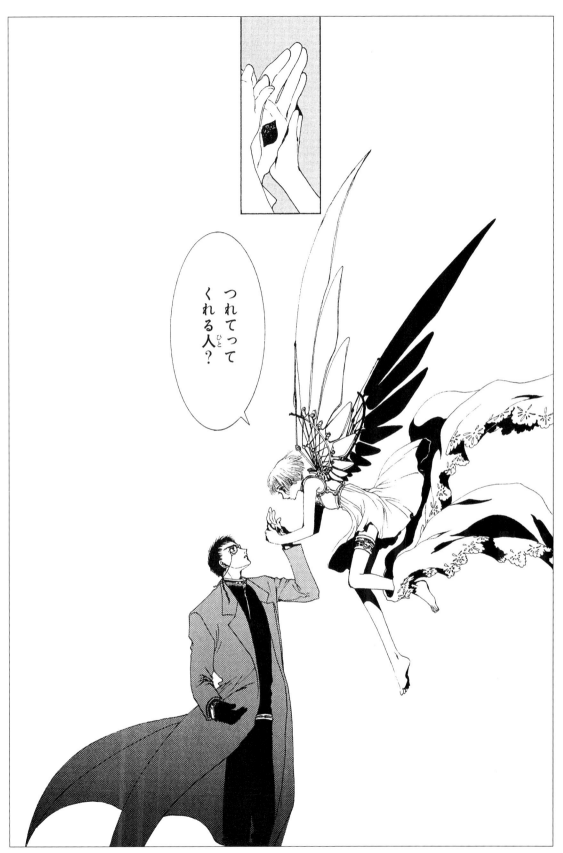

Striking page design, the use of negative space, and a cinematic focus on action and emotion make the 1997 series *Clover* unique among CLAMP's oeuvre.

Set in a retro Victorian sci-fi world of which Jules Verne would be proud, the story
centers on Sue, a paranormal woman pursued by sinister forces. From *Clover*, Vol. 1
© CLAMP / Kodansha

CLAMP proved their cross-gender appeal with 2001's *Chobitsu* (*Chobits*). Created for the *seinen* (young men's) magazine *Young*, it's a sexy sci-fi fantasy, in which a boy named Hideki rescues a discarded, deactivated persocom (personal computer built in human form).

Chobitsu is a kind of futuristic myth of Pygmalion, in which Hideki must teach Chi about the world in order for her to survive, while avoiding falling in love with her.
© CLAMP / Kodansha

before the story. Our method is kind of complicated if you think of it in terms of manga creating. Our process is more like animation, with a director, playwright, character designer, and painter; there are also background artist, creator, and publicist. We take turns doing all those things among the four of us.

— **How much do you use computers in creating manga?**

Nekoi: Almost never. I'm a good friend of the copy machine, though. There are some works for which we used a computer to color the pictures, but for black-and-white manga, we almost never use computers.

Ohkawa: There are only one or two works for which we used computers to color pictures, but we do sometimes use them.

— **When you do use it for color, do you draw by hand and scan the drawing, or do you do it from the beginning on the computer with a tablet?**

Nekoi: We sometimes use the

scanning method, and sometimes we just draw the rough draft using tablets.

Igarashi: We have a couple of painters, but only one can color by computer.

Mokona: Yeah, only Nekoi can do it.

— **How exactly do you use the copy machine?**

Ohkawa: When we were working on *Clover,* we wanted to make a picture look blurred. A lot of people would use a computer to do it, but we blurred it on the copy machine. It's hard to get it right, so we had to try many times.

— **You've published books on your own since you were in high school. Sometimes self-publication leads to a professional debut. Is self-publication important to the Japanese manga industry?**

Ohkawa: It's hard to say. I do think publishing books on your own could be important to the individual. But commercial magazines and self-published books are totally different, even if the commercial magazine doesn't sell as well as the self-published one.

— **Would you recommend self-publication to artists seeking to debut?**

Ohkawa: It depends on the person. When you publish a book by yourself, you can draw it just for you, but you can't do that when you work for a publisher. If you really want to go for commercial magazines, you need to understand that—otherwise you would suffer later on. Some people are suited for commercial magazines, so it's good for them to start there.

— **Who were the manga artists or works that influenced you the most?**

Nekoi: For me, it was the manga Takahashi Rumiko-sensei. And also the artist Wada Shinji-sensei.

Mokona: I was influenced by Matsumoto Reiji-sensei and Hagio Moto-sensei. I had seen Matsumoto Reiji-sensei's pictures since I was little. Animation affected my work, too, since I watched a lot of animation. And I also watched many westerns when I was small.

Igarashi: I was shocked when I first

read Tezuka Osamu-sensei's manga; it was the very first time I had read manga. And I was absorbed in Hagio Moto-sensei's works.

Ohkawa: For me, it was Nagai Go-sensei. He's an important person.

— Any other influences?

Ohkawa: Ichikawa Kon's movies, the ones made by Kadokawa Shoten long ago, written by Yokomizo Seishi-sensei.

— Do you have favorite artists now?

Ohkawa: Terada Katsuya—and not just because we are friends, though!

Igarashi: It's hard to name others. We don't read as many manga nowadays.

Mokona: We can watch movies while we are eating, but it's impossible to read comic books while eating.

— Are there themes in your work?

Ohkawa: Some readers and critics told us our works contain too much individualism. They think we dislike organizations or self-sacrifice. We've never done works like that consciously, but some readers told us that in letters.

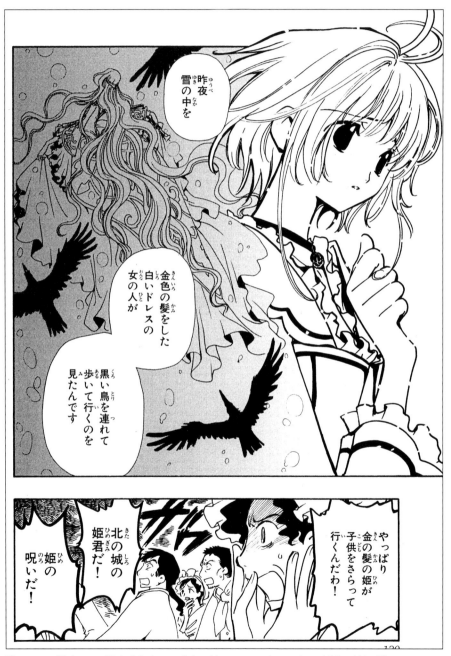

The return of Sakura . . . kind of: Set in a parallel world, *Tsubasa: Reservoir Chronicle* features appearances by several figures from other CLAMP stories—most notably Sakura of *Cardcaptor.* But it's an older Sakura, and in this universe she is a princess whose childhood friend Syaoran must save her from a magic-induced coma. CLAMP's art styles continue to change with the types of story and audience.
© CLAMP / Kodansha

— Has there been any change of style or methods during the last 15 years?

Mokona: The art styles of the pictures have changed.

Nekoi: But the methods haven't changed at all.

— Do you guys intentionally change the art styles in your stories?

Ohkawa: Yes, to suit the work and the magazine in which it will appear.

— What's a typical day for you? How many days a week do you work?

Ohkawa: We start working at 10 in the morning, eat brunch at around 11, and keep on working.

Igarashi: Oh, but we will take a break at 3 o'clock.

Mokona: Then, we keep working. We have dinner at around 6 p.m., and go back to work. There might be time to take a bath, but we'll basically keep on working until midnight or 1 a.m.

Nekoi: And "Good night!" We continue like that for about three weeks. Then we can have a day off; we'll go "Yeah!!" and play around on that day. It's been like that for 10 years, so it's just normal to us. Sometimes we take more days off, like once in two weeks.

— That's amazing. You are devoted to your work! Do you live together, as well as work together?

Ohkawa: Yes. Now we live in a house. The first floor is our office and each person lives in a room individually. So, we don't really know each other's private life.

Igarashi: It's a three-story house: The first floor is our office, two people live on the second floor, and two people on the third floor.

— How many pages do you draw in a month?

Ohkawa: Right now we have two weekly series, so we do about 120 to 130 pages a week.

Mokona: But when we have to do a color one, it takes more time.

— Are there any of your works that you are unhappy with? And what are your favorites?

Ohkawa: I'm not satisfied with our debut work. There are some actresses who would rather die than show their first movie; it's the same reason. But I have a lot of works that I like, so there's no number one.

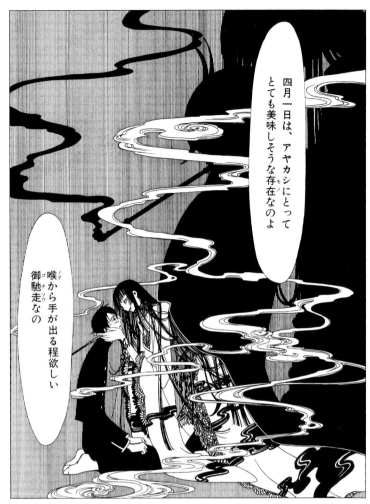

In the "Zone": Watanuki Kimihiro stumbles into witch Yuko's store, thinking he's escaped the ghosts that have followed him everywhere . . . but he is now forced to become Yuko's assistant. Yuko helps people with problems, but always at a price. CLAMP's writing for *xxxHolic* brings to mind TV shows like *The Twilight Zone* and *Outer Limits*—short vignettes with a Saki-like twist. Yuko doesn't so much solve problems as accelerate them, for good or for ill. The art is design-heavy, stylized, and claustrophobic.
© CLAMP / Kodansha

— Do you read any comics from other countries, such as American or Asian comics?

Mokona: I don't know much about American comics. For Asian artists, *eShin Amenosa*, which is serialized in a Japanese magazine, is fun.

Nekoi: And I like *Tintin* from France.

Igarashi: I also like *Peanuts*.

Ohkawa: I want to see *Blade*. I've seen the movie, but I've never read the original comic.

— Do you have any advice for aspiring manga artists? And is there anything you would like to say to your fans inside or outside of Japan?

Ohkawa: We don't have enough time to read it now, but we have all loved manga since we were kids. We hope as many artists as possible can begin making good comics.

— Any advice?

Ohkawa: If you have something you want to draw and can finish it without giving up, you will debut for sure. Do the work till the end. No matter how poor you think it is, there will be some people attracted to it. If it's a comic, finish one story. If it's a novel, also finish one story. The most important thing is to give your idea a concrete form.

List of works:

- *Seiden RG Veda,* Shinshokan, 1989–1996, 10 volumes
- *20 Menshou ni Onegai,* Kadokawa Shoten, 1990–1991, 2 volumes
- *Tokyo Babylon,* Shinshokan, 1991–1994, 7 volumes
- *Shirahime-Syo (Snow Goddess Tales),* Kadokawa Shoten, 1992
- *CLAMP Gakuen Tantei Dan (CLAMP School Detectives),* Kadokawa Shoten, 1992–1993, 3 volumes
- *Gakuen Tokukei Duklyon (Campus Police Duklyon),* Kadokawa Shoten, 1992, 2 volumes
- *Mahou Kishi Reiassu (Magic Knight Rayearth),* Kodansha, 1994–1996, 6 volumes
- *Fushugi no Kuni no Miyuki-chan (Miyuki-chan in Wonderland),* Kadokawa Shoten, 1995
- *Watashi no Suki-na Hito (The One I Love),* Kadokawa Shoten, 1995
- *Wish,* Kadokawa Shoten, 1996, 4 volumes
- *Kaado Kyaputa Sakura (Cardcaptor Sakura),* Kodansha, 1997–2000, 12 volumes
- *Angelic Layer,* Kadokawa Shoten, 1999–2001, 5 volumes
- *Suki Dakara Suki (Suki),* Kadokawa Shoten, 1999–2000, 3 volumes
- *Chobitsu (Chobits),* Kodansha, 2001–2002, 8 volumes
- *Goho Doragu (Legal Drug),* Kadokawa Shoten, 2001–2003, 4 volumes

Art books:

- *CLAMP North Side,* Kodansha, 2002
- *CLAMP South Side,* Kadokawa Shoten, 2002
- *Shirahime-Syo,* TokyoPop, 2004
- *X/1999,* Viz, 1996–present
- *Magic Knight Rayearth,* TokyoPop, 2003
- *The One I Love,* TokyoPop, 2004
- *Cardcaptor Sakura,* TokyoPop, 2003
- *Clover,* TokyoPop, 2001
- *Suki,* TokyoPop, 2004
- *Chobits,* TokyoPop, 2002
- *Tsubasa,* Del Rey Books, 2004
- *xxxHolic,* Del Rey Books, 2004
- (Viz: http://www.viz.com/)
- (Del Rey: http://www.randomhouse.com/delrey/manga/)
- (TokyoPop: http://www.tokyopop.com/)

Major works:

- *X,* Kadokawa Shoten, 1992– , 18 volumes to date
- *Clover,* Kodansha, 1997–1999, 4 volumes
- *Tsubasa: Reservoir Chronicle,* Kodansha, 2003– , 6 volumes to date

Top three:

- *X/1999* (Vol. 1 ISBN 1569311382)
- *Clover* (Vol. 1 ISBN 1892213664)
- *Tsubasa* (Vol. 1 ISBN 0345470575)

Web site:

- CLAMP's official Web site:
http://www.clamp-net.com/
- Unofficial information on CLAMP:
Prisms, the Ultimate Manga Guide
http://users.skynet.be/mangaguide/au228.html

Japanese manga artists you might like, if you like CLAMP:

- Kouga Yun
- Takahashi Rumiko
- Umino Chica
- Watase Yuu

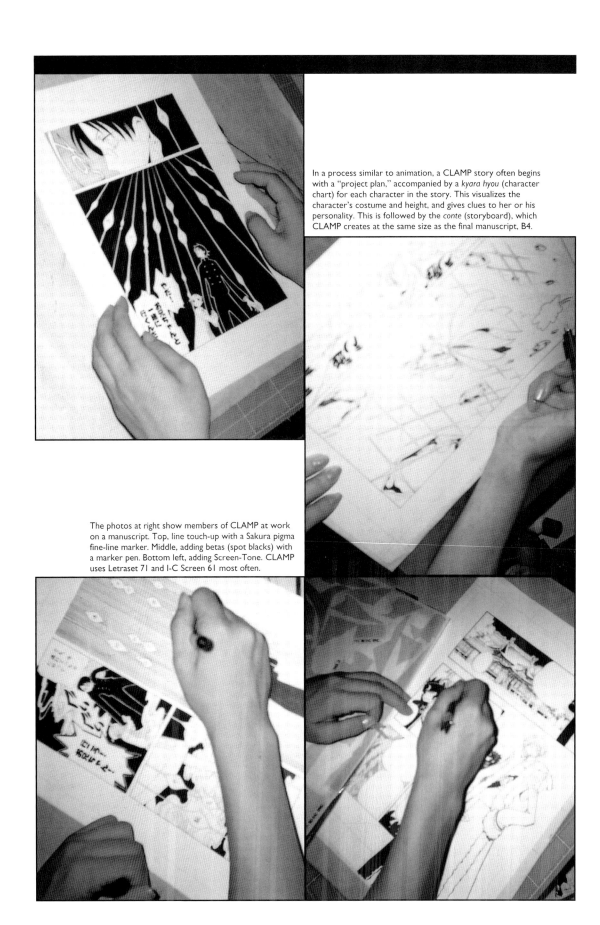

In a process similar to animation, a CLAMP story often begins with a "project plan," accompanied by a *kyara hyou* (character chart) for each character in the story. This visualizes the character's costume and height, and gives clues to her or his personality. This is followed by the *conte* (storyboard), which CLAMP creates at the same size as the final manuscript, B4.

The photos at right show members of CLAMP at work on a manuscript. Top, line touch-up with a Sakura pigma fine-line marker. Middle, adding betas (spot blacks) with a marker pen. Bottom left, adding Screen-Tone. CLAMP uses Letraset 71 and I-C Screen 61 most often.

▼ Kakyo, the cat, She has appeared on the cover illustration for *Watashi no Suki-na Hito.*

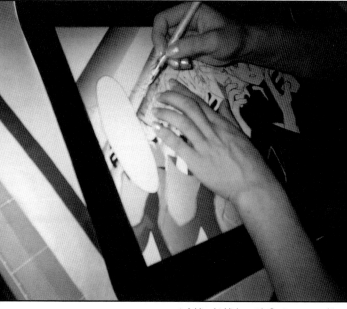

▲ Adding highlights with Copic opaque white and a mensofude.

▼ Coloring with Copic sketch markers over a drawing done in waterproof Sumi no Hana ink. Color work is done at B4 size, the same as black-and-white.

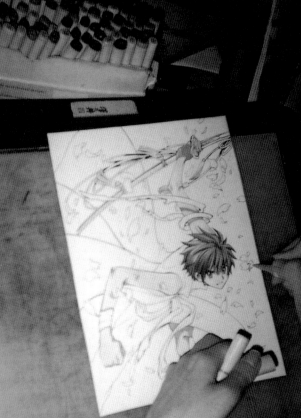

CLAMP's Tools

- Paper
 Conte: Copy machine paper, B4
 Manuscript: Custom-made paper and Genkouyoushi, 100 kg, B4
- sharp pencils, 0.5 mm
- Plus, TREE'S AIR-IN HARD erasers (Igarashi)
- Tombo Mono plastic erasers (Mokona)
- SAKURA MICRON PIGMA
 0.03, 0.05, 0.1, 0.2, 0.3, 0.4, 0.5 & 0.8mm
- Prockey markers (for betas)
- Pentel fude pen (brush pen)
- Sumi no Hana ink (waterproof)
- Zebra Kabura pen
- Dr.Martin's BLEED PROOF WHITE
- NOUVEL VISUAL WVR 3/0~1 mensofude
- 71 Letraset, 61 I-C Screen
- NT D-400 cutter
- Copy machine

Tools for Color Work

- Copic sketch markers, Dr. Ph.
 Dr.Martin's color ink,
 Turner Acryl gouache

Digital Tools

- Computer: Windows
- Tablet: Wacom Intuos i-900 9x12
- Adobe Photoshop 6.0
- Corel Painter 6

- BGM: MTV

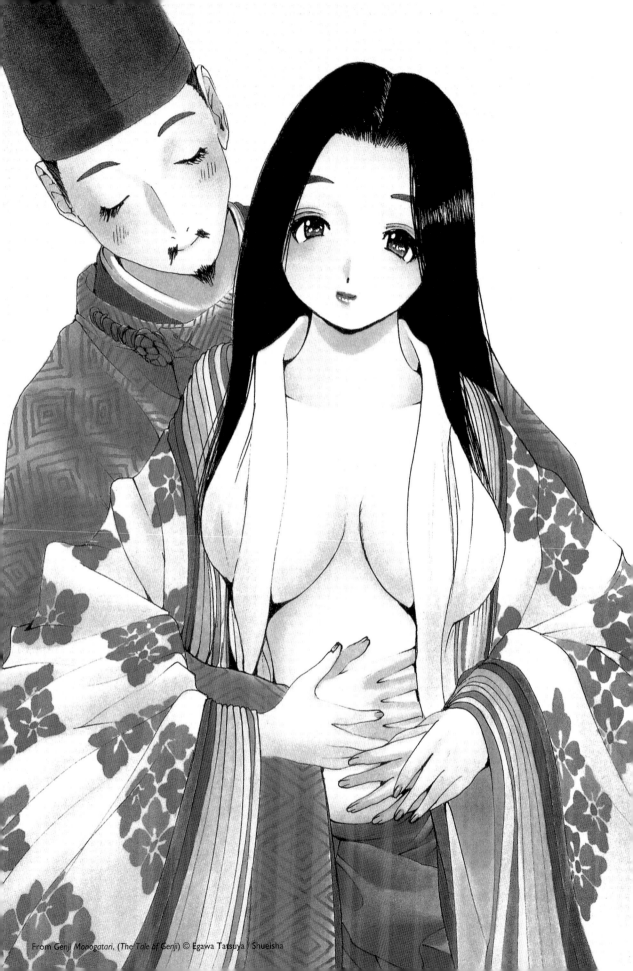

From Genji Monogatari, (The Tale of Genji) © Egawa Tatsuya / Shueisha

EGAWA TATSUYA

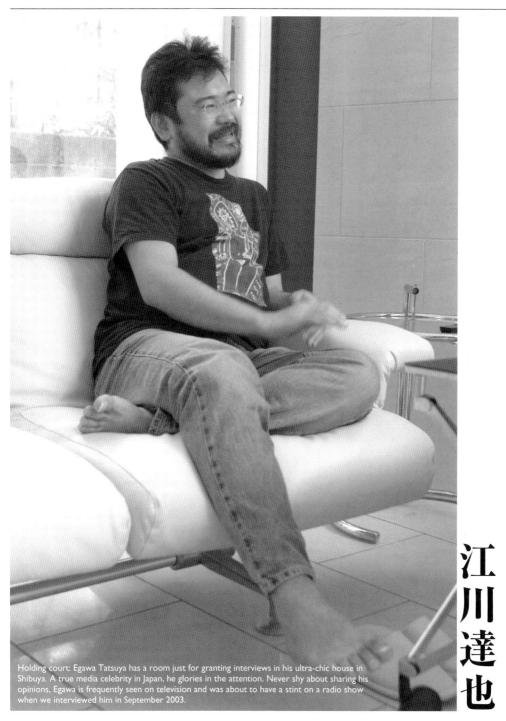

Holding court: Egawa Tatsuya has a room just for granting interviews in his ultra-chic house in Shibuya. A true media celebrity in Japan, he glories in the attention. Never shy about sharing his opinions, Egawa is frequently seen on television and was about to have a stint on a radio show when we interviewed him in September 2003.

江川達也

PROFILE

Place of birth: Nagoya, Japan

Date of birth: March 8, 1961

Home base: Tokyo, Japan

First published work:

Be Free! published in Comic Morning (Kodansha), 1984

Education:

University of Aichi, degree in applied mathematics

Career highlights:

1983 Junior high math teacher in Nagoya for five months

1983 Moves to Tokyo, becomes assistant to Motomiya Hiroshi for four months

1983 Don't Give Up wins Kodansha's Comic Morning open contest

1984 Be Free! begins

1994 Exhibition of original art in Tokyo

2002 Eropop, a retrospective of his career, published (Kadokawa Shoten)

Somewhat disheveled and moving slowly, Egawa Tatsuya met us at the front gate of his $6 million home, clad in a black T-shirt, blue jeans, and sandals. It was 10:30 on a Monday morning, and he looked as though he had just gotten out of bed. His white, minimalist home and studio in ritzy Shibuya is testament to his popularity in Japan, where in his 20-year career as a manga artist he has earned an estimated $25 million.

He led us through the garage sheltering two Mercedes and into his studio, a spacious, long room with pull-down tables for his assistants set in wall niches. It's an immaculate manga factory, where he and his staff produce an astounding 250 pages a month. At the far end of the room was a copy machine, fax, and Egawa's cluttered drawing table, covered with printers' proofs, pencils, and cartons of Coca-Cola. To the left was a bookcase heavy with volumes documenting the Russo-Japanese War, the subject of one of his current series and one of his obsessions.

He next ushered us down a hallway, through a gallery of nude paintings, up a staircase, and into a great room filled with light. This is where he grants interviews and meets with admirers. Egawa is a celebrity in Japan and relishes the attention. He warmed and energized as the interview progressed, and soon assumed what is apparently his favorite stance: sensei, the teacher/philosopher.

His first career was, in fact, that of a junior high school math teacher in Nagoya. He quit after five months, frustrated with a system geared to "stuffing knowledge into students' heads" rather than teaching them to think. He followed his heart and moved to Tokyo, becoming an assistant to a well-known manga artist, Motomiya Hiroshi.

"This experience had a huge influence on my life. In my career as a manga artist I have decided many times to throw away what I had." It also foreshadowed his central themes: Think for yourself, don't accept common sense, and rid yourself of illusions.

From Motomiya he learned the business of manga, but his storytelling seems to have come instinctively, as he pioneered cinematic techniques that could put you in the skin of his protagonists. He also developed a distinctive, sensuous pen-and-ink style.

Egawa has never been politically correct. He has depicted outrageous sex and scatological humor, but has always somehow made it palatable for mainstream magazines. And commercial success has given him freedom to do his current, more challenging, and probably less popular work.

In addition to the aforementioned antiwar story, he is producing a scholarly (and erotic) adaptation of the eleventh century novel *Genji Monogatari (The Tale of Genji)*, in which he presents the original text in archaic Japanese so readers can "feel" the language. He claims he would like to do the Bible like this, in the original Hebrew. " It would change the world," he says.

But despite his ego, there seems to be a tension between the businessman/entertainer he is and the literary artist he strives to be. For all his fame and success, Egawa still seems to long for respect.

EGAWA's interview

— How did you become a manga artist?

I began drawing manga when I was in the fifth grade. I had read Ishinomori Shotaro's *Kamen Raida (Masked Rider)* and didn't like how he drew the details of the character's belt. I was sure that I could do a better job. I was a teacher for a while, but the reason I became a teacher is similar. When I was a student I was dissatisfied with the way the teachers taught and had ideas about what I would do if I were a teacher. I actually wanted to be an elementary school teacher, but couldn't for various reasons. Japanese junior high schools concentrate on stuffing knowledge into students' heads. On the other hand, education in the first three years of elementary school is relatively free. That's why I quit not very long after I became a junior high teacher.

— So you went to school to become a teacher? You didn't receive any special training in manga?

No, I didn't receive any training in manga. My major was mathematics, so I taught myself how to draw manga. I bought a book called *Introduction to Manga* to find out what kind of tools I needed. After that, I thought I would just teach myself by looking at manga. I was still in elementary school, but back then I was already drawing better than some professionals.

A wall of books: Within reach of his drawing table, Egawa maintains a library devoted to the Russo-Japanese War, the subject of one of his current series. *Genji Monogatari (The Tale of Genji)* is another series for which Egawa has done extensive research.

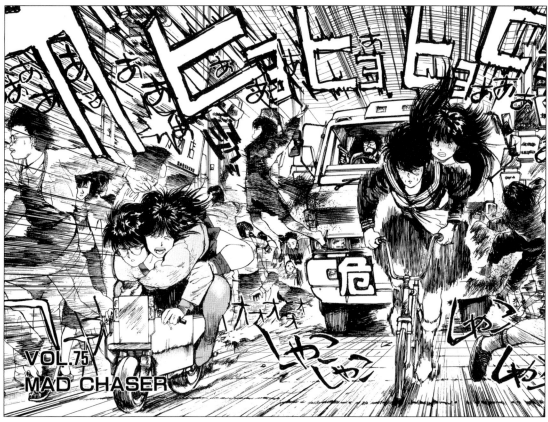

VOL.75
MAD CHASER

Bursting upon the manga scene in 1984, Egawa's debut work was *Be Free!*, an exuberant tour de force about a renegade high school teacher, full of anarchy and Egawa's trademark sexual imagery.
© Egawa Tatsuya / Kodansha

— Why did you plan on being a teacher instead of a manga artist?

When I was growing up, there were only a few manga magazines, and opportunities for becoming a manga artist were limited. Also, I was brought up in Nagoya, which was a very conservative area. Although there were a number of manga artists in Tokyo, there were hardly any in Nagoya. I chose to go to a teacher training university because there was a better chance of me becoming a teacher.

— Did your parents influence your decision to become a teacher?

My mother's father was a university teacher. He died at a relatively early age, and my mother had to drop out of high school, so she wanted her child to have a high level of education and a good job. She passed on her dreams to me.

— Was it hard to leave your job as a teacher and become a manga artist?

There was a part of me that was very uneasy about leaving a stable job. But I had to decide between following my heart and doing what I believed or taking the steady path and continuing in a job I didn't like. After trying teaching for a while, I couldn't take it anymore, and although it was a highly unnerving step, I decided that I should do what I really wanted to do. Soon after quitting my job as a teacher I went to work for Motomiya Hiroshi and was so glad that I had quit. I felt liberated. That experience had a huge influence on my life. I learned the liberation of letting go. In my career as a manga artist I have decided many times to let go of what I had. And although it is unnerving to do so, it always feels good when I do.

— How long did you work for Motomiya-sensei?

Four months. I was a teacher from April to the beginning of September, and from September to December I worked as an assistant for Motomiya-sensei. Before I went to Motomiya-sensei's place, he had told me that he would find me a place to live, but when

An 11-year-old Egawa emulated Ishinomori Shotaro's *Kamen Raida (Masked Rider)* [inset], by creating several volumes of a manga he called *Kamen Gyakotsu (Skull Mask)*.

Like a Jim Carrey on speed: Egawa is known for exaggerated, and at times grotesque, facial expressions. Shown here are the protagonists of *Tokyo Daigaku Monogatari (Tokyo University Story)*, Murakami Naoki and Mizuno Haruka. What starts out as a simple romance manga becomes a complex soap opera full of convoluted and obsessive relationships, but memorable characters. In the last volume (number 34), it is revealed to have all been the daydream of a precocious grade-schooler named Haruka-chan.
© Egawa Tatsuya / Shogakukan

I went there, he hadn't found a place [laughs], so I ended up sleeping in the restroom in the workplace. It was meant to be a short-term arrangement, but I ended up staying there for—I can't remember whether it was several months or a couple of years—but for a long time. There was no privacy whatsoever. [Laughs.] But I really liked living there.

— Your first published work was . . .

Be Free! The first month I was at Motomiya-sensei's place I completed a 30-page story and had him look at it. He liked it and showed it to the editors at the two magazines that he worked for at the time: *Jump* and *Morning*. *Jump* was really competitive, so the editor there told me that I needed to study more. On the other hand, at the time, *Morning* was struggling, publishing about 80,000 copies per issue and selling only about 10,000. *Morning* featured quite a lot of older manga artists. Anyway, they told me that they would serialize a story immediately. The one condition was that the main character was a teacher—since I was a teacher until recently. That's why my first work is set at a school. And since I could draw cute girls, they wanted me to include cute girls in the story as well. I showed Motomiya-sensei the *name* (thumbnail with script) I had prepared for the series, and the first two episodes got the go-ahead immediately, but I had trouble getting the third one through and had to fiddle around with it a lot. On the strength of the first two episodes, I decided to go ahead and have the story serialized in *Morning*. The first episode came out in the issue of *Morning* that went on sale on March 8, my twenty-third birthday. And that series continued for four years.

— What is the most important thing you learned from Motomiya-sensei?

When I handed Motomiya sensei that first 30-page story, before he went

Cinematic storytelling from Tokyo Daigaku Monogatari (Tokyo University Story): This sequence shows Murakami's reaction when he learns he failed the entrance exam. Over the course of 14 pages, we feel his pain.
© Egawa Tatsuya / Shogakukan

into his room to read it, he asked me, "Will this sell?" Those are the words I remember most. That was the first time I understood that manga, before being a work of art, was a product. Before then, I placed a strong importance on the theme of the story and so on. That might be my mother's influence. It's also a myth that other manga artists have created in various books and interviews. As I began taking my work to editors, I realized that this wasn't the case. Motomiya-sensei understood that manga was a product that readers paid money for. If you understand that, it's not hard to figure out how best to market your book.

— Have you ever experienced a low point in your career?

I always have plenty of ideas. But I'm not always sure those ideas will sell. I sometimes experience difficulty when I have to change a work to make it more marketable or think up a story that will sell. There was, however, a period when I had trouble keeping up my motivations. It was when I was working on Book 5 and 6 of *Be Free!* Book 6 was especially tough. In Book 5 I kind of lost control and destroyed the school. [Laughs.] The difficulty I had was in reconciling the story I wanted to draw and the story that sold well. By completely ignoring themes, I could create a story that sold well, but I couldn't achieve my goal of communicating to the readers. But when I did create a story that was heavy on theme, many readers didn't like it. I asked myself why I was drawing manga. I still ask myself that question.

— What genre would you say describes your work?

That's a difficult question. Intergenre maybe. (Laughs.) What I mean to say is that genres are stereotyped. And the problem is that people come to believe that stereotypes are the truth. I want to challenge what people take for granted, and make them see what they don't usually see. In *Tokyo Daigaku Monogatari (Tokyo University Story),* for example, the set idea of how a romance manga is supposed to proceed is gradually lost and the story becomes something else. A paradigm shift takes place and gives birth to a new genre that defies stereotypes and common sense. I guess I could call my work a "philosophy" genre.

— You must have a wide range of readers?

Some artists are dragged into a negative cycle and think their popularity among readers defines the value of their existence, but this just makes them slaves to the readers. I thought about this carefully and decided I should make an effort to change my audience each time. Since I change genres every time and alienate previous audiences, if you ask me who are my fans, I feel like I have none. For example, fans of *Nichirosensou Monogatari (The Russo-Japanese War Story)* are usually not fans of *Tokyo Daigaku Monogatari (Tokyo University Story),* and when those who became fans reading *Nichirosensou Monogatari* go back and read *Tokyo Daigaku Monogatari* they feel resentment and think, "I can't believe he was writing such a manga!" [Laughs.] It makes my job more interesting, too. That is why I'm not capable of giving a precise answer to that question.

— Do you think some readers might be enjoying the differences in the stories and art styles?

I guess those are the real fans. If they are truly enjoying the difference between stories, I guess I have succeeded in my efforts of trying to get people to challenge stereotypes by working as an intergenre artist. I would expect those kind of fans to be rare.

— How do you go about producing your manga? Do you first think of a story line and characters, or do you work from an image?

When I was working on *Be Free!* I worked from an image and then created the story line and discussed it [with the editor]. Now, though, I first create the *name* [loose plot mixed with thumbnails] and we talk about it. When I'm rushed, I can do 20 pages of *names* in 10 minutes. There are times when my hand has a life of its own. The *name* is basically all dialogue and no pictures. I can picture what will be drawn in my head, so there isn't much time spent there. My mind is an endless source of visuals. Sometimes I'll have one story line in mind, but it morphs as I progress and an unexpected story line is more interesting. I'm most happy when I can write whatever I want. [Laughs.] Whether it will be interesting to readers, I never know.

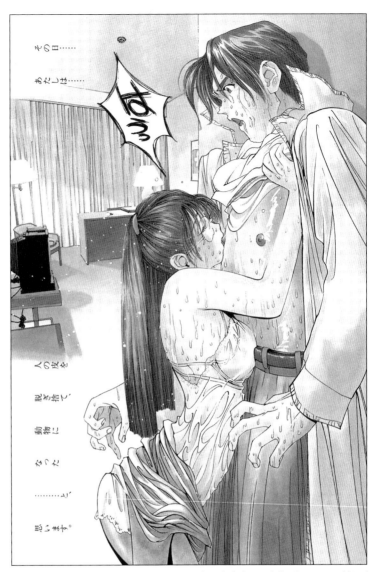

The reason he failed the exam: Murakami spent the night before with Eri-chan, a mutual friend of his and Haruka's. In the course of *Tokyo Daigaku Monogatari,* Egawa pushed the boundaries of depicting sex in mainstream magazines. He is credited by one writer as creating a visual genre of "sweaty sex." In the final volume of the series, he illustrated a childbirth in similarly graphic detail. © Egawa Tatsuya / Shogakukan

— Where do your ideas come from?

Enjoyment. It's a type of inspiration. Ideas come to me automatically, loads of them, when I am talking or doing something else.

— Are you influenced by books and movies?

Yes. By boring movies, especially. I find many things wrong with a movie and loads of new ideas come to mind. I always feel like I would be able to make it much better. Of course, good films have a positive influence on me as well, but there is always something that I would like to improve in a film. Visuals move about in my head, so I think I would be able to make an amazing movie, but I haven't had the opportunity yet. It may sound a little pompous, but I get all these ideas about how to improve even popular Hollywood movies featuring the latest special effects and visuals. I have already seen much more in my head.

— Do you keep an idea notebook?

I used to, but not anymore. The second an idea is written down, it doesn't expand any further. I don't write down ideas, but let them expand as far as they want. It's okay to forget them. They usually come back when I'm jotting

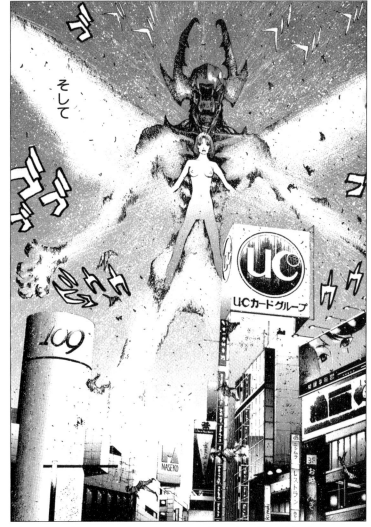

In *The Last Man*, Egawa plays with concepts pioneered by another of his childhood inspirations, Nagai Go. This scene is an obvious homage to Nagai's *Devil Man*.
© Egawa Tatsuya / Kodansha

down the story line. Once the words have been written down, the images that accompany them are limited. That's why I like doing things live— on the spot. While working on *Be Free!* I made the story for most of it while I was on Volume 3. By the time I got to the fifth volume, I didn't like it anymore and abandoned it all. I didn't want to be tied down by something I had thought of in the past.

— Do you make a rough draft with pencil after the story line is down?

I have a meeting with my editor because, after all, I'm a professional. We discuss each part and I take that into account when doing a draft.

— Can you explain the process from draft to completion, including what your assistants do?

Basically I want to do everything myself if possible, but when there isn't enough time or when it's a tedious part, I ask my assistants for help. The rough draft is really rough. The assistants only do backgrounds. Nobody can make something exactly the way I picture it in my head, so the base for the background is mostly tracing photos. I do backgrounds myself, too. I do the soldiers and people in the distance, too, but when there are images the assistants can use, I ask them to do it. I have five assistants and they work in shifts. It's their job to find photos to use for background images and contact the

copyright holder. The photos are then enlarged on a photocopier to the size we want. The composition of the picture cannot be changed, so we use a special tracing table to adjust the photo to the manga frame. The assistants can't draw people in motion, so I have them work on boats, for example. If I don't like the boats they draw, I discard what they may have spent three days working on and do it myself in an hour or so. The tone and etching are the assistants' job. For *Nichirosensou Monogatari (The Russo-Japanese War Story)* I give each assistant a page or two to do a day. Right now I have five assistants, so I create enough work for five people. If I had another assistant I would create enough work for six.

— How many series are you working on at the moment?

I am doing many if you include small jobs, but in terms of my regular work, I am currently doing *Nichirosensou Monogatari (The Russo-Japanese War Story)*, which is a weekly, as well as *Genji Monogatari (The Tale of Genji)* and *Yapoo, the Human Cattle*. *Yapoo* is in the final stage and I do it all myself. I also have *Egawa Tatsuya Study Methods in Saizo*, which is eight pages. I'm still working on a story about raising children, but that's only once every two months. That's about it for the main stuff. I also have a one-page thing in *SPA!* It comes out to about 250 pages a month.

— How many deadlines do you have in a month?

I have three deadlines a week and three meetings a week. Putting together my schedule is like working on a puzzle. A Japanese manga artist who drew a lot—it might have been Satonaka Machiko—did 1,000 pages a month, so compared to that it's nothing. [Laughs.] At his peak, I hear Nagai Go was producing 600 pages, and Ishinomori Shotaro produced 800 pages. Even in Japan it's rare for artists to produce that quantity. Those considered to produce a lot usually manage a bimonthly and a weekly. They also let the assistants do a lot of the work. I've always been picky on details, so I have to do the work myself. To make up for this, I work fast. People only have 24 hours a day, but by condensing work and producing it quickly, the time expands. The way Murakami-kun in *Tokyo Daigaku Monogatari* does many things in a split

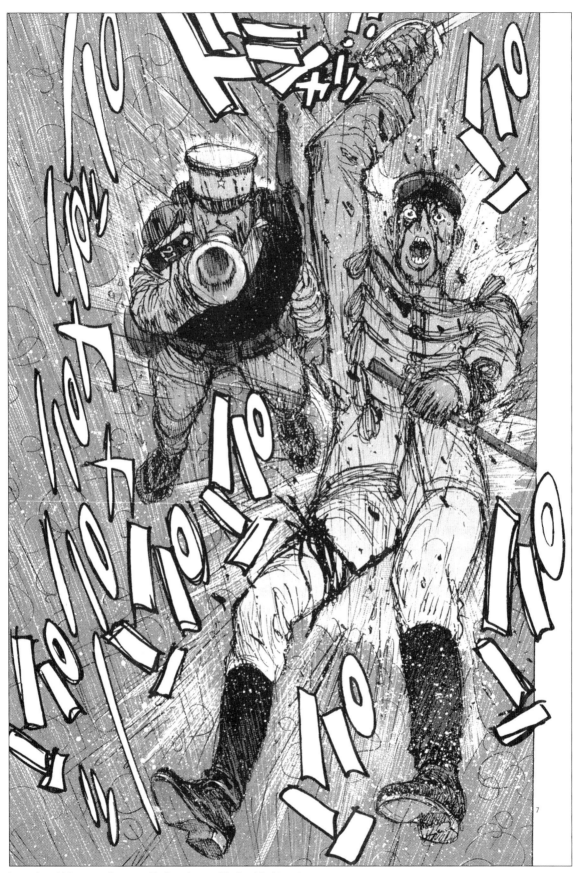

Images from *Nichirosensou Monogatari (The Russo-Japanese War Story)*. In this series,
Egawa examines the true-life horror of war and the politics behind it.
© Egawa Tatsuya / Shogakukan

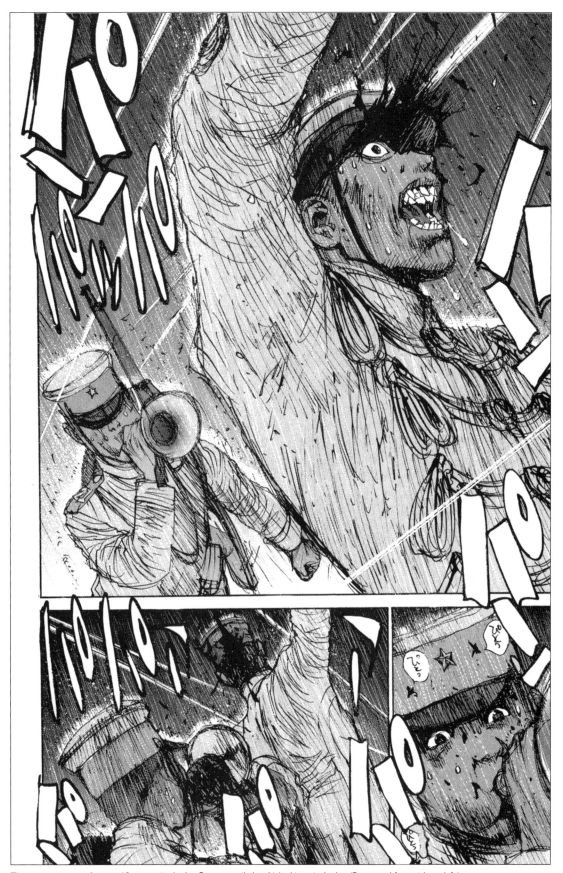

These two pages are from an 18-page episode that Egawa penciled and inked in a single day. (Pages read from right to left.)
© Egawa Tatsuya / Shogakukan

second is based on my own experience. When I do this condensing trick too much, I see the people around me move in slow motion, especially my assistants. After getting up in the morning I increase my speed gradually, and the adrenalin starts pumping, and I begin moving fast and even speaking fast. It really happens.

— Have you ever used computers for your manga?

No. My thesis in college was on computers, but the reaction time of a computer is too slow for me. [Laughs.] When I use software to draw pictures, I start getting annoyed with the computer and end up wanting to make my own program. I'm scared of moving in that direction, so I stay away from computers. Besides, when everyone is working using digital devices, everything becomes the same. It's key to move toward analog at times like this. I think it's better to show how good analog is, and once computers become more sophisticated and are able to understand analog, people will finally realize how superb analog is. The more the world leans toward digital devices, the more important analog becomes. A famous Japanese mathematician once said that when pursuing the essence of math, one comes to appreciate the greatness of a vague haiku. I really understand what he means.

— What do you think about the experimental manga magazine *Garo*?

It might have been good in the past, but I haven't read it in a while. I do hope that kind of experimental manga continues though. I might be just the kind of artist for *Garo*. [Laughs.]

— Have you ever felt restricted as an artist by drawing mainstream manga?

Always. But my plan was to become famous and secure my reputation. After that, I could go off with my own ideas. Now I do think a little about popularity, but I can focus more on what I want to do. And I succeeded in creating that kind of environment for myself. Even now, though, publishers have a lot of say. Japan is changing slowly, too, and my themes are becoming more accepted because society has moved in the direction I was hoping it would. For example, I never believed that having a strong

academic background equaled success or that the best form of education was cramming information into students' heads. Such things are changing in the direction I said they would.

— Are there any other manga artists you were influenced by?

Nagai Go-sensei, the author of *Devil Man*. I also like Mizuki Shigeru-sensei very much. There are many Tezuka Osamu fans, but those people tend to have a sort of Western complex. As a manga theme, there is a conflict between Western style and Eastern style, localism, and globalization. The Tezuka Osamu fans tend to lean heavily toward Western style. Mizuki-sensei has a sense of localism, or an Eastern theme. It's original. Tezuka

Osamu tends to borrow ideas. I don't mean to deny all Western things, but if I was going to have a Western profession, I would do math or science. In the field of manga and literature, the Eastern style has a much better way of expressing feelings. The important fact is the balance between the two. Tezuka Osamu said he was writing about science, but I don't think he really understood numbers and science.

— One theme I find in your work is overcoming illusions.

It's more than a theme; delusion and reality are key material for my work. I think there is a reality in your head, and that this differs from actual reality, and people should try to get what is in their head as close as possible to what is

Kids' stuff: *Magical Taruruuto-kun* is a series about a diminutive magician from another world who aids human children. This manga was adapted into an anime in 1990. Egawa created two other manga targeted at grade-schoolers: *Happy Boy*, about a kid with superpowers in a fairy-tale land, and *Madou Tenshi Unpoko (Mysterious and Automatic Angel Unpoko)*, about another small being helping troubled people. Egawa also currently has a bimonthly manga based on his experiences with his young sons, which began with the title *Take-chan to Papa (Take-chan and Papa)*.
© Egawa Tatsuya / Shueisha

in reality, or to develop a brain that is aware of reality. People can never actually see reality as it is, but my theme is that humans should aim to see things for what they are as much as possible. We can call it metaphysical and physical, or inside and outside the head. Words are limiting. When using English, one can only use English phrases, and Japanese limits the speaker to Japanese phrases. This was the reason for my interest in translating the original *Genji Monogatari*. Even within the Japanese language, by switching from contemporary Japanese to ancient Japanese and back, the reality shifts. With pictures you can create completely different worlds by drawing realistic pictures or simple pictures, like *Doraemon*. The same is true of Western drawings versus Japanese drawings. For this reason, I do a lot of experimenting with my drawings, too.

— **Can you can tell a different story by changing the drawing style?**

That's right. It's common for the drawing style to limit the story. When drawing a certain style, one can only have a certain type of story. So when you want to try a different genre, you are forced to change your style. I am able to change my drawing style as the story demands. I also think that Japanese is the closest language to drawing. The most logical language is math, and if I were to put the various languages in order after that, Japanese comes closest to drawing. A haiku poet in the Meiji era, Shiki Masaoka, said the same thing. In the times of *Genji Monogatari* even, there was a custom to view paintings while reading the *Genji Monogatari* novel. My personal research concluded that the reason manga become such a big part of Japanese culture is because the Japanese language is very close to drawing.

— **Your *Genji Monogatari* is very true to the oldest original manuscripts.**

I try to keep it as close to the original as possible. Recently, I have been working from the oldest copy in existence. I translate it myself, for my own research. Contemporary Japanese, as well as Japanese during the Meiji era, incorporates many foreign words and is not the pure form of what it was. I wouldn't be able to do what I wanted, if I didn't experience the original language and translate it. Almost more than relaying the story to my audience, my goal is to learn to read ancient Japanese. I find it more important to feel the language than to understand it. Japanese has a different feeling from other languages. Japanese even has a word to express the belief that uttering a thought breathes life into it. Japanese is the language with the most spirit in it. That is the reason that Japanese have trouble making logical conversation. Japanese uses both the right and left hemisphere of the brain. This is why a sound made by a cricket tends to be just noise to an English speaker, while a Japanese speaker perceives it in the speech center. Sound effects in manga are considered to be language among

Sex, history, and language: *Genji Monogatari (The Tale of Genji)* gives Egawa the opportunity to explore all three of his current passions. In his retelling of the classic eleventh century Japanese literary work, Egawa presents sentences from the source material in their original archaic Japanese, along with his translation and visual interpretation of the story. He says he wants readers to "feel" the language and much as read it.
© Egawa Tatsuya / Shueisha

Japanese. This is another reason why I think manga really took off in Japan.

— In your manga, you challenge what is considered common sense in society—socially and morally—and make people rethink what is normal.

It's the foundation of my philosophy.

— Do you believe this is a key role for an artist, to be a provocateur?

I don't know how I would define "artist," but manga is basically a form of entertainment. I don't find the need to make people think when they want to be entertained. People with themes, in Japan are called *sakka*, or literary authors. Literary authors and entertainers lie on different poles. Entertainers aim to envelope the audience in a mellow fantasy, while literary authors make the audience think and lead them into a fantasy. The way in which they do it is completely different. In order to earn a living, one must provide entertainment, but to survive in the entertainment world, one has to make the production as real as possible to lead people deeper into fantasy. In Japan though, that type of entertainment has become too strong and the educational aspect of it is being lost. People these days are less able to see reality. There are those who produce entertainment manga and those who produce literary manga. There are many who claim to be literary manga artists who are just entertainers. If you claim to be a literary artist, I think you should be producing stories that make people think and look at reality. If not, you should focus on selling more copies and go right along with the commercialism and its waves. Personally, I would like to be a literary manga artist, but I have nothing against people who are entertainers. I'm currently working on *Nichirosensou Monogatari (The Russo-Japanese War Story)* and would like military personnel to read this. The story hasn't reached the war scenes yet, but gradually there will be more battle scenes. I wonder what American military people will think if they read it. I really do think, considering future world affairs, the United States would find ways to solve various problems if they took in some Japanese culture. And, of course, one of the things they should take in is manga. My work, definitely. This is why I say I would like military personnel in the States to read my work. [Laughs.]

The bizarre Yapoo: Based on a series of novels written in post–World War II Japan, Egawa's *Yapoo, the Human Cattle* is on the surface a masochist's wet dream. In a future world, Japanese people are reconstructed to serve the white race as biological appliances—sexual and otherwise. An Orwellian nightmare, the novel has been described as the ultimate statement of racial self-hatred. It's the kind of multilayered, provocative material that Egawa enjoys.
© Egawa Tatsuya / Gentosha Comics

— What do you think about manga being translated?

If it opens up a window of communication, I think that's great. If it also leads to more people learning Japanese, that's even better.

— Do you have any advice for aspiring comics artists outside Japan?

When it comes to comics, Japan is the major leagues, so it may be interesting for artists to learn the rules of Japanese manga and try to publish in Japan. Artists wishing to improve their drawing skills could come to Japan, and if they get published here and make tons of money . . . after all, it's the biggest market. It's happened with some Korean artists, getting published here. So if an American came to a Japanese publisher and was handed all this yen for their work, and that became news in the States, that would be fun to watch!

LIST OF WORKS

List of works:

- *Take-chan to Papa (Take-chan and Papa),* Mamanga, 1995– , 3 volumes
- *Happy Boy,* Gangan, 1996–1998, 3 volumes
- *Madou Tenshi Unpoko,* Coro Coro, 1998–1999, 4 volumes
- *Bunkasai Ura Jikkouliankai,* Gotta, 2000–2001, 2 volumes
- *Yapoo, the Human Cattle,* Gentosha, 2003– , 3 volumes to date
- *Magikaru Taruruuto-kun,* Shueisha, 1988–1992 , 21 volumes
- *Golden Boy,* Shueisha, 1992–1998, 10 volumes
- *Deadman,* Shueisha, 1998–2000, 6 volumes
- *One Zero Nine,* Shueisha, 2001–2002, 4 volumes
- *Hatchigatsu no Koi,* Shueisha, 2003, 1 volume
- *Be Free!,* Kodansha, 1984–1988, 12 volumes
- *Last Man,* Kodansha, 1998–2001, 12 volumes

Art books:

- *Heisei Ukiyoe,* Mediafactory, 2001, book of nude paintings (ISBN 4-8401-0306-2)
- *Eropop,* Kadokawa Shoten, 2002, art book of Egawa work from 1984–2002 (ISBN 4-04-853409-2)

Major works:

- *Nichirosensou Monogatari,* Shogakukan, 2001– , 12 volumes to date
- *Genji Monogatari,* Shueisha, 2001– , 5 volumes to date
- *Tokyo Daigaku Monogatari,* Shogakukan, 1992–2001, 34 volumes

CHECK OUT

Top three:

- *Nichirosensou Monogatari* (Vol. 1 ISBN 4-09-186331-0)
- *Genji Monogatari* (Vol. 1 ISBN 4-08-782664-3)
- *Tokyo Daigaku Monogatari* (Vol. 1 ISBN 4-09-183251-2)

Web site:

- Egawa Tatsuya's official Web site: http://homepage3.nifty.com/egawa-tatuya/

Japanese manga artists you might like, if you like Egawa Tatsuya:

- Furuya Usamaru
- Oh! Great
- Sato Syuho
- Utatane Hiroyuki
- Yamada Akihiro
- Yamamoto Naoki

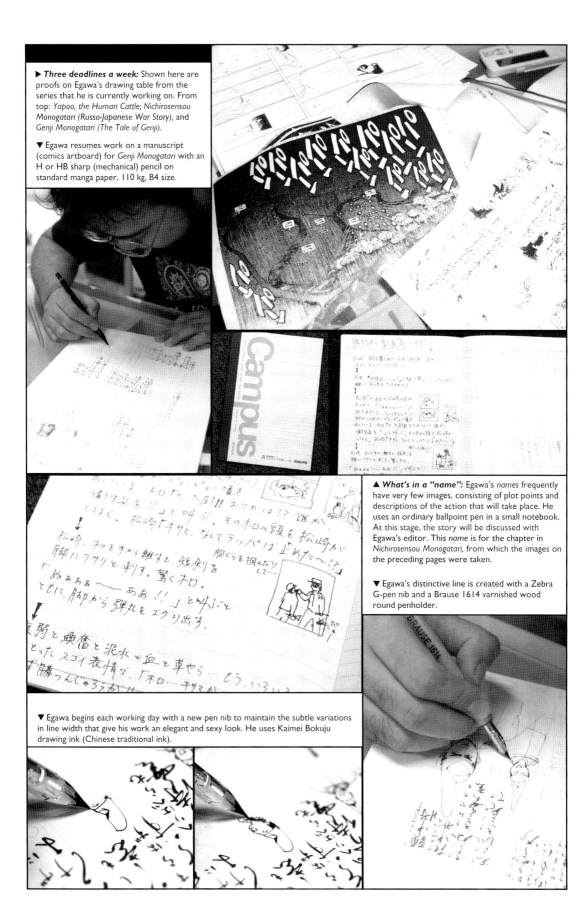

▶ **Three deadlines a week:** Shown here are proofs on Egawa's drawing table from the series that he is currently working on. From top: *Yapoo, the Human Cattle*; *Nichirosensou Monogatari (Russo-Japanese War Story)*, and *Genji Monogatari (The Tale of Genji)*.

▼ Egawa resumes work on a manuscript (comics artboard) for *Genji Monogatari* with an H or HB sharp (mechanical) pencil on standard manga paper, 110 kg, B4 size.

▲ **What's in a "name":** Egawa's *names* frequently have very few images, consisting of plot points and descriptions of the action that will take place. He uses an ordinary ballpoint pen in a small notebook. At this stage, the story will be discussed with Egawa's editor. This *name* is for the chapter in *Nichirosensou Monogatari*, from which the images on the preceding pages were taken.

▼ Egawa's distinctive line is created with a Zebra G-pen nib and a Brause 1614 varnished wood round penholder.

▼ Egawa begins each working day with a new pen nib to maintain the subtle variations in line width that give his work an elegant and sexy look. He uses Kaimei Bokuju drawing ink (Chinese traditional ink).

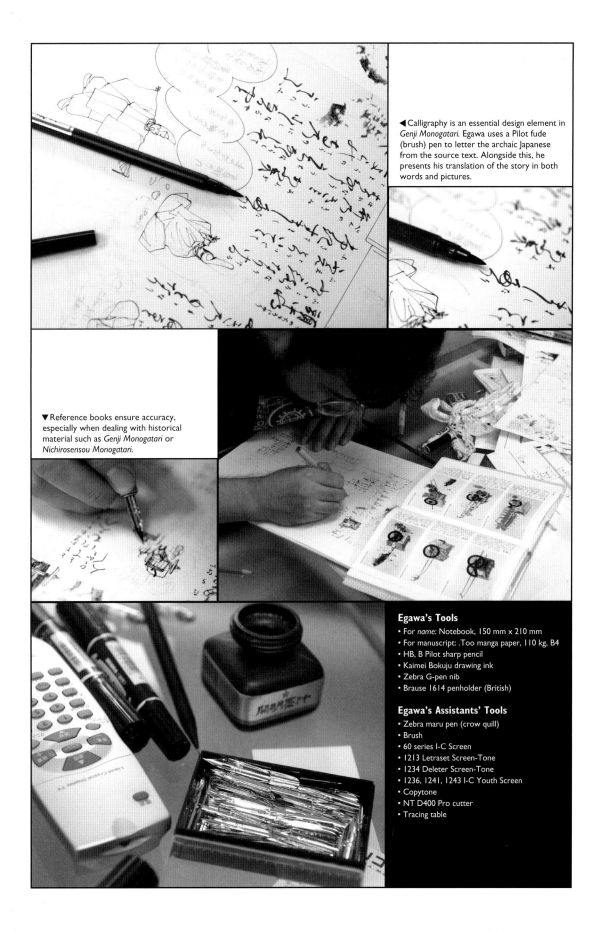

◄Calligraphy is an essential design element in *Genji Monogatari*. Egawa uses a Pilot fude (brush) pen to letter the archaic Japanese from the source text. Alongside this, he presents his translation of the story in both words and pictures.

▼Reference books ensure accuracy, especially when dealing with historical material such as *Genji Monogatari* or *Nichirosensou Monogatari*.

Egawa's Tools

- For *name*: Notebook, 150 mm x 210 mm
- For manuscript: .Too manga paper, 110 kg, B4
- HB, B Pilot sharp pencil
- Kaimei Bokuju drawing ink
- Zebra G-pen nib
- Brause 1614 penholder (British)

Egawa's Assistants' Tools

- Zebra maru pen (crow quill)
- Brush
- 60 series I-C Screen
- 1213 Letraset Screen-Tone
- 1234 Deleter Screen-Tone
- 1236, 1241, 1243 I-C Youth Screen
- Copytone
- NT D400 Pro cutter
- Tracing table

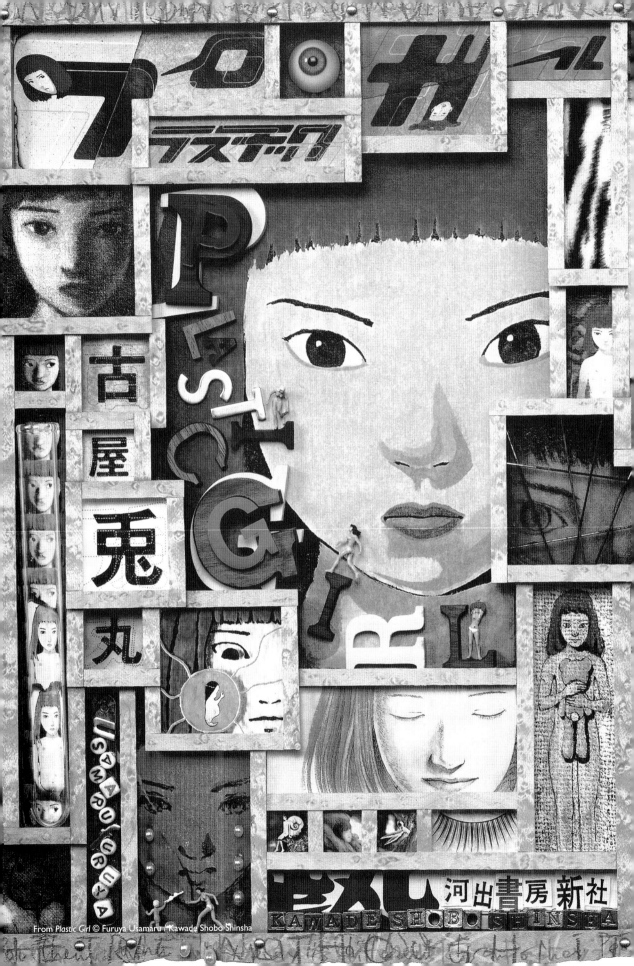

FURUYA USAMARU

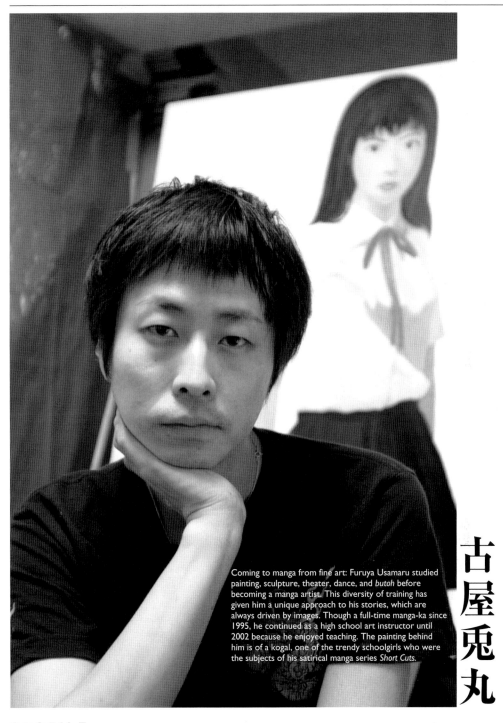

Coming to manga from fine art: Furuya Usamaru studied painting, sculpture, theater, dance, and *butoh* before becoming a manga artist. This diversity of training has given him a unique approach to his stories, which are always driven by images. Though a full-time manga-ka since 1995, he continued as a high school art instructor until 2002 because he enjoyed teaching. The painting behind him is of a kogal, one of the trendy schoolgirls who were the subjects of his satirical manga series *Short Cuts*.

古屋兎丸

PROFILE

Place of birth: Tokyo, Japan

Date of birth: January 25, 1968

Home base: Tokyo, Japan

First published work:
Palepoli, published in *Garo* (Seirindo), 1994

Education:
Tama Art University, degree in fine arts

JAPAN
Hokkaido
Honshu
TOKYO
Shikoku
Kyushu

Career highlights:

1990	Begins career as a high school art teacher
1996	Nagai Katsuichi fine work award (Seirindo)
1998	*Short Cuts* begins (Shogakukan)
2000	*Plastic Girl* (Kawade Shobo Shinsha)
2001	Part of an exhibition of manga artists at Stux Gallery in New York
2002	Quits teaching
2004	*Donki Korin* (Mediafactory)

As we followed Furuya Usamaru into his apartment/studio, we were greeted by a life-sized portrait of a kogal, the infamous Japanese "valley girl" of the 1990s. It was artwork for the cover of a new edition of Furuya's *Short Cuts,* a send-up of the kogal social phenomenon.

The painting was in a six-foot-square nook with blue-tarp-covered walls and tubes of gesso scattered over newspapers on the floor. He guided us on into the main room. Two female assistants were busy working on artboards at a long, low table the length of the wall to our left. They shared the table with a computer workstation. To our right was a much larger computer and the biggest scanner I had ever seen. Behind that was a wall covered with art books and manga, and in the most distant corner was Furuya's drawing table. And that was where he quickly retreated. Our arrangement was to observe and not to talk. He and his assistants would be creating 18 pages of manga in the next two days, and the interview would have to come later.

Furuya Usamaru still has the lithe body of a dancer. As a student, besides oil painting, theater, and sculpture, for several years he practiced *butoh,* the mystical Japanese dance form of white painted faces, shaved heads, and bizarre props. He was an artist in search of an art form . . . and he has found it in manga. But he started his career as a manga-ka by taking that art form apart.

Furuya's debut, *Palepoli,* was a breathtaking postmodernist manga deconstruction. With his mastery of art styles, it was as if Picasso, Botticelli, Bacon, Dali, and Art Spiegelman were all doing manga in the same book, in one-page, four-panel gags lampooning art, religion, Japanese television shows, and other manga. This chameleon-like ability prompted detraction as well as admiration. "I'm tempted to call him the best pure artist I've ever seen in manga," said Bill Randall, in the *Comics Journal,* "except that so much of his work jumps from style to style that I'm not sure what his own drawing even looks like." But for Furuya, drawing in different styles is no different than "singing songs in different keys."

After the parody and satire of *Palepoli* and *Short Cuts,* Furuya created the horrific *Emi-chan,* an expressionistic look into the soul of a pedophile/murderer, followed by *Plastic Girl,* an art book of two- and three-dimensional manga and fine art experiments. In 2001, he began *Marie's Music,* a lyrical, evocative fantasy for adults, and in 2002, *Jisatsu Sakuru (Suicide Circle). Jisatsu Sakuru* is the dark doppelganger of *Short Cuts.* Where the latter saw wacky humor in the "paid dating" of kogals, *Jisatsu* portrayed the real-life consequences of prostitution: young women driven to self-hatred and despair. All these stories begin with images that are constantly swirling about in Furuya's mind. His latest visions are of breasts. The series π has struck some of Furuya's fans as frivolous. Serialized in a young men's manga, π is at first glance a *Wayne's World*–variety trashy sex comedy. But the series has touches of surrealism and satire, and reveals what Furuya values most in his art form of choice: playfulness and spontaneity. "It's like seeing kids playing soccer, and one yells out 'I'm Ultraman' and they all join in a game of make-believe, while still kicking the ball. Are they still playing soccer or are they now playing Ultraman? Or something that is both? Manga is like that."

FURUYA's interview

— How did you become a manga artist?

It was around first or second grade when I first wanted to be a manga artist. My home was at the last station of the Chuo Line, and my father came home on the last train. There were always discarded manga magazines on the racks that he picked up, so I used to read most of the famous magazines such as *Jump, Magazine, King, Sunday* and *Champion.* That's when I first wanted to become a manga artist. In grade school, I would get together with friends and copy manga. In junior high, I used to send my imitation art to a magazine that had pages for fan art. Some amateurs who sent in art there became professionals later. My art appeared often, so I learned how to use a pen. The other artists were older than me, but I was very competitive, and that improved my techniques. When I got to high school, I kind of stepped away from manga, and I started going to underground theatrical performances and live music acts. I was influenced by my friends and I got interested in the arts. I totally left manga. I decided to go to a fine arts college, and started going to prep school.

— Did your parents support you?

My parents wanted me to be an athlete so I was involved in many sports—kendo (Japanese fencing), tennis, baseball, swimming. But in the end, I told them "I love drawing" and

Painting corner: Furuya maintains a spot in his studio to keep his hand in oil painting.

Influenced by postmodernism, Furuya set out to do a parody of manga for his debut work. In *Palepoli*, he used the styles of art movements as diverse as classicism and surrealism to poke fun at manga genres and artists, Japanese TV shows, and religion. Above, at right, is a piece derivative of Tsuge Yoshiharu's *Nejishiki (Screw Style)*, an underground manga classic of the late 1960s.
© Furuya Usamaru / Seirindo

they thought "we don't understand it, but, if you like it, we have to accept it." In college, I started acting. From body expression and acting, I went to dance. I learned dance, from an internationally known dancer, Teshigawara Saburo. And I also joined Sankaijuku (a *butoh* dance group) and did dance with them. My major was oil painting, but I was obsessed with body expression and creating sculptures out of iron, beeswax, and lead. My pieces were influenced by German artist Joseph Beuys and British sculptor Richard Deacon. That continued after I graduated from college, and, while I presented new art pieces once or twice a year, there was a part of me that felt uncomfortable. When I approached these things I was creating, I had to exclude my own wants. I had to exploit the THINGS in and of themselves, since that's the aesthetic theory. But frustration built up inside me. Then a friend asked me to do illustrations for a textbook as a side job. They were things like drawings of insects and plant photosynthesis. When I drew those things meticulously, something came back to me—the feeling I had had when I sent fan art to that magazine. The fun I had had when I was drawing came back, and I realized at that moment I wanted to do something with drawing. But I didn't yet know it was going to be manga. Manga was always . . . freedom. For people like me who did modern art, manga looked like a child playing around freely. Modern art isn't subculture any more; it's mainstream culture, and the critique is pretty strict. You can't do this or you shouldn't do that, and you don't really know what you can do. So I yearned for that kind of freedom and thought that it might be in manga. Fine art was agonizing . . . and maybe a dead end. The mainstream of fine art isn't Japan—it's in Europe and America. When doing fine art in a remote region like Japan, everyone in the art scene is conscious about the latest developments in Europe and America. In contrast, manga's mainstream is Japan; Japan is

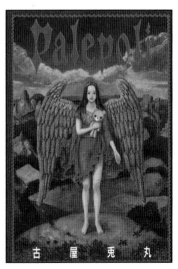

The "manga that influenced a generation":
Palepoli, debuting in *Garo* in 1994, quickly established Furuya's reputation in the manga world. The collected work was first published in 1996.
© Furuya Usamaru / Seirindo

Furuya's two-volume *Short Cuts* explored the '90s Japanese social phenomenon of kogals, trendy high-school girls (an American equivalent may have been the "valley girls" of the late 1980s). A mixture of sex, humor, and the bizarre, the series was Furuya's first venture into mainstream *seinen* (young men's) manga. Where *Palepoli* was parody, *Short Cuts* was satire.
© Furuya Usamaru / Shogakukan

vague what you call commercial. When my manga got in *Garo* about eight or ten times, an installment of *Palepoli*—"Death Comi"—got in a magazine called *Comic Cue*. There was a lot of feedback, and it called attention to the work I had done in *Garo,* helping with the sales of *Palepoli.*

— At this time, were you a teacher?

Yes, a high school art teacher—from the year I graduated until last year.

— Was getting in *Comic Cue* a breakthrough for you as a manga artist?

Yes. The money for "Death Comi" was the first paycheck I ever got for manga. And someone from *Weekly Young Sunday,* a commercial magazine, saw that work. So, as soon as I finished *Palepoli, Short Cuts* began. If you're only in *Garo,* it's very hard to go the next step to commercial magazines.

— How would you describe your manga?

I really don't know. The things that I thought were mainstream are sometimes called subculture, and the good thing about manga is that there's no framing. In fine art, there's a frame to what you're doing, like which subculture you're in or what movement you belong to. There's none in manga; they aren't conscious about it. I was watching kindergarten children playing soccer. The children say, "Let's play soccer," and then they say, "It's Ultraman [Japanese sci-fi TV show about superhero alien giants] soccer." So they start saying, "I'm Ultraman Taro (one of the Ultramen)," "I'm Ultra Seven (another Ultraman)," and so, while they play soccer, they also pretend to be a hero and kick the ball. At the end, they don't know if they're playing soccer or Ultraman or just running around. I think it's same with manga.

— Who are your readers?

It depends on the media and the magazine and the story. Basically, I think the youngest is a precocious junior high girl, then junior high, high school, and college students. But, when I did a fantasy story, I received a letter from someone past 30, so it depends on the work. I think the main readers are about 18 to 23, college students and individuals who want to absorb all kinds of knowledge.

kind of a royal road. The way Japan goes pulls along the rest of the world's comics, and I wanted to be part of that. I had these thoughts one night, and I started drawing manga the next day. But it had been a while since I last drew manga—in junior high school—and I didn't remember how to draw at all. I didn't think I could take it to a commercial magazine, so I naturally thought of going to the underground magazine *Garo.* I started sending manga to them every month, making a rule to draw 24 pages and submit it. Well, I was rejected . . . but I kept on doing that for eight months.

— How old were you then?

Twenty-five. After eight months, I thought, I'll try it one more time and, if I don't get in, I'll give up on *Garo* and try the slightly more commercial magazine, *Afternoon.* And I drew the four-panel comic strip *Palepoli,* thinking of it as my last, and took the pen name Furuya Usamaru. I submitted it, and it was in the magazine the next month. I thought, "It's in!" Nobody ever requested more, but I drew it on my own initiative and they kept putting it in the magazine. So it was never commissioned; *Garo* didn't pay anyway.

— So *Palepoli* was your first manga to go to a commercial magazine?

I don't know if you can call *Garo* a commercial magazine. If you mean you can buy it at a bookstore and it's not *doujinshi,* then, yes. Actually, you can get money from *doujinshi,* and it's really

Black humor: Together with a flair for parody and a chameleon-like mastery of art styles and techniques, Furuya displayed a razor wit and a dark worldview in *Palepoli*.
© Furuya Usamaru / Seirindo

— Both male and female?

I think so. When I do signing sessions, there may be more females. Perhaps 60 percent to 70 percent female. Right now, I'm drawing a manga about the nature of boobs (π), which is targeted for boys. But even that, I think, is more popular among girls than boys.

— Describe the process of creating a manga story. Do you write a scenario, or do you start with a name?

It depends on the work. *Marie no Kanaderu Ongaku (Marie's Music)* was in a monthly magazine, but, before the series started, I wrote a scenario for 500 to 600 pages, then wrote a *name,* and started from there. But for the manga I am doing now (π), there are only a few lines of scenario. All I say is that, in this story, something happens to someone, that's all, and, after that, I draw the *name* directly. I go with the flow, especially for the gags. When a story needs to drop an advance hint, then I write a scenario. So it depends on the work.

— Before you actually draw on the manuscript, how long does it take

Written while Furuya was producing *Short Cuts, Emi-chan* was serialized in the underground magazine *Garo.* The story was Furuya's first extended narrative, as opposed to the gag formats of both *Short Cuts* and *Palepoli. Emi-chan,* the portrait of a sexual predator, is still his most disturbing work. When reprinted in *Garden,* it was presented in a format that required cutting open sealed pages. Done in part to alleviate the concerns of nervous bookstores, this also forced the reader to participate in the story's horror.
© Furuya Usamaru / East Press

to plot the story and draw the names?

For *Jisatsu Sakuru (Suicide Circle),* I only had one month from start to finish, so I wrote the script in one day and did the *name* in four days and drew 170 pages in 25 days. It depends on the condition of my head. When thoughts come, it's very fast. For *Marie no Kanaderu Ongaku,* I did 500 pages of *names,* but I was able to finish them in about a week or less.

— For that work, did you initiate it, or were you approached by a publisher?

I was asked by the publisher to do a serial comic and I presented an image I wanted to draw. For *Marie no Kanaderu Ongaku,* I wanted to do a fantasy in an alternate reality—but it would be a cruel fantasy, not for boys and girls. I wanted to draw for older people, who don't usually read fantasy. It would also be a love story throughout to the end, so I presented that. Lastly, there was an image I had in mind: a giant clockwork goddess moving slowly around the world like a sun.

— For this work, the image came first, but do you ever write a scenario and then search for images?

No. I always have images in my mind floating around. For example, in my book *Garden* there's a story called "Tsuki no Sho" ("Waning Moon"). I had an image of a flower-shaped island in the middle of the sea, an image of a waning moon, and an image of alchemy. When I am asked to do a series, I pull out an image that will be appropriate to that magazine. *Comic Birz* was a fantasy magazine, so I was able to use the clockwork goddess Marie. Then I had it in me that I wanted to draw about boobs (π), and that would only fit in *Biggu Komikku Supiritsu (Big Comic Spirits),* and so on. Currently, I have an image of billiards that I want to do a manga about.

— Shiratori Chikao-san (Furuya's former editor at *Garo*) said that you described your creative process as "conscious and capricious."

The manga I'm doing now (π) is capricious, if I have to choose from the two. I just go with the ideas that come up and improvise and try to go with the rhythm. On the other hand, in *Palepoli,*

I was conscious of what my manga was—or what it meant to the manga industry—so I thought about those things while I drew.

— Shiratori-san said he had never met anyone who was more intentional about his work.

I do have a sense of purpose, but it's not anything for society or the world. The purpose is something for myself, to expand the range of my manga. Expanding the world for me is expanding the world of manga as a whole . . . I think it will lead to that.

— So you put everything into it, and try to expand your abilities?

Yes. I never do anything halfheartedly, because it is just work. With π, some people say I'm not doing my best, but that's not true. It's the thing I really want to do the most right now, and I am doing the best experiment for me. When it's a work that has a good fit for a commercial magazine, people say that kind of thing, but this work is something I need very much to do. All my work is done because I need to do it at that particular time.

— You have been called chameleon-like because of your ability to use many different art styles. Is this an advantage in what you are trying to do?

It's like changing your voice depending on the tune of the music. Even if you lower the key, it's still that person's voice; the nature of the voice does not change. You can change the key, or change the way you sing, or the way you vocalize. It's the same thing: I draw in the style that fits the work.

— How do you work with your assistants and with the computer?

I do an underdrawing with blue pencil. When I scan, the scanner doesn't read the blue line, so I can skip erasing. After that, I ink with pen and ink. If needed, I take photos and combine images with the computer and have my assistants trace them. The figures and background are all inked, and then scanned. I do the spot blacks and tone work on the computer. I do the characters, or specify the Screen-Tone for the characters myself, and the assistants do backgrounds. The assistants work on objects, backgrounds, and things that are time-consuming, but don't require the artist's touch.

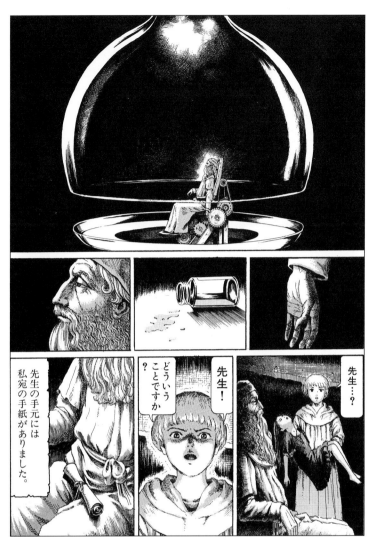

Three concepts inspired Tsuki no Sho (Waning Moon): A flower-shaped island in the middle of the ocean, a waning moon and alchemy. The story first appeared in *Comic Cue,* an alternative manga magazine, and was later part of Furuya's *Garden* collection, published by East Press. The single-episode story has elements that anticipated *Marie's Music.*
© Furuya Usamaru / East Press

— What are the good points and bad points about using a computer?

When I first started using it, I kept putting on Screen-Tone endlessly, or kept trying to perfect the art too much. But when I got used to it, I could balance those things. The computer is just a tool, so it's just a matter of getting used to it. So now, there's only good points. For example, when I take a photo and there's a character in a panel, and I want to paste the photo behind the character, it's a pain to adjust the size when you use a copy machine. But on a computer, I can have backgrounds traced once and use them again later; something drawn once becomes a resource that can be used many times.

— Do you also use the computer for adding tones?

Yes. For example, it's just a click to put tone in a 木, but if you did it by hand it would take five minutes per character. Just for that, for an 18-page story, that would be a big time-saver. If I didn't have a computer, I would need two more assistants.

— Did you do all the work on *Marie no Kanaderu Ongaku* with no assistants—just the computer?

Yes, that's true.

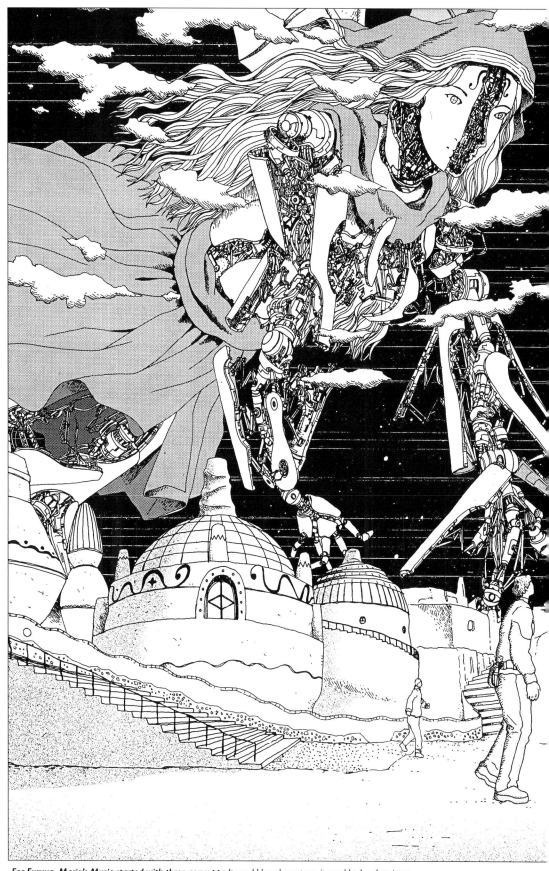

For Furuya, Marie's Music started with three concepts: It would be a love story, it would take place in an alternate reality, and it would have a huge clockwork goddess.
© Furuya Usamaru / Gentosha Comics

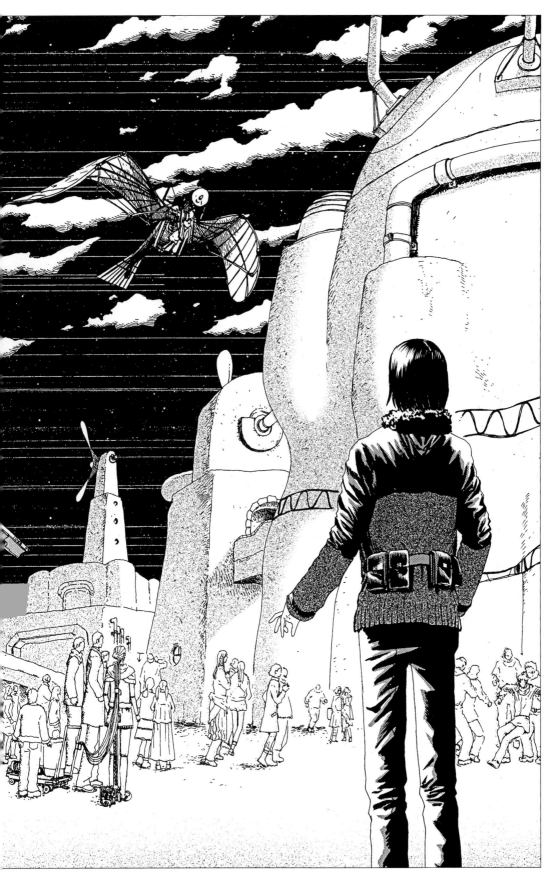

Furuya created a three-dimensional model of the small flying machine used by Pipi to serve as a visual reference while he worked on this story.

— Are *doujinshi*—and magazines such as the former *Garo*—important forums for new ideas? Are there other magazines that provide this?

Eighty percent of *Garo's* editors went to a magazine called *AX.* It took over for *Garo,* and its existence is very important. It's the only place where certain artists can present their work, and there's a lot of youthful power and energy there. Also, there are magazines like *Manga Erotics, Erotics F,* and *Comic H,* which have work that would only have been in *Garo* in the past. So *Garo's* demise might have been inevitable. For *doujinshi,* the base is too large. I doubt many people are doing it with consciousness. Even if it isn't a commercial magazine, going through an eye of an editor is important—that's why *Garo* was important. In *doujinshi,* there's no consciousness of being seen. Without that, it's basically just like graffiti—words drawn in spray paint on a wall. There's the impression that one can draw anything freely with *doujinshi,* but one needs the eye of an audience, and the more strict the eyes are, the more true freedom comes into existence. If it's free all the way, you can do anything and even the story is destroyed. You aren't thinking about entertaining the reader. In most *doujinshis,* in the first panel, a girl comes out begging to have sex, and just has sex till the end, or something like that— there's not even a story.

— Do you ever feel restricted working in mainstream manga?

There is restriction. First of all, nothing like *Palepoli* can be done. There are also many words you can't use, and expressions you can't do.

— Are you uneasy with that?

If what you want to do is always a parody or deal with killing or bigotry or those themes, then you might feel uneasy. But that's just one of the facets I have; I have other images and themes, so I don't have to use those, that's all . . . so I don't feel uneasy.

— Who are your artistic inspirations, from manga or other arts?

There are so many, it's hard to say. I love (Hieronymus) Bosch's art. I like Germany's Gerhard Richter. And Sigmar Polke, a modern artist, also from Germany. From Italy, a style called *arte povero* in the 1970s. In Japan, I like Lee U-Fan and the people who made the object subculture movement. Object

subcuture is, for example, just a stone on a glass. But I don't know if any of these have affected my style; I'm just saying what pops into my head. For manga artists, it's Umezu Kazuo, Moroboshi Daijiro, and Eguchi Hisashi. For recent artists, it's Furuya Minoru, Mochizuki Minetaro, Matsumoto Taiyo, and Yamamoto Naoki. Actually, I don't read manga now, so I don't know if I really still like them. I don't need other people's

manga to draw mine, and I don't think of input and output. I generate everything myself.

— Is satire an important element of π, as it was in *Palepoli*?

For π, it's not just satire. Many things are mixed together in a complex way and perhaps part of it seems to be satire. *Palepoli* was more of a parody than a satire. For *Palepoli,* I didn't know manga language, so I had to use

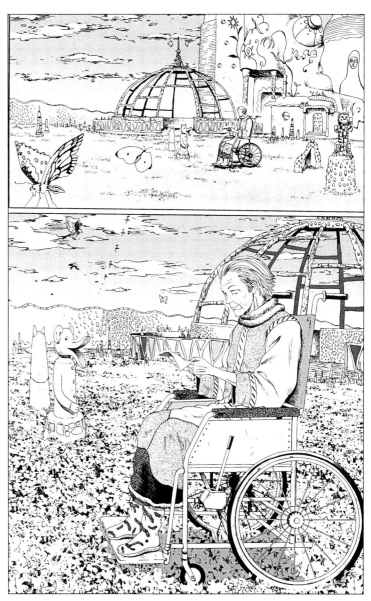

Furuya's masterpiece: *Marie's Music* is evocative of both the heartwarming anime of Miyazaki Hayao and the thought-provoking children's literature of Miyazawa Kenji. To render intricate scenes of this imaginary world, Furuya used computers extensively. Above, an aged Pipi, one of the central characters, reminisces near near the story's conclusion. Although not yet available in English, the two-volume work has been translated into French.
© Furuya Usamaru / Gentosha Comics

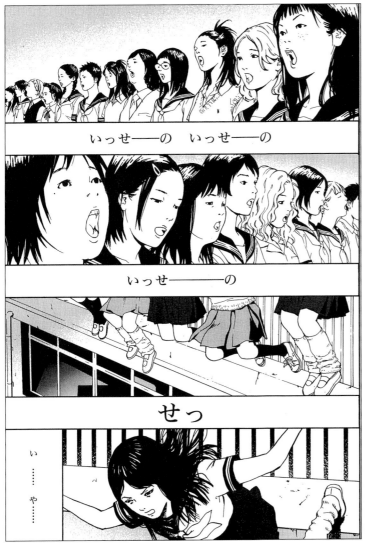

いっせ——の　いっせ——の

いっせ————の

せっ

い
…
…
や
…
…

Group suicide in Jisatsu Sakuru (Suicide Circle). This manga was an adaptation of the 2002 movie, done at the request of the film's director, Sono Sion. Although sharing many of the same concepts, the manga story is significantly different from the theatrical version.
© Furuya Usamaru / One-two Magazine sha

behavioral principal, there should be something underlying it, I think. Like valuing their friends. But I don't want to make it a point to do it. The very reason I started with manga was an envious feeling that it was childlike freedom, so I don't want to lose that.

— Has your drawing style changed over the years?

Fundamentally, my art is completely different. For *Palepoli,* the art was drawn with the greatest care of anything I've ever done, but it was drawn the worst. I compensated for my lack of drawing skill by overworking it. So, taking a lot of time, anyone who has graduated from art college can draw like that! I think my drawing techniques have improved a lot; I can draw much better than when I was doing *Palepoli.* I don't know if other people see it, but within me, it's evolving and getting better.

— What is your favorite medium?

Pen and ink. Computers are for finishing; the foundation is pen and ink.

— In terms of storytelling and design, are there any dos and don'ts you stick by? Any rules?

The essence is child's play. Like the things you do as a child, from putting firecrackers in frogs, or killing crickets and ants . . . to the innocent play of making things and playing make-believe. My basic mentality is to do everything, with no restriction.

— How many days a week do you work?

It depends on how much work I have. For π, I use Saturday, Sunday, and Monday for drawing. With more detailed art, it goes to Tuesday. On the other days, I do *names,* or other illustration work, or other manga work. So, I pretty much work the whole week.

— Are there any of your works that you are unhappy with, for any reason?

For the second volume of *Short Cuts,* my creative energy diminished somewhat. I kind of feel like I abandoned the project, and I regret that. I wish I could have finished it with the energy maintained. It was affected by my personal life, so that's why I couldn't get hyped up. But basically, I don't read what I have finished drawing, and don't rethink it . . . but I think I have done my best for all my other works.

my fine arts language. For example, in postmodern architecture you can combine elements from many things. Similarly, I brought elements of many manga from the past and mixed them together. I was asking, "What is manga?" I tried to make an architecture of metamanga, so I was conscious of doing parody in *Palepoli.* As a result, what I am doing itself is built upon the flow of manga made by the pioneers. I really love the style of those people in the past, so I have respect for them. But, I also have a mischievous side that I like to express in a playful way. Parody is a type of comedy everyone understands, so I'm most popular when I do parody.

— Are there themes in your work?

It depends on the individual work. When I draw, that's when I understand what I've been thinking about. I don't analyze it beforehand. There are themes, but I don't want my range to become narrower by trying to define them. For example, if I say that I will keep on dealing with love, or if I say that I will work on the paradoxes of life, there's a possibility that I won't expand from there. There's no inevitability in me that I must do only certain things. I really want to be a child with freedom. Children don't play Ultraman soccer to express their thought. In the same way, I want to play with sand, or raft, or play in the river next. But, in that child's

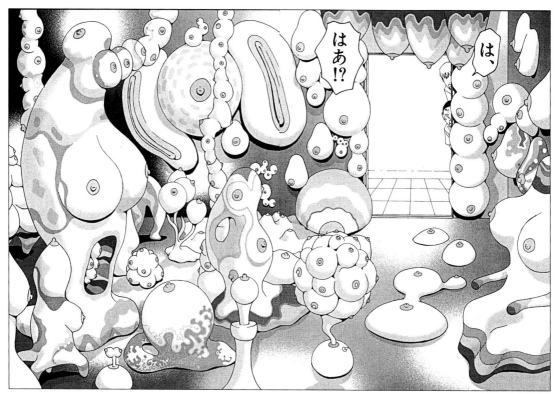

A "congress of bosoms:" Furuya was inspired to begin his current series π after attending a seminar of doctors and researchers of human mammary glands. It's an example of ideas that come to him unpredicatably from many sources. While π at first glance appears to be a typical *seinen* (young men's) manga, heavy on sexual situations, there is a distinct satirical element, which gives it another dimension.
© Furuya Usamaru / Shogakukan

— What is your favorite work?

There's no number one, but *Palepoli, Garden's Emi-chan* and *Tsuki no Sho,* and *Marie no Kanaderu Ongaku* are my favorites.

— Are there comics artists in Asia, Europe, or the U.S. that you have read or liked ?

I really don't know much about Asia. For Europe, I guess Enki Bilal and Nicholas de Crecy are two I read. For the U.S., there's an interesting comics adaptation of Paul Auster's *City of Glass,* done by David Mazzucchelli. He did a short story for *AX* once, and that's how I knew of *AX.* He came to Japan and did a lecture. He used to do *Daredevil* for Marvel, and then went on to underground comics.

— What advice would you give aspiring comics or manga artists?

One thing I can say is that this a job in which you use all your abilities, so it's really fun and there's nothing wasted. If someone's in school who really wants to be a manga artist, the things you learn now—like math, English, or social studies—all knowledge will be helpful, so study hard. I sound like a teacher, but that's what I think.

— Is there anything that you would like to say to your fans?

I would like to keep doing different things in major manga magazines. I know there are lot of people who like the flavor of *Garo,* or subculture, but I will keep doing experimental things, even in mainstream magazines. So I don't want them to look down on it because it's in a major magazine. There's always an essence of myself in it, so don't turn from me, please— something like that. [Laughs.]

List of works:

- *Wsamarus 2001,* East Press, 2000
- *Jisatsu Sakuru (Suicide Circle),* One Two Magazine, 2002 (ISBN 4-901579-09-6)
- *π*, Shogakukan, 2003–, 7 volumes to date
- *Donki Korin,* Mediafactory, 2004, book of four-panel manga based on reader input, combining elements of *Palepoli* and *π* (ISBN 4-8401-1038-7)

Art books:

- *Plastic Girl,* Kawade Shobo Shinsha, 2000, book of experimental manga, paintings and collages (ISBN 4-8401-0306-2)

In English:

- *Japan Edge,* (selections from *Palepoli*), Viz LLC, 1999
- *Pulp,* Vol. 4, No. 7 (Furuya interview), Viz LLC, 2000
- *Pulp,* Vol. 4, No. 10 (selections from *Palepoli*), Viz LLC, 2000
- *Secret Comics Japan* (selections from *Palepoli*), Viz LLC, 2000
- *Short Cuts,* Vol. 1, Viz LLC, 2002
- *Short Cuts,* Vol. 2, Viz LLC, 2003
- (Viz LLC: www.viz.com)

Major works:

- *Palepoli,* Seirindo, 1996; Ohta Comics, 2003 (reprint)
- *Garden,* East Press, 2000
- *Marie no Kanaderu Ongaku (Marie's Music),* Gentosha, 2000–2002, 2 volumes

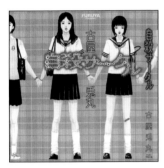

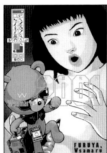

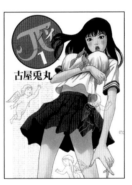

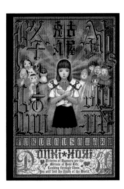

Top three:

- *Palepoli* (ISBN 4-87233-749-2)
- *Garden* (ISBN 4-87257-204-1)
- *Marie's Music* (Vol. 1 ISBN 4-78978-328-6)

Web site:

- Unofficial information on Furuya Usamaru can be found at Prisms, the Ultimate Manga Guide
 http://users.skynet.be/mangaguide/au298.html
- An English-language interview with Furuya Usamaru is posted at
 www.pulp-mag.com/archives/4.07/feature_03_interview.shtml

Japanese manga artists you might like, if you like Furuya Usamaru:

- Fujiwara Kamui
- Fukuyama Yoji
- Inoue Naohisa
- Matsumoto Taiyo

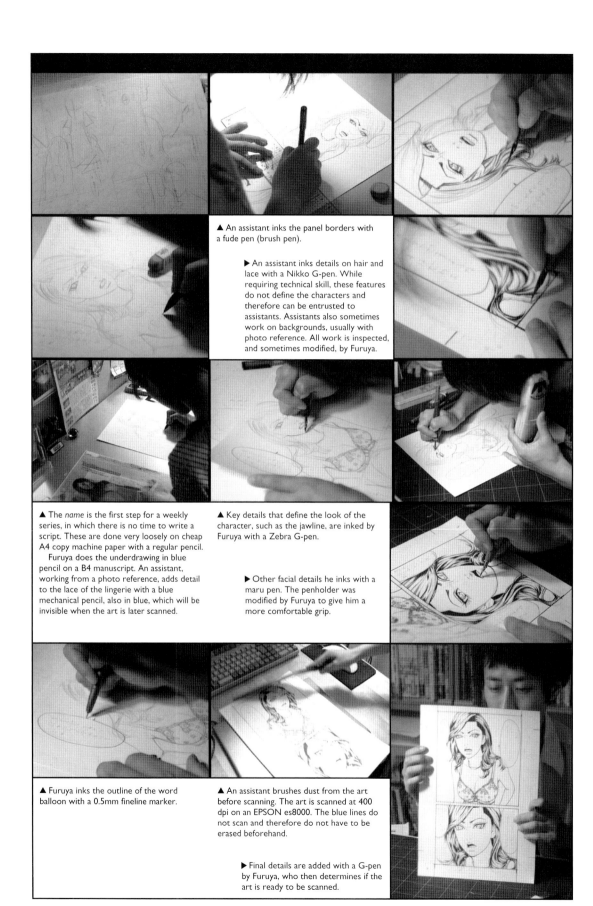

▲ An assistant inks the panel borders with a fude pen (brush pen).

▶ An assistant inks details on hair and lace with a Nikko G-pen. While requiring technical skill, these features do not define the characters and therefore can be entrusted to assistants. Assistants also sometimes work on backgrounds, usually with photo reference. All work is inspected, and sometimes modified, by Furuya.

▲ The *name* is the first step for a weekly series, in which there is no time to write a script. These are done very loosely on cheap A4 copy machine paper with a regular pencil.

Furuya does the underdrawing in blue pencil on a B4 manuscript. An assistant, working from a photo reference, adds detail to the lace of the lingerie with a blue mechanical pencil, also in blue, which will be invisible when the art is later scanned.

▲ Key details that define the look of the character, such as the jawline, are inked by Furuya with a Zebra G-pen.

▶ Other facial details he inks with a maru pen. The penholder was modified by Furuya to give him a more comfortable grip.

▲ Furuya inks the outline of the word balloon with a 0.5mm fineline marker.

▲ An assistant brushes dust from the art before scanning. The art is scanned at 400 dpi on an EPSON es8000. The blue lines do not scan and therefore do not have to be erased beforehand.

▶ Final details are added with a G-pen by Furuya, who then determines if the art is ready to be scanned.

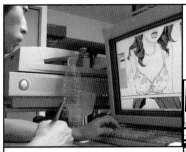

▲ Toning is done in Photoshop 6.0 using a Wacom Intuos 9 x 12 tablet. Hair is toned first by an assistant. Then Furuya tones subtle areas on the face.

▼ Eye details and a gradational background are added last.
 Art is printed out at 600 dpi with a LaserShot LBP740 printer on Takeda Ya high-quality paper, 110 kg, B4.

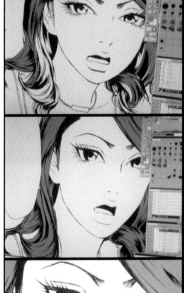

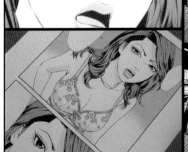

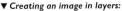
▼ *Creating an image in layers:*
A complex image may be composed in layers in Photoshop. Furuya has created as many as 52 layers for scenes in π.

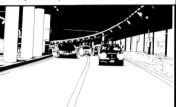

Furuya's Tools

- Paper
 Name: Copy machine paper, A4
 Manuscript: .Too paper, 110 kg, B4
 Printout: Takeda Ya wood freen paper, 110 kg, B4
- B pencil (for name)
- Caran d'Ache 370 blue pencil
- Pentel plastic eraser
- Copic Multiliner fine-line markers:
 0.1 ~ 1.0 mm
- Pilot Shokenyou ink (waterproof)
- Zebra G-pen nib
- Zebra and Nikko maru pen nibs
- SLR97 penholder (German)
- White: Pentel correction fluid pen

Tools for Color Work

- Caran d'Ache watercolors and pastels, Copic markers, oil paints.
- Other things needed: Mirrors, books (pose, background photography), fashion and motorcycle magazines
- BGM: Midnight radio show of Ijuin Hikaru ("dark humor, wicked tongue")

Digital Tools

- Computer: Windows (selfbuilt) Pentium, 1.5 GHz, dual PC, custom built
- OS: Windows 2000
- Capacity of HD: 160 GB
- Memory: 1.5 GB
- Monitor: EIZO Flexscan T960 21
- Tablet: Wacom Intuos i-900 9 x 12
- Scanner: Epson es8000
- B&W Printer: Lasershot LBP740
- Color Printer: Epson Colorio PM-3500C
- Digital camera: Nikon Coolpix 990, 3.3 megapixels
- Adobe Photoshop 6.0
- Adobe Illustrator 10.0
- Corel Painter 7
- Taschen 500 3D-Objects

[Editor's note: When using 3D CG objects, Furuya always integrates them into his art by drawing over them, maintaining the feel of hand-drawing.]

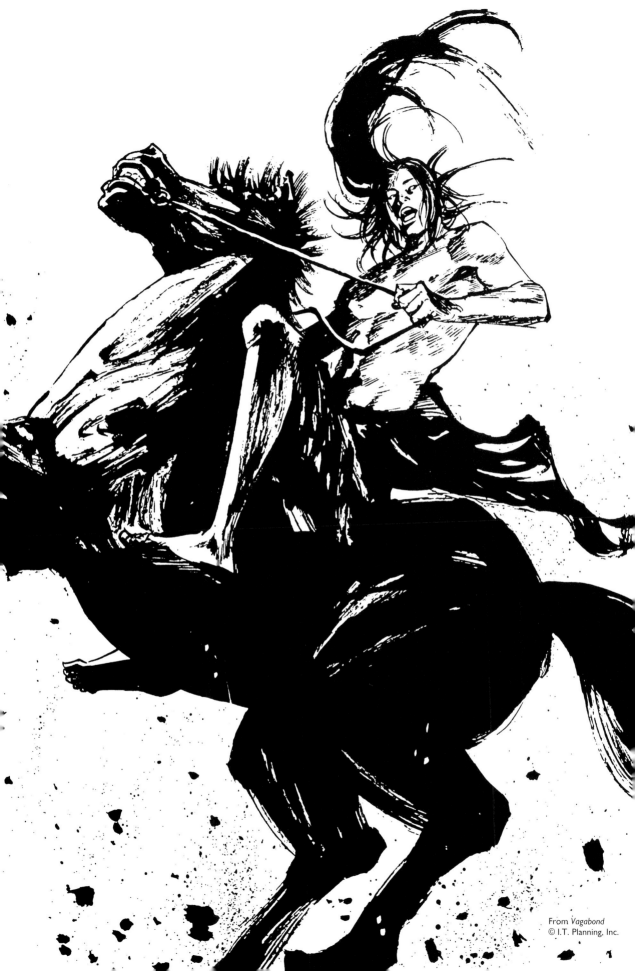

INOUE TAKEHIKO

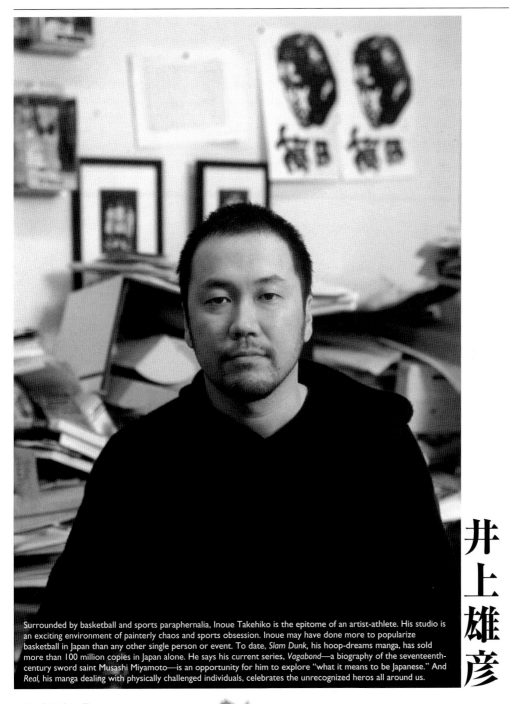

井上雄彦

Surrounded by basketball and sports paraphernalia, Inoue Takehiko is the epitome of an artist-athlete. His studio is an exciting environment of painterly chaos and sports obsession. Inoue may have done more to popularize basketball in Japan than any other single person or event. To date, *Slam Dunk,* his hoop-dreams manga, has sold more than 100 million copies in Japan alone. He says his current series, *Vagabond*—a biography of the seventeenth-century sword saint Musashi Miyamoto—is an opportunity for him to explore "what it means to be Japanese." And *Real*, his manga dealing with physically challenged individuals, celebrates the unrecognized heros all around us.

PROFILE

Place of birth: Kagoshima, Japan

Date of birth: January 12, 1967

Home base: Tokyo, Japan

First published work:

Kaede Purple, 1988

Education:

Two years at Kumamoto University

Career highlights:

1988 Tezuka Osamu Prize for best new manga-ka

1990 *Slam Dunk* begins (Shueisha)

1995 Shogakukan Manga Award for *Slam Dunk*

1998 *Vagabond* begins (Kodansha)

1999 *Real* begins (Shueisha)

2000 Kodansha Manga Award for *Vagabond*

2001 Grand Prize, Japan Media Arts Plaza manga division for *Vagabond*

2002 Excellence Prize, Japan Media Arts Plaza manga division for *Real*

2002 Manga grand prize, Tezuka Osamu Cultural Prize Manga Grand Prix for *Vagabond*

Inoue Takehiko was disappointed when the Detroit Pistons became the 2004 NBA champions—because they defeated his beloved Lakers to do so. Inoue is not just another basketball fan; it is possible that his manga *Slam Dunk* has done more to popularize the sport in Japan than any other single person or event. To date, it has sold 100 million copies in Japan alone.

I arrived late at the house that *Slam Dunk* built. I.T. Planning, Inoue's headquarters, is based in an imposing castle-like structure on Tokyo's west side, and I had been

delayed in getting there. As I entered his studio, instead of taking offense at my unintended rudeness, Inoue came over and in his most polite Japanese said, "I would like to take this opportunity to introduce myself."

I glanced around the room. A LeRoy Neiman painting was propped up against the wall behind a couch in the corner. Behind another was a bright yellow mountain bike. I saw kendo sticks, golf clubs, and basketball hoops, on the walls, Lakers photographs, toys, and souvenirs—and everywhere a million brushes of all shapes and sizes, amid painterly chaos on his worktables and shelves.

Inoue always wanted to be a painter, but studied literature in college. After a brief stint as an assistant to Hojo Tsukasa—of City Hunter manga fame—Inoue won a contest for rookie manga-kas and went solo. Two years later he made manga history.

In 1990 there had already been a rich tradition of sports manga, but never one about basketball. Inoue changed all that and evolved a dynamic form of storytelling, becoming a master of pacing and action. *Slam Dunk* was an action-filled epic. Telling the story of one fateful season of a struggling high school hoops team took six years in the weekly pages of *Shonen Jump*. Inoue's artistic expression grew exponentially with the series's popularity—which spawned an animated series and garnered awards.

When *Slam Dunk* ended in 1996, Inoue thought of quitting manga. Then an editor gave him the novel Musashi, by Yoshikawa Eiji, just to relax with. The story of Miyamoto Musashi, the wandering sword-saint of feudal Japan, gave Inoue a new raison d'être. In the course of traveling in other countries he had come to realize the distinctiveness of Japanese character. *Vagabond*, his adaptation of the novel, gave him a vehicle to explore the theme of "what it means to be Japanese." "I wanted to draw the faces of the characters and my hand started tingling," he says.

Vagabond has been immensely popular and has also been critically acclaimed, winning the Grand Prize for manga at the 2001 Media Arts Festival and the Manga Grand Prize of the 2002 Tezuka Osamu Cultural Awards. Switching exclusively to a brush midway through the series, Inoue intensified the subjective motion and emotion of the story and adopted a grittier, earthier feel that he says was influenced by the films of AkiraKurosawa.

In 1999, inspired by the Paralympics, Inoue began *Real*, a tale of determination in the face of great obstacles, featuring wheelchair-bound basketball players. "Manga is a very direct way of expression, and because of that, the artist himself is revealed easily," he says. In the range and depth of his stories, Inoue has revealed himself to be a complex and thoughtful creator.

INOUE's interview

— How did you become a manga artist? When did you decide you wanted to do this for a living?

Well, I liked drawing—not just manga, I liked drawing anything from my childhood, so it came naturally to me that I would be working on something that relates to drawing. Right around when I was going to graduate from high school, even though I wanted to draw, I didn't have enough skill to become a fine arts artist, so it was natural and realistic to think of drawing manga—something that I liked. When I was in college, I started sending out manga to *Shonen Jump*'s rookie awards [contest], and luckily I received a call from an editor. From there, it wasn't long until I

debuted. I was really pretty lucky.

— Did you have formal art training?

When I was a senior in high school, I wanted to go to a university of fine arts, so I went to a prep school for about a month and a half. It was just a summer program, and that's the only thing I studied for art. I didn't end up going to a university of fine arts, so that was the only time I learned [about art].

— What did you study in college?

Literature.

— So you studied manga by yourself?

Yes.

Go Lakers!: Inoue was a fan of the Los Angeles basketball franchise long before American basketball began being televised in Japan. When he was in high school and later, when he began *Slam Dunk*, Inoue had to rely on magazines and videos both to learn the game and for reference.

Early Inoue: Chameleon Jail (1988–1989) [shown on the left] was Inoue's first weekly series. A story about a shape-changing "risk hunter" who helps those whom the police have failed, the art showed the influence of Hojo Tsukasa, to whom Inoue had briefly been an assistant. In 1992, two years after *Slam Dunk* had begun, Inoue drew a short story

titled "Baby Face," about a kindhearted assassin. The art this time showed the influence of Ikegami Ryoichi, whom Inoue admired. The character even cries in some scenes, similar to Ikegami's Crying Freeman. But Inoue's heart was definitely in his basketball manga. © Inoue Takehiko / I.T. Planning, Inc.

— Did you ever work as an assistant to another manga artist?

I did that once. First, I drew manga by just imitating what I saw, but when I was 21—while Hojo Tsukasa-san was doing *City Hunter*—I had an opportunity to be his assistant for about 10 to 11 months. So I kind of learned the basics of how to draw manga there.

— What was your first published work and when did it appear?

Kaede Purple (Purple Maple), in 1988.

— Was there a low point in your career?

I never felt anything like a slump. Even if I did, I try not to think of it as a slump. I don't think that way.

— What would you call your manga or how would you describe it?

If I think in terms of age, I think it is proper to say that [my manga] is for *seinen* (young men's) magazines, but I really don't think about who I draw for.

— Who are your readers?

When I was doing *Slam Dunk,* since it was for a *shonen* (boys') magazine, there were many young people—both male and female. But recently, the age range has expanded to older readers; there are even [some in their] 60s.

— In creating a manga story, do you begin with a script, a *name* (thumbnail with dialogue), or just an image?

First, it's nothing like a script or a synopsis, but I write down a list of things that came to mind and that kind of becomes the plot. And then from there I do the *name,* or actually the manuscript.

The story that started it all: *Kaede Purple (Purple Maple)* won the Tezuka Osamu Prize for best new manga-ka in 1988, when Inoue was 21. Inoue has said that *Kaede* was the basis for *Slam Dunk,* portraying a high school basketball team. Although sports manga had been popular in Japan for decades, one had never been done about basketball prior to *Slam Dunk.*
© Inoue Takehiko / I.T. Planning, Inc.

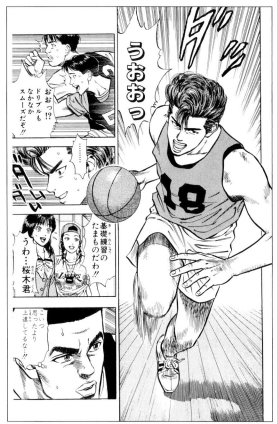
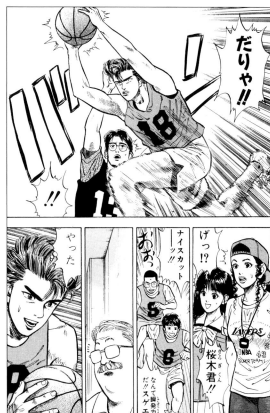

The early Slam Dunk: Sakuragi Hanamichi, trying to impress the girl of his dreams, takes up basketball at Shohoku High School. These pages, from the second volume of the 31-volume story, are typical of Inoue's art in 1990. The layouts and execution are standard action— manga fare, somewhat crude when compared to what he would be doing just a few short years later in the same series.
© Inoue Takehiko / I.T. Planning, Inc.

— **Between the *name* and the manuscript (final art), do you do any rough art?**

Usually, rather than a *name,* I just start on the manuscript.

— **You go directly from the list to the manuscript?**

Yes.

— **Where do your story ideas come from? Dreams, daydreams, reading, movies?**

Well, mostly, the backbone of the story or the motives of the characters and emotions are in that work's previous story, or the one before that, or maybe in the first or second *tankobon* (volume of collected stories), so the hint—or actually the answer—is mostly in there, so I hardly see movies or read books to get that. But for specific things, such as tips for sword fights, I may look at those [movies or books]—but hardly for the story.

— **For the manuscript, do you always work on the pages in order, completing one page at a time before moving on?**

I basically start from the first page. The reason is that I start without any *name,* so I will get mixed up if I don't do it in order.

— **How many assistants do you have? Describe how you work together.**

I have five assistants. To explain it simply, they do everything except the human figures. I do the inking and the finishes, but for the backgrounds I just make a general perspective, draw it roughly in pencil, and hand that directly to them.

— **Do you ever feel restricted working in mainstream manga?**

Hmm, hardly. In Japan, there are no restrictions. Depending on the country—if we take *Vagabond,* for example—there are scenes that have been omitted, such as cutting down people or the sex scenes. But in Japan, there's no problem.

— **Who were your artistic influences when you first started?**

There's nothing that influenced me directly. It kind of soaked into me from my childhood, and the layers of those things naturally made me think of becoming a manga-ka. For example, *Dokaben* [a famous baseball manga by Mizushima Shinji], and I liked Ikegami Ryoichi-san's art, I liked his *Otoko-gumi (Male Gang).* Besides that, Kobayashi Makoto-san [manga creator of What's Michael? and a judo manga titled *Judou-bu Monogatari*]. Those three are the ones that influenced my work style the most.

— **What were the initial motivations to begin each of your series?**

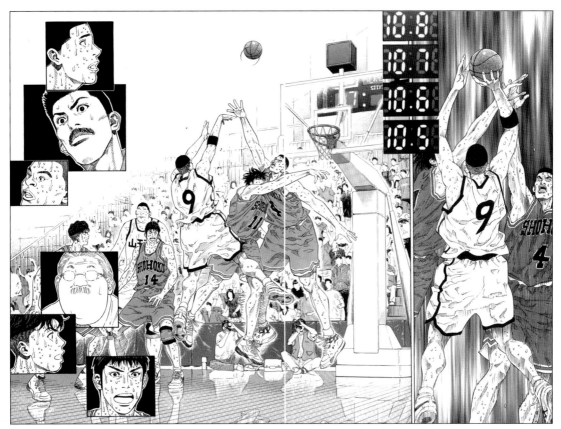

The later Slam Dunk: By 1996, Inoue was actively re-creating and redefining action manga. The story of a single basketball season for Shohoku High School's dream team had taken Inoue six years to tell in weekly installments. Part of the reason was Inoue's extensive use of slow-motion sequences, in which many pages could be devoted to actions taking place in a matter of seconds in the story's timeline. Another device he used extensively was what Scott McCloud calls 'aspect-to-aspect' transitions, in which the same scene can be seen from many different points of view at the same moment in time, such as the viewpoints of different characters or of different 'camera angles.'
© Inoue Takehiko / I.T. Planning, Inc.

Well, for *Slam Dunk,* I was in a basketball club in high school, and there were no manga about basketball at the time, so I thought I had to do it. For *Real,* I came across wheelchair basketball on TV and thought that it was very interesting and wanted to make it into a manga. *Vagabond* started after *Slam Dunk,* and that was a time when I wasn't drawing manga for a while. An editor from *Morning* recommended *Miyamoto Musashi* [the novel by Yoshikawa Eiji] to me, so I read it. After *Slam Dunk*, I had felt like ending my manga career, but when I read that, I wanted to draw the faces of the characters and my hands started tingling, so I started. In a nutshell, it's something like that.

— In another interview, you said that you grew and developed along with *Slam Dunk*. Tell us about that.

When I started *Slam Dunk,* I was very inexperienced as a manga-ka, so there are parts that are very unpolished. I was never satisfied with my work, and I tried to make each episode better than the one I had done the week before. I had feedback from readers, and there was a kind of give-and-take. I was showing the public how I was growing up, and I was revealing that to everyone in real time! When I look at it now, I really think that I changed a lot as a person and as a manga-ka from the beginning to the end.

— Regarding *Vagabond,* I read a comment by you that you were exploring "what it means to be Japanese."

What I wanted to say was simple: Nowadays in Japan, people around my age and much younger are pretty much out of touch with the history of Japan and our traditional culture. I myself was ignorant of those things. So I hoped that this would spark an interest in them.

— What kind of research did you do for *Vagabond?*

The basic things. When I started, I had little interest in history, so I didn't even know what I didn't know. For example, for armor, depending on the era, there are various types, and it changes according to [social] class as well. I didn't know which armor to draw. It was more than I could handle by myself. I didn't know about kimonos or hairstyles, so I couldn't figure out where to start. So at the beginning, there are many things that I'm not satisfied with now . . . but I'm not working on a history textbook. There were priorities, and ascertaining the historical evidence was a low priority back then.

— Some of the sequences in *Vagabond* are extremely cinematic. Are there any film directors you admire?

I think I would have to say that I've been influenced by Akira Kurosawa.

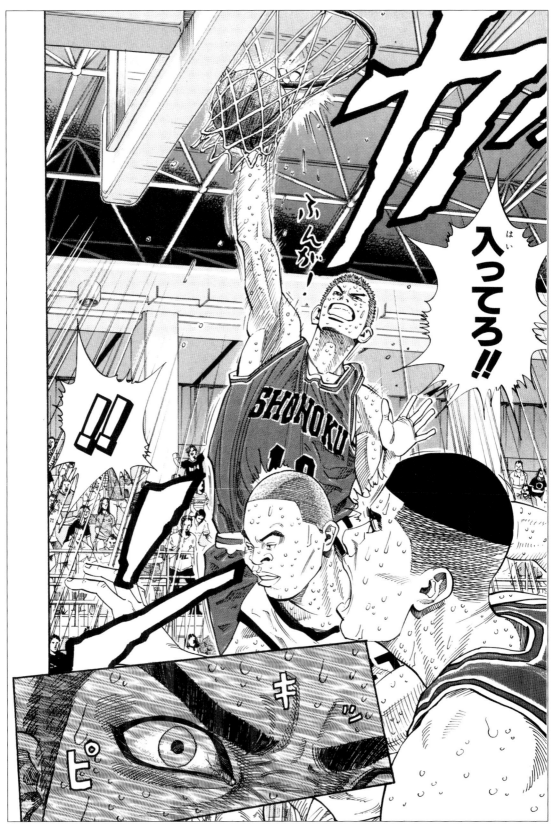

Hoops epic: The story of *Slam Dunk* takes place over the course of four months for a high school basketball team. The series, on the other hand, running weekly in *Shonen Jump*, took six years, beginning in 1990. Inoue has said that he matured as an artist along with the work, and his art toward the end of the series is remarkably advanced from where he began. *Slam Dunk* has become popular in Europe and Asia as well as Japan; unfortunately for American readers, only the first five volumes have been translated into English.

© Inoue Takehiko / I.T. Planning, Inc.

Fast action, high drama and intense emotion: In this sequence, which takes a total of nine pages, Sakuragi saves a ball going out of bounds and passes it to his teammate (and rival). The sequence was half of one week's 18-page installment of *Slam Dunk.* Not only Inoue's storytelling, but the quality of his rendering advanced dramatically in the course of the series.
© Inoue Takehiko / I.T. Planning, Inc.

One reason I started using a brush was that I wanted to get that dark and dirty feeling, I wanted the kind of art texture that *Shichinin no Samurai (Seven Samurai)* and *Rashomon* had. That's the feeling I'm trying to achieve in my art.

— **Tell me about the theme of** *Real.*

When things don't go right in your life, that's not the end of it and there's still more to go, so I wanted to draw about the things beyond that. When you haven't experienced that before, you think it's the end. A handicap is one example, but it can be other things in your life. For example, there's a character named Nomiya who quits high school, and people think it's unbelievable to quit high school and that there's nothing for him in the future. Beyond that, there's a lot of drama—there might be things that make you happy, that even make you want to cry, and there may be

things that don't go well, but that's what I want to draw.

— **Are there major themes in your other works?**

Well, I recognize it after the fact. I don't have a conscious intention, but when I re-read it later on, it's something like . . . an aspiration to be better, or that kind of thing, I guess.

— **Has your drawing style or methods changed over the years?**

My art is completely different from the first volume to the last of *Slam Dunk,* and for *Vagabond* from the middle of the Kojiro part, I started drawing with a brush. [Kojiro Sasaki is Musashi Miyamoto's main rival in the story.] I made that change because I couldn't express what I wanted with a pen, drawing through the lines; I had to use the touch of the brush to intensify the emotion, so the change was made by necessity. But right after I switched, there were parts that I wasn''t

used to, so there wasn't enough skill in it. I got more comfortable by doing it and now it has the feeling I like.

In between *Slam Dunk* and *Vagabond,* in 1998, Inoue wrote his most popular short story, and a possible prequel to *Slam Dunk.* Titled "Piasu" ("Pierce"), it is the encounter of two sixth-grade boys living by the ocean who struggle to enter a grown-up world. Inoue has said that the theme was perhaps too heavy for kids. Under the title "Piercing," the work has been translated into Italian.
© I.T. Planning, Inc.

— Do you use any reference material, such as photos, to draw from?

Of course.

— Do you yourself use them in drawing, or do you just give them to your assistants to refer to?

Well, especially for the backgrounds and scenery—those things cannot be drawn without a photo to provide the image.

— What is your favorite medium?

The brush. I'm getting used to it and I think my method has improved, so I like that the best.

— In terms of storytelling and design, are there any dos and don'ts you stick by?

I guess I do have one. I won't force the characters to do what's contrary to their nature, just because of the demands of the story. I don't want to force things on the characters just

because they're needed to advance the story, and only for that purpose.

— Has your storytelling technique evolved or changed over the years?

There's been a change within me. Back in the days of *Slam Dunk,* I was drawing what was "cool" and just the good side of things. But now, I think I've been able to draw things such as ugly people, or people having hard times, or the story of a killer. I think I've gotten better at drawing and writing about the not-so-good side of people. And one of the reasons that I draw is because I want to make manga about those kinds of things.

— What's a typical day for you? How many days a week do you work?

I really don't work much on a schedule. First of all, I want time to think about the idea before I start on a manuscript—three or four days. On those days, I wake up in the morning and go out and go around to places like cafes, and think about an idea. When I get enough ideas and plots, I face the manuscript. I spend around four to five days in front of the manuscript . . . if there's time. When there's not much time, I draw it in about three days. [Laughs.]

— How long does it take to do a page? How many pages a day do you do?

About four to five pages are ideal, but I'm little behind schedule recently, so I do like to do 10 pages a day, at the worst. [Laughs.] But there have been a lot of "worst" days recently. It's always like that on the last day, since I need to finish it by the deadline.

— On a day like that, do you do everything on those 10 pages . . . penciling, inking, backgrounds?

Yes, indeed. [Laughs.]

— Do you work overnight?

Uh-huh, I have to do that, of course. [Laughs.] My assistants are crying. The later I am with my work, the less time they have, so I hear "We have to do all this work in only this much time?!"

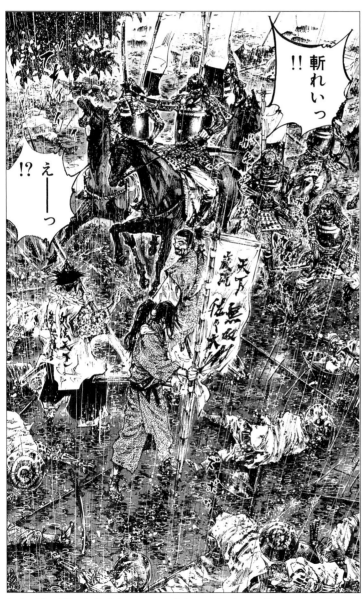

Authenticity of historic details in costumes and weaponry has increased in the course of *Bagabondo (Vagabond).* Inoue admits that when he began the series he didn't know much about feudal Japan. He was concerned simply with telling a passionate tale that explored the nature of Japanese character. As with *Slam Dunk,* he has continued to grow as an artist, striving for ever-higher standards.
© I.T. Planning, Inc.

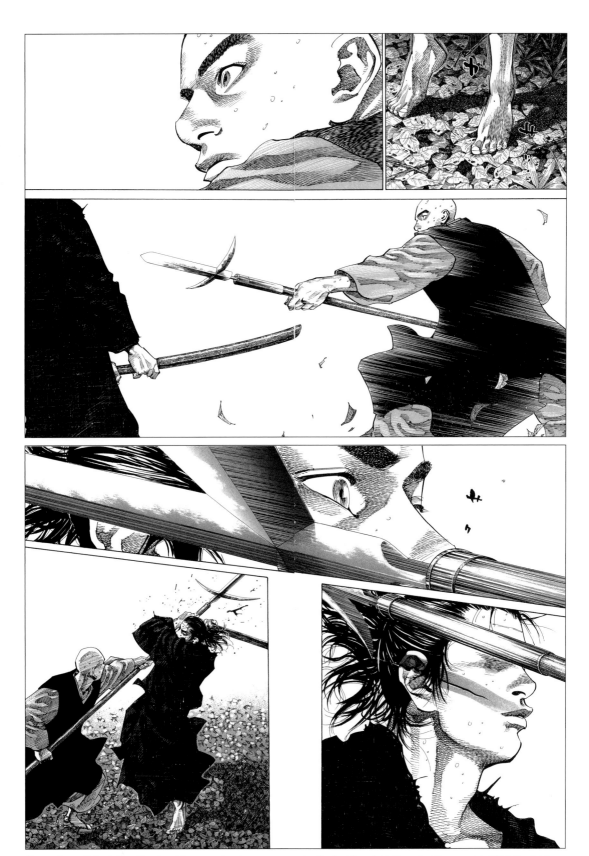

Cinematic martial arts from Vagabond: Inoue continued developing pacing and action in his adaptation of the novel *Musashi*, by Yoshikawa Eiji, a biography of the seventeenth-century mystical warrior, Miyamoto Musashi. Inoue switched from pen to brush shortly after this point in the series. These pages are from the eighth volume, published in Japan in 2000. *Vagabond* is being translated into English by Viz, LLC.
© I.T. Planning, Inc.

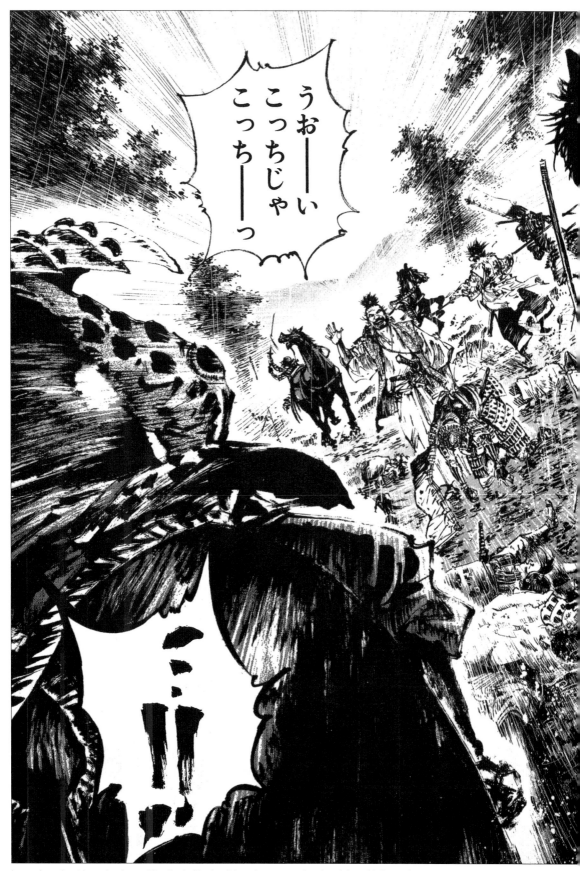

Images from the eighteenth volume of *Bagabondo (Vagabond)*. Inoue's expressive brushwork has added period atmosphere to the story.
© I.T. Planning, Inc.

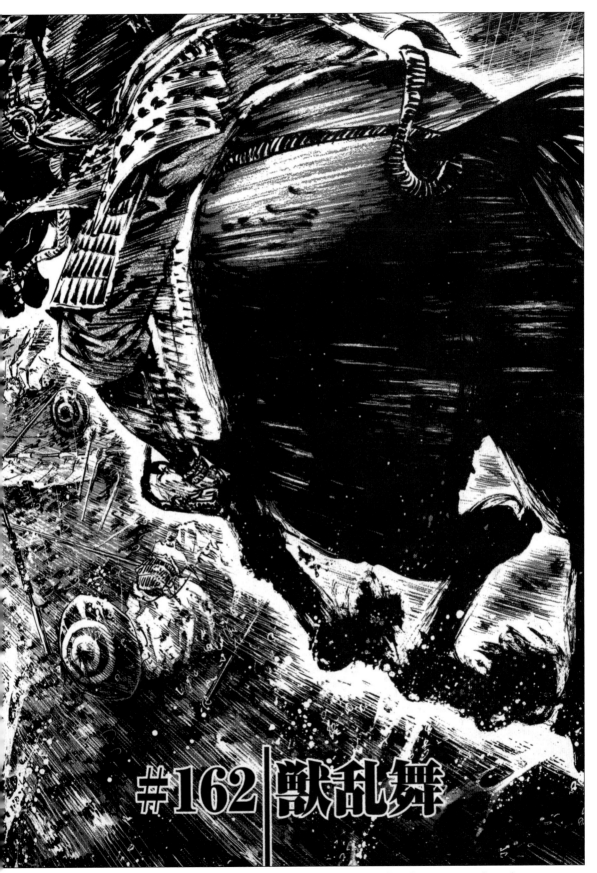

#162 獣乱舞

Subjective motion—giving the reader the point of view of a participant in the story—is one of Inoue's strongest storytelling tools.

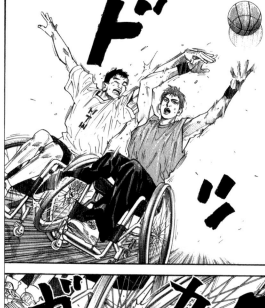

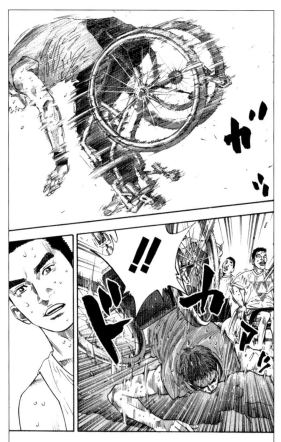

Inspired by observing the Paralympics, Inoue decided to do a story about athletes with disabilities. *Real* has been an intermittent series since 1999. Inoue has said he wanted to show that, with determination, anyone can achieve their dream. Fans have described *Real* as more sophisticated than *Slam Dunk,* because of its focus on people whose lives are not usually considered glamorous or exciting. Although not published in English to date, an English-language scanlation is available at http://www.omanga.net/.
© I.T. Planning, Inc.

— **Other than the tools we see here in your studio, is there anything else you need for doing manga?**

I have a basement floor and there's a Japanese room there, so I just shut myself away there when I do *names* or rough drawings or think of a story. Later, when I'm doing manga up here, I usually have music on. And I drink a few cups of coffee. That's about it. Nothing special.

— **Any particular music?**

I don't have any principles, so I listen to anything. Recently, I was only listening to Brazilian music and bossa nova. I even listen to hip-hop. When I was depressed, or felt hurt, I listened to Hawaiian tunes, and couldn't listen to anything else. But I'm all right now—I can even listen to loud music, too. [Laughs.]

— **Are there any of your works that you are unhappy with?**

I do have those, of course. The body of my work may be good, but there are stories [in the middle] that I thought didn't go well, actually.

— **What is your favorite work?**

I can't compare them. The two works that I am doing now haven't ended, so I really can't say. As for my feelings, the two that I am working on now are the ones that I like best [*Vagabond and Real*], but it's really something that can't be compared. I don't really have a feeling that I like one the best—I really like all of them.

— **What are your favorite manga or comics by other artists?**

I really don't read manga and look forward to it, like I used to in the past. There's nothing that comes to mind.

— **What advice would you give to any aspiring manga artists?**

Manga is a very direct way of expression, and because of that, the artist himself is revealed easily. It can show what kind of person you are, so—although it's important to develop your manga skills and acquire knowledge—I want you to think about developing yourself when you work on them.

— **What is the most important thing in drawing a manga?**

The most important thing is having a feeling that you want to pass along to the reader. For me, it's the best way of expressing myself naturally.

— **Is there anything you would like to say to your fans outside of Japan or inside Japan?**

Well, it is an accepted theory that my manga's story moves a little slowly, but I hope you will stick with me doggedly. I want to make a story that will satisfy you in the end, so please keep reading.

List of works:

- *Kamereon Jeiru (Chameleon Jail)*, Shueisha, 1988–1989, 2 volumes (a scanlation of this manga can be found at http://www.omanga.net/)
- *Buzzer Beater,* Shueisha, 1997–1998, 4 volumes (This was originally an online comic on the ESPN home page.)

Art books:

- *Inoue Takehiko Irasuto Shuunzu (Inoue Takehiko Illustrations)*, Shueisha, 1997 (ISBN 4-08-782408-X)

In English:

- *Slam Dunk,* Gutsoon! Entertainment, 2003–2004, 5 volumes (Vol. 1 ISBN 097250379X)
- *Vagabond,* Viz LLC, 2002–, 15 volumes to date (Viz LLC: http://www.viz.com/)

Major works:

- *Slam Dunk,* Shueisha, 1990–1996, 31 volumes (24 volumes in Perfect Collection)
- *Bagabondo (Vagabond),* Kodansha, 1998– , 20 volumes to date
- *Riaru (Real),* Shueisha, 1999– , 3 volumes to date

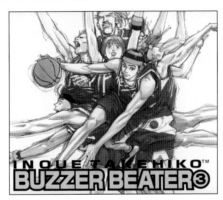
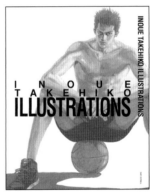

Top three:

- *Slam Dunk Perfect Collection* (Vol. 1 ISBN 4088591909)
- *Vagabond* (Viz, LCC English version) (Vol. 1 ISBN 1-59116-034-0)
- *Riaru* (Vol. 1 ISBN 408876143X) [Note: Scanlations in English available at http://www.omanga.net/]

Web site:

- Inoue Takehiko's official Web site: http://www.itplanning.co.jp/
- Unofficial information on Inoue Takehiko can be found at Prisms, the Ultimate Manga Guide http://users.skynet.be/mangaguide/au535.html

Japanese manga artists you might like, if you like Inoue Takehiko:

- Asada Hiroyuki
- Hirata Hiroshi
- Kojima Goseki
- Samura Hiroaki

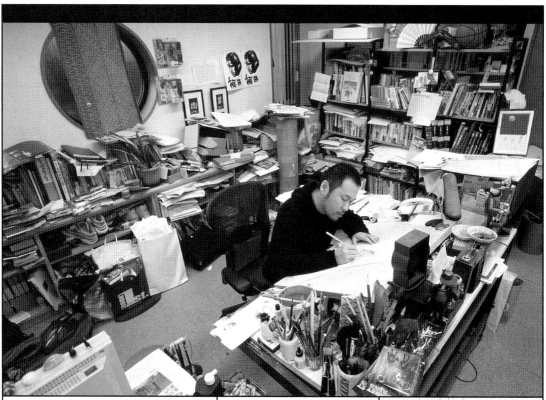

Painting with a pencil: Inoue's underdrawing is vibrant and expressive, full of the dynamism of his finished work. He will indicate the most basic perspective for backgrounds, which are created in full by his assistants. Inoue inks and finishes all figures and portraits of his characters. Midway through *Vagabond,* he switched to inking with a brush, preserving more of the original pencil's vitality.
© I.T. Planning, Inc.

▼ Some of Inoue's most frequently used media: Kaimei's Lettering Sol waterproof black ink; Luma concentrated watercolors; Holbein Acryla and Turner Acryl gouache. To the right of the photo are his G-pen, pencil, and mensofudes.

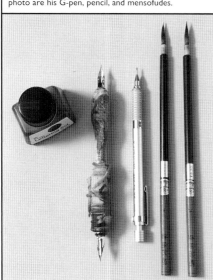

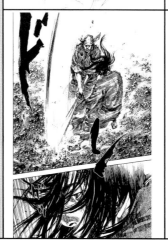

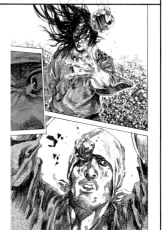

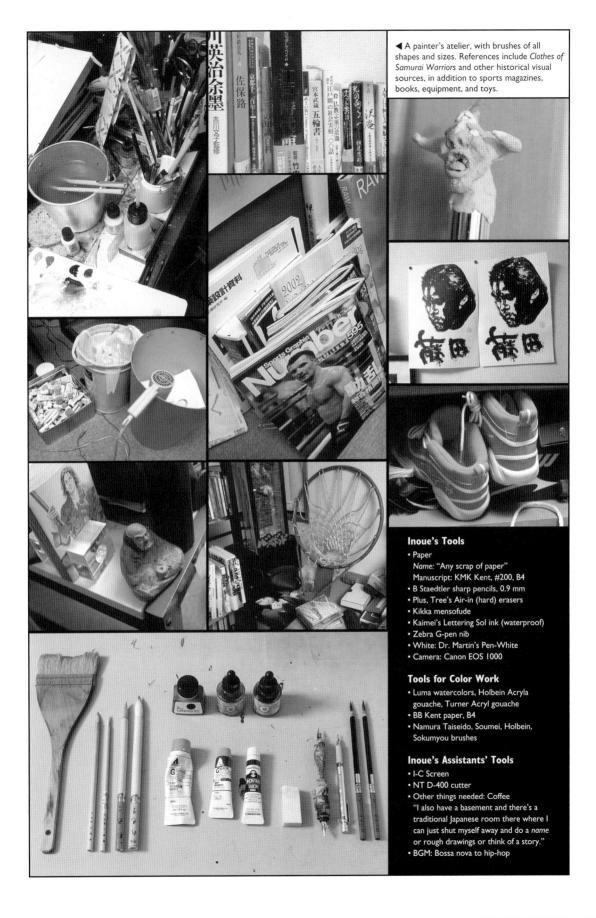

◀ A painter's atelier, with brushes of all shapes and sizes. References include *Clothes of Samurai Warriors* and other historical visual sources, in addition to sports magazines, books, equipment, and toys.

Inoue's Tools

- Paper
 Name: "Any scrap of paper"
 Manuscript: KMK Kent, #200, B4
- B Staedtler sharp pencils, 0.9 mm
- Plus, Tree's Air-in (hard) erasers
- Kikka mensofude
- Kaimei's Lettering Sol ink (waterproof)
- Zebra G-pen nib
- White: Dr. Martin's Pen-White
- Camera: Canon EOS 1000

Tools for Color Work

- Luma watercolors, Holbein Acryla gouache, Turner Acryl gouache
- BB Kent paper, B4
- Namura Taiseido, Soumei, Holbein, Sokumyou brushes

Inoue's Assistants' Tools

- I-C Screen
- NT D-400 cutter
- Other things needed: Coffee
 "I also have a basement and there's a traditional Japanese room there where I can just shut myself away and do a *name* or rough drawings or think of a story."
- BGM: Bossa nova to hip-hop

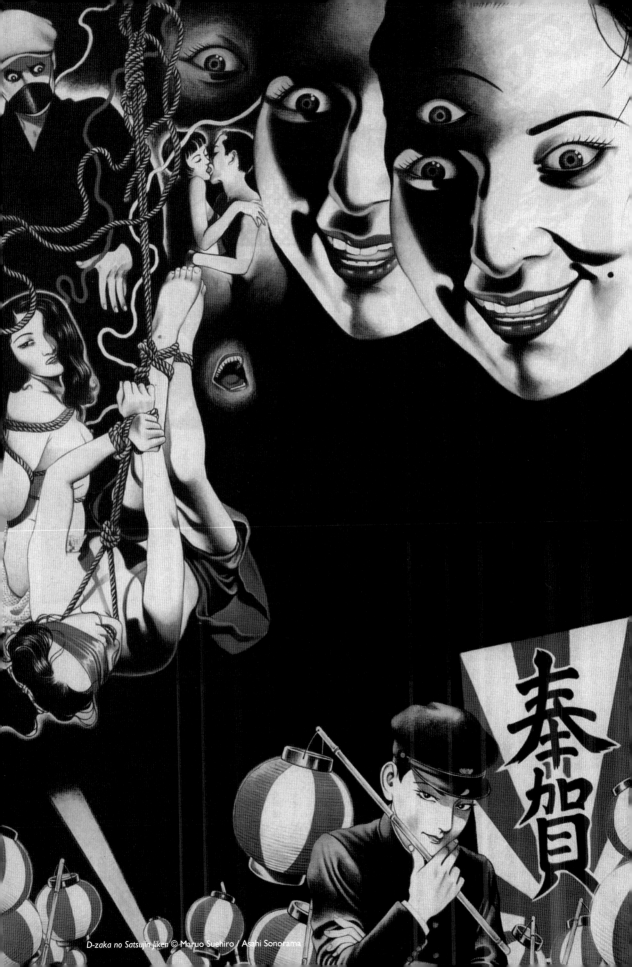

MARUO SUEHIRO

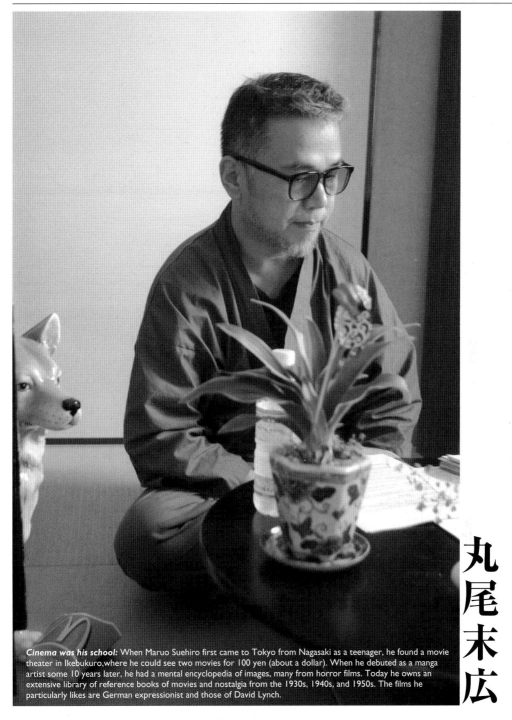

丸尾末広

Cinema was his school: When Maruo Suehiro first came to Tokyo from Nagasaki as a teenager, he found a movie theater in Ikebukuro,where he could see two movies for 100 yen (about a dollar). When he debuted as a manga artist some 10 years later, he had a mental encyclopedia of images, many from horror films. Today he owns an extensive library of reference books of movies and nostalgia from the 1930s, 1940s, and 1950s. The films he particularly likes are German expressionist and those of David Lynch.

PROFILE

Place of birth: Nagasaki, Japan

Date of birth: January 28, 1956

Home base: Tokyo, Japan

First published work:
Ribon no Kishi (Ribbon Knight), 1980

Education:
Junior high school

Career highlights:

1982 *Bara-iro no Kaibutsu (Rose-Colored Monster)* (Seirindo)
1984 *Shojo Tsubaki (Camellia Girl)* (Seirindo)
1988 *Edo Showa Kyosaku Muzan-e Eimei 28 Shuku (Bloody Ukiyo-e)*
 (Libroport)
1991 Part of an exhibition of manga artists at Pomeroy Purdy Gallery in
 London
1998 *Warau Kyuuketsuki (The Laughing Vampire)* (Akita Shoten)—started
2000 Part of an exhibition of manga artists at Stux Gallery in New York
2000 *New Century SM Pictorial* (Asahi Sonorama)

Maruo Suehiro sat cross-legged, like a beatnik Buddha, in his green kimono, horn-rimmed glasses, short-cropped hair, and goatee. We were in a traditionally styled receiving room, with tatami mats covering the floor and a low, black-lacquer round table between us. Nearby was the room where he draws, transcribing the movies in his head onto paper. "It's the only place I can work," he said. The reasons were all around us.

Numerous bookcases in both rooms were filled with the stuff of nightmares—books on classic horror movies and

photographs of dead bodies—but also illustrations, manga, and toys from '40s and '50s Japan, a time for which Maruo has great fondness. On top of the bookshelf behind him was a model of the Boris Karloff Frankenstein monster and a still from Das Kabinett des Doktor Caligari, one of his favorite films. We were in Maruo's museum of twentieth-century kitsch.

With each question, he took a deep breath, which he then expelled with a short, clipped answer. In each brief pause that followed, he would grab a McDonald's french fry from the packet on the floor to his right and pop it into his mouth. He was clearly uncomfortable; Maruo is a shy and solitary person, and has always worked on his manga alone.

He began his career as a manga-ka at the age of 24 doing pornography, the only manga work he could find. Some years earlier, having moved to Tokyo from Nagasaki,

he had discovered the Bungeiza movie theater in Ikebukuro, a place where he spent many hours collecting visual impressions, filing them away in his encyclopedic memory. Even in his early manga, amid the sex, was *ayashii*—a mysterious, spooky, dark element, which came to him naturally, unplanned. He eventually tired of doing porn, and set out to develop a personal style, appearing intermittently in the alternative magazine Garo, and doing illustrations for novels.

Maruo's manga belong to a subgenre known as ero-guro, meaning "erotic-grotesque," which fuses sex and violence. His subjects can be supernatural horrors such as vampires, but also the more familiar—and more disturbing—human horrors of murders, mutilations, sexual perversion, torture, and cruelty.

But Maruo's work has other elements that make it difficult to dismiss as total decadence and depravity. His draftsmanship is exquisite and beautiful, full of lavish detail. There is an immediate, powerful dissonance between revulsion for his subject matter and attraction to his art. There is also a strong sense of elegy in much of his work, a nostalgia for things lost. One of his favorite references is titled *Tokyo's Vanished Street Corners*, a book of photographs from the '30s and '40s.

But most surprising in Maruo is his humor. "Instead of working on a theme, having it be funny is enough," he said. The humor is sometimes satiric, like that of *Planet of the Jap*, in which Japan wins World War II. It can also be an ironic juxtaposition of text and images. But most often it's a David Lynch type of surrealistic dark humor—like the boy who cries "Heil Hitler!" to the giant snail he hallucinates in *Season in Hell*. Maruo particularly likes Lynch's *Eraserhead*.

Maruo's images are unforgettable. His description of another artist's work seems apt for his own: "They aren't pictures about goblins; the pictures ARE the goblins."

MARUO's interview

— How did you become a manga artist?

My debut was when I was 24 and it was in a porn magazine. With porn magazines, it was fairly easy to get your foot in the door. That's why I ended up publishing in porn magazines. It wasn't that I wanted to do porn manga.

— When exactly did you decide to make this your career?

Hmm. Back when I was in middle school.

— Did you ever work at another job?

I've had many occupations. Thirty or so. They were all small jobs, so I

don't know if they can even be considered occupations.

— What was your education? Did you have formal art training?

I've only been through compulsory education. I haven't attended any art schools, either.

— Were you influenced by your parents in becoming an artist?

No, not at all.

— Where did you learn how to draw manga? Did you work as an assistant of another manga artist?

No, I didn't.

— Did you ever self-publish a *doujinshi*?

No.

Dracula, Gigantor, and Eightman are among the horror and nostalgia items in Maruo's collection. Eightman [appearing on the toy on the right] was a manga that Maruo liked in childhood, when he spent hours tracing the popular action character.

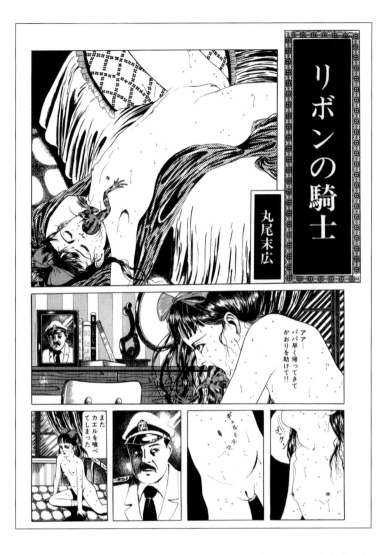

A wicked sense of humor characterizes Maruo's work, as much as its horror or erotic elements. His debut manga, shown above and at left, was titled *Ribon no Kishi (Princess Knight)*, the same title as the classic *shojo* (girls') manga by Tezuka Osamu. Any Japanese reader would understand the irony of juxtaposing Maruo's bizarre content with the wholesome girls' fantasy-adventure. Maruo's *Ribon no Kishi* was first published in 1980.
© Maruo Suehiro

— When was the first time you submitted a manga to a porno magazine?

It was 1980.

— What is the name of your first published *tankobon*?

It's called *Bara-iro no Kaibutsu (Rose-Colored Monster)* and was published by Seirindo in 1982.

[Editor's note: Maruo's first surving published individual manga, *Ribon no Kishi*, appears in *Bara-iro no Kaibutsu*. See the illustrations on this page.]

— When was this published?

When I was 26 years old.

— Did you ever experience a low point or slump in your career?

I have. More than a slump. There was a time when I didn't have any work. I was doing porn manga for a long time, but didn't want to do that

anymore, so there was a period when I didn't have work.

— What did you do in order to change genres?

I just went on drawing whatever I wanted. Even when I wasn't asked to produce manga, I got myself to keep at it and got through that time.

— So you got through that time solely on your own motivation?

That's right.

— And then your work was published in *Garo*.

[Editor's note: Maruo's first manga story in Garo was in 1982.]

I was working for *Garo* prior to that. Only *Garo* didn't pay enough. That made me worry a little.

— So, if *Garo* didn't pay enough money, were you doing other work

at the time as well?

Yeah, I drew illustrations for novels.

— Was that all through the time you were working at *Garo*? Until it went out of business?

Yes. That's right.

— If you were to categorize your work, which genre do you think it belongs to?

Hmm. I think they would go in the alternative category.

— What kind of audience do you think you have

I imagine them to be guys and girls around their 20s.

— When creating manga, do you start from a story or from images?

I start with a story. I've prepared some things to show you today. This is like a storyboard for a movie.

[Editor's note: Maruo is referring to his *e-conte*.]

I make something like this first and draw using this as a basis. My finished work isn't exactly like the storyboard, but it gives me a general picture of what I want to make.

— You make your storyboards on this large piece of paper?

Yes, it's the same size as the actual manuscript copy. [Editor's note: Maruo's *e-conte* is the same size as the final printed piece, B5 size (7 × 9.88 inches). The manuscript is 120 percent larger, B4 size (10.12 × 14.33 inches). See page 110.]

— How do you come up with ideas for the story?

Hmm. By watching movies and such.

— Do you go watch movies even now?

I haven't been out to a theater lately, but I watch movies by renting videos and DVDs.

— I heard that you used to go watch movies in Ikebukuro when ou first became a manga artist.

Yes. I went to many movies at a theater called Bungeiza, which is no longer there.

— Do you have a general idea of a story before writing down the story line? Or does the actual story line complete itself in the process of writing it?

In the process.

— Is there a step between the storyboard and the finished work?

No.

— And you use pencil, ink, and tone after this?

Yes.

— Computers don't play a role in your work. Do you have any assistants?

I don't have any. I draw everything myself from start to end.

— What is your impression of *Garo*?

Garo has become very weird. It used to be good.

— Do you find any major changes in the way you deal with editors, comparing the time you produced for *Garo* and now, when working for *Young Champion*?

There hasn't been much change.

— Do you still initiate ideas for serialized stories, rather than being asked to do certain things?

Of course.

— Do you think that is the reason [the fact that they respect your ideas] your interactions with the publisher haven't changed much, even though you've switched magazines?

Yes. I think so.

— Do you consider the difference in the magazines when thinking of ideas for stories?

Yes. I do match them up.

— Were you influenced by any writers when you first started drawing manga? Of course, it can be other manga artists or people in different media.

I like Umezu Kazuo.

— Which work of his do you like especially?

I like *Orochi*.

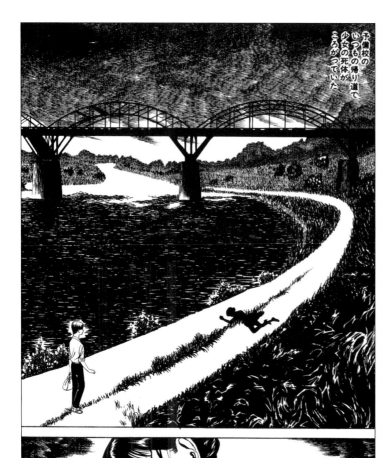

A nightmare of madness and lost memory: Jigoku no ichi Kisetsu (A Season in Hell) begins as a boy discovers a brutally murdered gir's body. It later turns out that he himself is actually the killer. The story appeared in Maruo's 1982 *tankobon, Yume no Q-Saku (Q-Saku Dream)*. It was also one of the selections in the English-language collection of Maruo's work, *Ultra-Gash Inferno*, published in 2001 by Creation Books.
© Maruo Suehiro / Seirindo

CHAPTER TWO

THERE'S NO PLACE LIKE HOME

Maruo's masterpiece: *Shojo Tsubaki (Camellia Girl)* was published in 1984, when Maruo was 28. Based on a Japanese folktale, this story of an orphan trapped in a circus of malevolent freaks has a strong surrealistic flavor, in addition to Maruo's grotesque and erotic images. It is also very sad. An English-language translation was published in 1992 by Blast Books, with the title *Mr. Arashi's Amazing Freak Show*. A treat for English readers, the book contains some of Maruo's most accomplished draftsmanship.
© Maruo Suehiro / Seirindo

One of Maruo's most artistic works, *Die Andere Seite* is a surrealist collage of post–World War II reconstruction, drawing from images worldwide. The periods immediately before and after the war in Japan are frequent settings for Maruo's stories. Many contemporary Japanese have nostalgia for what they consider a simpler time, prior to the most recent wave of rapid modernization and westernization. Maruo has his own obsessions with this period of time, not only in Japan, but also in Germany. *Die Andere Seite* appeared in the 1983 collection *DDT*.
© Maruo Suehiro / Seirindo

— What influenced you in the past? And have the things that influence you changed from the time you first became a manga artist to now?

It hasn't changed much for me. I used to like the German expressionist movie called *Das Kabinett des Doktor Caligari,* and I still like that today.

— Has a particular movie director stayed in your mind?

That would be Luis Buñuel. He's not German, though. I also like David Lynch. I especially like his movie *Eraserhead.*

— Was there a scene in *Eraserhead* that really stands out in your memory?

Yeah, just that it's really good. No, I can't pick out a particular scene. I like it as a whole.

— Do you think David Lynch's taste is in sync with yours?

Yes, I do.

— I believe your work before watching *Eraserhead* was already similar to it. How did you feel when you saw the movie?

I thought, "Whoa, cool." I mean, you don't need seed money to make a manga, but movies cost a lot, so it's quite a different thing.

— The scene when the boy with a birth defect appeared was quite memorable. It moves just slightly, doesn't it? I don't think that movie cost too much to make, but let me move on to the next question. Do you have specific ideals?

No, not really.

— If you were to put into words the themes of your work, what would that be?

Hmm. Well, this is a question that I'm asked often, but I believe instead of working on a theme, having it be funny is enough.

— Has your style or technique changed over the years?

Recently my eyesight has gotten quite bad and it has made detailed work a little difficult.

— But the basics haven't changed?

The basics haven't changed, no.

— Do you use photos and other references when drawing?

Yes. That I have a lot of.

— What is your favorite drawing tool?

I use a thin pen called a maru pen.

— In terms of storytelling and design are there any dos and don'ts you abide by?

Hmm. There's nothing, really.

— Do you work at home?

Yes.

— Please tell me how a typical day goes.

I get up in the morning now. I used to get up and work at night, but now I start work in the morning.

Japan wins World War II in *Nihonjin no Wakusei (Planet of the Jap)*. Atomic bombs are dropped on San Francisco and Los Angeles, and America is occupied by the Japanese. Far from being a celebration of militarism, the story is a scathingly satiric look at warlike attitudes. The short story appeared in the *tankobon*, *Paranoia Star*, in 1986, and in the English-language collection *Comics Underground Japan*, from Blast Books in 1996.

© Maruo Suehiro / Kawade Shobo Shinsha

A boy in 1950s Japan gets his picture cards stolen at school and then has nightmares about the bullies who terrorized him. Maruo's nostalgia is not characterized by happy events. It is the appearance and style of the past, that he is attracted to. This story, titled "Shonen Gaho," appeared in *Kokuritsu Shonen (National Kid)* in 1989.
© Maruo Suehiro / Seirindo

American-occupied Japan is the backdrop of "Non-Resistance City." A woman hoping for the return of her soldier husband is pursued by a dwarf. After she succumbs to his advances, she discovers he has butchered her son. The story appeared in *Ultra-Gash Inferno.*
© Maruo Suehiro / Seirindo

— **How many days of the week do you work?**

At least six days.

— **How much time, on average, do you spend on one page?**

It takes one day to finish one page. [Editor's note: Maruo is referring to inking only.]

— **Have you had any works in the past that you are not satisfied with?**

Many.

— **Why are you not satisfied with them?**

Things that I had to finish in a rush because of a deadline or other reasons, I don't like.

— **Then, what is your favorite work?**

The one I'm working on now. [Editor's note: Volume 2 of *Warau Kyuuketsuki (The Laughing Vampire).*]

— **That's great that your current work is your favorite. Do you have** any other favorites?

Hmm. When time passes, I lose interest in my own work from the past.

— **What are your favorite comics by other artists—Japanese, European, Asian, or American?**

I like the French artist Enki Bilal.

— **Any others?**

I'm not really familiar with artists from abroad.

— **Is there any advice you would give to any aspiring manga or comics artists?**

Well . . . make the deadlines.

— **Is there anything you would like to say to your fans in Japan and abroad?**

Let's see. I'll be releasing a book soon, so I hope they'll look forward to it.

— **Is there anything else?**

I don't have anything in particular to say.

— **Is there a story behind a key** work in your career that you could tell us?

Hmm. Umm. Well, I don't know.

— **What are your favorite books, music, and movies? Perhaps your top three of each?**

Books . . . I have many. Three books? That's a tough one. There are many movies I like, too.

— **What movie genre do you like, other than director David Lynch and German expressionist movies?**

I like, for example, *Un Chien Andalou,* which was a collaboration between Buñuel and Dali. I also like *L'Age d'Or.*

— **What kid of tools do you use to draw manga?**

In my case, I use a maru pen and black ink.

— **What kind of paper?**

Manga manuscript paper is available in Japan. I would think it's only in Japan that something like that is available.

"Night of the living dead in *Imi Nashi Houichi (Houichi without Ears)*. Maruo's strength is in-your-face horror. It is his attention to detail that makes his visions powerful and convincing. The above image may be an example of how Maruo makes use of photographic references. The bus in this scene may have been taken from the book *Tokyo Kieta Machikado (Tokyo's Vanished Street Corners)*, which we found on Maruo's bookshelves. [See page 111.] This story appeared in Volume 2 of *Maruo Jigoku* as well as in *Lunatic Lovers*.
© Maruo Suehiro / Seirindo

© Maruo Suehiro / Seirindo

— **What about the paper for your e-conte?**

I use facsimile, or fax, paper. The same thing as this [pointing to the *e-conte*]. I don't draw manga on this. I use better paper for that.

— **How about your eraser and pens for rough drafts?**

I use various things, nothing special.

— **What is the percentage of the Screen-Tone you use most often?**

I usually use ones that are 70 percent.

— **When you sit down to work on a piece, do you arrange your desk in a certain way or organize before starting?**

I don't do anything in particular. I am working on that desk right now but there isn't anything special done to it.

— **Are there any other tools you use?**

Yes, I keep necessary references around me. That makes it impossible to draw any other place. I can't draw unless I'm in my own room.

— **Have you considered buying a computer?**

Yes, I am thinking about it a little.

— **Do you think there is a lot of difference between hand-drawn pictures and CG?**

They are totally different, don't you think?

— **Do you like any of the work done with a computer?**

I'm very impressed when I see movies like *Jurassic Park.*

— **Is there any manga done by computers that you like?**

I'm not familiar with any manga done by computers yet.

— **In a previous interview you said that movies have been a major inspiration for your work. Was there a particular movie that influenced you the most?**

That would definitely be the German expressionist films.

— **Were there specific images that you took away from these movies?**

Specific images. Hmm. I guess silent movies like that are very close to manga. Because there is no sound and it relies solely on visuals.

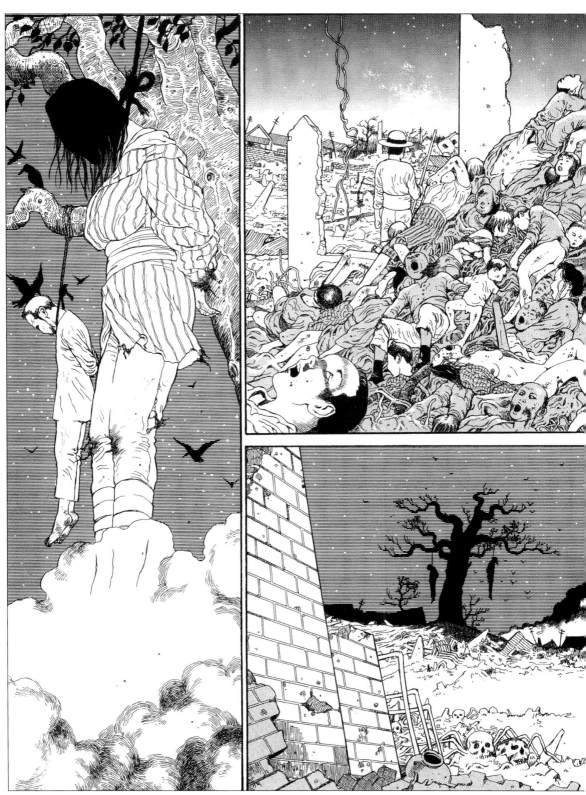

Images from the second volume of *Warau Kyuuketsuki (The Laughing Vampire)*.
This is Maruo's most sustained story line, at over 500 pages for both volumes.
© Maruo Suehiro / Akita Shoten

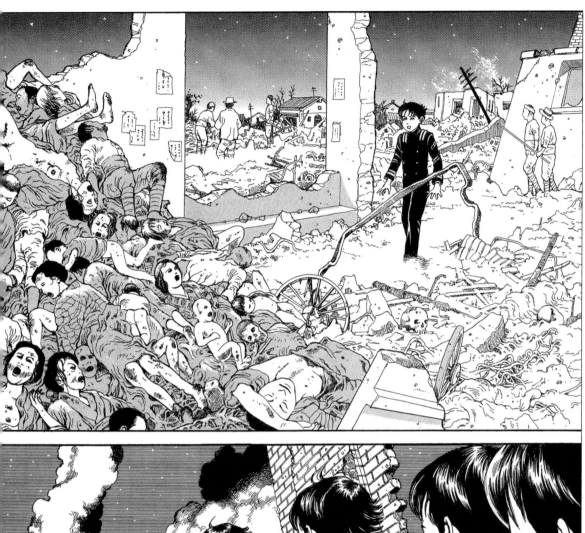

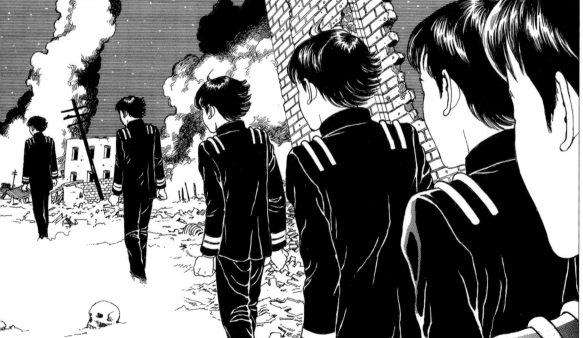

The apocalypse never seems far away from Maruo, who was born in Nagasaki, site of one of the American atomic bomb blasts.

Frederic Wertham was right: Reading comics rots your mind. Maruo poked fun at himself and his own work in the short story "Romanji Title" ("Something about My Boyhood"), in which reading manga becomes a dangerous pastime. The story appeared in *Maruo Jigoku (Maruo Hell),* Volume 1, and *Shin Nashonaru Kido (New National Kid).*
© Maruo Suehiro / Seirindo

— **Did you watch *Das Kabinett Des Doktor Caligari* at the Bungeiza too?**

Oh, no. Bungeiza didn't play that

Page from *Bloody Ukiyo-e:* This art book paired Maruo with Hanawa Kazuichi, another manga artist. They produced contemporary versions of the so-called atrocity prints of nineteenth-century artists Yoshitosi Tsukioka and Yoshiiku Ochiai. The book is divided evenly between the modern and traditional works.
© Maruo Suehiro / Libro-port

kind of thing. I went to a different place.

— **You said in an interview that the concepts of *yoki* (mysteriously sexy and spooky) and *sakki* (a sense of being killed at any time) are significant elements for the atmosphere of your work. In what way did these things become a part of your work? Was there a particular event that led to solidifying this tone?**

Hmm. I would have to say the process of them becoming part of my work was unplanned and natural. There wasn't a defining moment or anything of that sort.

— **Do you think that the *muzan-e* (atrocity print) tradition serves a useful function in society, perhaps as a catharsis for our darker impulses?**

When you put it in words, it sounds kind of scary, but yes, I guess that is correct.

— **Perhaps one reason Japan has a lower crime rate than the U.S. is because there is greater tolerance for all forms of fantasy. People can act out things in fantasies instead of in real life.**

Yes, I guess so.

— **In a previous interview you said that *Gichi Gichi-kun* was your favorite work. What aspects of it do you like the most?**

Oh, I answered that without thinking. I was in a situation where I had to answer something, so I just said what came to mind. I like what I'm working on right now the best. It's ending next week. Here are some proofs; it will become a book at the end of this year [2003].

When I first saw Sensei's work, the disturbing nature of your subject matter, contrasted with the beauty of your drawing, deeply affected me. I was repulsed and fascinated at the same time. An acquaintance translated some of your works for me, and, when the pictures were accompanied by words, the effect was even greater. I'm hoping that more of your work will be translated. Sensei is a man of few words, but your work speaks for you.

List of works:

- *Bara-iro no Kaibutsu (Rose-Colored Monster)*, Seirindo, 1982
- *Yume no Q-SAKU (Q-SAKU Dream)*, Seirindo, 1982
- *DDT*, Seirindo, 1983; Seirinkogeisha, 1999
- *Kinrandonsu*, Seirindo, 1985
- *Kokuritsu Shonen (National Kid)*, Seirindo, 1989
- *Maruo Jigoku (Maruo Hell)*, Vol. 2, Seirindo, 1995
- *Tsuki Teki Aijin (Lunatic Lovers)*, Seirindo, 1999
- *Only You*, Tokyo Adult Club, 1985
- *Paranoia Star*, Kawade Shoten Shinsha, 1986
- *Inugami Hakase (Dog Spirit Sorcerer)*, Akita Shoten, 1994
- *Kaze no Matenro (Demon Revolution Wind)*, Tokuma Shoten, 1994
- *Gichi Gichi-kun*, Akita Shoten, 1996
- *Shin Nashonaru Kido (New National Kid)*, Seirinkogeisha, 1999

Art books:

- *Bloody Ukiyo-e*, Libro-port, 1988 (ISBN 4-8457-0312-2)
- *MaruoGraph*, Vol. 1, Treville, 1996 (ISBN 4-8457-1089-7)
- *MaruoGraph*, Vol. 2, Treville, 1996 (ISBN 4-8457-1090-0)
- *New Century SM Pictorial*, Asahi Sonorama, 2000 (ISBN 4-257-03604-4)

In English:

- *Mr. Arashi's Amazing Freak Show (Shojo Tsubaki)*, Blast Books, 1992
- *Comics Underground Japan* (includes *Planet of the Jap*), Blast Books, 1996
- *Ultra-Gash Inferno*, Creation Books, 2001

Major works:

- *Shojo Tsubaki (Camellia Girl)*, Seirindo, 1984; Seirinkogeisha, 2003
- *Maruo Jigoku (Maruo Hell)*, Vol. 1, Seirindo, 1988
- *Warau Kyuuketsuki (The Laughing Vampire)*, Akita Shoten, 2000–2004, 2 volumes

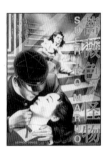 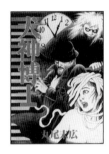

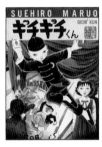 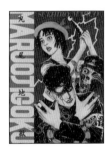 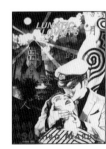 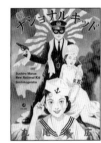 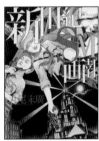

CHECK OUT

Top three:

- *Mr. Arashi's Amazing Freak Show* (ISBN 0-922233-06-3)
- *Maruo Jigoku*, Vol. 1 (ISBN 4-7926-0355-2)
- *Warau Kyuuketsuki* (Vol. 1 ISBN 4-253-10310-3)

Web site:

- Maruo Suehiro's official Web site
 http://www.maruojigoku.com/
- Unofficial information on Maruo Suehiro can be found at Prisms, the Ultimate Manga Guide
 http://users.skynet.be/mangaguide/au1113.html

Japanese manga artists you might like, if you like Maruo Suehiro:

- Fujiwara Kamui
- Fukuyama Yoji
- Inoue Naohisa
- Matsumoto Taiyo

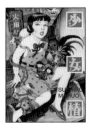 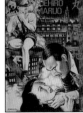

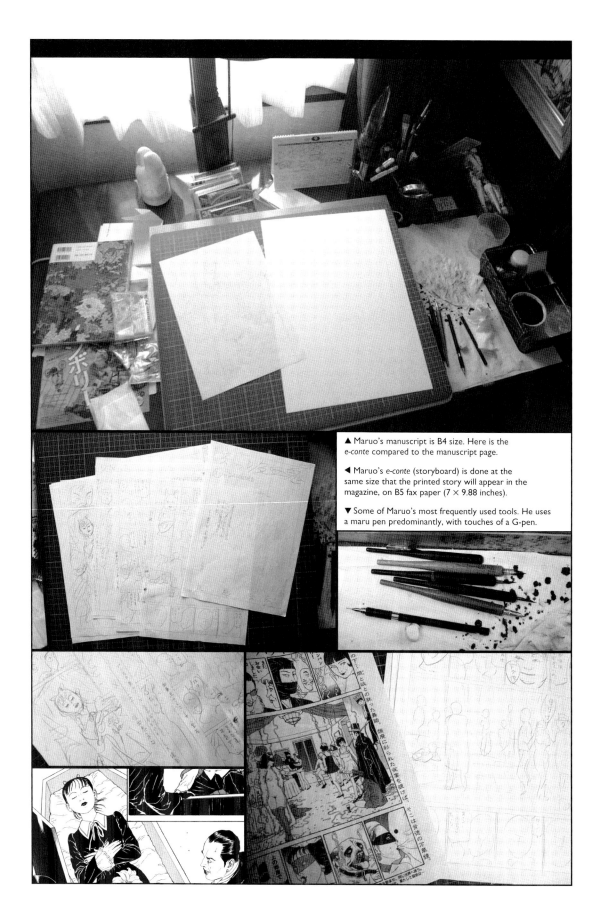

▲ Maruo's manuscript is B4 size. Here is the *e-conte* compared to the manuscript page.

◀ Maruo's *e-conte* (storyboard) is done at the same size that the printed story will appear in the magazine, on B5 fax paper (7 × 9.88 inches).

▼ Some of Maruo's most frequently used tools. He uses a maru pen predominantly, with touches of a G-pen.

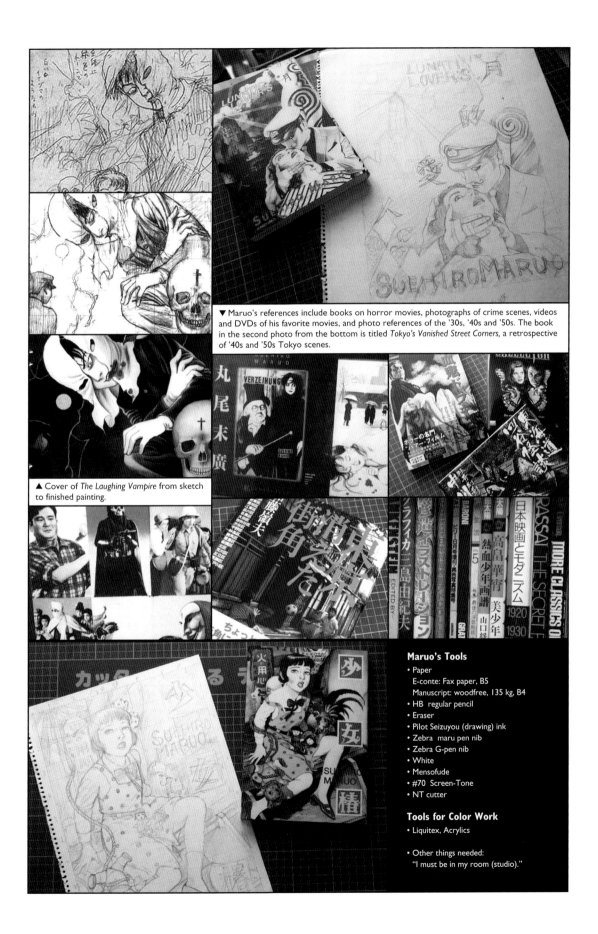

▼ Maruo's references include books on horror movies, photographs of crime scenes, videos and DVDs of his favorite movies, and photo references of the '30s, '40s and '50s. The book in the second photo from the bottom is titled *Tokyo's Vanished Street Corners*, a retrospective of '40s and '50s Tokyo scenes.

▲ Cover of *The Laughing Vampire* from sketch to finished painting.

Maruo's Tools

- Paper
 E-conte: Fax paper, B5
 Manuscript: woodfree, 135 kg, B4
- HB regular pencil
- Eraser
- Pilot Seizuyou (drawing) ink
- Zebra maru pen nib
- Zebra G-pen nib
- White
- Mensofude
- #70 Screen-Tone
- NT cutter

Tools for Color Work

- Liquitex, Acrylics

- Other things needed:
 "I must be in my room (studio)."

ARTIST GALLERY

MANGA
Masters of the Art

雄彦 高屋未央
未広 谷口ジロー
玲子 津野裕子 子
ニリカ ひろき真冬

Manga is an incredibly expressive medium. In Japan, it is mostly a black-and-white art form, and its creators have developed remarkable, subtle visual languages within those monotones.

But color can also be a delight to the eyes. This section is a full-color gallery showcasing each of the artists included in this book. Here, intensified by color, is a taste of the astonishing diversity of contemporary Japanese comics art ... manga. Enjoy.

Timothy R. Lehmann

ASAMIYA KIA

麻宮騎亜

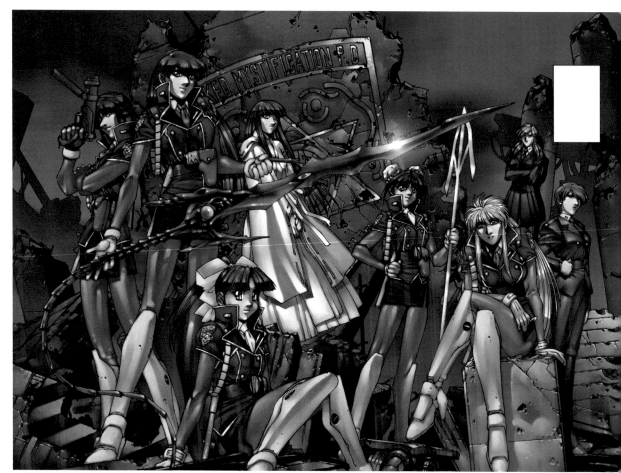

From *Silent Möbius*. © Asamiya Kia / Kadokawa Shoten

From *Young Rose* 1994-nen, 12-gatsu, Gou Yokoku.
(Young Rose 1994, December issue, preannouncement.)
© CLAMP / Kadokawa Shoten

CLAMP

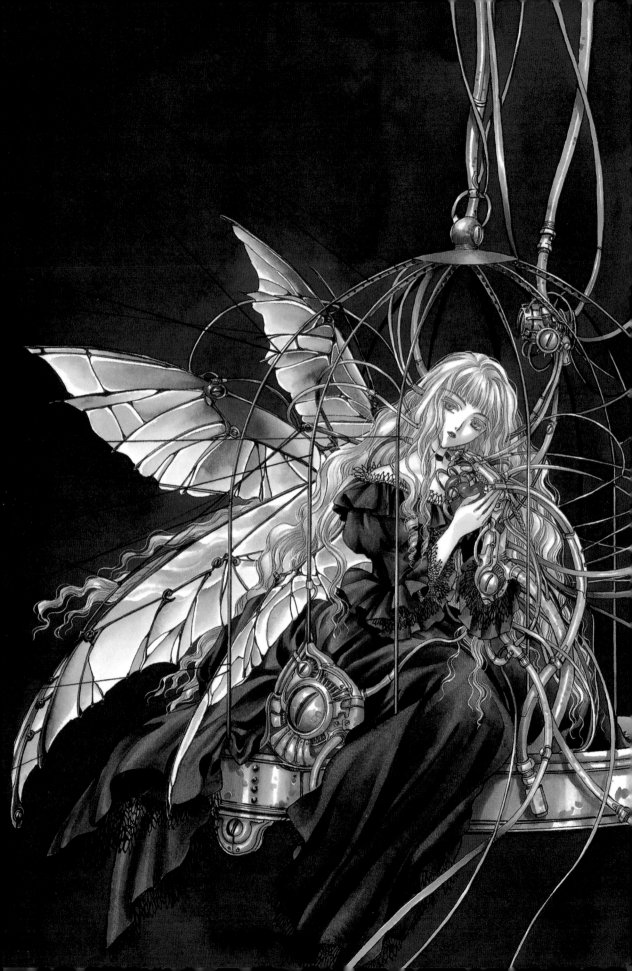

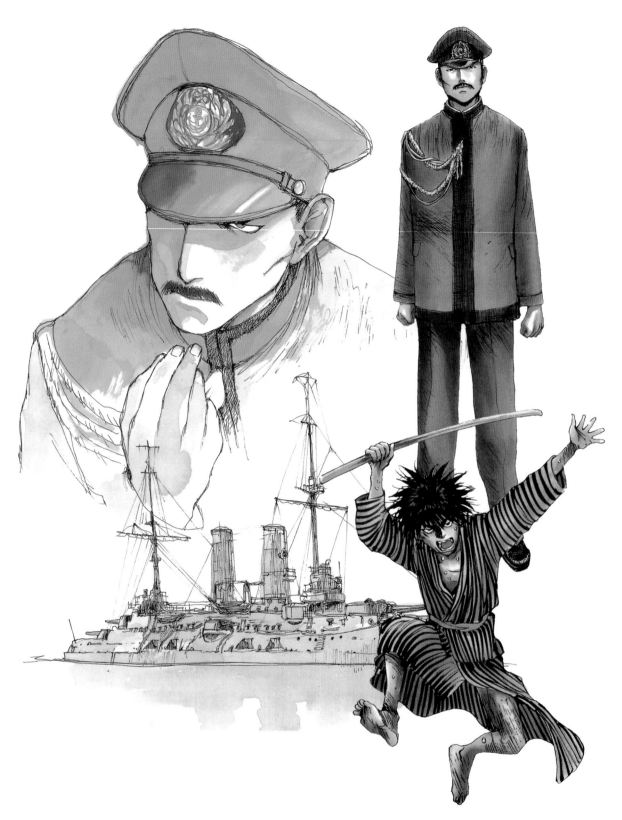

From *Nichirosenso Monogatari*, cover for Volume 1, *Eropop.*
© Egawa Tatsuya / Shogakukan / Kadokawa Shoten

EGAWA TATSUYA

江川達也

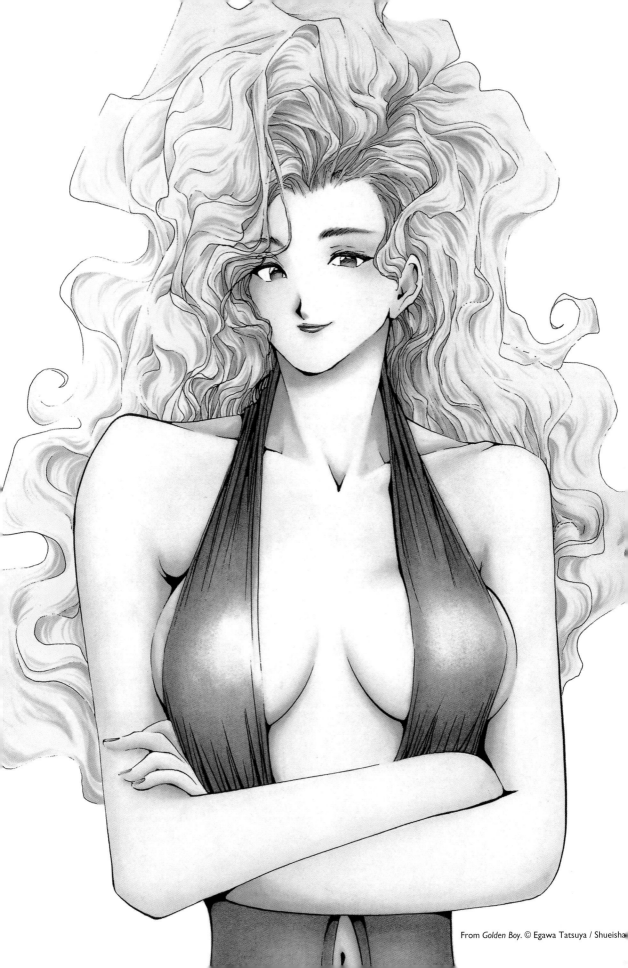

From *Golden Boy*. © Egawa Tatsuya / Shueisha

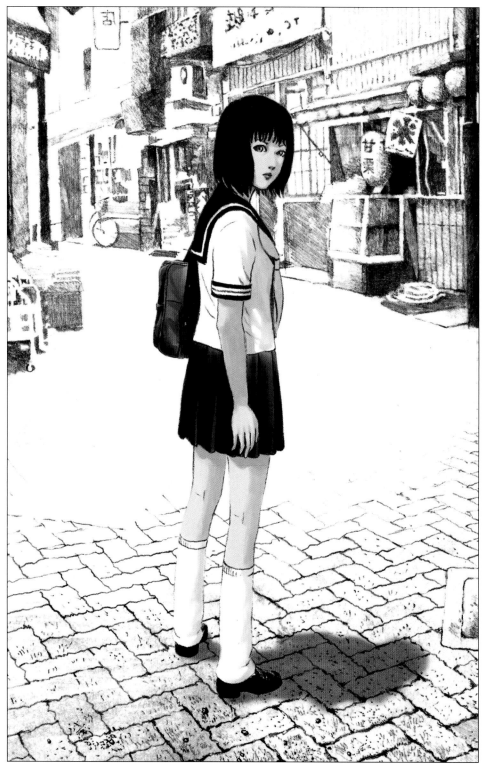

From *Jisatsu Sakuru*, pin-up. © Furuya Usamaru / One Two Magazine

FURUYA USAMARU

古屋兎丸

From *Plastic Girl.* © Furuya Usamaru / Asahi Sonorama

みんなおはな。きれいなおはな。

いにおいでわたしをやさしくつつんでくれるの、、、、

につたまっかなちがわたしをまどろみからひきはなした。

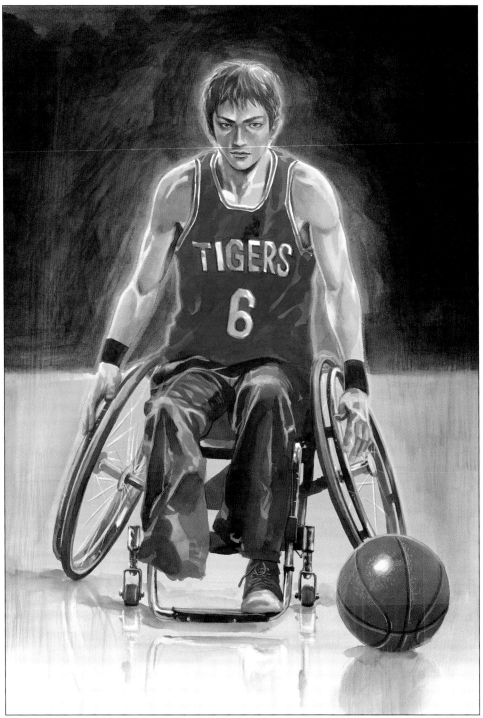

From *Riaru*, title page for Volume 2. © Inoue Takehiko / I.T. Planning, Inc. / Shueisha

INOUE TAKEHIKO

井上雄彦

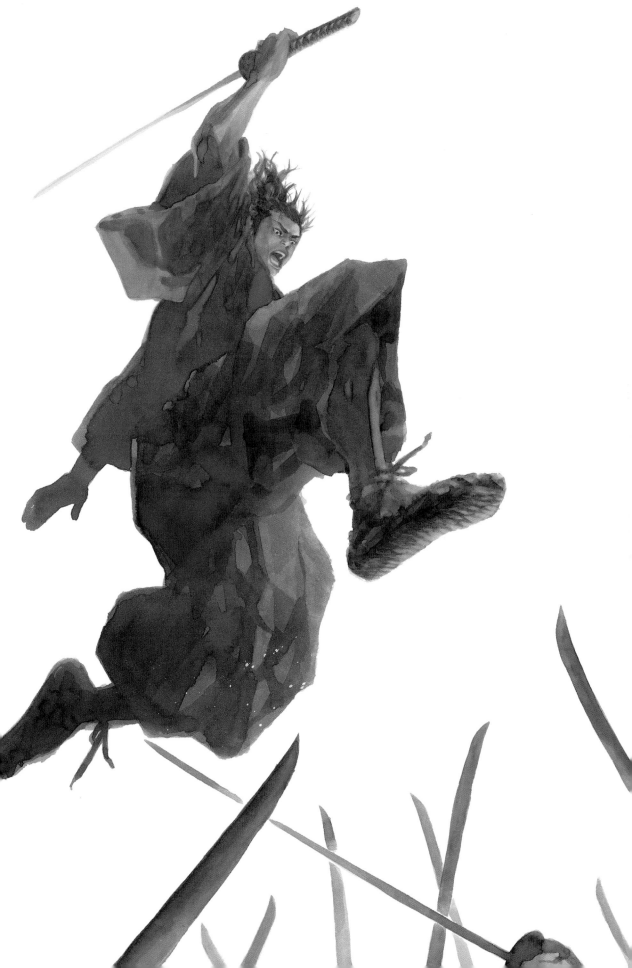

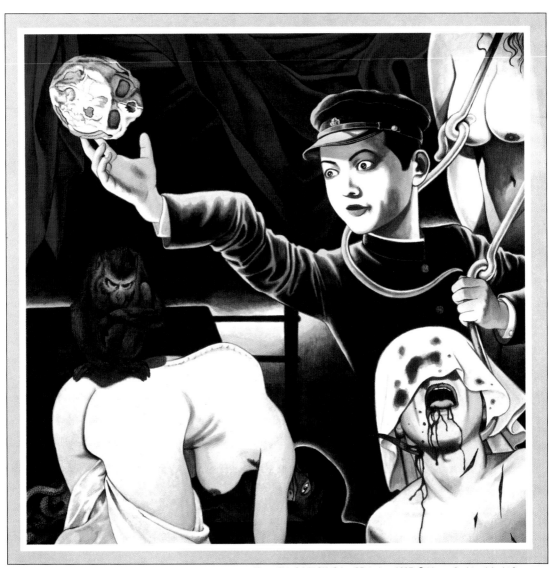

From *Shin Sekiki SM Gaho*, CD jacket, 1997. © Maruo Suehiro / Asahi Sonorama

MARUO SUEHIRO

丸尾末広

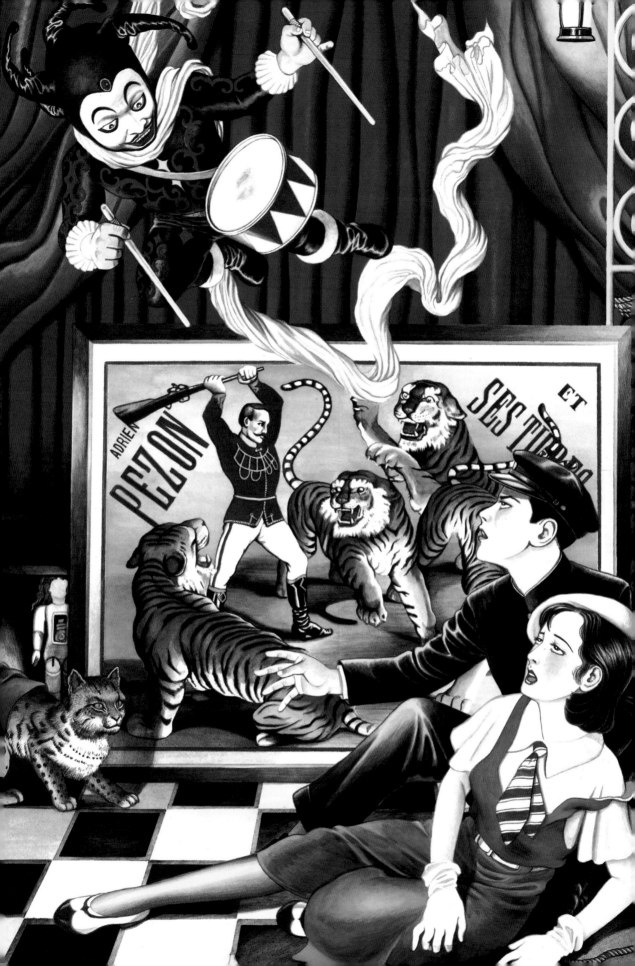

From *On-myoji*, title page for Volume 10. © Okano Reiko / Hakusensha

OKANO REIKO

岡野玲子

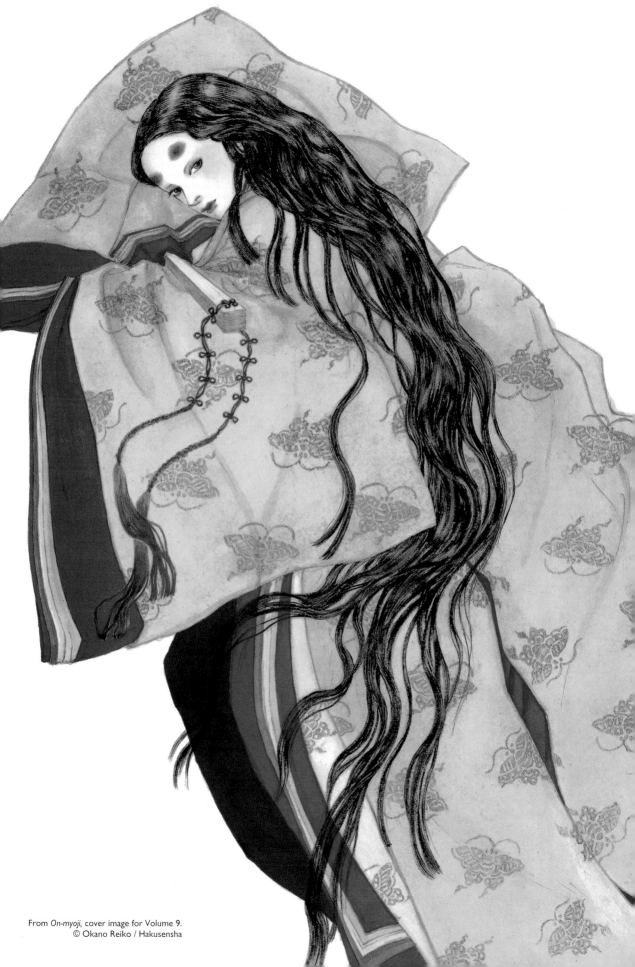

From *On-myoji*, cover image for Volume 9.
© Okano Reiko / Hakusensha

From *Love Vibes*, frontispiece. © Sakurazawa Erica / Shueisha

SAKURAZAWA ERICA

桜沢エリカ

From *Body & Soul*, frontispiece. © Sakurazawa Erica / Shodensha

TAKAYA MIOU

高屋未央

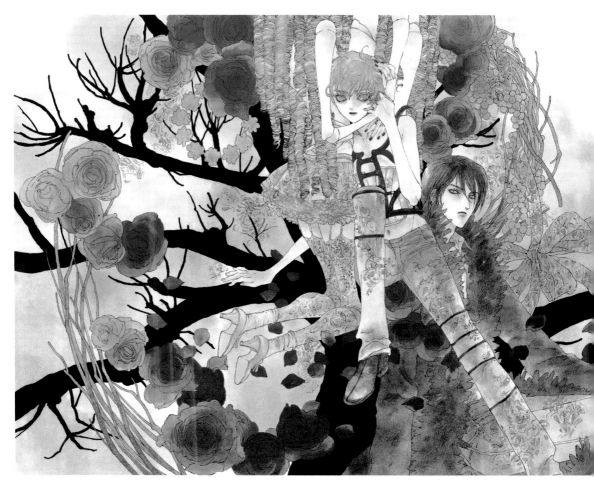

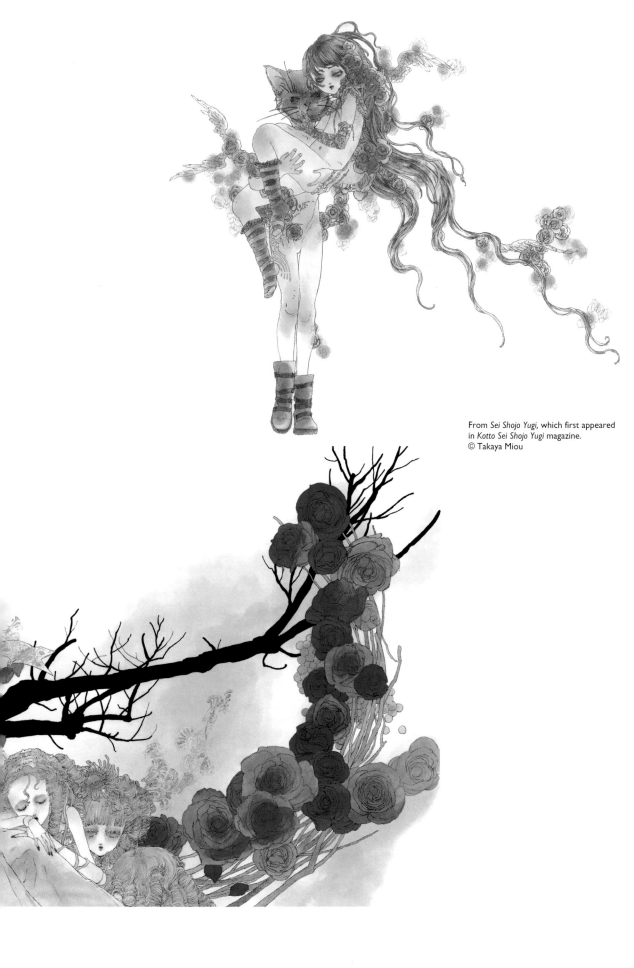

From *Sei Shojo Yugi*, which first appeared in *Kotto Sei Shojo Yugi* magazine.
© Takaya Miou

From *Genju Jiten.* © Taniguchi Jiro / Kodansha

TANIGUCHI JIRO

谷口ジロー

From *Amamiya Seppyo.* © Tsuno Yuko / Seirindo

TSUNO YUKO

津野裕子

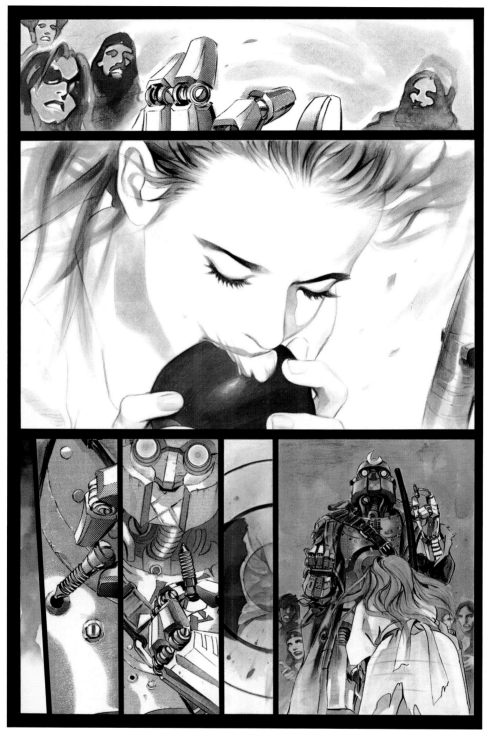

From "Apples," and *Error, Vol. 00.* © Hiroki Mafuyu / Bijutsu Shuppan-Sha

HIROKI MAFUYU

ひろき真冬

From *Modern Lovers*, and *Slip.* © Hiroki Mafuyu / Asuka Shin Sha

modern lovers

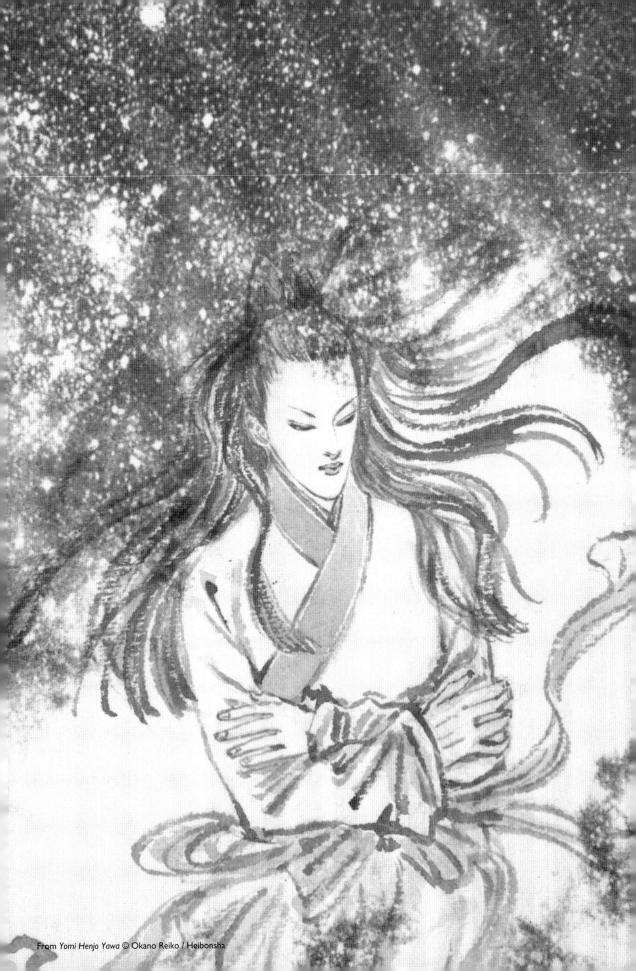

From *Yomi Henjo Yawa* © Okano Reiko / Heibonsha

OKANO REIKO

岡野玲子

Inspired by The Wild Bunch: In high school, Okano Reiko had considered becoming a novelist, but when she saw the shoot-out scene in Sam Peckinpah's famous western, it was an epiphany. She had one thought: "manga." The multiple camera angles, split screens, and frenetic intercutting convinced her that the stories in her head could only be expressed within the frames of manga, rather than with a novelist's words. Though she considers her work *shojo* (girls' manga), she has readers of both sexes and a wide range of ages for stories that frequently delve into metaphysics, but always with a dose of humor. Artistically, she has brought a graphic arts training to manga and has invented elaborate techniques that create the look of classical printmaking.

PROFILE

Place of birth: Ibaraki, Japan

Date of birth: unknown

Home base: Tokyo, Japan

First published work:
Esther, Please (Shogakukan), 1982

Education:
Two years at a vocational school for graphic design

Career highlights:

1984 *Fancy Dance* begins (Shogakukan)

1989 Shogakukan Comic Award (For *Fancy Dance*)

1993 *Onmyo-ji* begins (Scholar)

1995 *Yomi Henjo Yawa* begins (Fusosha)

2001 Tezuka Osamu Cultural Prize Manga Grand Prix
 for *Onmyo-ji*

2002 Gashu *Onmyo-ji* (Onmyo-ji Gallery) (Hakusensha)

2002-2003 Part at a touring exhibition of manga artists
 in Europe

Okano Reiko is a graceful princess in a literal tower, weaving tales of legend and myth—with a hint of subversion. As we entered her home, the most striking feature before us was a yin and yang symbol on the tiled landing. We circled the mystical emblem, passing from yin to yang, as we ascended a spiral staircase to reach the white double doors of her studio.

That ancient symbol is indicative of her most well-known work to date, *Onmyo-ji (The Story of Imperial Astrologist, Abeno Seimei)*, the 12-volume saga of an imperial astrology in tenth-century Japan. Originally based on a series of novels by the Japanese writer Yumemakura Baku, Okano has gone in her own direction with the story, sewing threads of Egyptian as well Japanese mysticism into the narrative.

Okano's manager seated us at one end of the room, dominated by tall, black bookshelves and a sleek, glass-topped drawing table. There were numerous notes, copies of book pages and maps tacked up at various places. Next to the copy machine, at one end of the bookshelf, I noticed the title of a book: *Applied Pharaonic Mathematics*. Souvenirs from a trip to Egypt were displayed along a black cabinet against the far wall.

Okano glided in and welcomed us. In the formal exchange of *meishi* (business cards) that followed, she produced a flat, black, oval-shaped object. It opened like a clam shell and she slid out her card, the shape and color of a lotus petal. Okano is married to royalty: Her husband is Tezka Macoto, a visualist and the son of Tezuka Osamu, the revered "god of manga." Okano confesses that she never read Tezuka while growing up, but laughs, "I read him very quickly just before I got married."

Her sense of humor was the key to her breakthrough work in 1984. *Fancy Dance* was unique for a *shojo* (girls') manga. Though it had the familiar elements of fashion and romance, the story focused on a young man coming to terms with an obligation to head a Zen monastery. Okano had to convince a skeptical editor to proceed with the series, but—with its offbeat humor—it was an immediate hit. The experience taught Okano to trust her instincts, both comedic and narrative.

Fancy Dance also revealed Okano's more earnest side. For research, she frequented monasteries (for up to a week at a time) and included elaborate footnotes in the manga, complete with diagrams explaining aspects of life in a Soto-sect Zen temple.

That devotion to authenticity continued in *Onmyo-ji*. Okano attended Shinto ceremonies and secret rituals, taking thousands of photos to get the details right. To capture the aura of this lavishly elaborate historical period and its supernatural tone, she invented an art technique that is a closely guarded secret. She makes extensive use of complex layers of copytone, which give her manga the look of etchings.

For *Yomi Henjo Yawa (Fantastic Metamorphosic Chinoiserie Tales)*, her other current series, she has reinvented her look, exclusively using brush-and-ink washes that have the flavor of Chinese scroll paintings. But she has given free rein to her comedic impulses, creating a kind of humor-filled *X-Files* set in ancient China. Her character the General is a cross-dresser lusted after by both sexes, and there are wild goings-on rendered in Okano's sensuous brushstrokes. Delicious, graceful subversion.

OKANO's interview

— How did you become a manga artist? When did you decide you wanted to do this for a living?

It was over 20 years ago. Stories have always just popped into my head naturally. I first tried to write a novel, but couldn't express everything in writing, so I moved on to manga.

— Did you ever work at another job?

No.

— What was your education?

I graduated from a regular high school and then attended a graphic design school. I was into music while in high school. In Japanese high schools you choose either art or music for your fine arts requirement. Since I was doing music throughout high school, I didn't have credits in art, which prevented me

from going to art school, so I went to a vocational school instead.

— Did your parents encourage you to become a manga artist?

Not really. There was a novelist living close by and I visited this person quite often. When I first told my parents that I wanted to become a manga artist, they wanted to discourage me from it, because artists often make a poor income. They went to the novelist to ask her to help convince me to take a different path, but instead, he told them to let me do as I wanted.

— Did you ever work as an assistant to another manga artist?

I've never done that.

— So you've taught yourself everything?

Yes, but my graphics design background helped a lot.

— What was your first published work and when did it appear?

That would be *Esther, Please*, in 1982.

— Did you ever experience a low point in your career?

I've never experienced a slump in terms of not being able to draw, but there was a time when my work wasn't getting published.

— What was your breakthrough?

A comedy I wrote called *Fancy Dance*. Comedy comes easily to me. Although, when I first became a manga artist, I stuck to serious topics, thinking it wouldn't be good to do comedy.

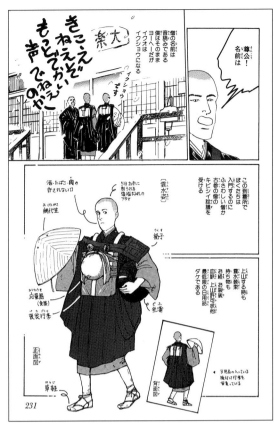

Okano's breakthrough came with the 1984 series *Fancy Dance*, in which she gave her comedic instincts free rein. It's the story of a rock' n' roll–loving Tokyo college student, Yohei, who struggles with a family obligation to oversee a Zen monastery, and his tumultuous relationship with his girlfriend, Masoho. For authenticity in depicting a Soto-sect Zen temple, Okano spent time at actual monasteries and shared her research in footnotes and diagrams [above left].

Despite her editor's misgivings, the series was a hit, running in the *shojo* [girls'] manga magazine *Petite Flower* until 1990, when Yohei, seeing a vision of the cosmos as a mandala while watching a pachinko machine [above right], decides to commit to both Masoho and his Zen heritage. *Fancy Dance* inspired a live-action movie in 1989.
© Okano Reiko / Shogakukan

— Humor seems to be an important aspect of your work. What genre do you think your work falls into?

I would like to think it is in the *shojo* [girls'] comics genre.

— Who are your readers?

I don't specifically aim for girls or guys. Age-wise, the audience ranges from people who are 80 or 90 to boys in grade school. Still, the main audience is women, from high school age to those in their 40s.

— In creating a manga story, how do you begin?

Hmm. It depends on the manga. Of the ones I am working on now, *Onmyo-ji (Master of Yin and Yang)* had an original work [a series of novels by Yumemakura Baku]. For the first volumes, I worked from the original, expanding on the story, but from the eighth volume on, the story is completely my own. The ninth volume is when the emperor's palace goes up in flames. This is something that actually happened, recorded in diaries of the emperor and court nobles at the time. I worked from those diaries. Other stories are created by the characters themselves, who take on a life of their own.

— For your other work, *Yomi Henjo Yawa (Evening Metamorphic Tale)*, does the story also emerge from the characters?

Hmm. That's a difficult one. Philosophically, I'm a total hermeticist [an ancient spiritual/magical tradition that sees humanity on a spiritual journey, returning to unity with the Divine]. [Laughs.] Images come to me as I draw, and I try not to self-edit or censor these visions because I'm afraid people will think I'm weird.

— Do you have an overall idea for the story when you begin, or do you pull it together as you go along?

It's definitely not organized ahead of time. [Laughs.] I decide what to draw about when I wake up that morning, and as I'm drawing. I sit at the desk and think, "What is it that make me want to draw today?"

— In that case, do you start by making a *name* (visual outline), or do you start drawing directly?

Sometimes I start drawing immediately. Other times, I put on music that I feel like listening to, and if

It started as a joke: *Ryogoku Oshare Rikishi (Stylish Ryogoku Sumo Wrestlers)* attempted to do for sumo wrestling what *Fancy Dance* had done for the Zen priesthood. The protagonist is Shouryuu, a handsome sumo wrestler proud of his brawn, and the story begins quite amusingly with his struggle with the whole flabby image of sumo, as epitomized by his archrival, Yukinowarabe. Okano's heart wasn't totally in this 1989 project, which was the suggestion of an editor, and, while entertaining, the series never achieved the balance between comedy and thoughtful reflection that *Fancy Dance* had. Okano quips that the art was easier, since so much space was taken up by the large bodies of the wrestlers.

© Okano Reiko / Shogakukan

the music happens to have lyrics, I look up the meaning of the lyrics. There are hints in things like that and I follow these hints, and in some way, the story gets organized naturally.

— Do you ever get ideas for your stories from dreams, movies, or novels?

I don't get ideas from movies anymore, or novels—basically there aren't any that I want to read, although the oens I need to read come into my view some how. When one comes, I read it, and sometimes there is information in it that I can use. Dreams . . . this also depends on the moment. Actually, dreams tend to come after I've written something. I sometimes have an informative dream on something that I wrote. I don't have these dreams beforehand, though. They always come afterwards. [Laughs.]

Okano's playful sense of the absurd was evident in the 2001 reissue of *Ryogoku*. The covers parodied four famous works of Western art. Volume 1 was a send-up of Pre-Raphaelite Edward Burne-Jones's 1880 painting *The Golden Stairs.*

Ghostbusters in ancient Japan: Onmyo-ji (imperial astrology) is dark and mysterious, set in tenth-century Kyoto, at the imperial court. Okano's manga is based on a series of novels by Yumemakura Baku. The title character, Abeno Seimei [in the center panel above], uses his powers to rid the nobility of phantoms and demons born of their own frustrations and desires. Okano's faithful depiction of historic costumes and rituals is breathtaking. The supernatural is expressed visually through a dizzyingly complex use of custom-made tone patterns and layered art—created laboriously by hand, without computers.
© Okano Reiko / Yumemakura Baku / Hakusensha

In 1991, Okano began an adaptation of American writer Patricia A. McKillip's classic fantasy *The Forgotten Beasts of Eld,* with the title *The Calling, the Forgotten Beasts of Eld.* The Tolkein-esque tale centers around a proud and powerful enchantress, Sybel, who learns the meaning of love and forgiveness when, into her secluded world of

mythic animals and books, a knight enters asking her to raise her sister's child. Okano's lyrical art complemented the original novel's beauty and mystery. This three-volume manga was translated into Italian in 2004.

© Okano Reiko / Magazine House

— Does making a *name* help your work, or do you just go directly to the manuscript?

This is not a job that is done alone. Many people are involved, and a schedule is set. If we can't get it done in that time frame, everyone leaves and the work is canceled. This becomes the biggest hurdle most of the time, and sometimes I start work with nothing prepared. A *name* is very useful when I need to decide on the pagination (the breakdown of pages), at least. But it's nearly impossible to come up with dialogue when there are many people around. At times like that, I have everyone leave the room for a while, and I make a script. Then we work from there.

— How many people are present?

Six or seven people, my assistants. For serious stuff I work alone, but hints can come from jokes made when a bunch of people are working together.

— So an assistant may come up with a hint or idea for a story?

Nothing that might directly come into the story or affect the course of the story. It's more like I have an idea and I am wondering if I should write about it. Jokes and stories told while we are woking may help me make my decision.

— Do you make a rough draft between the *name* and the final draft?

I don't, no.

— When you actually start the manuscript, do you work in order from page one?

Yes. I need to go one scene at a time or the story won't come. Sometimes, when I'm pressed for time, I have an assistant work on a page way ahead of what I'm doing, but that never works out. [Laughs.]

— How do you work with your assistants?

I have six assistants. They work in a rotation schedule, and three actually draw. The rest basically work on tone, though sometimes they make alternative content. I'll let anyone do a rough draft with pencil, if they're capable.

— For those rough drafts, do assistants draw only backgrounds?

For the main characters, I do the rough drafts (pencil drawing) and inking myself. For example, I might draw the feet but have an assistant do a very detailed rough draft of the sandals. But I always finish it myself. My assistants do the tone work, but I specify what goes where. After the tone is on, I do all etching and finishing myself.

— You use copytone to create intricate patterns and special effects. Do you do all that yourself?

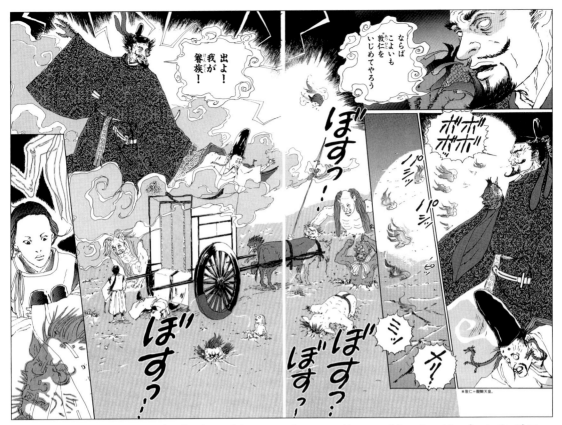

The first seven volumes of *Onmyo-ji* were based on the novels by Yumemakura Baku, the ninth volume of a diary of the Heian Emperor, and from there Okano went in her own direction. Her research consisted not only of reading, but viewing movies, visiting museums and exhibits, and traveling to Kyoto and other places to view festivals and rituals. In the scene above, from Volume 1, a young Abeno Seimei first demonstrates his powers of discerning spirits and protecting others from harm. Okano was just beginning to experiment artistically with depicting supernatural happenings. In the 11 years she has worked on this series, her art has become more abstract and expressive in portraying metaphysical realms.
© Okano Reiko / Yumemakura Baku / Hakusensha

Yes, I do. Recently though, I have taught my assistants and I have them make simple ones. I always do the main tone work myself. I sometimes forget how I made something and can't re-create it. I also sometimes use ones that were miscopies. The photocopy machine is crucial. It breaks sometimes. The pictures it produces when it's broken are quite good, too. [Laughs.] I make a lot at times like that.

[Editor's Note: For *Onmyo-ji*, Okano creates custom tone using copytone; patterns are imprinted on copytone sheets by passing them through a copy machine.]

— I understand that you don't use computers. Have you ever considered it?

It's a secret. Or rather, the fact that I can't use a computer is the secret. [Laughs.] I have a very short temper. When I'm using a computer, I blow up at it, like "You slow idiot!" [Laughs.]

— Do you find a difference between hand-drawn work and CG work?

CG isn't sexy. [Laughs.]

To draw more in an eccentric way, hand-drawing is much better.

— You said that the pages are penciled in order, but when it comes to inking, do you sometimes skip around?

I can't do that. [Laughs.]

— In *Yomi Henjo Yawa*, you are now using a brush exclusively. How did you decide to do that?

When I was asked to do a new series, I was reluctant, because the way I was working [with copytone] really takes a lot of time and effort. But they were very persistent, so I came up with the easiest way, which was to use a brush. [Laughs.] I also specified that it be a comedy. Still, as I went along, the work became more and more time-consuming. I always lead myself into that kind of mess.

— What is your favorite medium?

Drawing with a brush stays close to the pencil draft and lets me draw in detail, so the character's facial expression comes out. With a pen, the expression changes, even with the most care.

— What did you think of the magazine *Garo*?

I've actually never read it, so I can't say. I actually don't read much manga.

— I heard that you didn't even read Tezuka Osamu's work.

I read it very quickly before getting married. [Laughs.] [Editor's Note: Okano is married to Tezuka Osamu's son, Tezka Macoto, a visualist.] I was writing *Fancy Dance* at the time and thought I should read Buddha and Hi no Tori, so I read those.

— Do you ever feel restricted working in mainstream manga?

Luckily, they've editors always considered me a manga artist who didn't sell well, so they let me do pretty much whatever I wanted. Whenever I knew there was going to be a big fight with my editor over what I wanted to write, by coincidence, I would get a new editor. So, before the new editor would get to know me, I would sneak in what I wanted to do. This has happened repeatedly. [Laughs.] So I've never had a fight with my editor, or anybody else, for that matter.

— Who were your artistic influences when you first started?

My first published manga was in a magazine called *Petite Flower.* This publication was full of very talented artists with great techniques. The editors were really good, too, and everyone trusted them. When I first started, I didn't know much about manga, so looking at other manga in that magazine really helped.

— Were you influenced by the manga you read as a child?

I didn't read much as a kid. What I can remember reading is Umezu Kazuo [laughs] and *Orochi.* My mother really liked him. She even bought me his manga as a birthday present. Takebe Motoichiro, who does book illustration for science fiction and fantasy novels. I think he has many fans in the U.S., too. He did the illustrations for E. R. Burrough's sci-fi novels translated into Japanese. He drew many beautiful and sexy women.

— Is it true that the film *The Wild Bunch* was the reason you became a manga artist?

Yes. [Laughs.] I love [Sam Peckinpah].

— Was there a particular scene that impressed you?

There was a gunfight in *The Wild Bunch,* and there was a scene where they cut between three angles every three seconds of people falling down from the roof, the storefront window . . . the glass breaking, and a person coming out through the broken glass. When I saw that, I got this intense feeling. I realized that manga was the way to portray different times simultaneously. I mean, you couldn't do it in a novel, could you?

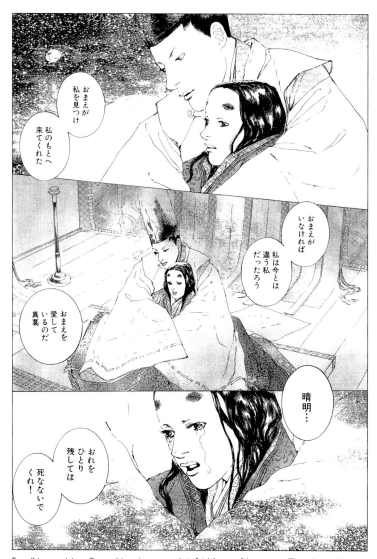

For all its mysticism, *Onmyo-ji* is at its core a *shojo* [girls' manga] love story: The relationship between Makuzu and Abeno Seimei becomes increasingly important in the course of the series. Makuzu first appears as a young, somewhat tomboyish girl, but matures and becomes an indispensable partner to Seimei. As he ventures progressively deeper into mystical realms to purify danger, his emotional link to Makuzu enables him to always return safely.
© Okano Reiko / Yumemakura Baku / Hakusensha

— Have your influences or inspirations changed?

I'm not influenced as much now.

— Are there major themes in your work?

I do have themes, but I can't express them in words. That's why I do manga.

— *Onmyo-do* is the philosophy from ancient China that all things are divided into yin and yang. Do you, yourself, believe in this?

I think that it's a process. I think there is one source for all, and the division is a kind of translation of it.

So, I take it in as the truth, rather than believing it.

— As the story of *Onmyo-ji* unfolds, the character Makuzu becomes an important partner for Seimei. Is this most of all a love story?

I do think it's all a love story. [Laughs.] But that doesn't mean to say it's just between Seimei and Makuzu.

— Do you use any reference material, such as photos, to draw from?

I do. I go out and take pictures myself.

— I read that you traveled extensively to take pictures for *Onmyo-ji*.

[I was getting] more than the visual images, though. The fact that these festivals are still around is fantastic. They started 800 years ago!

— When did you become interested in Japan's history and traditions?

It was when I was working on *Fancy Dance*. I had a friend who was doing traditional music and dance, and was playing the *Sho* (the *Shinto* flute).

— How did you come to do *Onmyo-ji*?

I first saw *Onmyo-ji* at the bookstore. Up to that point, Yumemakura Baku-san had been sending me all his work, but he hadn't sent me *Onmyo-ji*. But I already had images for this type of story in my head. The publisher was Bungei Shunju, and I knew an editor there, so I called them up immediately and said, "I would like base my next manga on this book. Please relay that to Yumemakura-san." Within a week, a completely different publisher, called Scholar, contacted me, asking if I would make Yumemakura-san's *Onmyo-ji* into a manga in the *Comic Burger*. I took it without hesitation. Actually, when I first heard from Scholar, it was right after I had done *Ryogoku Oshare Rikishi,* and Baku-san had had books on pro wrestling and such made into manga, so I automatically assumed, "They're going to give me an offer to do a pro wrestling story!" But then they said it was *Onmyo-ji*.

— Can you tell me about the research you did for *Onmyo-ji*?

For *Onmyo-ji,* I'm already in the eleventh year. For the first five years, I went to museums and exhibitions quite often. After that, I mostly went to watch performances of *Shingaku* (the oldest existing religious music in Japan) and *Gagaku* (the oldest existing court music). And, like the pictures I showed you, I went to festivals where they wear traditional costumes. There are festivals that take place during the night, that most people aren't aware of. I know a lot of people in the [Shinto] shrines, so they inform me of these festivals and I go to observe. Similarly, for *Fancy Dance,* I went to [Buddhist] temples often for *zazen* (meditation) while I was working on it.

Yomi Henjo Yawa, set in feudal China, relates the wacky adventures of a young nobleman, Seitan. As a rising star, he travels to the capital to become a high official, but is relegated to an obscure department to investigate ghosts and spirits (à la *The X-Files*). Although the artwork has the look of a traditional Japanese scroll painting, *Yomi* is a wild comedy. Seitan's weakness is beautiful women; unfortunately for him, they frequently turn into monsters.
© Okano Reiko / Heibonsha

— How did going to places like Kyoto and Nara inspire you?

There are so many things that you can only learn by going there. I can feel the ancient energy that's still in those places. I try to incorporate that energy into my work and hope that my readers receive it as well.

— Do you show respect by portraying these special places accurately?

I do.

— Are the many books on your shelves references for both *Onmyo-ji* and *Yomi Henjo Yawa*?

Yes. I have many books in the hallway, too!

— I saw a book on your shelves called *Applied Pharaonic Mathematics*.

Yes, it's very interesting. It's not translated [into Japanese]. I'm always asking my editor to have it translated, but apparently it won't sell enough.

— In terms of storytelling and design, are there any dos and don'ts you stick by?

That would be that I don't decide things on my own. I don't force myself, too. I don't make a decision like "this is too weird. I shouldn't do this" by myself.

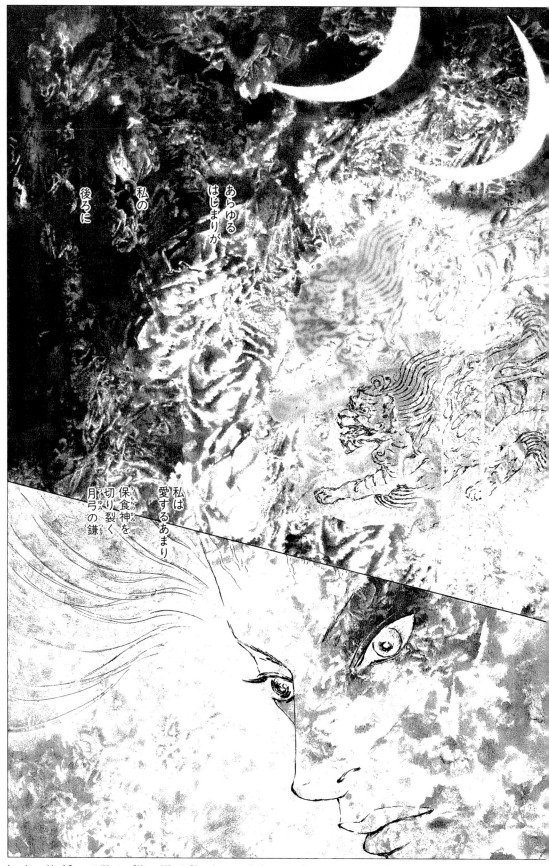

あらゆる
はじまりが
私の
後ろに

私は
愛するあまり
保食神を
切り裂く
月弓の鎌

In volume 11 of *Onmyo-ji (Master of Yin and Yang)*, Okano's art reached an apex of expressive power and astonishing technique.
© Okano Reiko / Yumemakura Baku / Hakusensha

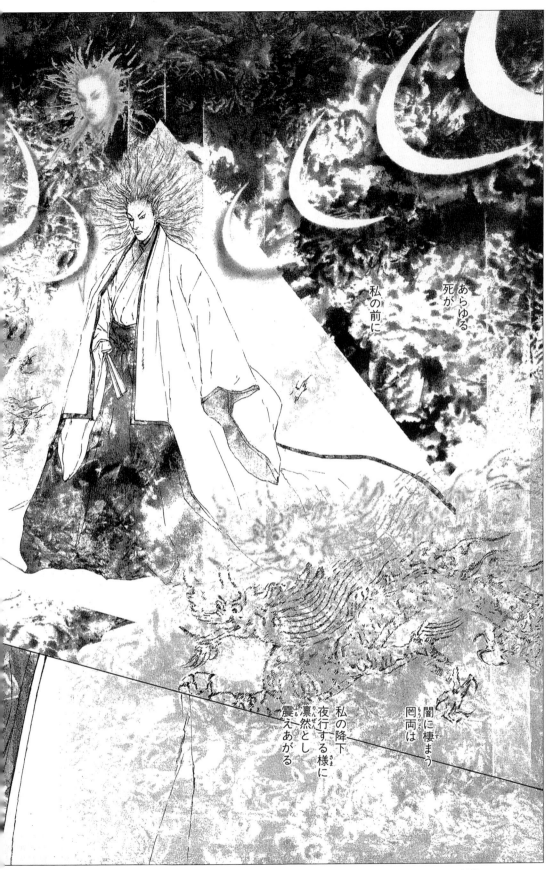

あらゆる
死が
私の前に

闇に棲まう
罔両は
凛然とし
夜行する様に
私の降下
震えあがる

This 11-volume work, published from 1994 to 2004, won the Tezuka Osamu Cultural Prize Manga Grand Prix in 2001.

— **Has your creative process changed over the years?**

I stopped using my brain, which resulted in me not preplanning things.

— **Do you mean you have developed confidence in your imagination?**

Yes, and in my staff.

— **What's a typical day for you? How many days a week do you work?**

I don't wake up in the morning, but around noon. [Laughs.] I sleep about seven hours, so everything except for that is spent working. I work about three weeks out of a month. Close to the deadline, I only sleep about three or four hours a night.

— **How many pages, on average, do you draw in a day?**

My goal for a day's work is three pages. The most important thing in production is cooking. [Laughs.] My staff makes meals for me. When jobs overlap, both the staff and myself become huge eaters. But that's what gives us the strength to keep going.

— **You said you work for three weeks. Does this mean you work three weeks straight, 21 days, and then take a week off?**

Days off are intermixed with the 21 workdays.

— **Are there any of your works that you are unhappy with?**

The one I'd like to eliminate from the record is *Ryogoku Oshare Rikishi*. [Laughs.] I started it as a joke. I actually hate sumo wrestling. [Laughs.] The goal was to see how well I could portray how much I hate sumo. It was a fun job, though. [Laughs.]

— **Which of your works do you like best?**

Let's see, what do I like? Would it be *Ryogoku Oshare Rikishi?* [Laughs.] The work was always done when I woke up in the morning. The assistants finished it up without me. [Laughs.] I was such a breeze for me. I never thought this job could be so easy.

— ***Yomi Henjo Yawa* has humor as well as the traditional aspect of *Onmyo-ji*. Do you feel you are doing the best work of your career?**

I think that is correct. With *Onmyo-ji*, I feel like I'm making a scientific piece, and, with *Yomi Henjo Yawa*, a humanities piece.

— **Your work has fashion, love, philosophy, history, and humor. Which of these is most important?**

The most important thing is the picture—whether it's beautiful or not.

— **What are your favorite manga or comics by other artists?**

Yamagishi Ryoko-sensei's *Hi Izuru Tokoro no Tenshi (Emperor of the Land of the Rising Sun)*. I thought that was an excellent work.

— **What advice would you give to any aspiring artists?**

How about I write it up and hand it over on a later date? This is difficult to answer.

— **Is there anything you would like to say to your fans outside of Japan or inside Japan?**

Hmm. Perverts beget perverts. Have confidence in yourself. [Laughs.]

Seitan's master, the General [at right, above], is a cross-dresser, who sparks lust in both sexes. Though Okano had specified to her editor that she wanted to do *Yomi Henjo Yawa* in ink-wash for the sake of speed (she was still doing *Onmyo-ji* at the time), her art has gotten characteristically more complex, so that the time saved is no longer as great.
© Okano Reiko / Heibonsha

List of works:
- *Esther, Please,* Shogakukan, 1982
- *Myougi no Hoshu (Remuneration of Exquisite Skill),* Shogakukan, 1983
- *Kiesarishi Mono (Missing Link),* Shinsho Kan, 1984
- *Diane de Rose no Inbo (The Conspiracy of Diane de Rose),* Shinsho Kan, 1984
- *Ryogoku Oshare Rishiki (Stylish Ryogoku Sumo Wrestlers),* Heibonsha, 1989–1990, 4 volumes
- *The Calling (The Calling, the Forgotten Beasts of Eld),* Magazine House, 1991–1993, 3 volumes

Art books:
- *Onmyo-ji,* Hakusensha, 2002

CD:
- *Onmyo-ji* (Music inspired by Onmyo-ji, composed by Shiba Sukeyasu, Brian Eno and Peter Schwalm), Victor Entertainment, Inc. (vicp-60980~1), 2000

Major works:
- *Fancy Dance,* Shogakukan, 1984–1990, 9 volumes
- *Onmyo-ji,* Hakusensha, 1994–, 11 volumes
- *Yomi Henjo Yawa (Fantastic Metamorphosic Chinoiserie Tales),* Heibonsha, 1999–, 3 volumes to date

Top three:
- *Fancy Dance* (Vol. 1 ISBN 4-09-191291-5)
- *Onmyo-ji* (Vol. 1 ISBN 4-592-13211-4)
- *Yomi Henjo Yawa* (Vol. 1 ISBN 4-582-28752-2)

Web site:
- Okano Reiko's official Web site http://www.najanaja.co.jp/index.html

Japanese manga artists you might like, if you like Okano Reiko:
- Akisato Wakuni
- Hagio Moto
- Sumeragi Natsuki
- Yamagishi Ryoko

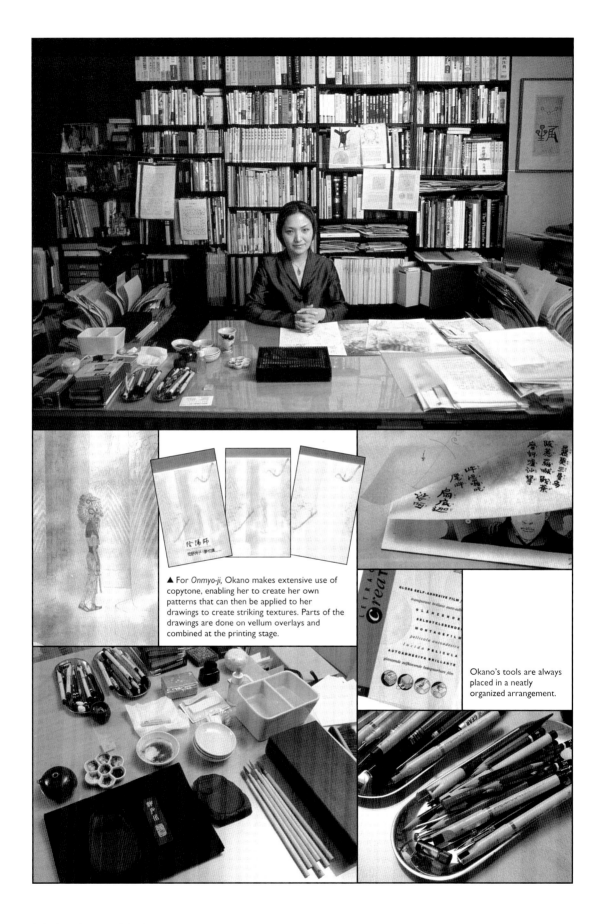

▲ For *Onmyo-ji*, Okano makes extensive use of copytone, enabling her to create her own patterns that can then be applied to her drawings to create striking textures. Parts of the drawings are done on vellum overlays and combined at the printing stage.

Okano's tools are always placed in a neatly organized arrangement.

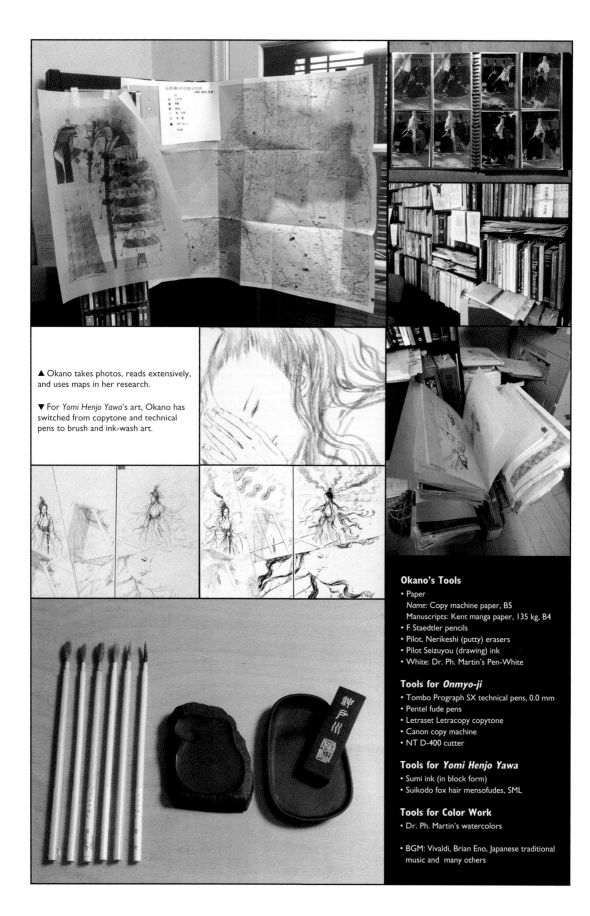

▲ Okano takes photos, reads extensively, and uses maps in her research.

▼ For *Yomi Henjo Yawa*'s art, Okano has switched from copytone and technical pens to brush and ink-wash art.

Okano's Tools

- Paper
 Name: Copy machine paper, B5
 Manuscripts: Kent manga paper, 135 kg, B4
- F Staedtler pencils
- Pilot, Nerikeshi (putty) erasers
- Pilot Seizuyou (drawing) ink
- White: Dr. Ph. Martin's Pen-White

Tools for *Onmyo-ji*

- Tombo Prograph SX technical pens, 0.0 mm
- Pentel fude pens
- Letraset Letracopy copytone
- Canon copy machine
- NT D-400 cutter

Tools for *Yomi Henjo Yawa*

- Sumi ink (in block form)
- Suikodo fox hair mensofudes, SML

Tools for Color Work

- Dr. Ph. Martin's watercolors

- BGM: Vivaldi, Brian Eno, Japanese traditional music and many others

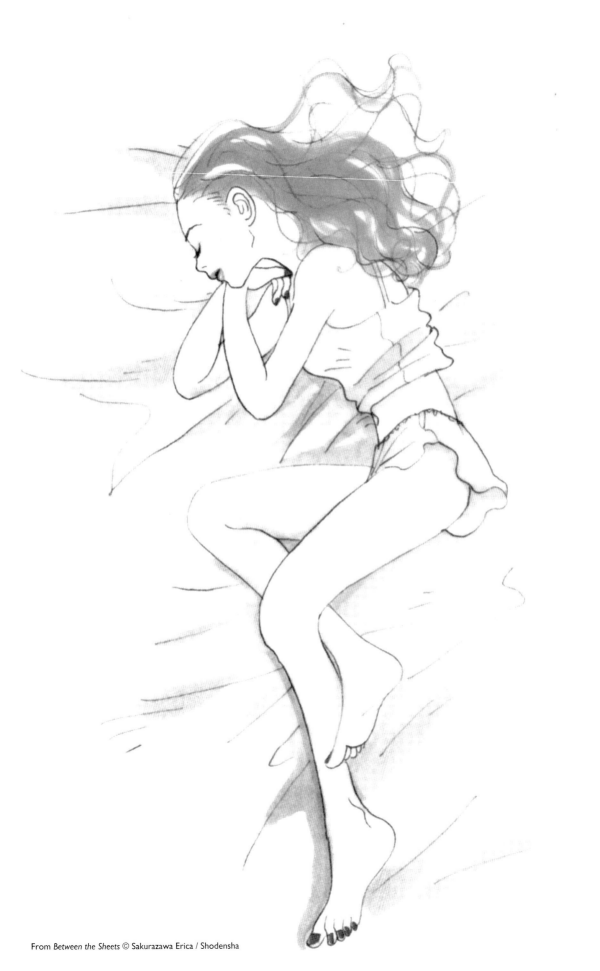

From *Between the Sheets* © Sakurazawa Erica / Shodensha

SAKURAZAWA ERICA

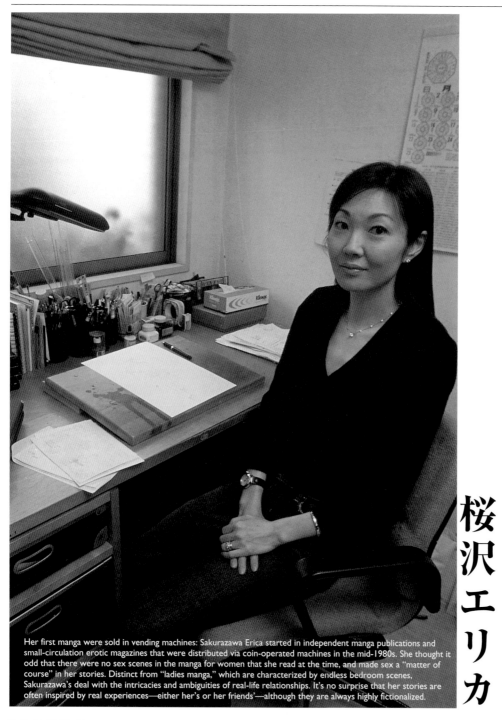

Her first manga were sold in vending machines: Sakurazawa Erica started in independent manga publications and small-circulation erotic magazines that were distributed via coin-operated machines in the mid-1980s. She thought it odd that there were no sex scenes in the manga for women that she read at the time, and made sex a "matter of course" in her stories. Distinct from "ladies manga," which are characterized by endless bedroom scenes, Sakurazawa's deal with the intricacies and ambiguities of real-life relationships. It's no surprise that her stories are often inspired by real experiences—either her's or her friends'—although they are always highly fictionalized.

桜沢エリカ

PROFILE

Place of birth: Tokyo, Japan

Date of birth: July 8, 1963

Home base: Tokyo, Japan

First published work:
Kawaii Mono (A Pretty One) (Kawade Shoten Shinsha), 1985

Education:
High school, one year of fashion design school

Career highlights:

1989 Jasuto Rabazu (Just Lovers) (Magazine House)

1991 Love So Special (Kadokawa Shoten)

1997 Sakurazawa Erica Selected Works (Asuka Shinsha)

2000 Sakurazawa Erica Library (Mediafactory)

2001 The Luxurious Childbirth (Asuka Shinsha)

2002 The Aromatic Bitters (Shodensha)

We sat around a glass-topped table in Sakurazawa Erica's elegant Shibuya condo, drinking green tea. Her young husband was attending to their infant daughter at one end of the living room, filled with Euro furniture and fixtures. I felt like the character in Sakurazawa's *Aromachiku Bitazu (The Aromatic Bitters),* who remarks that even tap water tastes better out of a Baccarat glass. We were surrounded by sophisticated refinement, and Sakurazawa was its personification—reed thin and exotically beautiful. A Tokyo magazine had recently done an article on her decorating sensibility, dubbing it "the Erica style."

Periodically, contented coos would come our way from the baby. One of Sakurazawa's current manga is about the raising of her two young children. It's being serialized in the same magazine that carries her current erotic romance stories. She draws the material for both from life, fictionalizing her experiences—and those of her girlfriends—to create entertaining, engaging "chick lit."

Sakurazawa's work has been compared to the television series *Sex and the City.* Think of Carrie Bradshaw chronicling her quest for the perfect relationship in manga form. But Sakurazawa is not just aiming for light comedic entertainment. Her tales of Japanese young adults falling in and out of love have poignancy because of the complexity and ambiguity of her characters. Amid unpredictable events, the characters sometimes seem as mystified as others by their own behavior.

Sakurazawa has been doing *josei* (women's) manga—a genre read by women between the ages of 18 and 37—for 19 years. Barely out of high school, she started in independent and alternative publications, doing whimsical stories and fantasies. But she was also reading pornographic manga intended for men. At the time, there were no erotic manga for women. Sakurazawa thought it odd that sex scenes did not occur in the natural course of stories intended for women, so she began to include them in her narratives.

Some female manga artists would take sex to extremes. The late '80s saw the rise of the notorious genre of *redikomi* ("ladies' comics"), which consisted of endless (and often kinky) bedroom scenes. Other women manga-ka would opt for overly romanticized, dreamlike views of lovemaking. Neither were the Erica style. In contrast, she showed love and lust in the context of believable relationships—from a woman's point of view. But her readers quite possibly include men. Boyfriends, she speculates, probably glance through her manga at their girlfriends' apartments "when they're bored."

Art has often served a healing function in her life, Sakurazawa says. She's been able to work out things she was going through by turning them into manga. As the psychological aspect of her stories has become more complex, her art has become more straightforward and stylized, expressive, and gestural. Her techniques haven't changed much in the course of her career. The only touch of technology in her methods has been the use of a digital camera and a copy machine.

Sakurazawa shows in images rather than tells in words. The editing she does to her stories consists of eliminating unnecessary text to let the pictures communicate as much as possible. Her clean, sparse pen lines mirror her instinctive, nonsensational approach to erotic realism. Sakurazawa Erica has substance as well as style.

Sakurazawa's interview

— How did you become a manga artist? When did you decide you wanted to do this for a living?

I've read manga since I was a child and always wanted to become a manga-ka, but I never sent my manga to publishers. I always thought that there had to be a way to become a manga-ka without going through the process of submitting manga to a publisher [laughs], so when I was 20 . . . how should I say this? I started going to the publishers of subculture porn magazines, or should I say, indies (underground magazines). From there, I started getting illustration work, little by little. I've gradually moved on from indies to major [manga] magazines. The first place I drew was at a magazine that was only sold at vending machines, published by Arusu. Tatsumi publishing had a porn mag called *Carmen,* and I got work there little by little, then went on to magazines for men such as *Playboy* [a Japanese manga magazine] and *Heibon Punch,* and then moved on to magazines for women.

Elle Deco and *House Beautiful* are among the magazines and books in Sakurazawa's reference library. Stylish, high-fashion settings are characteristic of her manga, and she has become known for the "Sakurazawa style."

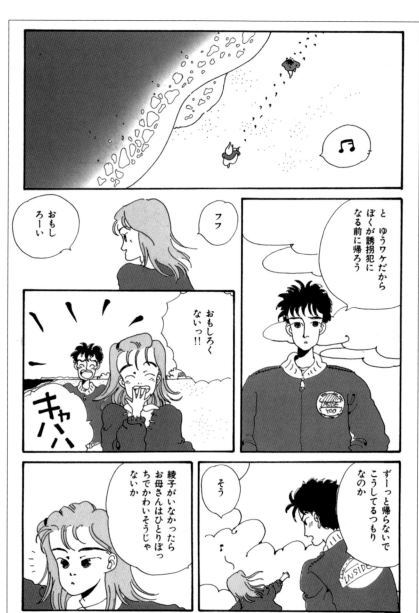

Images from "A Girl of Ten Summers," in Sakurazaw's 1985 collection, *Kawaii Mono (A Pretty One)*. Her early work was published by a number of companies that catered to alternative artists, and, in 1987, she even appeared briefly in the underground manga magazine *Garo*. *Garo*'s publisher, Seirindo, produced Sakurazawa's 1987 collection *Cherry ni Omakase! (Trust the Cherry!)*. Her stories of this period were more whimsical than erotic.
© Sakurazawa Erica / Kawade Shobo Shinsha

— Did you ever work at another job?

I worked for about a month as a part-timer at a clothing store, but [I] hardly [ever worked].

— What was your education?

After graduating from high school, I went to a school for drawing called Setsu Mode Seminar, but I only attended full-time for about a year, I guess.

— Did you ever work as an assistant to another manga artist?

I've never had that experience. It was all by myself . . . what you would call "self-taught."

— What was your first published work and when did it appear?

Aside from illustration work, the first manga was a *yon koma* manga (four-panel comic strip). I think I was 19. I don't remember the title.

— Was there a low point in your career? If so, what turned it around? What was your breakthrough?

I did take a break, when I was around 30. I just kept playing around and used up all my savings—so I was forced to work again. [Laughs.]

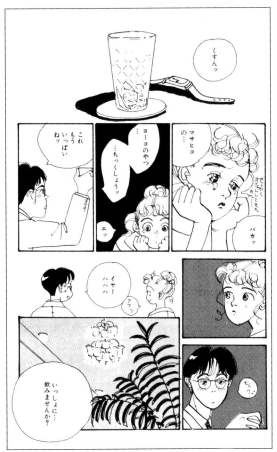

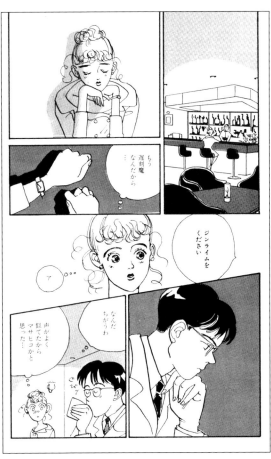

Evolving style and storytelling: Jauto Ravazu (Just Lovers), Sakurazawa's 1989 collection, demonstrated a number of manga storytelling devices that were becoming part of her visual vocabulary. Establishing shots (such as the bar scene at upper right), angular panel shapes, and attention to details and stylish props (the glass and wristwatch at upper left) were by this time common in her stories. Her figure drawing was also becoming looser and more confident.
© Sakurazawa Erica / Magazine House

— What would you call your manga, or how would you describe it?

Josei, manga for women.

— Who are your readers?

Women from 18 to around 37 or 38 . . . and their boyfriends. When my books are at their girlfriends' place, boys will read them when they get bored, I think.

— In creating a manga story, do you begin with a script, a synopsis, or do you go directly to a *name* (thumbnail outline with some dialogue)?

I start directly with a *name.*

— You usually don't draw manga based on other people's stories, but I believe the manga you are doing now *(Body & Soul)* is an adaptation.

Not quite . . . more like an inspiration. I talk with the author about what kind of story I am going to make out of it, and have the author check what I made.

— When you're creating your own stories, where do your ideas come from: dreams, daydreams, reading, movies?

I don't get influenced by other things, such as novels or movies made by other people. I like them, but I hardly get any influences. I often create stories based on my experiences, or on conversations with my friends.

— I read a 1998 interview with you in *Comic Link,* in which you said that once you experienced a peaceful love relationship, it was difficult to do erotic manga. Is it still like that?

Yes, now especially since I've had a baby. I can hardly think about romance while I'm nursing my baby.

— In that interview, you also said that you made all your memories into manga—even unhappy ones, like unhappy love affairs.

That's true. Well, I don't draw everything like it really was, but most of them come from what I've experienced, or from my friends' stories, or things that happen around me.

— Did you ever regret revealing too much about yourself in a manga story?

No, it's fictionalized. It's not that semiautobiographical or anything. But if I draw something inspired by terrible experiences, I can forget them by drawing. And by doing that, I kind of care for myself.

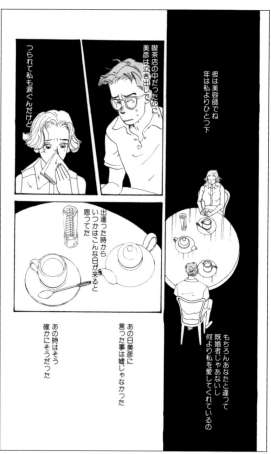

Isometric perspective was first used in 1991's Love So Special: As shown in the scene at left, this convention, common in architectural rendering, gave Sakurazaw's art a more sophisticated and somewhat dispassionate, documentary look, even as the emotional content of her stories increased. As shown in the scene above, betrayal and love triangles had become common themes, as Sakurazawa traced the vicissitudes of relationships with characters whose motivations were sometimes as mysterious to themselves as to others. Sakurazawa's sense of design and balance is also demonstrated in these scenes.
© Sakurazawa Erica / Kadokawa Shoten

— So drawing manga can have a healing effect on you?

That's right, I guess.

— When you work on a *name* for a story, do you do it all at once, or do you make notes first?

Notes don't work. When I try to come up with dialogue and write it down, it doesn't look good at all when I see it afterwards. The best things are the words that come out naturally when I am working on [the name].

— When you are moving from the *name* to the manuscript (artboard or final art), can it change? For instance, can the number of pages increase?

The number of pages won't increase, but there are times when dialogues are deleted. When I draw from the *name,* it's natural to take out dialogues that can be described graphically. The best thing is to be understood visually, so I delete words as much as possible.

— When you are working on the manuscript, do you always work on the pages in order, completing one page at a time before moving on?

I go in the easiest way. When there are drawings that are more difficult, I may have time to finish them later.

— Do you complete everything in pencil before moving on to inking?

There are times when I pencil one page at a time and hand it over to my assistant to ink, and there are situations where I complete all the pencils at one time. It depends on how close I am to the deadline, so I do it the most efficient and easiest way.

— You don't use a computer?

That's right. I use a Xerox [copy machine], but no computers.

— How do you work with your assistants?

I have three assistants, at the most, but there's only one who always works with me. Depending on the need, it may increase, but only to a maximum of three. Assistants do backgrounds and screen tones. And betas (spot blacks), too. I do the penciling of human figures and perspective of the backgrounds. I also tell them which [screen] tone to use, but there are parts that I just leave up to them.

— So you have some very trusted and skilled assistants.

Yes, for example for screen tones . . . in the backgrounds, I go most of the way drawing it with perspective. The assistants finish drawing it, and then there's an assistant who's good at showing how the lights glow in a room at night.

High drama begins, Koi no Okite (The Rules of Love): Taku, a player, gets a call from his suicidal ex-girlfriend. Another girl, Chizu, will soon try to get him to change his ways during a bittersweet summer relationship. Sakurazawa's stories believably chronicle the young urban singles' dating scene of the '90s. *Koi no Okite* appeared in 1994 and was translated into English by TokyoPop in 2004.
© Sakurazawa Erica / Shodensha

don't have to go all the way to a place like *Garo*.

— Who were your artistic influences when you first started— from manga or other arts?

For art, my very first were artists such as Ichijo Yukari-sensei and Ooya Chiki-sensei. I grew up with all the people from *shojo* (girls') manga, so the person I got influenced the most from in art when I was young was Ooya Chiki-sensei. After that, when I was 20, I was influenced a lot by the art of Takano Fumiko-san and Sabe Anoma- san. I don't know after that, but there are trends depending on the time, so when I read [others' manga], it kind of comes into me naturally. So, I really don't know who I am influenced by now, but certainly it's changing little by little.

— In the early 1980s, there was a so-called New Wave movement. You were one of three female manga artists who began drawing erotic manga for women. The others were Okazaki Kyoko-san and Uchida Shungiku-san. Was there a common influence on the three of you at that time, and did you influence each other?

I really didn't have the feeling that I was working on "erotic" manga. But it did occur to a few people at the same time that it was unnatural not to have sex scenes in comics for women! Besides me, those people were Kyoko-chan and Uchida-san, I guess. And so the people who started drawing that naturally were said to be a "new wave," but back then, there were many people who did that. There were also many people who drew only sex scenes—but they never lasted. At that time, I was reading a lot of third-class *gekiga* (hard-edged, realistic, or men's comics) or porn *gekiga,* porn for men. But I don't know if I was influenced by them.

— Is there a difference in the way men and women manga artists portray love and sex?

I kind of think that [erotic] manga by women is more unnatural. It's more dreamlike, it's not that realistic, not part of life—most of the scenes are drawn as though they're inside of a dream. That's where my manga is different—the [erotic scenes] I draw are in the [context of the] lives of people. Those scenes come naturally, I think, but when I see the way other people draw them, sex is the high point [of the

— So you don't have to tell them how to put in the shadows.

Right. I just ask them to "make it night here." That's all. I just leave those things to them.

— Since you worked in indies early in your career, what did you think of the magazine *Garo?*

Garo's publisher published two of my books, but I only worked once in the magazine itself. [Laughs.] I was a reader myself in good days, before it got confused [in its direction], but I didn't have the chance to work there. There was a time when *Garo* was taking on a lot of female manga artists, and I thought that

wasn't a good thing. I thought that—if my work got in it—that image might increase, or people would think of it differently. I thought, it wouldn't be *Garo,* it wouldn't be fun anymore.

— Yoshida-san: So you have many friends who were authors of *Garo*, but you think that you aren't really the *Garo* type, correct?

Uh-uh.

— Compared to *Garo,* do you ever feel restricted working in mainstream manga?

Well, I'm lucky, and am able to do what I want to do, pretty much, so I

Understated elegance: By 1996, Sakurazawa had hit her stride in terms of art and storytelling. This image is from *Shitsu no Sukima (Between the Sheets),* a haunting story of obsession. One of Sakurazawa's masterpieces, it follows a young woman, Minako, who finds herself attracted to her roomate, Saki. This work was translated into English by TokyoPop in 2003.
© Sakurazawa Erica / Shodensha

While *Shitsu no Sukima* showed a tragic and obsessive same-sex relationship, *Rabu Vaibazu (Love Vibes)*—shown above—had a more positive outcome in a similar situation. These two works, both from 1996, were Sakurazawa's venture into *yuri* or *shojo ai* (girl love) manga. She had touched on the theme of *yaoi* (stories about relationships between homosexual males) in 1995's *Ai Shiau Koto Shika Dekinai (Nothing But Loving You)*, depicting a love triangle involving a woman and two men. Far from sensational, Sakurazaw's stories are always done with taste, restraint, and, above all, style.
© Sakurazawa Erica / Shodensha

Another scene from Love Vibes:
Sakurazawa's characters are complex, the situations in which they find themselves ambiguous and true to life. Sakurazawa's figure drawing is expressive and gestural.
© Sakurazawa Erica / Shueisha

story], so it's not as natural. The main part of my manga is not sex, but in the course of events, there is sex and it's a natural thing—that's the way I draw it. But in most manga by women, they draw the process up toward sex and that's the point, and the scenes have flowers flying and the lights come [laughs], that's what I see mainly.

— Are there major themes in your work?

I hardly ever thought about that. [Laughs.] I don't make up a theme and do it, I guess. But for now, I'm certain that romance isn't the thing I admire the most. In my romance manga, the romance part has been reduced a bit.

— Is your manga reflecting your life?

Yes, probably.

— Has your drawing style or methods changed over the years?

No, I haven't changed much. When I first started, I used to use a Rotring [technical pen] so [my manga] would be different from the others, but I soon realized that it wasn't the look I wanted, so I switched to a pen and have been drawing with a G-pen ever since . . . so there's not much of a difference.

— Do you use any reference material, such as photos, to draw from?

Photos for my backgrounds are very important, so I go to Shibuya and take photos. I make a background catalog and use photos; I use just about anything.

— What is your favorite medium?

Hmm, maybe pencil.

— In terms of storytelling and design, are there any dos and don'ts you stick by?

Tehshi (Angel) has a special place in Sakurazawa's heart: Written before she had children, one story in this 1999 collection portrayed a neglected latchkey child as one of the characters befriended by an angel. This manga was unusual for Sakurazawa, mixing fantasy elements more common in her earlier, indie work, with her current urban realism. Tenshi was translated into English by TokyoPop in 2003. © Sakurazawa Erica / Shodensha

Hmm . . . something that I won't do. Are there any?

[Looks at Yoshida-san.]

— Yoshida-san: I feel that, in your stories, people may do things against the law, but you never depict them beng "cool." For example, people who do drugs may appear, but you don't draw them as "cool punks."

So, I guess I do have some sort of moral. [Laughs.]

— What's a typical day for you? How many days a week do you work?

I don't work five days a week. I work just before the deadlines. I try not to work overnight these days, but I may work until early in the morning at the end, though.

— How long does it take to do a page? How many pages a day do you do?

Well, it changes according to the situation. When I am drawing, I can draw 14 to 15 pages a day, but I can't draw at all the next day after a few days like that. [Laughs.] So I can do 32 pages in about four days. I did 50 pages in six days the other day.

— Are there any of your works that you are unhappy with? For what reason?

I try not to think about that, like, "I should have done that." I try not to think about that when I'm doing the next work.

— What is your favorite work and why?

The work that I like . . . Hmm . . . in the past, I used to say "The work I'm doing now is my favorite," but among my past works, I think I like *Tenshi (Angel)*.

Only new parents would understand the excitement of small milestones in baby's development. This is an image from *Kyou mo Otenki (Today's Weather)*, Sakurazawa's monthly diary of child-rearing, which appears alongside her current work, *Bodei & Souru (Body & Soul)* in *Feel Young* magazine. The readership is women 18-35 . . . and their boyfriends.
© Sakurazawa Erica / Shodensha

The climax of *Shitsu no Sukima (Between the Sheets)*. Minako realizes that she has lost Saki forever, not only as a lover, but as a friend.

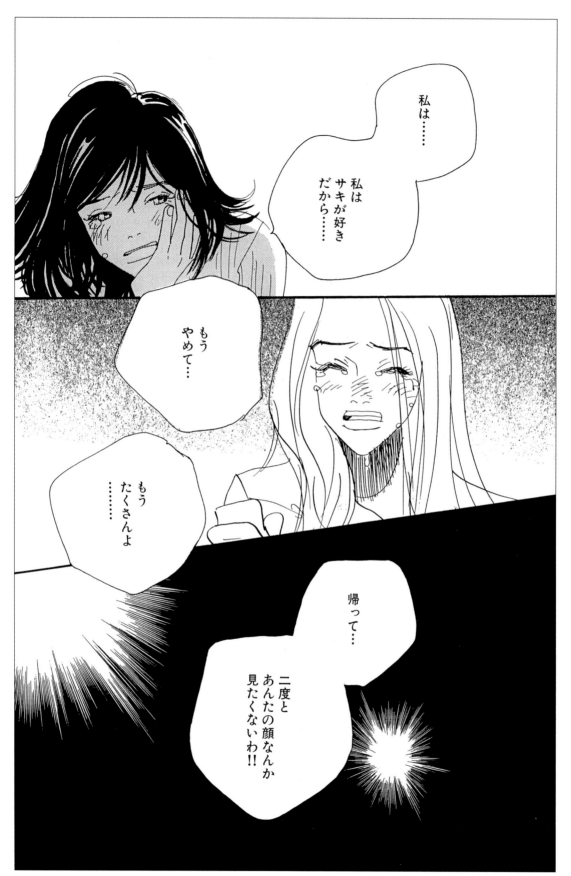

Sakurazawa is at the height of her powers, in terms of both art and storytelling, with this work, published in 1996.
© Sakurazawa Erica / Shodensha

— What are your favorite manga or comics by other artists— Japanese, European, Asian or American?

Let me see. I don't read manga much currently . . . The one that's in a magazine that I enjoy reading is Ichijo Yukari-sensei's *Pride*. There are others like *Black Jack ni Yoroshiku (Say Hello to Black Jack)*, but Ichijo-sensei's work is the one I look forward to the most, I think.

— What advice would you give to any aspiring artists?

I think that being a manga-ka is really a good occupation. There is a dream that you may become a billionaire, and I think it is a good thing that the work you have drawn can become a book and live on— so I think it's a good choice as an occupation.

— Is there anything special needed besides drawing tools when you draw?

Not really. When my assistants come over, I set up a *chabu-dai* (small Japanese dining table). That place is clear today. Ususally there's only enough space for drawing, and there are many things piled on it.

— Is there anything you need besides tools, such as music or coffee?

I don't play music. I drink tea, Japanese tea. But that's about it.

— Have you ever considered using a computer for drawing?

Never. I sometimes Xerox the art I draw and color it with a marker, and when I was coloring the same art over and over, my assistant said "You could do that on a computer nowadays, Sensei."

— A computer does make it easy to redo things.

Yes, but there's a feel that you can only get by hand, so I use my hand. And there is art that fits computers and art that doesn't.

— You said earlier that your favorite work is *Tenshi*. Can you tell us the reason why, or a little bit behind the scenes?

Tenshi was . . . how should I put this, what should I say? It had a different world than what I had drawn in the past.

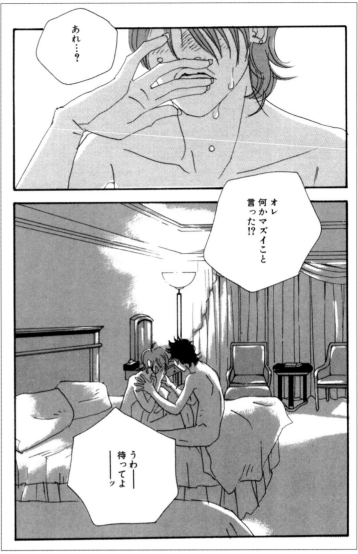

Master of mood: Sakurazawa's subtle use of lighting to express emotion is evidenced in this scene from *Aromachiku Bitazu (The Aromatic Bitters)*. Hide beaks down when her young lover suggests they have children together.
© Sakurazawa Erica / Shodensha

— Was it a turning point?

I guess so. It was before my pregnancy.

— Was it prophetic?

I think so. I'm a type that can only draw what I have experienced, so before I got married, I could not draw a manga with the theme of marriage— even when I was asked. I didn't have any interest in it. [Laughs.] Even so, there is a story where a child appears in *Tenshi* . . . but I didn't have a child [then]. But the reason I wanted to work on that story was that—as I think about it now—I got pregnant later so

that my body actually mirrored what I was thinking about!

— Is there anything you would like to say to your fans outside of Japan or inside Japan?

The major portion of my titles have not been published in US just yet. I sincerely hope they will be widely distributed to as many readers as possible in future.

LIST OF WORKS

List of works:
- *Kawaii Mono (A Pretty One),* Kawade Shobo Shinsha, 1985
- *Cherry ni Omakase! (Trust the Cherry!),* Seirindo, 1987
- *Furuzu Paradaisu (Fool's Paradise),* Kawade Shobo Shinsha, 1987
- *Mainichi ga Aki no Sora,* Publisher Name?, 1988
- *Shippo ga Tomodachi (Even You, Shippo),* Shueisha, 1989
- *Jasuto Ravazu (Just Lovers),* Magazine House, 1989
- *Rabu Sutorizu (Love Stories),* Shueisha, 1991
- Love So Special, Kadokawa Shoten, 1991; Shodensha, 2003 (reprint)
- *Sekai no Owari ni wa Kimi to Issho ni (End of the World),* Asuka to Seikatsusha, 1992; Shodensha, 2004 (reprint)
- *Salon,* Asuka to Seikatsusha, 1992; Shodensha, 2003 (reprint)
- *Maikin Happi (Makin' Happy),* Shodensha, 1992
- *Esukipu (Escape),* Shodensha, 1996
- *Tenohira ni Diamondo,* Shodensha, 1997
- *Enjieru Buresu (Angel Bless),* Shodensha, 1997
- *Romansu no Izumi (Love Fountain),* Shodensha, 1998
- *Keseran Paseran,* Shueisha, 1999
- *Lovely!,* Vol.1–3, Shodensha, 1999
- *Zeitaku na Osan (The Luxurious Childbirth),* Asuka Shinsha, 2001
- *Kyou mo Otenki,* Shodensha, 2002
- *Yume no Katachi (Shape of Dreams),* Shueisha, 2003
- *Sukuru Daizu (School Days),* Shodensha, 2003
- *Bodei & Souru (Body & Soul),* Shodensha, 2004

Collections:
- *Sakurazawa Erica Library,* Mediafactory, 2000, 10 volumes
- *Sakurazawa Erica Selected Works,* Asuka Shinsha, 1997– , 10 volumes to date
- *The Best of Sakurazawa Erica,* Shueisha, 2002
- *Sakurazawa Erica Reprint Series,* Shodensha, 2001– , 7 volumes to date

In English:
- *Between the Sheets,* TokyoPop, 2003
- *Angel,* TokyoPop, 2003
- *Angel Nest,* TokyoPop, 2003
- *Nothing But Loving You,* TokyoPop, 2003
- *The Rules of Love,* TokyoPop, 2004
- *The Aromatic Bitters,* Vol. 1, TokyoPop, 2004 (Tokyopop: http://www.tokyopop.com/)

Major works:
- *Between the Sheets/Love Vibes,* Shodensha, 2002 (reprint)
- *Crash,* Shodensha, 1999, 2 volumes
- *Aromachiku Bitazu (The Aromatic Bitters),* Shodensha, 2002–2003, 2 volumes

CHECK OUT

Top three:
- *Between the Sheets/Love Vibes* (ISBN 4-396761562)
- *Crash* (Vol. 1 ISBN 4-39676198-8)
- *Aromachiku Bitazu* (Vol. 1 ISBN 4-396762747)

Web site:
- Sakurazawa Erica's official Web site http://www.shu-cream.com/
- Unofficial information on Sakurazawa Erica can be found at Prisms, the Ultimate Manga Guide http://users.skynet.be/mangaguide/au1627.html

Japanese manga artists you might like, if you like Asamiya Kia:
- Anno Moyoko
- Minami Q-ta
- Okazaki Kyoko
- Uchida Shungiku
- Yamada Naito

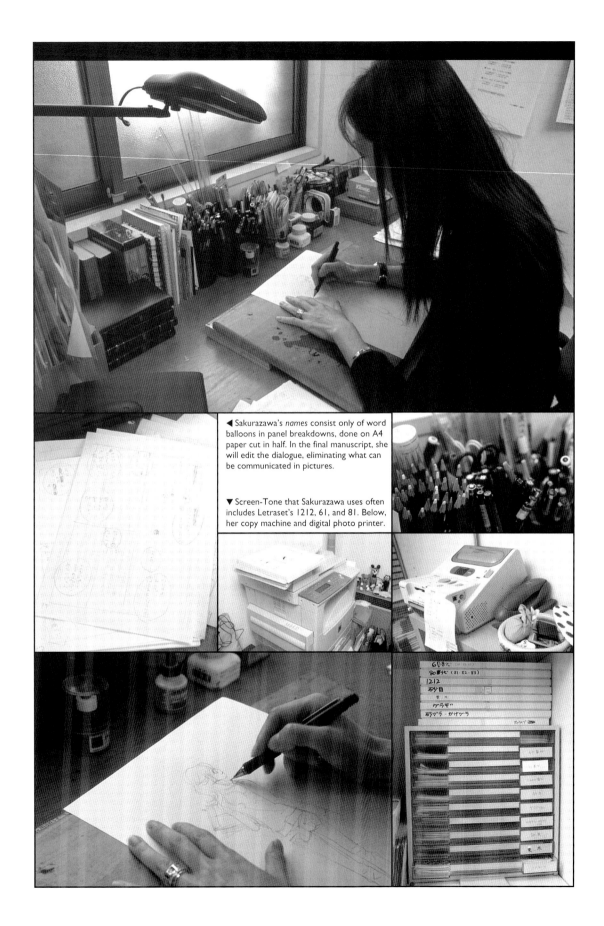

◀ Sakurazawa's *names* consist only of word balloons in panel breakdowns, done on A4 paper cut in half. In the final manuscript, she will edit the dialogue, eliminating what can be communicated in pictures.

▼ Screen-Tone that Sakurazawa uses often includes Letraset's 1212, 61, and 81. Below, her copy machine and digital photo printer.

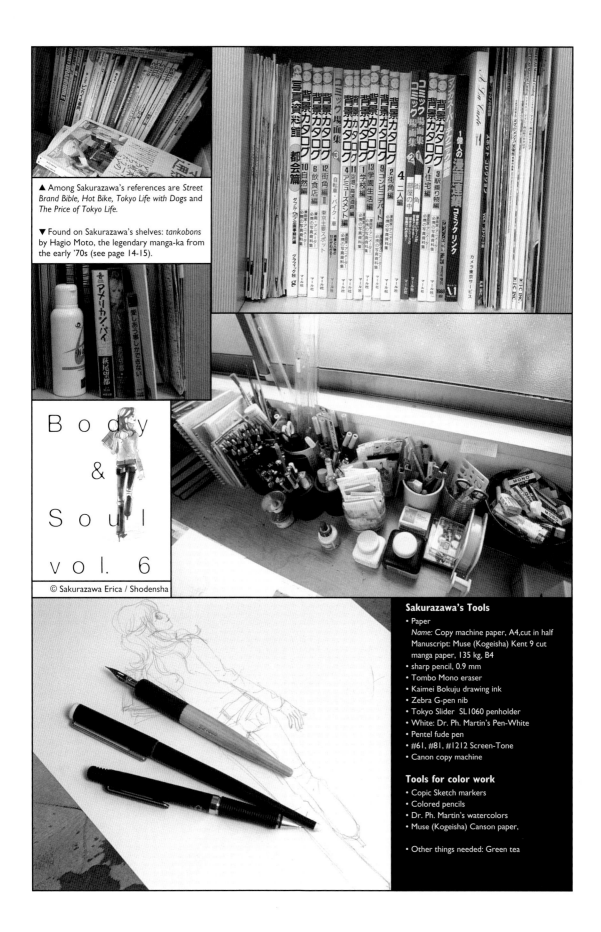

▲ Among Sakurazawa's references are *Street Brand Bible*, *Hot Bike*, *Tokyo Life with Dogs* and *The Price of Tokyo Life*.

▼ Found on Sakurazawa's shelves: *tankobons* by Hagio Moto, the legendary manga-ka from the early '70s (see page 14-15).

B o d y
&
S o u l
v o l. 6

© Sakurazawa Erica / Shodensha

Sakurazawa's Tools

- Paper
 Name: Copy machine paper, A4, cut in half
 Manuscript: Muse (Kogeisha) Kent 9 cut
 manga paper, 135 kg, B4
- sharp pencil, 0.9 mm
- Tombo Mono eraser
- Kaimei Bokuju drawing ink
- Zebra G-pen nib
- Tokyo Slider SL1060 penholder
- White: Dr. Ph. Martin's Pen-White
- Pentel fude pen
- #61, #81, #1212 Screen-Tone
- Canon copy machine

Tools for color work

- Copic Sketch markers
- Colored pencils
- Dr. Ph. Martin's watercolors
- Muse (Kogeisha) Canson paper,

- Other things needed: Green tea

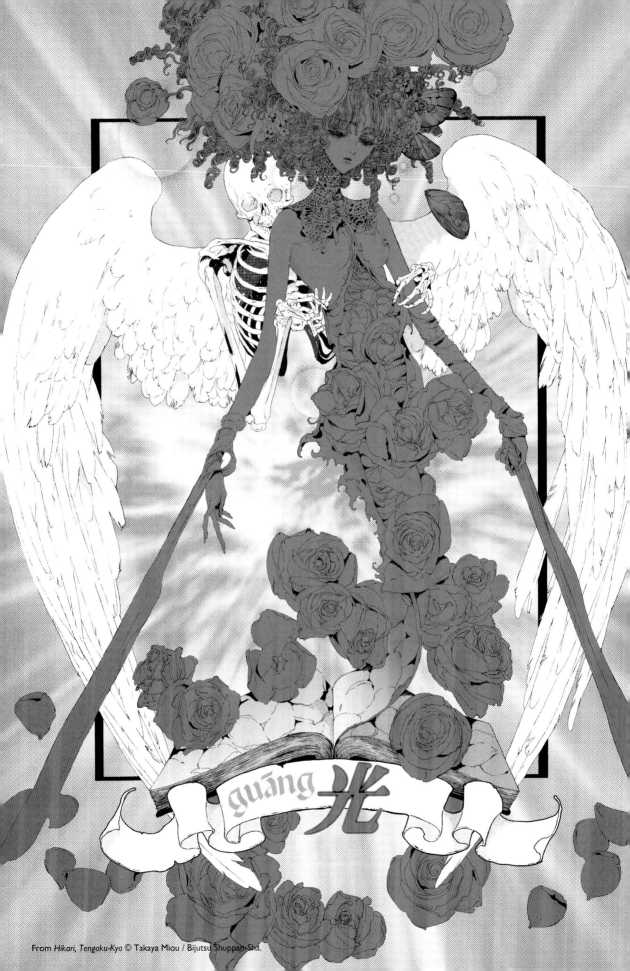

guǎng 光

TAKAYA MIOU

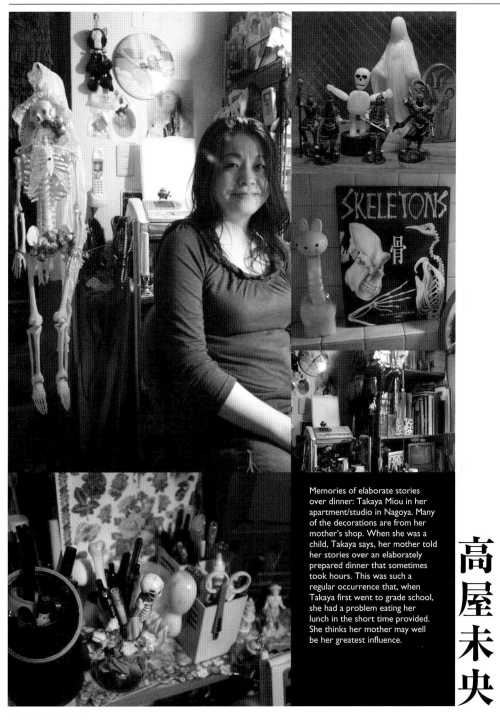

Memories of elaborate stories over dinner: Takaya Miou in her apartment/studio in Nagoya. Many of the decorations are from her mother's shop. When she was a child, Takaya says, her mother told her stories over an elaborately prepared dinner that sometimes took hours. This was such a regular occurrence that, when Takaya first went to grade school, she had a problem eating her lunch in the short time provided. She thinks her mother may well be her greatest influence.

高屋未央

PROFILE

Place of birth: Nagoya, Japan

Date of birth: unknown

Home base: Nagoya, Japan

First published work:
cover art for Kaifu Shito Enbu (written by Fuji Minako, Tokuma Novels), 1993

Education:
Studied at a university for two years.

Career highlights:

	
1991	Sei Shojo Yugi self-published (Newm;Kz) begins.
1993	cover art for Kaifu Shito Enbu (written by Fuji Minako) Tokuma Novels
1996	(az)Pg (Newm;Kz)
2000	Kikai Jikakeno Ousama (King of Mechanics) (Taiyo Tosho).
2001	Tengoku-Kyo (Crazy Heaven) and Seisho-Zu(Map of Sacred Pain) (Bijutsu Shuppan-Sha)
2002	Kairaku Busshitsu Endorufin series begins (Taiyo Tosho)

Like a prom queen at a punk show, I found Takaya Miou at Comic Market, the Woodstock-sized festival of doujinshi (amateur manga), in the late summer of 2001. Comiket, as it is commonly referred to, is the largest such event in Japan, attracting half a million people to the Tokyo Big Sight exhibition center over the course of three days. There, amidst X-rated parodies of other manga, Takaya was selling her wonderful books, beautifully drawn and extravagantly packaged in gold foil and embossing. She served them up like decadent deserts for the young women in their 20s who continuously approached her table.

It may surprise some Westerners that Takaya's tales of transgressive love – so eagerly sought after by those young women – more often than not portray impossibly beautiful, sometimes androgynous men. Takaya could be considered part of the bishonen (beautiful boy) tradition of shojo (girls') manga, a stream which dates back to the '70s. But the folklore-like trappings of her stories, combined with the lavish production values on her gorgeously-crafted books, set Takaya apart. She stradles the line between independent and commercial manga; while published by several companies, she maintains her own print label, Neurone Konzentrationslager (the German word suggests the self-imposed isolation she needs to create).

I had first seen her highly detailed pen-and-ink work in Comickers magazine in 2000. She had struck me as an artist with the graphic sense of Beardsley, the intricacy of Von Bayros, and an erotic sensibility to match either. The story read like a lost legend. From the accompanying commentary, she was obviously well-read and sophisticated, acquainted with gay punk murder novels, French avant-garde theater, and multi-cultural religious mythology.

That day at Comic Market, I was expecting someone in her mid-to-late 30s. I was suprised to find her only in her late 20s, with a girlish demeanor disguising a brooding philosophical nature.

Some weeks later, in her industrial-style apartment in Nagoya, she served us coffee and chocolate, a local tradition. My interpreter and I were quickly put at ease by her graciousness and self-effacing nature. She had apologized over the phone that she didn't really have a studio, "so we might be cramped." Indeed, her library and computer room doubled as an ironing room and she did all her drawing at a standard-sized desk next to the window at one end of the long narrow room that was her kitchen, dining room and, yes, studio.

Everywhere there was Takaya Miou paraphernalia, models for images in her sometimes kitschy, but always fantastic, creations: a full-sized skeleton in a wedding dress, rosaries, paintings of martyred saints and a gilded plaster cherub in a corner of the window. Everything from Jesus to John Malkovich (a still from the movie "Being ..." affixed to her india ink bottle). Much of the decoration was from the establishment of her mother, a dealer in sundry goods. Her mother, Takaya admits, is her greatest influence.

Takaya Miou oozes quiet intellectual intensity. But she also has a quick and infectious laugh, which she shared with us many times during the interview.

TAKAYA's interview

— How did you become a manga artist? When did you decide you wanted to do this for a living?

My goal was never to become a manga artist. What I'm doing lately is drawing manga and pictures, so that's my job – but I've been drawing and writing stories ever since I was a kid. So I don't know where the hobby ends and where the work starts.

— Did you ever work at another job?

No.

— What was your education?

I went to a university to study philosophy but dropped out. I would rather not say which school [laughs],

since I didn't really graduate.

— That's OK. Why did you choose philosophy?

I didn't have any plans of where to go from there. I think I liked to think and was interested in what-does-it-mean-to-be-human?-type questions.

— When you left school were you making money drawing manga?

Yes. I started doing illustration work and self-publishing at about the same time, and both were making money. It wasn't exactly that I dropped out. I simply went to classes less and less until I stopped going completely. The reason I stopped initially … When I'm in a group of people I tend to change myself

Delightful chaos: Sensory overload is abundant in Takaya's apartment/studio.

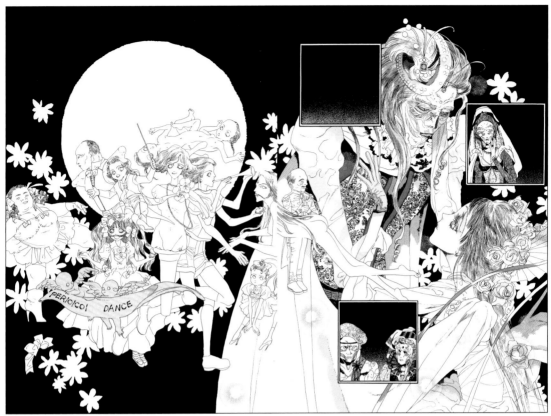

Some of Takaya's earliest works are still among her favorites: These images are from *Mikaeru (Michael)*, which Takaya originally published under her Newm;Kz label in 1994. Her art already displayed a strong sense of design. This story reappeared in her self-published Beauty Equation collection in 1997, and again in 2001's *Tengoku-Kyo (Crazy Heaven)*, the first volume of Takaya's collected works published by Bijutsu Shuppan-Sha.
© Takaya Miou / Bijutsu Shuppan-Sha

to fit my surroundings. So I thought that I would have to eliminate everything around me to really find out who I was. So it was a little abrupt, but I tried to eliminate everything around me, and the university got in the way of this process.

— **Did you have formal art training?**

I didn't have any training in drawing.

— **Were your parents supportive of you becoming a manga artist?**

My father still asks when I'm going to quit. [Laughs.] He doesn't believe that drawing, or even writing novels, are real jobs. My mother was supportive, though. She manages a general merchandise store. She sells clothes, small items, and flowers ... that angel came from her shop [pointing to a decoration on the wall]. My father is an architect. When he asks me when I plan to quit, I think he's joking.

— **How did you learn to tell a manga story?**

Hmm. I think I liked to read. I believe it's natural that people who like to read move on to creating stories themselves. So, I didn't learn from someone or go to school for it or anything.

— **What was your first published work and when did it appear?**

It was a book illustration – so I don't know if I can call it my publication – but that was my first job, in 1991. For my own work, the earliest one [Nansou Satomi Hakkenden] was also in 1991. The publisher that saw this book gave me the [illustration] job.

— **In creating a manga story, do you begin with a script?**

First come the words. I usually have a notebook with me and make notes whenever something comes to mind. I have many of these notebooks. Then I try to come up with stories that would give most significance to the phrases. I take it from there and adjust the length for the number of pages needed for a manga story. Then I draw. I first make an e-conte (script, sometimes with pictures), kind of like a blueprint for the draft. The e-conte is like a scenario or screenplay. So, first I write the words, then divide them into pages, and after that draw pictures on each page. This is the process before drawing the rough draft (first version of the drawn story, usually at a smaller size). It depends on the editor of each job, but this editor wants to see the rough draft by fax.

— **What size is your manuscript?**

The regular size [B4].

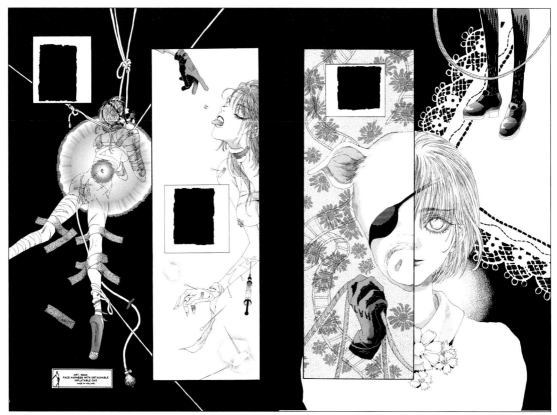

(az)Pg was inspired by a dream: Rather than trying to tell the same story as the dream, Takaya wanted to create its feeling. This short story has many themes that are common to her works: love and obsession, with undercurrents of violent fantasy, fetishism and bondage. It was originally published by Takaya in 1996, and also appeared in the first volume of her collected works *Tengoku-Kyo (Crazy Heaven)*, in 2001.
© Takaya Miou / Bijutsu Shuppan-Sha

— Does the editor ever suggest changes?

No, that doesn't happen. The people I work with now don't tell me "do this," or "do that." They probably see what I've self-published, so they know "this is what she does." They come to me with that mentality. It's not that they don't make any comments. They have some limitations, since they are publishers, but they haven't made any drastic demands that have made it impossible for me to draw. There are no limitations on the drawings. The comments are on the flow of the story and how I might want to make it clearer. If the editor doesn't like what I do and suggests things and I don't agree with that view, I go ahead with my own ideas. But sometimes the editor throws light on aspects that I couldn't see. At times like that, I do what they say.

— What's next, after the rough draft?

My publisher says, "Draw so you make the deadline." [Laughs.]

— Has your storytelling technique changed since your debut?

At the time of my debut, I don't think I understood what it meant to draw and have people look at it. When you start, there are rules in manga, expression techniques … that I don't use now. Shuchu-sen ("concentration lines"), for example. Whether to use this or not is one of the many manga rules, or techniques. I don't use this either, but another example is kake ami (cross hatching). You start by learning things like that and, at first, learning techniques is a lot of fun. Currently I don't like adding shuchu-sen to make something stand out; I actually don't use it at all. But if you don't know that that kind of technique exists, you don't know what you need and what you don't need. So there was a process [of my development] when I eliminated such techniques. But acquiring techniques expands the range of what you can express. Thus, you are in a position of choosing what you want to use. Also, most people read manga as pictures, so they think pictures are the

main thing. I believe it's not as picture-oriented as the reader might think. Parts other than the pictures, such as the words or lettering, have great importance.

— In a Comickers interview, I believe you talked about the making of a book as an art in itself.

I like making books. [Laughs.] If I didn't like making books and just wanted to draw manga, I think I would have just become a regular manga artist.

— Where do your story ideas come from? Dreams, daydreams, reading, movies, other sources?

Dreams are quite often the source. For example, az(Pg) was based on a dream. Only, I don't make into manga the dreams; my idea was that I wanted my readers to feel the same way I did in a certain dream. I don't really know where my other ideas come from.

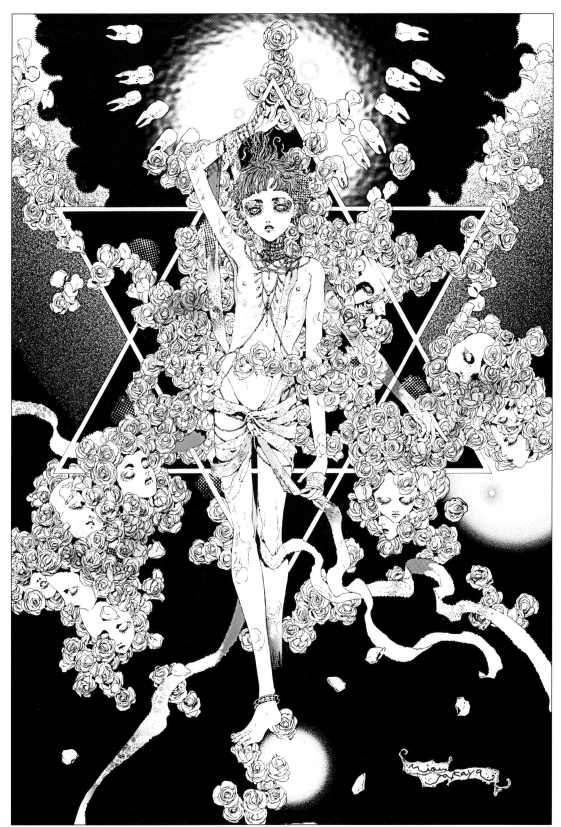

Those pretty, pretty boys that she calls friends: Bishonen are impossibly beautiful, androgynous men. Takaya estimates that 90 percent of her readers are young women in their 20s. This demographic has made bishonen a staple of manga for women. There is no equivalent genre in Western comic books. This image, titled *Heliogabalus, the Brutal Boy Emperor from Rome*, is from 2001's *Tengoku-Kyo (Crazy Heaven)*, the first volume of Takaya's collected works.
© Takaya Miou / Bijutsu Shuppan-Sha

— When you draw, do you work from the start to the end of the story, or do you draw in whatever order that is easy to work with?

The pencilling is in order. Until I get to the inking, I do everything in order. Once I get to that point, the creative process is basically over and the order for inking doesn't matter.

— Do you have any assistants?

No.

— Who were the people that were with you at Comic Market?

Although I work alone, I have people that help sell – on a volunteer basis.

— There was a designer listed in your book Eroticize Intelligence. Was that an unusual thing?

I took those pictures myself and did the design. This "Makami" person is me. It's another one of my names. [Laughs.]

— What is the best doujinshi (fanzine) festival in Japan?

Comic Market is certainly the largest. It's the only one that attracts 500,000 people in three days. But what I'm
doing is a little different from others at Comic Market, so I actually can't speak for doujinshi. I actually don't like to be categorized as a "doujinshi artist." "Doujinshi" right now refers to manga that uses existing anime characters or characters from novels for parodies.

— Who are your readers?

I think they are 90 percent women; most seem to be in their 20s.

— Do you think that self-publishing is a place where creativity flourishes, as opposed to the commercialized manga industry?

In my case it doesn't make a difference either way. There are limitations in self-publishing too. I don't think the basics differ much.

— What did you think of the alternative manga magazine Garo?

I think Garo tried to have Garo-type manga, so I wouldn't say they were revolutionary. Not like, for example, French comics with artists like Moebius and Enki Bilal. Their art is considered to be graphic novels, right? I think what is interesting about graphic novels and manga is different. So if you read graphic novels expecting them to be like manga, they are not fun to read. Inserting graphic-novel-type elements in Japanese manga might appear to be revolutionary, but whether that is interesting to read as a manga is quite different. It's not a matter of which is good or bad, or which is better.

— So you consider them to be completely separate things?

Yes, although it's possible to insert graphic novel elements into manga, and also to create manga-like graphic novels. There are manga-like French comics and American comics, too.

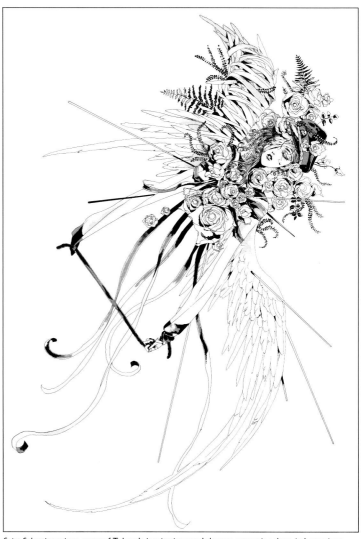

Saint Sebastian mixes many of Takaya's inspirations and themes, wrapping them in her unique iconography. This illustration juxtaposes gay punk trappings with the Baroque symbolism of martyrdom. Using imagery of 17th-century Western religious art, Takaya creates striking – sometimes shocking – visions, but never crosses the line into vulgarity.
© Takaya Miou / Bijutsu Shuppan-Sha

— I feel like your work is closer to graphic novels, or bande dessinee (French comics), because you take more care with the pictures than with the story.

I think the Japanese manga audience might think the opposite. I don't think that there is more emphasis on the drawings, but I don't have many opportunities to get feedback from my audience so it's hard to know what they are thinking.

— Your work reminds me of the British artist, Aubrey Beardsley.

I like Beardsley. His work was influenced by Japanese ukiyo-e and Greek [vases]. You can see it in the balance of white and black. I don't necessarily consider Beardsley's style unique. In art history his distinct use of black and white is considered unique, but I don't feel that way. I feel close to it. I did think at one time that it would be interesting to make a manga like Beardsley's work. But if you were to

actually do that, the manga would lose movement. It would become too flat. Taking that kind of art into manga makes it too flat and uninteresting.

— Perhaps you have been influenced by him, but didn't imitate him?

Mmmm. Yes. Being influenced is a tricky concept. I don't notice it but when you say it I think, well, maybe.

— When you started, were you influenced by any other manga artists?

I think the ones I read as a child influenced me.

— Are there new influences or inspirations now?

I'm not inspired by other manga. Influence … I get it from anything and everything. I think everything is interconnected. So going back to your question about where the ideas come from, I can't say for sure but they probably come from everyday life.

— Your work has a strong erotic element. Did anything inspire that?

I'm drawn to the extremes like life or death, black or white. I think I lack the ability to understand what is in the middle, the gray zone. When I portray the extremes it inevitably becomes erotic. In life or death there is always an erotic element.

— Are the erotic elements connected to life or death?

Both. I think dying and living are not separate matters.

— So what you are saying is that eroticism exists in the two extremes and not in the middle gray zone?

Yes. The extremes. When making that into a picture, whether it's a person or not, I draw them as one. As things, as dead matter, or something that is not alive. There is eroticism there.

— You portray people as things that aren't alive?

Whatever you are drawing, once it's drawn it's a thing. So the line of vision always becomes a kind of fetish. Then it is definitely erotic. I don't try to draw erotic stories. When I think about what is needed to portray a scene, it just naturally goes to [eroticism].

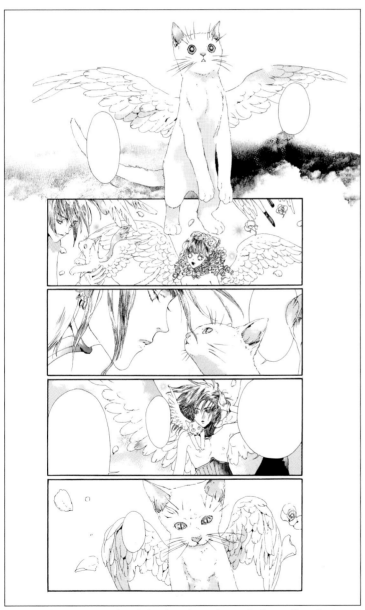

Eroticize Intelligence appears at first blush to be a whimsical story of a deceased kitty. But it soon takes on a darker edge, involving human suicides. Takaya first published this manga in 1999; it also appeared in 2001's *Seisyo-Zu*.
© Takaya Miou / Bijutsu Shuppan-Sha

— **In a Comickers interview you used extracts from the Iroha-uta (Iroha song). Does this have special significance to you?**

Iroha-uta is a song that kids used to sing to memorize the Japanese alphabet. It doesn't repeat the same sound twice, but the song has a meaning. It sings of shogyomujou ("all things change"). There's a part that goes "There may be a scent to the color but it will die." The word for "color" here also means flower. It also can mean life. So the flower refers to life which equals humans. It says that the flower may bloom beautifully but will someday die. This "floating" state can be taken as one who has thrown away mortal life, but that's not the case… it's the mortal world … I don't know how to explain it. This becomes quite a Buddhist thing. Everything in the world changes. So even people with money will die eventually and a time will come when having money isn't going to be beneficial. It means that, in simple terms. This is not to mean that earning or living is a waste. If the song is taken that way, everything one does in this life seems like a waste. But that's not the case … you should go ask a monk.

— **Everyone will die eventually so everything can be considered pointless – OR everything is more precious because it is so transient.**

Mmmm, yes … If we consider material things unimportant, then we must think about what is really important.

— **Like what it means to be human?**

Yes. I thought that this Iroha-uta was perfect for portraying that kind of thing. "There may be a scent to color but it will die; this mortal world is not constant for anyone" is a saying that means that even if flowers bloom they'll die eventually and asks "what does not change in the world?"

— **I would like to ask about the elements of Catholicism and the symbols of death in your work.**

I've liked myths – regardless of whether they were Catholic, Hindu, or Buddhist – ever since I was six or seven years old. I read the Bible like I was reading any other myth. It was very interesting as a story, not as a religious text. Myths are all symbolic. More than wanting to use only Catholic symbols, I've liked symbols in general. For example, if you didn't know the Bible and saw someone had a picture of a bleeding man in their room, without that knowledge it would be quite erotic, don't you think? Someone who is trying to get away from a bondage situation. The same can be said for the Mary or Pieta statues carved by Bernini.

— **So you view these symbols without the religious connection?**

Yes. For example, this book is a collection of paintings of Saint Sebastian. Don't you think the pictures depicting martyrdom are quite erotic? These pictures were produced for churches. So the churches had these kinds of pictures in them even though they were all strictly practicing asceticism. Some of the pictures of angels I like just because they're pretty. That was initially why I started looking.

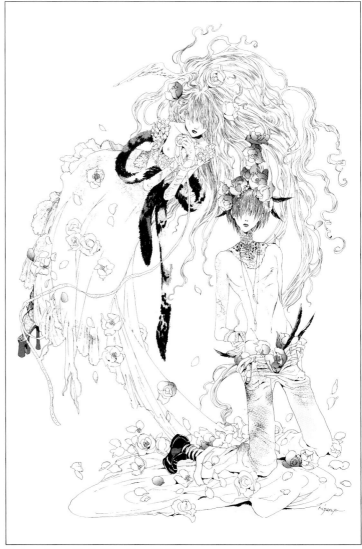

The image from *Seisho-Zu* (*Map of Sacred Pain*).
© Takaya Miou / Bijutsu Shuppan-Sha

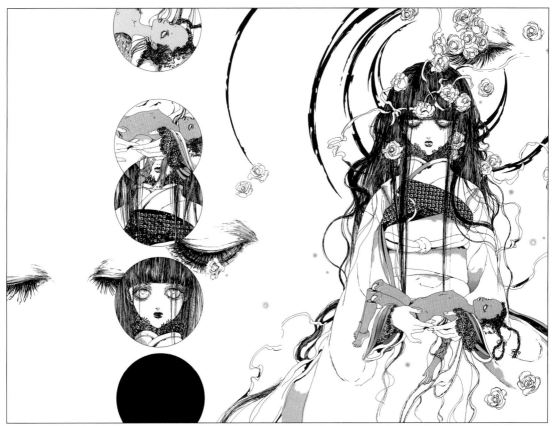

Images from *Kikaijikake no Ousama* (*King of Mechanics*): Originally self-published beginning in 1993, this manga was re-drawn by Takaya for a revised serialization in Craft magazine. Craft's publisher, Taiyo Tosho, has published two tankobons of the series to date. The story involves androids and Hans Bellmer-like dolls in an elegantly-designed extended narrative.
© Takaya Miou / Taiyo Tosho

— Do you have a particular religion or set of beliefs?

No, I don't have a religion.

— What about a philosophy?

I think what I said earlier about the life or death extremes and being drawn to these religious symbolic elements are related. I think very beautiful things have a sense of extreme sadness and tragedy. I like it as long as it doesn't get too tasteless. I like stopping right before it becomes tasteless.

— Like the fine line between pornography and erotic art?

That's right. I like to settle in the border between the two. But depending on the person who sees it, some take it as porn or in bad taste.

— What are the major themes of your work?

People. I don't think there is anything else. But I should probably explain more. I think it is the same thing as the Iroha-uta. I don't think there is an absolute answer to what is most important when considering material things to be useless. The way I think now, I believe the most important thing is to feel and think.

— Did you have any special training – or inspirations – for writing?

I haven't had any special training. Inspirations … sometimes I don't know if I found the author because I like the work or because I was inspired and my work became like theirs. This is true of Jean Genet. I also like an American author named Dennis Cooper, a novelist and poet.

— Do you use any reference material, such as photos, to draw from?

I do use photos as reference sometimes. For buildings especially.

It's hard to get the details without seeing the actual thing. When drawing a room, or the top of a desk, there are things that I want on that desk. I tend to draw the objects that are on my own desk.

— What is your favorite medium?

I like black and white more than color.

— Do you have a schedule in the week with work days and off days?

On particular days? No, not really. I just do it when I feel like it. [Laughs.] I don't have a set time that I start, like a job. Close to deadlines, I work all seven days. I'm not very fast when drawing. It takes some time for me to start too, and since finishing one page takes a long time, I end up working continuously close to deadlines.

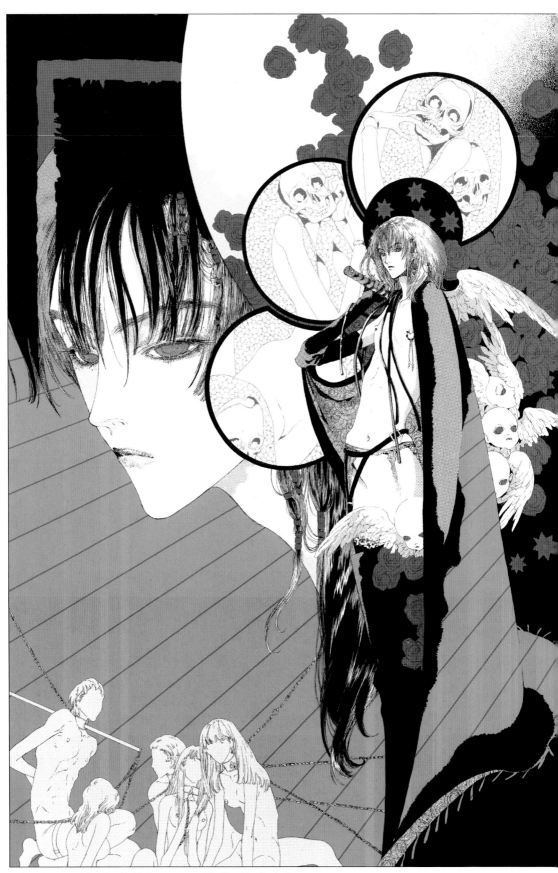

In the lush picture-fable *Hikari (Light)*, the emperess of Sui (Death) willingly dies
to give her husband what he has always longed for – a perfect soul.

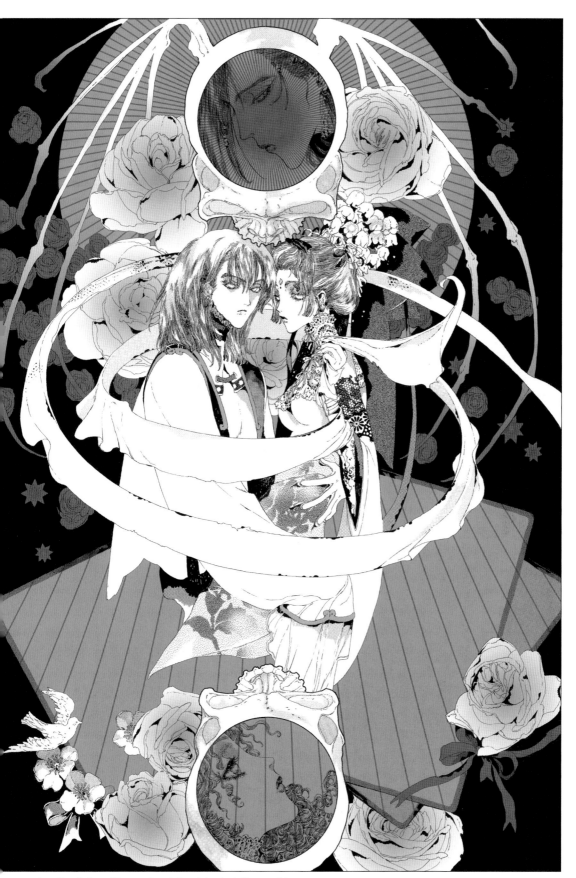

Jean Genet's *Funeral Rites* may have indirectly inspired this masterful manga,
which appeared in *Comickers* magazine, and in the collection *Tengoku-Kyo*.
© Takaya Miou / Bijutsu Shuppan-Sha

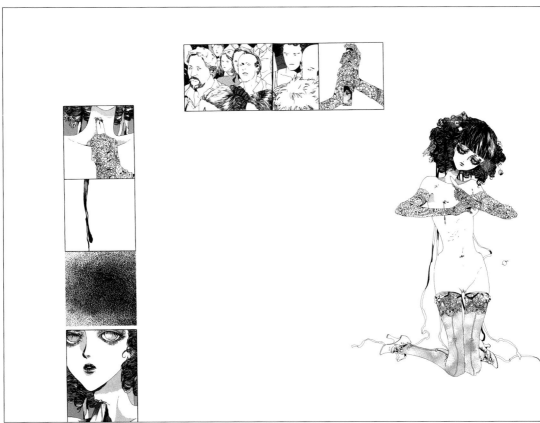

Gothic Lolita: Animated dolls, delicate and fragile – and which may or may not be human – populate the world of *Kikaijikake no Ousama*. It is also a world of hurt bodies and deformed cripples, rendered in Takaya's delicate, precise lines. Takaya's works always portray a beauty which also contains an element of sadness, not unlike the Buddhist concept of *shogyoumujou*, the awareness of the impermanence of human existence. Takaya, an ex-philosophy student, is still doing philosophy. © Takaya Miou / Taiyo Tosho

— How long does it take to do a page?

For everything it may take one day or even more for one page. But, once the rough draft is completed in pencil I can do a page per day.

— Are there any of your works that you are unhappy with?

Hmmm [laughs]. It's more like, am I happy with any of them? After finishing them, I tend to loose interest. I can only see the bad parts when I'm drawing. So after it's done I don't want to look at those bad things [laughs]. I put it out of my mind.

— Do you have a favorite work?

I like (az)Pg and Mikaeru (Michael) fairly well. I like bizarre things. Even if the pictures themselves weren't done perfectly, I can live with it if other parts are good.

— What are your favorite manga or comics by other artists – Japanese, European, Asian or American?

I don't really read manga … [She takes out a book].

— Oh, [Guido] Crepax. Do you like Maruo Suehiro-sensei [looking at book on shelf]?

Oh, I like Maruo-san too.

— And Moebius?

I like him too. And what I mentioned earlier …

— But Crepax is a favorite?

Hmmm. Yes. The ones I like the most, that is a tough one. I think what I like is what I read as a child and what I read when I couldn't draw for myself. I like all the Japanese manga artists.

— What advice would you give to any aspiring manga artists?

I'm really not in a position to be giving advice … [laughs].

— Is there anything you would like to say to your fans outside of Japan or inside Japan?

I can't think of anything … I'm not really thinking when I draw. [Laughs.]

LIST OF WORKS

List of works:

- *Sei Shojo Yugi*, Newm;Kz 1991
- *Kaifu Shito Enbu* written by Fuji Minako, Tokuma Novels, 1993
- *(az)Pg*, Newm;Kz, 1996
- *Muyoku Tenshi Rui Sei Shonen Ka (Department of Non-Wing Angels)*, Newm;Kz, 1998
- *Eroticize Intelligence*, Newm;Kz, 1998
- *Kikai Jikake no Ousama (King of Mecanics)* 2 vols., Taiyo Tosho, 2000
- *Muma no Tabibito* written by Shinoda Mayumi, Hakusensha 2001
- *Tengoku Kyo (Crazy Heaven)*, Bijutsu Shuppan-Sha, 2001
- *Seisho-Zu (Map of Sacred Pain)*, Bijutsu Shuppan-Sha, 2001
- *Otosareshi Mono* written by Shinoda Mayumi, Tokuma Dual Bunko, 2001
- *Kunoichi Genroku Cho* series, Tokuma Bunko, 2002
- *Kairaku Busshitsu Endorufin*, Taiyo Tosho, 2002
- *Metafisica (Metaphysics)*, Newm;Kz, 2002
- *Uranomania (Metaphysica 2)* , Newm;Kz, 2003
- *Sharian no Maen* written by Yukirin, Shueisha Cobalt Bunko, 2003

Major works:

- *Kikaijikake no Ousama (King of Mechanics) Planet of Earthquake,* Taiyo Tosho, 2000– , 2 volumes to date
- *Tengoku-Kyo (Crazy Heaven)*, Bijutsu Shuppan-Sha, 2001, Vol. 1 of collected works
- *Seisho-Zu (Map of Sacred Pain)*, Bijutsu Shuppan-Sha, 2001, Vol. 2 of collected works

CHECK OUT

Top Three:

- Kikaijikake no Ousama (Vol. 1 ISBN4-8130-0830-5)
- Tengoku-Kyo (ISBN4-568-50226-8)
- Seisyo-Zu (ISBN4-568-50235-7)

Web site:

- Takaya Miou's official Web site
 www1.linkclub.or.jp/~miou/

Japanese manga artists you might like, if you like Takaya Miou:

- Kasai Ayumi
- Kusomoto Maki
- Shurei Kouyu
- Yazawa Ai
- Yuki Kaori

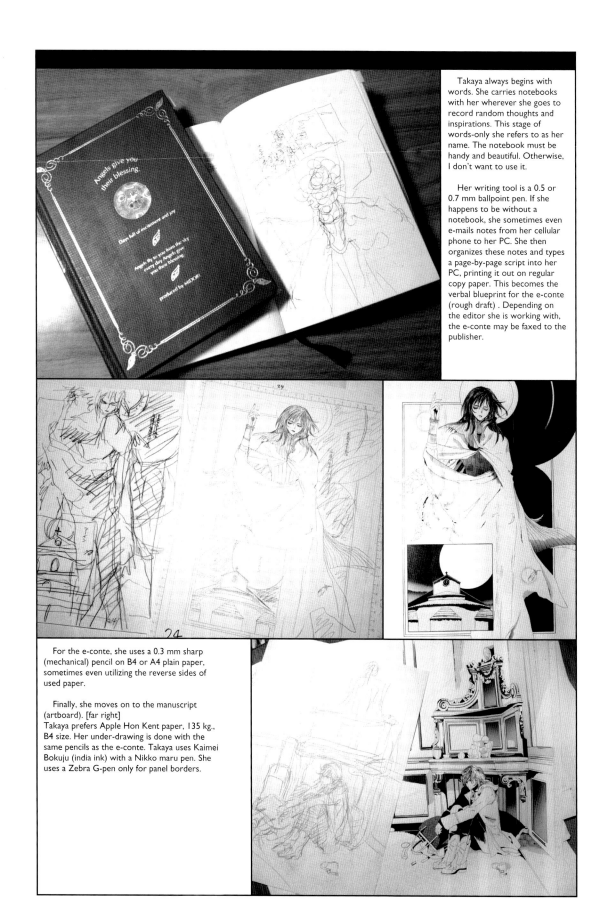

Takaya always begins with words. She carries notebooks with her wherever she goes to record random thoughts and inspirations. This stage of words-only she refers to as her name. The notebook must be handy and beautiful. Otherwise, I don't want to use it.

Her writing tool is a 0.5 or 0.7 mm ballpoint pen. If she happens to be without a notebook, she sometimes even e-mails notes from her cellular phone to her PC. She then organizes these notes and types a page-by-page script into her PC, printing it out on regular copy paper. This becomes the verbal blueprint for the e-conte (rough draft) . Depending on the editor she is working with, the e-conte may be faxed to the publisher.

For the e-conte, she uses a 0.3 mm sharp (mechanical) pencil on B4 or A4 plain paper, sometimes even utilizing the reverse sides of used paper.

Finally, she moves on to the manuscript (artboard). [far right]
Takaya prefers Apple Hon Kent paper, 135 kg., B4 size. Her under-drawing is done with the same pencils as the e-conte. Takaya uses Kaimei Bokuju (india ink) with a Nikko maru pen. She uses a Zebra G-pen only for panel borders.

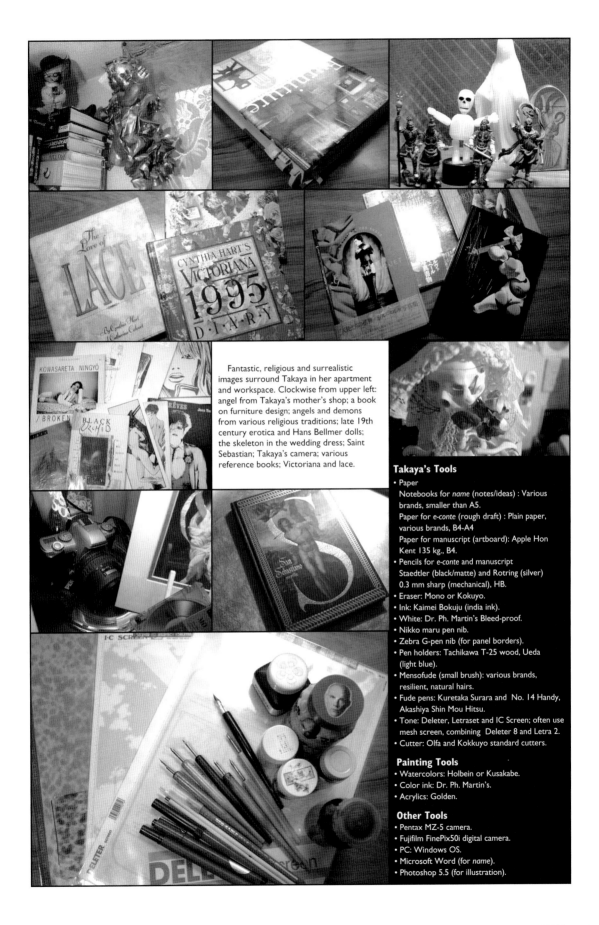

Fantastic, religious and surrealistic images surround Takaya in her apartment and workspace. Clockwise from upper left: angel from Takaya's mother's shop; a book on furniture design; angels and demons from various religious traditions; late 19th century erotica and Hans Bellmer dolls; the skeleton in the wedding dress; Saint Sebastian; Takaya's camera; various reference books; Victoriana and lace.

Takaya's Tools

- Paper
 Notebooks for *name* (notes/ideas) : Various brands, smaller than A5.
 Paper for *e-conte* (rough draft) : Plain paper, various brands, B4-A4.
 Paper for manuscript (artboard): Apple Hon Kent 135 kg., B4.
- Pencils for *e-conte* and manuscript
 Staedtler (black/matte) and Rotring (silver) 0.3 mm sharp (mechanical), HB.
- Eraser: Mono or Kokuyo.
- Ink: Kaimei Bokuju (india ink).
- White: Dr. Ph. Martin's Bleed-proof.
- Nikko maru pen nib.
- Zebra G-pen nib (for panel borders).
- Pen holders: Tachikawa T-25 wood, Ueda (light blue).
- Mensofude (small brush): various brands, resilient, natural hairs.
- Fude pens: Kuretaka Surara and No. 14 Handy, Akashiya Shin Mou Hitsu.
- Tone: Deleter, Letraset and IC Screen; often use mesh screen, combining Deleter 8 and Letra 2.
- Cutter: Olfa and Kokkuyo standard cutters.

Painting Tools

- Watercolors: Holbein or Kusakabe.
- Color ink: Dr. Ph. Martin's.
- Acrylics: Golden.

Other Tools

- Pentax MZ-5 camera.
- Fujifilm FinePix50i digital camera.
- PC: Windows OS.
- Microsoft Word (for *name*).
- Photoshop 5.5 (for illustration).

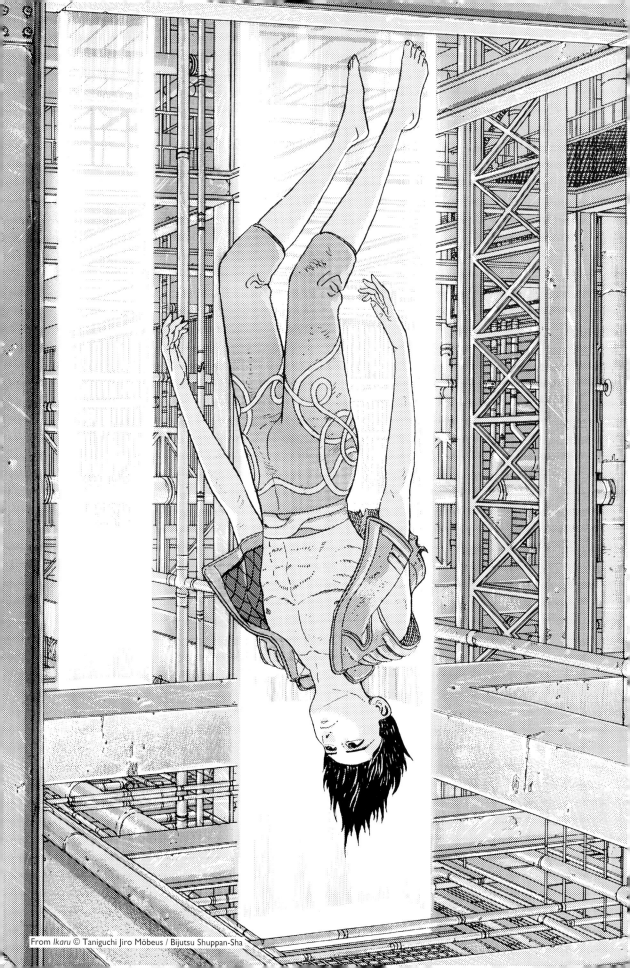

TANIGUCHI JIRO

谷口ジロー

Prolific and diverse, Taniguchi Jiro has written and drawn manga ranging from hard-boiled detective stories to a Buddhist-like meditation on the wonder of everyday life. Greatly influenced by bande dessinee—the artsy, painted picture-book-like comics of France and Belgium—Taniguchi has created a form of manga that combines elements of novels and movies. He has received numerous awards and recognition for his work both in Japan and internationally, particularly in Europe.

PROFILE

Place of birth: Tottori, Japan

Date of birth: August 14, 1947

Home base: Tokyo, Japan

First published work:
Kareta Heya (The Barren Room, Shonen Gaho sha), 1972

Education: High school

Hokkaido

JAPAN
Honshu
TOKYO
Tottori
Shikoku
Kyushu

Career highlights:
1987 Begins *Botchan no Jidai* (Futabasha)
1990 Begins *Aruku Hito* (Kodansha)
1992 Shogakukan Manga Award, Committee Member Special Award (for *Inu wo Kau*)
1998 Tezuka Osamu Culture Award (for *Botchan no Jidai*)
1999 Media Arts Festival Award (for *Harukana Machi-e*)
2000 Begins *Kamigami no Itadaki* (Shueisha)
2001 Media Arts Festival Award (for *Kamigami no Itadaki*)
2003 Participated the 1st International Manga Festival
2003 Alph Art Award at Angouleme (for *Harukana Machi-e*)

Taniguchi Jiro sent an assistant to meet us at the train station and bring us to his studio, located in an aging apartment building in a small urban area just to the west of Tokyo. We walked along a shallow canal, past small shops. We were in the neighborhood of *Aruku Hito* (*The Walking Man*), Taniguchi's manga story done with a vibrant clear line and contemplative calm.

We entered a bachelor pad setting—casual disarray in low-ceilinged rooms where Taniguchi and three assistants labored. From floor to ceiling in each room (including the kitchen) were books—French hardbound comics and

countless reference volumes on architecture, history, weapons, wildlife, and travel, the library of someone with an insatiable curiosity about the world.

Taniguchi is a gentle man with a soft voice and a twinkle in his eye like a favorite uncle, totally unpretentious despite his success. He commutes 30 minutes to work daily, any other professional. It's his time for relaxing, he says. As the interview proceeded, his answers were measured and thoughtful.

Taniguchi makes manga for grown-ups. Not just in the *gekiga* ("dramatic pictures") sense of hard-boiled detective stories that appeal to middle-aged men—although he's created striking examples of this in his more-than-30-year career (*Benkei in New York*'s stunning film-noir sequences

come to mind). Nor in the sense of apocalyptic science fiction rendered in extraordinary detail, such as *Chikyu Hyokai Jiki* (*Ice Age Chronicle of the Earth*). But grown-up in the sense of imaginative, thoughtful, and intensely human stories—in a word, literature. *Botchan no Jidai* (*In the Time of "Botchan"*), a vast narrative that took Taniguchi a decade to finish as it followed the lives of literary figures of the early 1900s Meiji era, is perhaps the best example of what manga, bande dessinée, or comics can aspire to—a true "graphic novel."

And next to Taniguchi's epics are the *Aruku Hito*–type narratives, the Ozu Yasujiro–like stories of common people and everyday life: *Chichi no Koyomi* (*My Father's Time*), *Inu wo Kau* (*Raising a Dog*), *Keyaki no Ki* (*The Elm Tree*), and *Harukana Machi-e* (*The Faraway Town*). This last work won the Alph'Art award for best story at the 2003 Angouleme festival, the "Cannes of comics" held annually in France—the first Japanese work to ever be so honored.

They have loved Taniguchi in Europe for two decades—and the esteem has been mutual. Taniguchi encountered European bande dessinee, with its highly developed illustrative aesthetic, very early in his career and it had a profound impact on him. He readily admits the BD influence, with the quiet confidence of an artist secure in his abilities and having nothing to hide. "If fused with Japanese manga to some extent, a new kind of manga might be created," he says.

What explains Taniguchi's diversity? True, he has had many collaborators, but as I glanced at the books that surrounded us, I was struck again by his thirst for knowledge—and his willingness to take risks by attempting new things. "[Manga]'s a wonderful form of expression," he said with a sincerity that cannot be faked. It's the childlike wonder of a young-at-heart creator who is still excited every day about his chosen profession of visual storyteller.

TANIGUCHI's interview

— How did you become a manga artist? When did you decide you wanted to do this for a living?

I had been reading manga since childhood and mimicking the art. I decided to become a manga artist while working at a job after graduating from high school. Since the job wasn't interesting, I decided manga was the thing for me, and I started looking for a chance to become a manga artist's assistant.

— Did you have formal art training?

I didn't go to a special school, but I learned various things as an assistant to a manga artist whose name was Ishikawa Kyuta-sensei.

— What was the most important thing you learned from Ishikawa-sensei?

I learned not only art techniques,

but the whole process of making manga. And I learned how important communication with the editor is.

Like walking into a Paris bookstore: Taniguchi's studio is filled with the French hardbound comics known as bande dessinee. The numerous figurines of various creatures that share the crowded shelves reflect his early career doing stories with animal protagonists. Taniguchi maintains a deep reverence for the natural world.

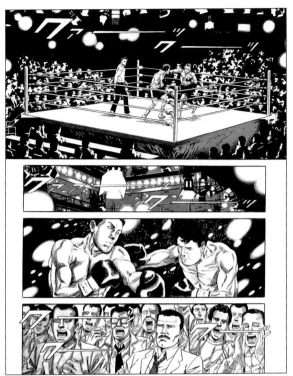

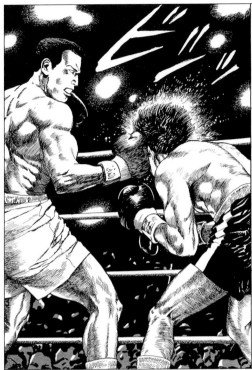

Images from Knuckle Wars, Taniguchi's 1982 collaboration with the writer Carib Marley, with whom he worked in the early '80s. Stories of boxing, gangsters, and detectives are typical *gekiga* (realistic) or *seinen* (men's) manga fare, and Taniguchi quickly mastered the genres.

The dark tones of the art match the noir elements of the narratives. Even at this early stage of his career, Taniguchi's attention to detail is evident.
© Taniguchi Jiro, Carib Marley / Akita Shoten

— What was your first published work and when did it appear?

I'm not sure about which was the first one, but the one listed in my profile is *Kareta Heya* (*The Barren Room*). It was a short story made at either the beginning of 1970 or the end of 1969. It was out of the mainstream of those days, but it ran in the magazine called *Young Comic*, which was popular among young manga artists. That was my debut, but work didn't come constantly after that.

— Was there a low point in your career?

Well, it wasn't really a slump, but there was a time I worked too hard and got sick. Also, there are times when I feel stress—when I'm trying to come up with the next story after a series is over. Also, even if a series has started, I don't usually have the entire story in my mind. I think it out as I draw, so sometimes I run up against a wall. If that happens, I read books, go to a movie, and take in various things so that I can manage to squeeze out a story. [Laughs.]

— What would you call your manga?

They usually call it *gekiga* [realistic, adult-oriented manga].

— Who are your readers?

Men, in their late 20s to 40s or 50s. There are some female readers, but only a small percentage, I think. I draw several different types, so readers may differ depending on the work.

— In creating a story, do you begin with a script, an idea, or an image?

Sometimes an editor gives me a *daihon* (script or scenario) made by a writer, suggesting that I make a manga of it. If it's interesting and I feel like working on it, I make a manga based on it. Other than that, I present what I would like to work on to an editor and, if okayed, I come up with a *name* (loose script in storyboard form) first. For an outline, I just talk with the editor and hardly make any notes. I don't do anything like writing a synopsis first.

Bullet time from Kaikei Shuten (Hotel Harbour View), a hard-boiled detective story written by Sekikawa Natsuo, one of Taniguchi's most frequent scriptwriters. The scene above is evidence of Taniguchi's cinematic influences. Published in Japan in 1985, this work was translated into English in 1990 by Viz, becoming the first foreign translation of Taniguchi's work.
© Taniguchi Jiro, Sekikawa Natsuo / Futabasha

— Do you show the *name* to the editor, or do you communicate with him only verbally?

No, I show the *name*. I talk to the editor about the story and how it develops. We discuss the rough outline and agree on the contents of the story, and decide to try with the first story [of the series]. So I make *names* of the first episode and talk with the editor again. Sometimes changes are made, and, if okayed, I go right into the work.

— If another creator is doing the writing, are scenarios of all stories in a series given to you up front?

If it's a long series, usually about three stories are done, at most. There have been exceptions, though, when everything was given to me at the beginning.

— Do you do the *name* first and fit the final script and dialogue to that? Or do you finalize a script first and make the *name* according to that?

No, the *name* is the only script, including the words of the story and dialogue. So, dialogue, script, and pictures are done together.

— Is this process the same if you have a collaborator, another writer?

Yes, everything is still done together. The only difference is, when there is an original story that I am working from, there is a scenario already. If I make the story myself, there's no scenario—I go right into making the *name*.

— Where do your story ideas come from? Dreams, daydreams, reading, movies, other sources?

All of those, I think. Mostly I get inspiration from novels and movies.

— Do you ever carry a notebook with you to jot down story ideas?

It depends on the work. I do different types of work, and the approach may be different each time. When I drew a story about a dog called Blanca, I just came up with an initial idea—that of a dog from Russia crossing the Bering Strait and coming to Alaska—and I tried to come up with a story about that. Then it gradually expanded; so that the dog turned out to be a monster that was genetically engineered, then I started to build up a story from there. Another example is *Aruku Hito* (*The Walking Man*). That

didn't have a plot as such and was created by walking around and trying to think of a scenario. Other than that, I might define only the beginning, middle, and end of a story and, while doing the work, the story is made through a process of exchanges with the editor. So, depending on the work, the methodology might change.

— Most artists are satisfied working in a single genre, but your work is extremely diverse. Why is this?

When I encounter interesting novels and movies, I immediately think "it would be nice if I could express this kind of story" and I just try it.

— *Aruku Hito* (*The Walking Man*) is almost a meditation on the wonder of everyday life—not a commercial work. Where was it published?

Kodansha has a magazine called *Morning*, and it ran once a month in the extra edition called *Party Extra*. I was talking to the editor about what I should work on and he said, "What

A different kind of action hero: The main character in *Aruku Hito* (*The Walking Man*) is an architect, but his profession is never mentioned in the narrative, which consists of a series of situations. We see only his home life, especially the time he spends alone, strolling through his neighborhood. This manga has been described as poetry, a meditation, and compared to the films of Ozu Yasujiro, Japan's Kurasawa of the everyday person. Taniguchi has said that he wanted to express that, in some part of daily Japanese life, there exists something precious that might be forgotten. This 1990 work was translated into English in 2004 by Fanfare/Ponent Mon. © Taniguchi Jiro / Kodabsha

about a walking person?" I'd never heard such an idea, so I agreed to try. The work was an experiment. The methodology wasn't established with the first episode, but as I worked on the second and third, I found a kind of style. It's often said that the work is poetic, or that it's a manga that reads like a poem. Although not rated highly in Japan, it was well received in Europe, which made me very happy. In Japan, it seems that a work is not accepted as manga unless there's a story to it. *Aruku Hito* just depicted situations.

— Was there a theme or atmosphere to this work that you were trying to communicate?

Yes, I tried to express something with this work. It was the time when the Japanese—maybe the entire globe, but especially the Japanese— had been just running, in terms of economy, but while running about, there may be many things that've been lost or overlooked. Thus, we don't have to be in such a hurry; let's take time to slow down and discover the things around us—that was the sort of message I tried to include.

— This manga is often compared with the films of Ozu Yasujiro. Does that please you?

Yes. My work is not as deep as Ozu's, but I wanted to bring something like the essence of Ozu's films to manga. I discussed this with the editor before I worked on *Aruku Hito*. So I am very pleased to hear it is Ozu-like.

— You said *Aruku Hito* was experimental. Is experimental manga important? And are there magazines for experimental work in Japan today?

Aruku Hito tried to convey something, so although it was experimental in principle, I still tried to make it understandable. As for a magazine, there isn't one that stands out now. There used to be a magazine called *Garo* ; now there is a magazine called *Ax*, from Seirinkogeisha. I think there are others.

— Are there any lessons you learned from doing *Aruku Hito* that you were able to apply to later works?

Well, it did have significant meaning for me. Before that, I drew a story of the Meiji era called *Botchan no Jidai* (*The Time of "Botchan"*) and I think that led to *Aruku Hito*. In *Aruku Hito*, I found I could describe a story of everyday life. Afterward, I worked on science fiction and various other things, but I also started to make stories with daily happenings as a theme, or about a family such as in *Chichi no Koyomi* (*My Father's Time*) and *Harukana Machi-e* (*The Faraway Town*).

— *Botchan no Jidai* has an epic scope. How did you go about researching the visuals for this manga?

For materials, there were many pictures from the Meiji period, but not as many as are available now. So I went to secondhand bookshops to look for them. I went to the place that's the main stage of the story, which is downtown Tokyo, but now everything has been transformed ino modern buildings. So I went to local towns with similar old buildings still there, took photos of those places, and applied them to the scenes of Tokyo of the Meiji Era.

Science fiction images inspired by European comics artists such as Jean Giraud (Moebius) and Francçis Schuiten marked Taniguchi's early career. The scenes above, with elements of Taniguchi's noirish pulp stories, are from *The White Zone*, a kind of detective/sci-fi tale coauthored by Sekikawa Natsuo in 1984. Taniguchi would later shake off such obvious artistic influences and develop a more personal style
© Taniguchi Jiro / Kodabsha

— What reference books are on the Taniguchi Jiro-sensei shelves?

Various types. The official list of my works starts with a hard-boiled detective story, but the first work I actually did was an animal story. I drew many stories with Alaska and similar places as locations. I made a story of the Himalayas, too. Thus, my reference books range from the Meiji era to Alaska and the Himalayas, covering a variety of genres.

— I read that you actually traveled to Nepal when you worked on *Kamigami no Itadaki* (*Mountain Peak of the Gods*). Is that true?

Yes, I did. Only up to Kathmandu, though. I'm not very physically tough. [Laughs.] At first, I was to go higher, to about 5,000 meters. But at that height, you suffer from the lack of oxygen. So I decided to first research the town of Kathmandu and then to go to Mount Everest. That was a sightseeing tour—

we got close to Mount Everest in a plane. Later, I went to a Sherpa's house for an interview and went on to Pokhara. It's a wonderful place, really.

— How did you solve challenges such as realistically portraying the scale of huge mountains?

I'm not sure I was able to solve them. It's like the process of climbing the mountains. I wanted to show the hardship and difficulties of that process, as well as the height and extreme cold. Since I've never actually climbed, I had to do it in my imagination. But I had seen other mountains in winter and documentaries of mountain climbers, so I worked at expanding my imagination. Things that are hard for readers to visualize from text only, I tried to express with drawings.

— Is *Chichi no Koyomi* (*My Father's Time*) at all autobiographical?

Well, sort of. The fire [episode] in the region of Tottori actually occurred. Many things I experienced during my childhood were included, but the overall story is fiction. My experiences in the area are embedded in the details, but the relationships of people or within the family were all made up.

Classics Illustrated, Japanese style: Natsume Soseki is confronted by the main character of his novel *I Am a Cat*, in a scene from the epic series *Botchan no Jidai* (*The Times of "Botchan"*) by Taniguchi and Sekikawa Natsuo. Running intermittently from 1985 to 1996, the series profiled Japanese literary greats of the Meiji period (1864–1912). It has been described as manga literature, with its sweeping scope and wealth of historical detail, both in story and in the meticulous rendering of architecture and costumes. The series has been honored in Japan and translated into French, Spanish, Italian, and—beginning in 2005—English (by Fanfare/Ponent Mon).
© Taniguchi Jiro, Sekikawa Natsuo / Futabasha

In *Benkei in New York*, Taniguchi employed lighting effects brilliantly to heighten suspense in a story about a Japanese assassin-for-hire specializing in revenge. *Benkei* appeared in Japan in 1994 and was translated into English by Viz in 2001.
© Taniguchi Jiro, Mouri Jinpachi / Shogakukan

Intense action and high drama: In *Kaze no Sho (Samurai Legend)*, Taniguchi not only researched the period by traveling to the old Japanese capital of Kyoto, but also referred to the work of a fellow manga artist noted for accurate historical rendering, Hirata Hiroshi.

Kaze appeared in Japan in 1992 and was translated into English in 2003 by Central Park Media.
© Taniguchi Jiro, Koyama Hiroshi / Akita Shoten

— **What was it like collaborating with the French comics artist Moebius? Was *Ikaru* (*Ikaro*) a satisfactory project for you?**

It was started by the magazine *Morning*. They came up with a plan and, without deciding on the manga artist, they asked Moebius to write a scenario. Since *Aruku Hito* happened to be published in French, they had seen it and asked me to join. The editor must have talked to Moebius. There must have been various candidates, but it could be that they were all busy. [Laughs.] I knew Moebius's works quite well, so I said I would like to do it, by all means. I waited for the scenario to be ready, and there are a lot of arrangements and so on, so I first started to work on it five years after I accepted the offer. What was difficult was that the European point of view is not easily understood by the Japanese. So the issue was how to modify it so that it was easy for Japanese readers to understand. And, since it was a scenario, some parts were explained in a long way that needed to be shortened. I remember that it was pretty hard to work on that. The artwork was also difficult. I talked to Moebius about whether it was okay to make changes. It's unfortunate that the work is still at the stage of prologue, the first volume. Since the editorial policy of *Morning* changed, the series was discontinued.

— **Besides Moebius's work, *Ikaru* also reminded me of the work of the Belgian François Schuiten.**

I know both of them very well. I met him and respect him greatly, and even visited his studio. I like Schuiten['s work] very much. I went to Angouleme [site of an annual international comics festival] in France in 1991, and in 1994 or 1995, Schuiten came to Japan, invited by *Morning*. I recall I talked to him a little and gave him a copy of *Botchan no Jidai*. After that, between 1995 and 1997, I visited his studio.

— **Would you say you have been more influenced by European bande dessinee than most Japanese manga artists have been?**

Yes, probably the most-influenced one in Japan.

— **Is this exchange of ideas and art inspirations beneficial to both European and Japanese artists?**

Yes, it's significant. I think I first became interested in European manga about 30 years ago. I was not completely satisfied with Japanese manga or their characters, and when I first saw BD at a foreign bookshop [in Japan], I was surprised to see such artwork. It was perhaps 1975, although I'm not sure about the exact year. So I've been interested in BD for a long time.

— **What are some of the main differences between BD and Japanese manga?**

Since I can't read the stories, I can't talk about the content, but if I were to point out the easily spotted differences, BD might have a picture-book-like structure. Therefore, a sense of speed or time is not felt in European comics. This may be partly due to the limitation on the number of pages, and I'm not saying it's good or bad, since it's a style of European manga. If fused with Japanese manga to some extent, a new kind of manga might be created.

— **Do you have any favorite American comics artists?**

I don't know about recent ones, but I like Mike Mignola's *Hellboy*. I don't recall the names, but I used to have a lot of favorite artists, like [Bill] Sienkiewicz.

A quiet moment is a key event in *Saikai* (Reunion), one of the short stories in the collection *Kayaki no Ki (The Elm Tree)*. A man, separated from his daughter in the wake of a divorce, encounters her decades later at an exhibition of her paintings, while maintaining the secret of his identity. Taniguchi continued his Ozu-like art style begun with *Aruku Hito* in this 1993 manga, working with the writer Utsumi Ryuichiro.
© Taniguchi Jiro, Utsumi Ryuichiro / Shogakukan

And the artists of *X-Men*, although many different artists worked on that. I've heard there are other types of artists than those of superhero stories. *Ghost World*, which recently became a film, interests me very much.

— **They are called alternative comics. A lot of Japanese mainstream comics would be considered alternative in the U.S. Mainstream comics in the U.S. are superhero stories.**

Is the number of readers [of alternative comics] small?

— **Yes, compared to mainstream comics. However, those works are gradually becoming more accepted.**

I hope that happens.

— **I do, as well. By the way, other than your own works, which manga deserves to be translated into English or other foreign languages?**

Works such as those of Tsuge Yoshiharu. I can't think of others offhand. [Laughs.]

— **When you are penciling, I guess you would work in the order of the pages, but do you sometimes skip around when you are inking?**

No. It's difficult to get the right [facial] expressions unless you work in order. There are continuous subtle changes in expressions.

— **How may assistants do you have?**

Currently three. Sometimes four.

— **Who were your artistic influences when you first started?**

At the very beginning, the sensei I worked for was the biggest influence. After him, artists such as Ikeda Ryoichi, Murano Morimi, Saito Takao, and Hirata Hiroshi. When I did a period piece called *Book of the Wind*

[*Samurai Legend*], I drew while referring to Hirata's artwork.

— **Are there major themes in your work?**

I don't have a special philosophy, but when I do an animal story, I try to communicate that nature and human beings can coexist, that people can't live without nature. Many things are being destroyed nowadays in many ways.

— **Your art style changes depending on the work. Is this deliberate?**

Unless it changes, it's not possible to tell the story. When I looked at the scenario of *Botchan no Jidai*, I felt that the black-dominant artwork for hard-boiled works couldn't express the story. My style underwent changes as I explored the way. By the third episode, it finally took shape.

In *Chichi no Koyomi (My Father's Time)*, a man returns to his hometown for his father's funeral, after an absence of 15 years. His childhood memories are hazy, but the wake is an occasion to come to terms with the stormy relationship that he had with his father, and to see his father's life as a whole. This is a poignant tale, dealing with the Ozu-like themes of unvoiced thoughts and the feelings of children for their aging parents. Though fictional, this 1994 story includes details of Taniguchi's early years in Tottori. He has said that he was moved to make this manga by a return trip to his hometown, the encounters he had there with old friends, and the feelings his visit inspired.
© Taniguchi Jiro / Shogakukan

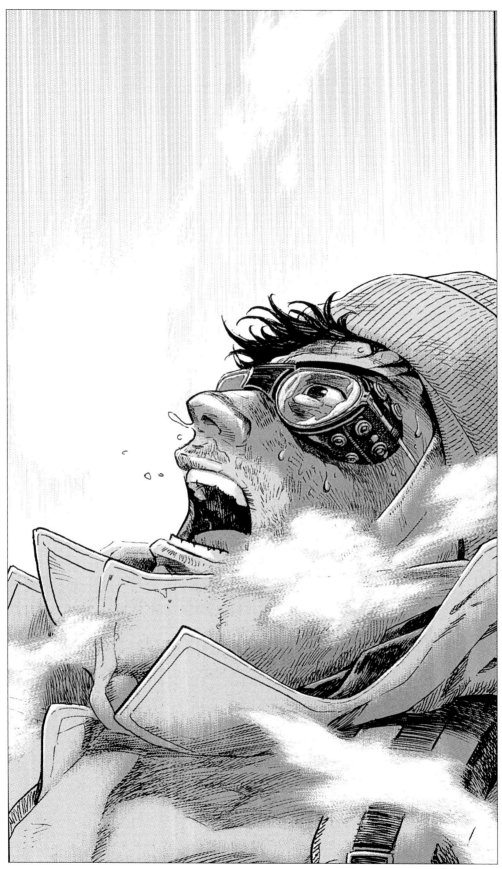

Taniguchi traveled to Nepal to research *Kamigami no Itadaki (Mountain Peak of the Gods)*, which he created with the writer Yumemakura Baku.
© Taniguchi Jiro, Yumemakura Baku / Shueisha

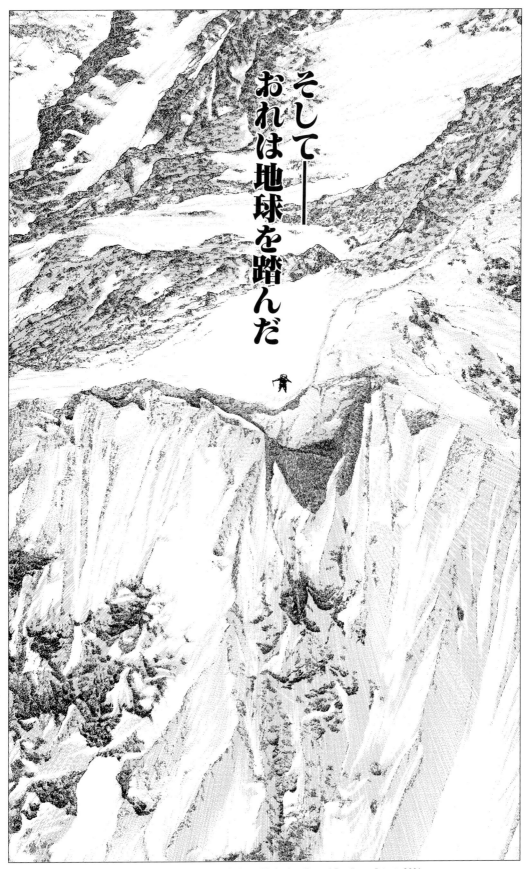

そして――
おれは地球を踏んだ

This five-volume work, published from 2000 to 2003, won the Japan Media Arts Festival Excellence Prize in 2001.

— What is your favorite medium?

I'm interested in brush, but since I can't draw very well by brush, I hope to do that in the future, with a real calligraphy brush and india ink—not with a brush pen. I need to think of a story that fits with the brush touch. I haven't found the right story yet.

— What's a typical day for you? How many days a week do you work?

First, I get up around 10 or 11 a.m. My home is about 30 minutes away by train. I consider commuting a time for relaxing. When I wake up about 11, I arrive here at noon or half past 12 or 1 p.m. [Laughs.] I spend about nine hours here. I work for eight hours and take one hour to eat or walk in between. After work, I go back home, take a light meal, and drink beer. [Laughs.] I watch a video or TV or read a book for several hours until I go to bed. So I go to sleep around 2 or 3 a.m. So I roughly divide a day into three segments: work, sleep, and time for looking at many things. On a monthly basis, it depends on how much work I have, but I take a rest when it's needed. I take about four to five days off per month.

— How long does it take to do a page? How many pages a day do you do?

From sketch to drawing the figures, two to three pages. Very slow. [Laughs.]

— How about in a month?

Forty to fifty a month.

— Are there any of your works that you are unhappy with?

There are several works I was not satisfied with. One was not popular and I was told to stop halfway, for example. And there are works that had a certain timeline fixed at the beginning, such as half a year, where all the stories could not be accommodated in the time allotted. There were several works where I wanted to add one more episode at the end.

— What are your favorite works?

From the work I produced alone, my favorite may be *Blanca*. Also *Aruku Hito*, which was made next, and—although it was not popular—I liked *Chichi no Koyomi*. I felt I had accomplished better work than expected with *Blanca*; I like *Aruku Hito*

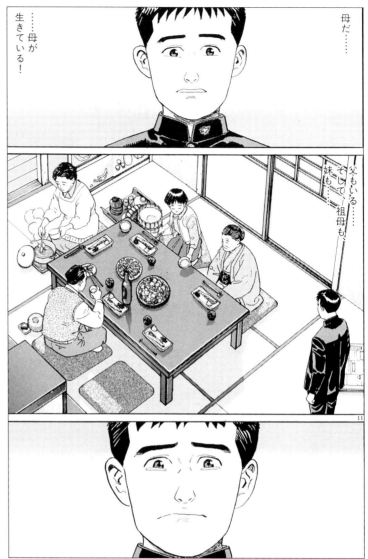

Living his life over again: Harukana Machi-e (The Faraway Town) takes the premise of *Chichi no Koyomi* and adds a fantasy element. The protagonist decides on a whim to take a train back to his hometown. The moment he pays respects at his mother's grave, he is transported back to a summer when he was still in junior high school—but with all his middle-aged knowledge intact. On this journey across time, he begins to understand the difficulties his parents faced. In the scene above, he sees them for the first time as his transformed self. Published in 1998, this manga won the Agency for Cultural Affairs Media Arts Festival Award for Excellence in 1999 in Japan, and won the Alph Art award for best scenario at the Festival International de la Bande Dessinée at Angouleme, France, in 2003.
© Taniguchi Jiro / Shogakukan

because I was able to make it somewhat freely; *Chichi no Koyomi* impressed me in that I was able to express things I had thought impossible. Other than that, I like the hard-boiled *Jikenya Kagyo (Trouble is My Business)*, which was done with Sekikawa Natsuo, and *Botchan no Jidai* is an important work that produced a change of style in my work.

— Is there anything you would like to say to your fans outside of Japan or inside Japan?

I would like them to read manga. If you learn how to read the frames of manga, you can enjoy it, no matter what your age. It's a wonderful form of expression.

LIST OF WORKS

List of works:

- *Jikenya Kagyo* (*Trouble is My Business*), Futabasha, 1979
- *Ao no Senshi* (*Blue Fighter*), Shogakukan, 1982
- *Live! Odyssey*, Futabasha, 1982
- *Knuckle Wars*, Futabasha, 1983, 3 volumes
- *Mori E* (*Into the Forest*), Seirindo, 1984
- *Buranka* (*Blanca*), Shodensha, 1985~1986, 2 volumes
- *Enemigo*, Akita Shoten, 1985
- *Kaikei Shuten* (*Hotel Harbour View*), Futabasha, 1986
- *K*, Leed-sha, 1988
- *Animal Origin Encyclopedia*, Kodansha, 1990
- *Hungry Wolf Story*, 1990 (Japanese original *Genju Jiten*, 1990, Kodansha)
- *Samurai Non Grata*, Shogakukan, 1990, 2 volumes
- *Kaze no Sho* (*Samurai Legend*), Akita Shoten, 1992
- *Chikyu Hyokai Jiki* (*Ice Age Chronicle of the Earth*), Futabasha, 1988–1992, 2 volumes
- *Keyaki no Ki* (*The Elm Tree*), Shogakukan, 1993
- *NY no Benkei* (*Benkei in New York*), Shogakukan, 1994
- *Chichi no Koyomi* (*My Father's Time*), Shogakukan, 1994
- *Kami no Inu* (*God's Dog*), Shogakukan, 1996
- *Kodoku no Gurume* (*The Lonely Gourmet*), Fushosha, 1997
- *Harukana Machi-e* (*The Faraway Town*), Shogakukan, 1998–1999

- *Tokyo Genshiko* (*Tokyo Visual Hallucination*), Kodansha, 1999 (collection of earlier work)
- *Sosakusha* (*Quest for the Missing Girl*), Shogakukan, 2000
- *Ikaru* (*Icaro*), Bijutsu Shuppan-Sha, 2000
- *Ten no Taka* (*Sky Hawk*), Futabasha, 2001

In English:

- *Hotel Harbour View*, Viz, 1990
- *Benkei in New York*, Viz, 2001
- *Samurai Legend*, Central Park Media, 2002
- *Icaro, Part 1*, ibooks, 2003
- *Icaro, Part 2*, ibooks, 2004
- *The Walking Man*, Fanfare/Ponent Mon, 2004
- *The Times of "Botchan,"* 2 volumes to date, Fanfare/Ponent Mon, 2005

Major works:

- *Botchan no Jidai* (*The Times of "Botchan"*), Futabasha, 1987–1997, 5 volumes
- *Aruku Hito* (*The Walking Man*), Shogakukan (reprint), 1992
- *Kamigami no Itadaki* (*Mountain Peak of the Gods*), Shueisha, 2000–2003, 5 volumes

CHECK OUT

Top three:

- *Botchan no Jidai* (Vol. 1 ISBN 4-575-93059-8)
- *The Walking Man* (ISBN 84-9334409-9-5)
- *Kamigami no Itadaki* (Vol. 1 ISBN 4-08-782567-1)

Web site:

- Unofficial information on Taniguchi Jiro can be found at Prisms, the Ultimate Manga Guide
http://users.skynet.be/mangaguide/au1902.html

Japanese manga artists you might like, if you like Taniguchi Jiro:

- Akana Shu
- Fukuyama Yoji
- Hirata Hiroshi
- Hirokani Kenshi

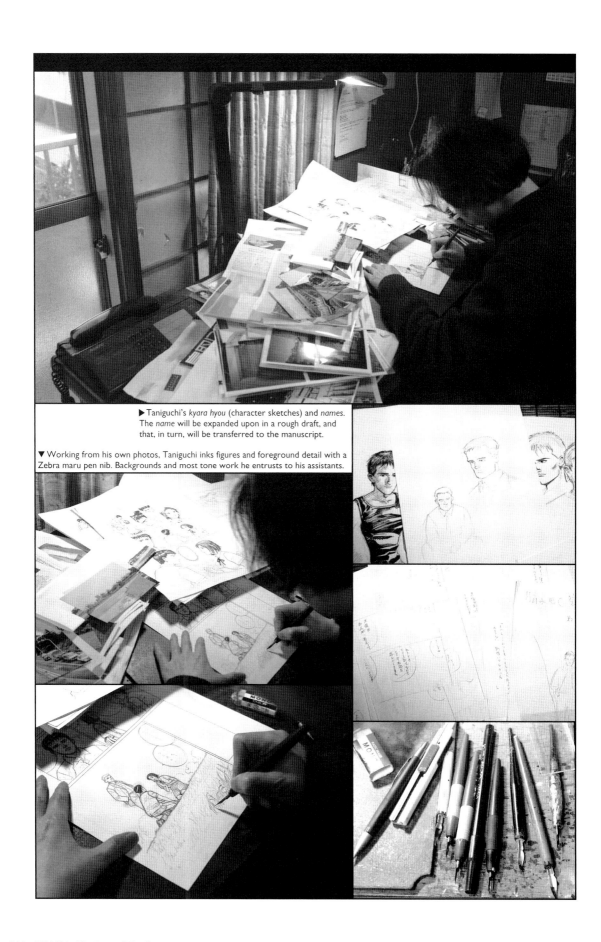

▶ Taniguchi's *kyara hyou* (character sketches) and *names*.
The *name* will be expanded upon in a rough draft, and
that, in turn, will be transferred to the manuscript.

▼ Working from his own photos, Taniguchi inks figures and foreground detail with a
Zebra maru pen nib. Backgrounds and most tone work he entrusts to his assistants.

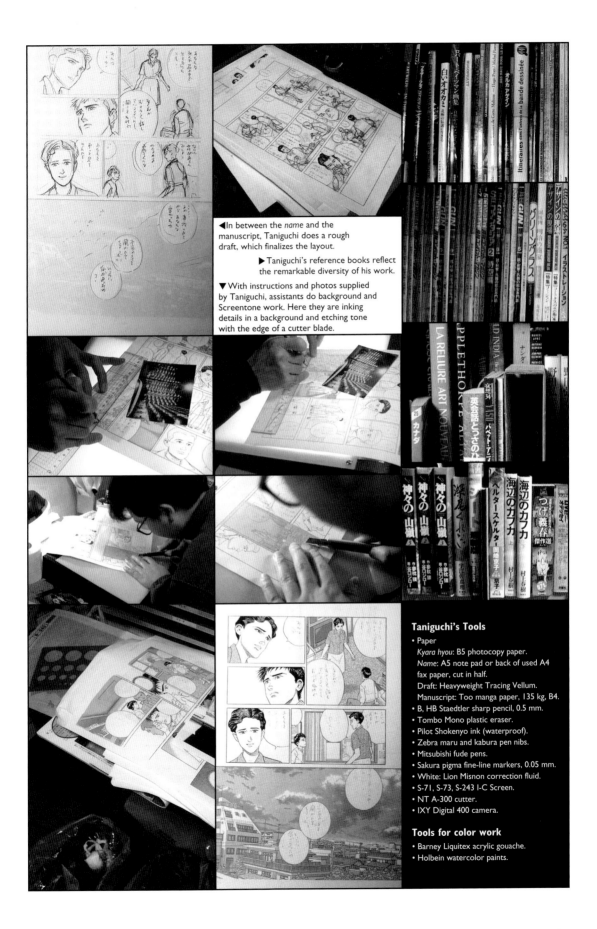

◄ In between the *name* and the manuscript, Taniguchi does a rough draft, which finalizes the layout.

► Taniguchi's reference books reflect the remarkable diversity of his work.

▼ With instructions and photos supplied by Taniguchi, assistants do background and Screentone work. Here they are inking details in a background and etching tone with the edge of a cutter blade.

Taniguchi's Tools

- Paper
 Kyara hyou: B5 photocopy paper.
 Name: A5 note pad or back of used A4 fax paper, cut in half.
 Draft: Heavyweight Tracing Vellum.
 Manuscript: Too manga paper, 135 kg, B4.
- B, HB Staedtler sharp pencil, 0.5 mm.
- Tombo Mono plastic eraser.
- Pilot Shokenyo ink (waterproof).
- Zebra maru and kabura pen nibs.
- Mitsubishi fude pens.
- Sakura pigma fine-line markers, 0.05 mm.
- White: Lion Misnon correction fluid.
- S-71, S-73, S-243 I-C Screen.
- NT A-300 cutter.
- IXY Digital 400 camera.

Tools for color work

- Barney Liquitex acrylic gouache.
- Holbein watercolor paints.

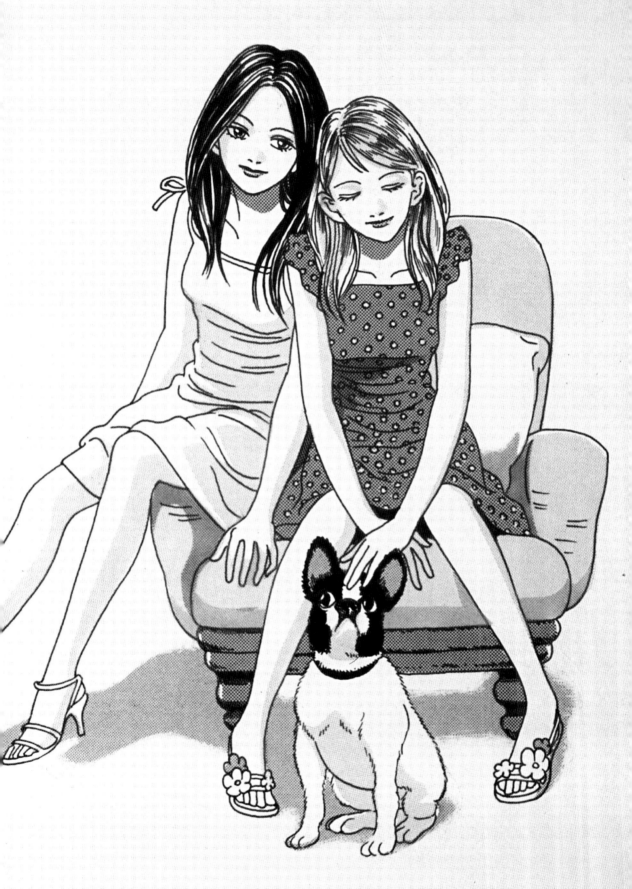

This drawing was created by Tsuno Yuko specifically for this book.
© Tsuno Yuko

TSUNO YUKO

津野裕子

Tsuno Yuko has never moved out of her parents home in Toyama, nor has she ever been a full-time manga artist. She works as a graphic designer. When doing manga, she kept it a secret, so her fellow workers wouldn't know she had stayed up late at night. All the manga stories in her career have been produced in a small room in her parents' home. Exclusively published by *Garo*, Tsuno had a high regard for Nagai Katsuichi, the magazine's founder – the person who, she says, "gave me permission to do manga."

PROFILE

Place of birth: Toyama, Japan

Date of birth: February 5, 1966

Home base: Toyama, Japan

First published work:
Reizoko (Refrigerator) published in Garo (Seirindo), 1986.

Education:
High school, degree in graphic arts

Career highlights:

1986 debuted simultaneoulsy in Bessatsu Margaret (Shueisha) and *Garo* (Seirindo).

1988 Derishasu (Delicious) (Seirindo).

1994 Ame Miya Yuki Kohri (Rain, Princess, Snow, Ice), (Seirindo).

2000 Rinpunyaku (Powdered Fish Scale Medicine), (Seirindo).

What if Emily Dickinson had made manga instead of composing couplets? Tsuno Yuko may be the answer. She met us at the train station in sneakers, carrying a lace-trimmed umbrella, and looking all of 20 years old – though she's in her mid-30s. Tsuno has an air of youthful innocence, but it's deceptive. Much like the clear, stripped-down lines in her manga, which belie rich and complex stories that read like precisely-penned poetry. Yamada Murasaki, a manga artist known for lyrical feminist works, described Tsuno's stories as "sewn together," like the lace Tsuno made for a time after studying design in high school.

Tsuno has never made her living doing manga. She had taken a day off from the graphic design studio where she works to do the interview. Though known only to a handful of fans even in Japan, and having only produced three tankobons (collections) in her entire career, Tsuno has caught the attention of critics as far away as the U.S. Bill Randall, in The Comics Journal, has praised her "stories of loss and wonder." Only one has been translated into English. In 2000, "Secret Comics Japan," an anthology of Japanese underground manga, contained Tsuno's "Swing Shell." With its blurred lines between dream, memory, and reality, it's been called a Freudian fairy tale.

Like Emily Dickinson, Tsuno has never left her hometown. Toyama, on Japan's north coast, is surrounded by sea, mountains, rice paddies, forests and open spaces, all of which appear frequently in her manga, next to worlds that exist only in her imagination.

After a short walk, we arrived at her parents' modest home. Her mother greeted us, then quietly melted away, as we climbed the stairs to Tsuno's room. In that 12-by-12 room – with stuffed animals, a parakeet, and a framed picture of Charles Schulz's "Peanuts" characters – kneeling at a short table next to her bed and working late at night, she has written some of the most remarkable fiction created in any medium. Stories that mix the miraculous and the mundane without skipping a beat, and have the texture of dreams – just beyond understanding, yet feeling profound. Fables of fathers that turn into circus bears, girls that lose colors, rivers of milk, and medicine-merchant uncles who get lost in mirage cities.

She downplays their significance. "My stories aren't the kind that connect the thread. They're more like a dish that, by combining many ingredients, turns out tasting good." The symbols Tsuno weaves together frequently resonate with her readers, whom she says are "sensitive young girls and dangerous old men."

As she drew an illustration for us, she described her story-making process. She can be inspired by a novel, a memory, or an object – like the folk medicine packet with the picture of a bear that she pulled from a drawer to show us. She meditates on the story ... and synchronicity invariably takes over. A schoolgirl on the train will be talking about the same subject, or something happens that fits seamlessly. Once, while pondering a story with a fish, she was startled to see a sunfish-shaped dirigible. "It made me happy," she said, " ... It makes me feel my stories are connected, somehow, to the world."

TSUNO's interview

— What was your education, prior to becoming a manga artist?

It was high school. At that high school, there was a specialized course—a design course—and so I went there.

— And after that?

In the high school, where you could get training in things such as machinery, in order to get employment. After graduating, for about a year and a half, I went to a company that makes lace, like in the decorative flaps of clothing. After that, I still wanted to do something with drawing, so I left that company...it was long ago, so I really don't remember exactly. And I didn't have any work for about year and a half, but then my manga went in [a magazine] pretty fast.

— Were you submitting mangas during this period when you did not have a job?

To a major one and *Garo*, which is no more. I got into both, but it was impossible to work with the major one. I thought it was impossible. I can't draw [this], this can't be, that's what I thought [laughs], so I did some part-time work, like dress-making classes, and kept on drawing. I did that for about a year and a half.

— Is there a reason you didn't go to the major magazine? And what was the name of the magazine?

It was Shueisha's Bessatsu Margaret, and I did have a chance to debut in there. But how should I put this—it

A few of her favorite things: Tsuno surrounds herself with objects which may provide inspirations for manga stories. Note the Charles Schulz characters in the upper right and the mortar and pestle on the bottom shelf.

didn't fit me. Shojo (girls') manga in those days, were like high school boys and girls, kisses at the end...that kind of very typical romance was in demand, and after I drew my debut comic, I already thought, "This can't be." After your debut, you worked for another, I believe.

It was a big publisher, so they had magazines for minor league and AA league. I drew one for the AA league magazine and it did go in [that magazine], but after that, I thought, "There will be no more."

— So what was it like after that?

Since we're in the country, I couldn't live with doing manga in a magazine like *Garo*. It felt awkward, and I felt sorry for my parents. So, from that time, I have kept working [at another job], right up until today.

— Do you still work?

I got a day off today. [Laughs.]

— Can you tell us about the work you do?

This is my New Year's postcard [Editor's note: In Japan, New Year's cards are exchanged, much as Christmas cards are in the U.S.]. I have enough skill to design these things, so at the company where I work, I make fliers and ads for department stores. Besides that, I draw various kinds of illustrations, mostly with a Mac. This one's a failure [referring to her New Year's card]. But the thing I said about Margaret...it was simply because I didn't have the talent. Please don't get me wrong about that. If it had been possible, I did want to continue, but I didn't have the sophistication, so I couldn't help it. I didn't quit on my own, because I had some noble principle or anything.

— What was the reason you wanted to draw manga, or wanted to become a manga-ka (manga artist)?

That's hard question. [Laughs.] All I ever did was draw pictures since I was little. Until then, all I drew were illustrations, but when I got into the design course [at high school], everyone there drew, and among them there were many doing manga. So I did something like a doujinshi with them, and so I thought I would give it a try.

— Did your parents encourage you to become an artist?

I think they didn't want me to do it. [Laughs.]

'My sister died in a refrigerator when she was seven': Thus begins Tsuno's debut manga, Reizoko (Refrigerator), which appeared in *Garo* in 1986. Within a few days of this, another story appeared in Bessatsu Margaret, a typical shojo (girls') manga magazine. Tsuno, who was 20, decided she couldn't produce on a regular schedule for a mainstream magazine, nor could she fit into the sensiblilty of shojo, with its emphasis on idealized love stories. She stayed with the underground *Garo* until its demise in 2002. © Tsuno Yuko / Seirindo

— Do you remember which was the first magazine that your manga appeared in, *Garo* or Margaret?

It was about two or three days difference, and was about at the same. I was 20 years old.

— Did having these two works published encourage you to continue doing manga?

I guess it was because they got in [the magazines]. I kind of thought I could do it, and I could think about doing it.

Tsuno's New Year's card.

— **What would you call your manga, or how would you describe it?**

I really don't know.

— **So you don't think about that when you draw? The magazine _Garo_ itself had a kind of "alternative" character.**

When I was introduced once in a magazine or something like that, they said that I was a gekiga (manga known for narsh realism) artist and I was very surprised.

— **Who do you think are your main readers?**

Well, I think they are very young and sensitive girls...and dangerous old men, maybe. [Laughs.] Something like that. And there are decent people, too.

— **Normal working people?**

Yes. But there are many mysterious people, too, like musicians and people that drop out.

— **Bohemians?**

Yes, yes [laughs], that's it.

— **When you start working on a manga, do you formulate a plot by writing notes? How do you begin, when you first think of a story?**

I go to an open place first, like an area of reclaimed land, or to the sea, or the mountains, and stroll around there, wondering if it can be done somehow. So by going to those places, and by combining things that I like, I kind of set it...it's done somehow. [Laughs.]

— **And how does that become a manga? Do you start by doing a name (script with thumbnails), or do you determine it all with written notes first?**

Well, um, this is the one that was left from the last manga I did, so [you can see] I do it sloppily. [Referring to her name. See page 216.] This is embarrassing ... I really don't want to show it. This is the schedule, when I was doing it all along...this is horrible. [Looking at the notes.] "Tin sign"?! What?! Argh.

— **Are those notes related to your work?**

No, it's nothing like that. I think I wanted to draw a tin sign or something, maybe. Um, how did I draw it...I remember. So, I collect these image fragments, and squish them into

my head, and think about that around dawn. This really makes me sick. [Looking at her name.] [Laughs.] Argh. And then I somehow put that together and there's a time that it goes well. Like, "I can't believe that this fits that!" My manga's no big deal at all - there's only 10 pages. Mine isn't the type that has a connecting thread; it's more of a type that, by setting out many symbols, they somehow work together—like, "by combining many ingredients, it turned out tasting good." And if it goes well that way, then that's fine, it's that kind of manga. I'm connecting it all that way somehow. And after this

process of thinking out the story, I start typing the dialogue.

— **So, the images come first.**

That's the only way I have. [Laughs.] My manga only has that.

— **You said that you go to an open space and you put together things that you like. Are those things ever movies or novels?**

It happens to be novels many times. Novels and things that are in my mind . . . things that have been in my mind for a long time, and things I have liked since I was little, I guess.

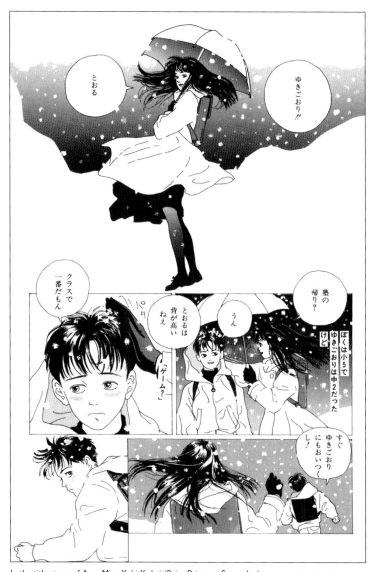

In the title story of Ame Miya Yuki Kohri (Rain, Princess, Snow, Ice), a young man must come to terms with the death of his girlfriend. He enters a storm sewer looking for her remains and encounters her ghost. Womb-like spaces and experiences of loss and transformation are recurring themes in Tsuno's stories.
© Tsuno Yuko / Seirindo

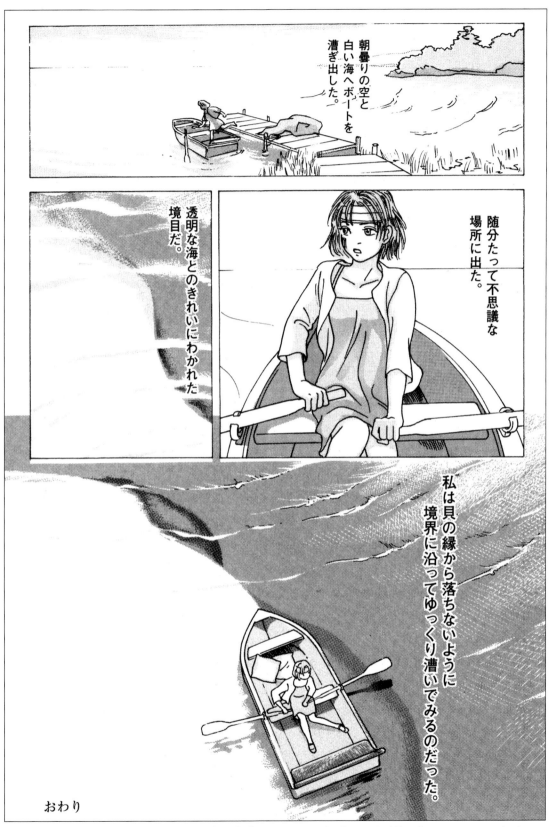

朝靄りの空と
白い海へボートを
漕ぎ出した。

随分たって不思議な
場所に出た。

透明な海との
きれいにわかれた
境目だ。

私は貝の縁から落ちないように
境界に沿ってゆっくり漕いでみるのだった。

おわり

Tsuno's only work that has been translated into English, Swing Shell appeared in the 2000 collection, Secret Comics Japan (Viz, LCC). The dreamlike story has been described as a Freudian fairy tale. A girl, whose mother was once a circus performer, feels threatened by her father, a novelist. Her memories and dreams, and his novel become intertwined in the narrative. When she attempts to escape in a boat and reaches a place where rain-clouded water meets the open sea, she ends up rowing along "the edge of the shell."

© Tsuno Yuko / Seirindo

— **Are you ever inspired by dreams?**

I don't really get it from dreams much. But that doesn't mean that I don't get any inspiration at all. That can happen.

— **Can you tell us more about the things that you like?**

The things that I like. Let me see, what do I like...living things. Hmm.

— **You have a bird.**

I started keeping it last year. It perches on my hand. [She pauses.] Medicine. About a year ago I did a manga on medicine. You know, they're cute. That's why I thought I'd draw them. And since it's Toyama, [laughs] it's easy to get reference. *Tsuno brings out a packet of folk medicine with a drawing of a bear on the cover. Editor's note: Toyama has been a traditional center of Japanese folk medicine for over 300 years.*

When I write the dialogue at the end, it's kind of a bother to check kanji [Chinese characters] afterwards, so I mostly break the story into panels while I'm thinking in my head. And so I input the lines of the dialogue on a notebook PC, taking a long time. So this is the dialogue, and this is how I clearly break the panels by seeing this. *Referring to a computer printout of dialogue and a name. See page 216.* It's not that clear, actually.

— **When you start drawing the manga, using the name as a guide, do you do a preliminary drawing on another piece of paper and trace this onto the manuscript page? In other words, do you use the light box, as you did with the illustration today, or do you go directly to the manuscript page?**

No, not like this illustration. I do the under-drawing directly on the manuscript and ink on top of that.

— **What is the size of the manuscript?**

I buy a regular (commercially-produced) B4 manuscript. I do the under-drawing on that paper and ink it directly.

— **Can we see how you finish a manuscript—things like tone work and spotting blacks?**

I'll show you. This drawing is being done the same way as an actual manga manuscript [See page 216.]

The title story of Rinpunyaku (Powdered Fish Scale Medicine) has the surreal fluidity of a dream. After several strange events involving a lost color and a young man in a rabbit costume, a girl takes a bath. The water reminds her of visiting her sick grandfather as a child. She remembers distinctly the smell of the medicine in his room. Tsuno's stories always have details - smells, sounds and colors—that give them a believability, no matter how fantastic the happenings.
© Tsuno Yuko / Seirindo

— **Your work appeared in *Garo*. What are your thoughts regarding the magazine *Garo*?**

Garo was a very good magazine in the begnning. There was Nagai (Katsuichi) shacho-san who made *Garo* and who said to me "We can't pay for the pages, but please draw." [Laughs.] He was a very kind person in many ways. He had a wonderful stance on manga and his own magazine, but he was a very old man and has passed away. And after that...maybe this is something that I shouldn't say. The editors changed, but they still asked me to work, and—since it was a magazine created by Nagai-shacho-san—I thought I would try to help as much as possible, so I kept drawing. But it was painful at the end. It's a sad story, actually.

Editor's note: Tsuno uses a double honorific when speaking of Nagai Katsuichi, the founder of Garo. She adds "shacho" (president) to his name, before the customary "-san" (Mr.) to indicate a higher-than-usual level of respect.

— **Since *Garo* is not being published any longer, are there any**

Images from *Mi wo Yokotaete (Laying Down the Body)*: A pair of female characters is a favorite motif in Tsuno's stories. Often one is older and more sexually-aware, the other an innocent who gains knowledge in the course of the narrative. *Mi wo Yokotaete* also contains allusions to death and loss – the title referring to Freud's Thanatos, as well as Eros. In a 2000 interview in *Garo*, Tsuno stated that she had become less ashamed of sex as a theme in the course of her career. *Mi wo Yokotaete* appeared in Tsuno's third tankobon, *Rinpunyaku*.
© Tsuno Yuko / Seirindo

other magazines that you're interested in, or would like to draw for?

No, there aren't any. It's not something that I should choose. I don't think there's any need [for my kind of work].

— **Who were your artistic influences when you first started—from manga or other arts?**

Well, I think it's Charles Schulz-san's Snoopy [Peanuts]. That's number one. Also, Hagio Moto sensei. Takano Fumiko. And Otomo Katsuhiro that I read when I was in high school.

— **Were there specific influences for your art style?**

Art style ... I don't know. But way back, I used to do a cute imitation of Hagio Moto-sensei's art. And in high school, I used to imitate Otomo-san's art and had a lot of fun. [Laughs.]

— **Have your influences or inspirations changed?**

Now...can it be authors that I just like?

— **That's fine.**

Well, I can't come up with the name, this can't be. [Laughs.] It's [Wilhelm] Jensen. There's only one novel [translated] in Japan, but I guess this came out because Freud introduced it. But I really love it, especially the story about dreams. And I read Mandiargues recently. [Laughs.] Other than that, I like Greek stories recently, so books by Shiono Nanami sensei [Japanese female author, who has written many books on ancient Rome]. And I like Abe Kobo [Japanese male author, known for fantastic novels of existential crisis].

— **Do you subscribe to a philosophy?**

Oh, those complicated things. It is indeed complicated. [Pause.] I don't know.

— **Are there any themes in your work? Anything you can put into words?**

Let's see, that's a hard one. [Laughs.] Maybe synchronicity. It happens often when I draw, something like a synchronicity. When I think of drawing something, then that something appears in a book that I read, or I see that very thing somewhere.

— **Do you mean, after you have finished the work?**

No, these things come to me a lot while I am drawing. Then I think that I can draw it. It's kind of weird. [Laughs.] It's a strange thing.

— **Do you mean that things you need for the drawing, and things that you want to draw, come to you, unplanned?**

Yes. For example, when I was on the train, high school girls start talking about [the thing that I'm drawing], or when I was thinking of a scary story, then something a bit scary happens.

— **A ghost phenomena?**

Not exactly. For instance, I was working on a scary story and drawing a skull. Then I heard the sound of a harmonica. And I thought, "What was that?" Then I thought, maybe it's the sound of breath through a toothless skull. [Laughs.] When things like that happen, I feel that many things in the world are connected somehow, and it makes me want to keep drawing— there's a kind of amusement.

'One of the most remarkable comics I've ever read': A comment on Tsuno's Turbidity by critic Bill Randall of The Comics Journal. Randall notes that Turbidity mixes dreamlike and realistic elements so thoroughly that the protagonist, along with the reader, becomes totally disoriented. In a climactic scene, she runs to the "white road," but it turns out to be a stream of milk.
© Tsuno Yuko / Seirindo

I do go take pictures. Besides that, I look at magazines. But it's awful. When I go out early in the morning and take pictures, people think I'm a strange person. Once I was getting caught on a metal wire while taking pictures, there was someone watching me and...aargh! And there was a time when a wild dog was there at the place I took pictures and I was scared.

— What is your favorite medium?

Pencils, these thick ones, that's the best way to have fun drawing. This is an 8B.

— When drawing manga, are there any dos and don'ts you stick by?

It used to be that I promised not to drink liquor until I was done. Something like that? But I drink now. [Laughs.] What should I say, was there something? Let me see. I don't sleep, I guess.

— How about in your process?

Like, use a new eraser - is that what you mean?

— Have there been any changes in the way you tell a story?

I guess it's really an unskillful thing, so I try to draw things that readers can somehow relate to in some way. I wonder what...it's difficult.

— When you first started drawing manga and now, for example, is there a change in the storytelling?

Well, back then it was more like just what came up from my mind, or just one idea...well, it hasn't changed much now. [Laughs.] I don't change much.

— When Garo was published monthly, how long did it take to do a manga? You said that you didn't sleep and that you would think about story ideas in the early morning. Did you stay up all night often?

It was all for nothing if I couldn't come up with an idea. It was awful.

— Did you ever go to work without sleeping?

When I was doing manga, I would say, "I'm going to sleep for at least three hours, damn it." I used to hear the sparrows chirping. It took four to five days to put on screentones, but when I had a day off in-between [weekends], I did it in three days somehow. When I include the time

— Has your storytelling or art technique evolved or changed over the years?

There's no evolution. It's getting worse. I think I drew more sensitively in the past. Maybe it was because I had more time. When there's not enough time, I can't avoid [the manuscript] being white.

— Do you mean you're busier at your job and there's not enough time for manga?

No. When Nagai-san was alive, I never was asked to draw. [He let me] draw whenever I felt like it. So I drew when I wanted to draw and took as much time as I needed, so I was able to draw as many details as I wanted. After Shacho-san passed away, I was happy they ask me to draw...but they made deadlines. When it [Garo] became a monthly, I had to think of a story worth eight to 10 pages every month. I had to gather references and draw everything by myself. The background and the buildings and the references! So for those reasons, it became impossible.

— How do you use references? Do you take photos yourself and trace them sometimes?

thinking of the story, it took about half a month, I guess. The time that I wasn't drawing was about a week, so I kept at it for about three weeks. Why, in the world, for a manga like this! It was like that.

— How long did it take to finish a page, on average?

Including coloring and putting on the screentones? There are pages that take a lot of time and there are pages that don't take much...I mean a delightful page that doesn't take much time. That's hard. It takes two to three hours to put a tone on one page, so about five hours, maybe. I don't know.

— Are there any of your works that you are unhappy with, for any reason?

Of course there are. There are ones in which the art is awful, and there were ones that, if I had more time, I could have connected things more, and work that I did when there was enough time but still [were unsuccessful].

— What is your favorite work and why?

There was a time when everything went well and I was really thankful, but my manga didn't connect successfully. But the manga, *Damu Suwan (Dam Swan)*, was fun, just for myself. But that was after the company [Seirindo] had gone bad, so it's not in a tankobon (book). I have forgotten the titles of the others. I remember *Mi wo Yokotaete (Laying Down the Body)* was well-received. It's not for a good reason, but it was a work that connected well.

— What are your favorite manga or comics by other artists?

The ones that I mentioned earlier are the ones. There are lots of others, I guess, but when I'm asked, I can't come up [with the titles]—weird. But recently, I like these old ones. [She brings out old reprints of old magazines and manga.] This person is from around World War II. I like old people. These are kind of cute, kind of an unbelievable world. I got this at an auction. It's really frustrating that it's so hard to get. And I got ripped-off. I bought it in a set. It's a girl's dream in 1940s and 1950s after the war. [Laughs.] This is 1953, a very "maidenly" world, or should I say, nostalgic. It's full of dreams. There are a lot of handmade things, and it's a lot of fun. You don't see these kind of

things now. I get something from the photos, and it starts to become delightful. It's fun to see old photos.

— You get inspirations from them?

They're just dreams, just romantic things. It's beyond reality and all there are are fun things. The illustrations are cute and it's full of illustrations you won't see nowadays. There's many like Junior Soleil and Himawari (Sunflower).

— What advice would you give to aspiring manga artists?

There's no such thing. [Laughs.] There really is none, there's nothing I can say. Just keep on doing it. Sticking to something becomes powerful.

— Is there anything you would like to say to your fans?

Please keep going with your eyes half open. We tend to be good at those things we like...no, that's not it. It's really tough to continue something, isn't it? Hmm, what should I say? I'm not the type that can say something to others...

Mixing the mundane and the miraculous: A childhood toy becomes an link between past and present, and two generations. Damu Suwan (Dam Swan), Tsuno claims, was done for her own amusement. The personal nature of her work is one of its great strengths. This story appeared in the December 2001 issue of *Garo*. © Tsuno Yuko / Seirindo

Images from Umigumo (Sea Spider), one of Tsuno's last manga before her current hiatus. It appeared in the October 2002 issue of *Garo*.
© Tsuno Yuko / Seirindo

Umigumo is awash in Freudian symbols. The girl comes to see her grandfather as a sea spider, weaving a web of control, and herself as a one-eyed monster.

— Is there a story behind one of your works?

There were a lot, but...umm. I wrote a story once where a big red sea bream [sunfish] appears, and I went to the sea then. And there I saw an airship in the shape of a big fish. I was happy to see that. [Laughs.]

— What movies or music do you like?

For movies, Suzuki Seijun [director of Japanese gangster films] right now. And [Luis] Bunuel [surrealist film-maker] and Blade Runner [director] Ridley Scott. For music, Burt Bacharach. I don't really like music that much. I used to like Chemical Brothers and Denki Groove, but not anymore.

— I wondered if you knew you had gotten critical acclaim in the U.S.?

That can't be! Impossible.

— It's true.

No, no, no. I'm not going to be fooled.

— Really. A writer in a noted U.S. magazine of comics criticism expressed great admiration for your stories of "loss and wonder."

Editor's note: This is a reference to a review of Tsuno's work in The Comics Journal, No. 250.

Oh, I see. I guess I like sad things. [Laughs.] Yes, come to think of it, that may be true.

Images from Yutan: Tsuno draws on the tradition of folk medicine in Toyama *[see photo on page 204]*. The girl Yutan likes the fact that her uncle gives out balloons along with the medicine he distributes. When he leaves mysteriously after the sighting of a mirage city in the harbor, someone says that perhaps he's gone there to sell his wares. Soon after, packets of medicine appear, washed up on the shoreline. This story appeared in the July 2002 issue of *Garo*.
© Tsuno Yuko / Seirindo

'It's full of dreams': Tsuno enjoys reprints of manga and magazines from the '40s and '50s. She feels nostalgia for the simpler, more romantic time depicted in them.

List of works:
- *Derishasu* (*Delicious*), Seirindo, 1988
- *Ame Miya Yuki Kohri* (*Rain, Princess, Snow, Ice*), Seirindo, 1994
- *Runpunyaku* (*Powdered Fish Scale Medicine*), Seirindo, 2000

In English:
- *Secret Comics Japan*, (includes the story, Swing Shell), Viz, 2000 (Viz LLC: www.viz.com/)
- *The Comics Journal*, No. 250, (review of Tsuno's work) *Fantagraphics*, 2003 (www.fantagraphics.com/)

Major works:
- *Derishasu* (*Delicious*), Seirindo, 1988
- *Ame Miya Yuki Kohri* (*Rain, Princess, Snow, Ice*), Seirindo, 1994
- *Runpunyaku* (*Powdered Fish Scale Medicine*), Seirindo, 2000

Top Three:
- Derishasu (ISBN4-7926-0180-0)
- Ame Miya Yuki Kohri (ISBN4-7926-0246-7)
- Runpunyaku (ISBN4-7926-0330-7)

Japanese manga artists you might like, if you like Tsuno Yuko:
- Fujiwara Kaoru
- Hatoyama Ikuko
- Nananan Kiriko
- Oshima Yumiko
- Yamada Murasaki

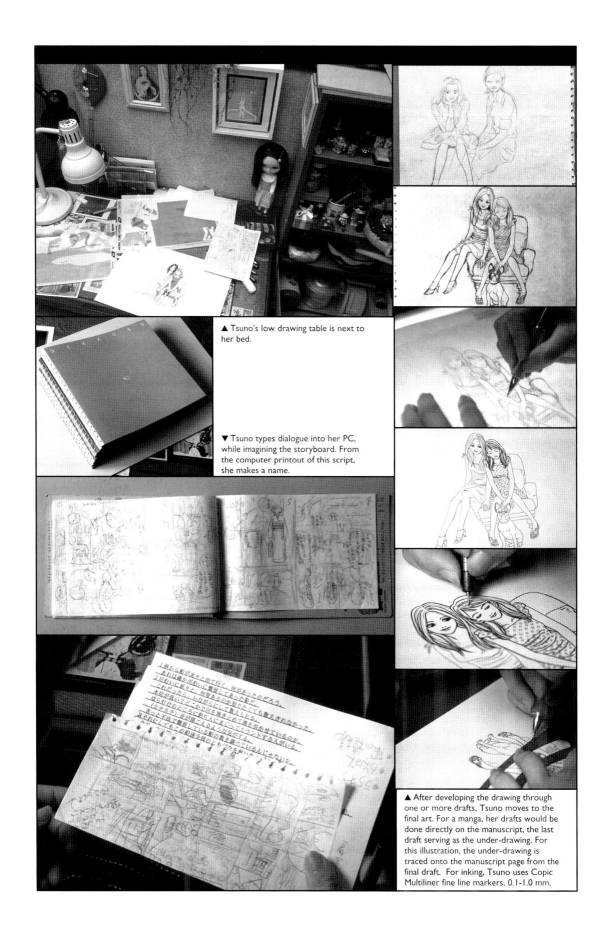

▲ Tsuno's low drawing table is next to her bed.

▼ Tsuno types dialogue into her PC, while imagining the storyboard. From the computer printout of this script, she makes a name.

▲ After developing the drawing through one or more drafts, Tsuno moves to the final art. For a manga, her drafts would be done directly on the manuscript, the last draft serving as the under-drawing. For this illustration, the under-drawing is traced onto the manuscript page from the final draft. For inking, Tsuno uses Copic Multiliner fine line markers, 0.1-1.0 mm.

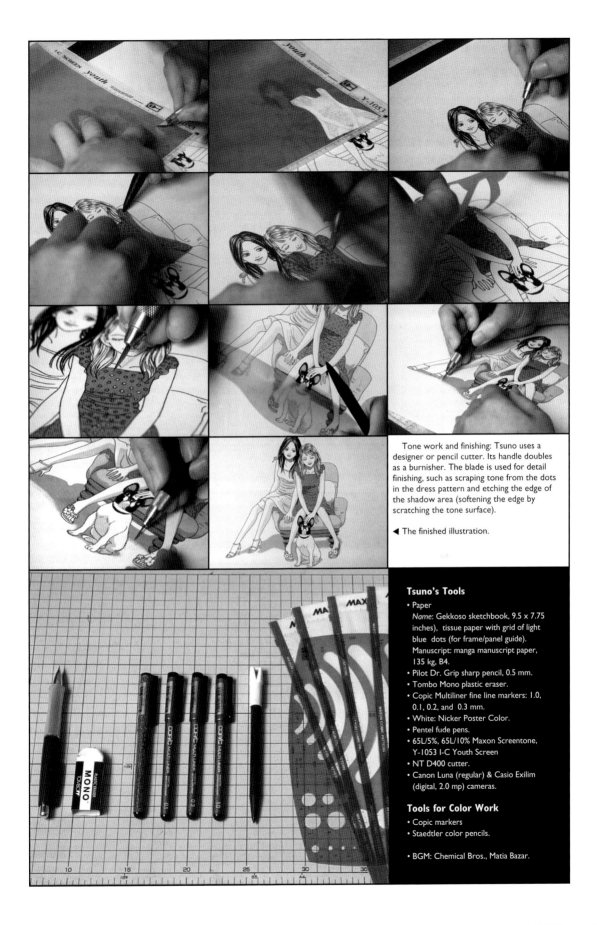

Tone work and finishing: Tsuno uses a designer or pencil cutter. Its handle doubles as a burnisher. The blade is used for detail finishing, such as scraping tone from the dots in the dress pattern and etching the edge of the shadow area (softening the edge by scratching the tone surface).

◀ The finished illustration.

Tsuno's Tools

- Paper
 Name: Gekkoso sketchbook, 9.5 x 7.75 inches), tissue paper with grid of light blue dots (for frame/panel guide). Manuscript: manga manuscript paper, 135 kg, B4.
- Pilot Dr. Grip sharp pencil, 0.5 mm.
- Tombo Mono plastic eraser.
- Copic Multiliner fine line markers: 1.0, 0.1, 0.2, and 0.3 mm.
- White: Nicker Poster Color.
- Pentel fude pens.
- 65L/5%, 65L/10% Maxon Screentone, Y-1053 I-C Youth Screen
- NT D400 cutter.
- Canon Luna (regular) & Casio Exilim (digital, 2.0 mp) cameras.

Tools for Color Work

- Copic markers
- Staedtler color pencils.

- BGM: Chemical Bros., Matia Bazar.

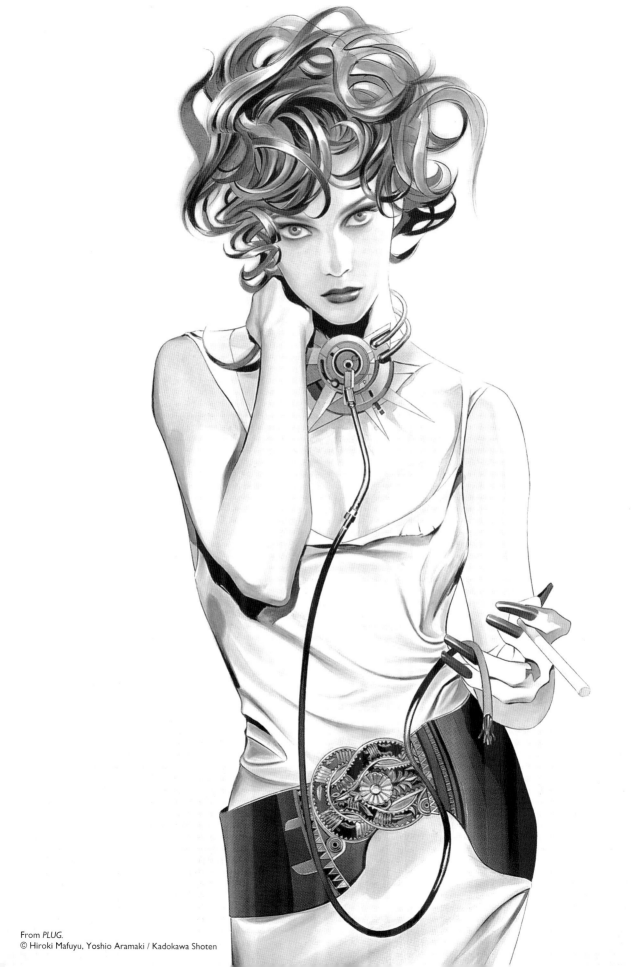

HIROKI MAFUYU

ひろき真冬

Trusting the process: Hiroki Mafuyu coaxes images and a story out of a dialogue with the page. Using techniques honed through his years as an illustrator, he creates images in a hyper-realistic style that serves stories woven together in a loose, stream-of-consciousness method.

PROFILE

Place of birth: Tokyo, Japan

Date of birth: February 15, 1955

Home base: Tokyo, Japan

First published work:
Kaidan published in *Young Comic* (Shonen Gaho-sha), 1973

Education:
High school

JAPAN
Hokkaido
Honshu
TOKYO
Shikoku
Kyushu

Career highlights:

1974	First prize, new artist in *Garo* (Seirindo)
1987	Began career as illustrator
1990 and 1992	Reader's Choice award in *SF Magazine* (Hayakawa Shobo)
1995	*Louise* (Shincho-sha)
1998	First exhibition of illustration in Tokyo
2000	*Etiquette of Violence* (Asahi Sonorama)
2001	Personal Exhibition in Tokyo, Nagoya, and Osaka

Hiroki Mafuyu set up a ministudio for us in a conference room at the offices of Bijutsu Shuppan-Sha—a studio that he pulled miraculously out of his little black backpack. And in that impromptu setting, he gave us insight into not only his art techniques for doing manga . . . but also his creative vision.

As he worked, he talked about ritual, showing us his pencils sharpened like a Zen archer's darts. He selects those weapons carefully, in a passionate struggle against mediocrity. While we watched, he skipped from page to page, inking small textured areas with a pen here, a brush there. His choice of tools seemed as much based on emotion as on technical considerations. "If I want to draw from my feelings I use a G-pen," he said.

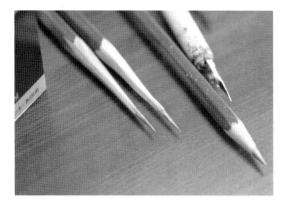

I was awed by the level of care in each detail. Instead of using ready-made gradational Screen-Tone for transitions from light to dark, he laboriously created his own. He overlapped small pieces of tone, cutting out tiny shapes and expertly scraping away miniscule dots with his cutter.

He had begun this process in his home studio, with a scribble. He has no script—not even an idea—when he begins to draw, using a soft lead pencil on textured paper.

Like a child doodling with a crayon on construction paper, he strives to bring up elements from his unconscious. It's not so much drawing as it is archaeology . . . uncovering clues, hints of a primal image. He endeavors to discover a story by starting a dialogue with the page.

He was continuing that conversation in front of our eyes, flitting from area to area, page to page. And all the while we listened to David Bowie's *Heathen*. Music is Hiroki's constant companion and muse, and it is essential to his art. The music he likes best comes from a give-and-take, not slick overproduction. Music that's a product of struggle, like his manga . . . and his career.

Thirty years ago, he was a teenager breaking into the manga business, inspired by a wave of experimentation, and anxious to contribute to a new age of storytelling. But he fought with deadlines for commercial manga magazines, trying to produce work that he was happy with. He finally switched to illustration, finding a niche in science fiction, and perfecting a cybererotic surrealism. But he never forgot manga, nor surrendered his vision of what it could be.

His manga are rare these days, but when he does them, he brings to bear all the skills honed through his years of illustration. Though at first glance realistic in style, those manga are an exquisite balance of realism and abstraction. Rough brushstrokes complement areas of tight rendering. All is in balance: black and white, brush and pen, dense and open . . . digital and analog.

Two years ago he started working in Photoshop. He mastered it quickly, but still loves what he calls "analog"—hand-drawing. The computer is just one tool, one weapon, in his good fight.

Hiroki Mafuyu is pure in his passion for manga, and he was gracious and generous in giving us time to observe and interview him.

HIROKI's interview

— Do you make your living as a manga artist or as an illustrator?

Illustration is my main work. I also teach illustration once a week at a vocational school. And the rest of my income is royalties from my illustrations. Work doing manga is very irregular.

— But you started your career in the early 1970s exclusively as a manga artist, is that right?

Yes.

— When did you first start thinking of becoming a manga artist?

A childhood friend says I was talking about that in first grade! So

from a very early age I wanted to be working in art, but I never thought that I could.

— What was your education?

I graduated from a regular high school.

— So all your art training is self-taught?

I had a teacher of manga that I met when I was in high school. What I learned at his studio was the biggest influence on me. I was something like his assistant, but since I was still a student, I just went there after school and hung out and kind of played around. His name was Miyaya Kazuhiko-sensei, and to me he was just

Sound support for an image: The selection of background music while drawing is very important to Hiroki. The right theme song keeps the creative process flowing as he works on a manga story.

like a pop star of the '70s. He was my sensei, my master.

— How did you meet him?

When I was a high school student, there was an exhibition of Miyaya-sensei's original artwork in Shinjuku. When I went to see it, I discovered he was there and I was able to see him in person. I had some of my drawings in my hand, and when Miyaya-sensei saw them, he was very impressed. "How old are you?" "15." "You're only 15 and you can draw like this?" So that was the first time I gained confidence in myself.

— What was the most important thing Miyaya-sensei taught you?

An attitude as an artist. Of course, I absorbed many techniques there, but the greatest thing was an attitude as an artist.

— What was your first published manga work and when did it appear?

It was the year I graduated from high school, so I was 18 and it was spring. I finished my first 22-page manga and took it to an editor and it got into a magazine, so that was my debut. There is still a magazine called *Young Comic,* but it was a totally different thing then. *Young Comic* in the old days was a magazine associated with subculture. It wasn't as dark as *Garo.* In *Young Comic,* there were many experimental manga artists like my teacher Miyaya-sensei and a lot of other young innovative manga artists. That's why I took my manga there first.

— You also had a manga in *Garo*— the following year, I believe.

Yes, my second manga was for *Garo.*

— That was a horror story, very intense and very different from your current work. Was that typical of the kind of stories you were doing at the time?

Dark fantasy. That was because I was a kid. Yes, the manga that went in *Young Comic* was also a dark fantasy. Since I was young, I drew two of that kind, and used it all up. What I mean is that, since I didn't know much about the real world, all I could do was dark fantasy. And I thought I would keep on drawing those kinds of stories, but I ran out of it instantly. After those two, I couldn't draw any more manga for four years. [Laughs.]

Dark fantasy: A 19-year-old Hiroki spins a nightmare from his imagination. This story, Hiroki's second manga, was titled *Genso-ki (Dream Demon),* and appeared in the April 1974 issue of *Garo,* the legendary avant-garde manga magazine, which was often a starting place for young artists in the '70s.
© Hiroki Mafuyu / Seirindo

— When you started as a manga artist in the early '70s, was there a lot of exciting experimental manga being produced? What magazines published this work?

One of the typical magazines was *COM. COM* was a wonderful magazine. I first saw it when I was in fifth or sixth grade. Now, *Garo* had *Kamui-den (The Legend of Kamui)* and

Mentored by Miyaya: While still in high school, Hiroki spent time with the *gekiga* manga artist, Miyaya Kazuhiko, learning his craft. This art is from a surrealistic story by Miyaya that appeared in *Garo* in 1977.
© Miyatani Kazuhiko / Seirindo

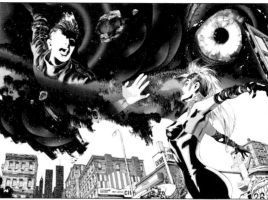

Image from "Calling": This story was done in 1987, and appeared in Bijutsu Shuppan-Sha's *Manga Supa Tekunikku Koza (Super Manga Technique Seminar)* the following year. It was reprinted in Hiroki's seminal *Louise* in 1995. Note how the image changed from pencil sketch to final art.
© Hiroki Mafuyu / Bijutsu Shuppan-Sha

I kind of had a feeling that Garo was scary. But *COM* was more casual and had a lot of artists who were doing experimental work. And Tezuka Osamu was doing his masterpiece, *Hi no Tori (Phoenix)* there. I was an ordinary reader who read *Shonen Magazine,* but they showed me a totally different worldview, which was subculture. *COM* was the biggest. *Young Comic* and *COM* produced a feeling that manga magazines could have challenging material. I was drawn to that kind of manga.

— So *COM* and *Young Comic* fit your personality better than *Garo*. Was *Garo* too extreme?

Garo almost seemed like a cult to me. If I got hooked on that, I kind of thought something horrible might happen. [Laughs.]

— Was this before French *bande dessinée* started appearing in Japan? Your work reminds me of some of that material. Were you aware of French BD?

We already had *bande dessinée* in Japan. When I was in high school, I'd go to a Western import bookstore and seek it out and look at it. And Miyaya-sensei had a collection of BD, which I saw and greatly envied. I had great admiration for European comics, and also American comics by artists such as Neal Adams.

— When I first saw your manga, it reminded me of Neal Adams' work instantly—but I thought there was no way you could know of him!

At the time I started drawing manga in my late teens, around 1974,

much of the subculture part of manga had started to vanish. So by the time I started working, the situation was different from that time of experimention I had loved. There was no *COM, Garo* didn't have Kamui-den, and the tone of manga had become much more commercialistic. I was trying to hold on to the feeling . . . I was trying to stay motivated by looking to those foreign artists.

— Do you believe that experimental manga is important for the development of manga as an art form?

Absolutely. Although not everything is good, of course. And not all commercialistic manga is bad. There are great artists there as well. But it's a rating of 1 out of 10 for both.

— Is there any magazine that is publishing good experimental manga now?

I don't know. There are just too many manga magazines today—it''s too hard to follow. I always have my 10 favorite artists, but I only buy their *tankobons.* There's no magazine that always has good "edgy" new artists showcased.

— What would you call your manga, or how would you describe it?

That's something I still can't do. That's why editors can't get a grip on my image. For my career, it might be easier if it was categorized. But after my book *Louise* was published, things became a lot easier for me. With that book, I think many recognized that here is an artist with a certain stance and way

of doing manga and illustration.

— Was the publication of *Louise* your breakthrough?

There were a few events here and there, but *Louise* was definitely the biggest.

— Was there a low point or slump in your career as an artist?

I really think I'm always in a low point. I've never had times when I'm in good shape. There's no good condition, but there are moments when a switch goes on and 'm totally obsessed with something. The manga I'm working on now (*Moon Child*) is like that.

— So you get that periodically— something that gets you excited and keeps you going?

I do get those. But even in commercial magazines, when the timing isn't right or the feeling just doesn't fit, then I can't do it, no matter how good that work is. There were times that I couldn't draw and I couldn't take it . . . and those times used to be really big.

— Who are your fans or readers of your manga?

From what I see of fan letters, it seems I have many female fans, especially for my illustrations. I never think about my audience, but I always think vaguely that there's someone out there who wants to read this kind of manga. I don't think there is any particular generation or age group or gender. There is just a type of reader out there who likes my work.

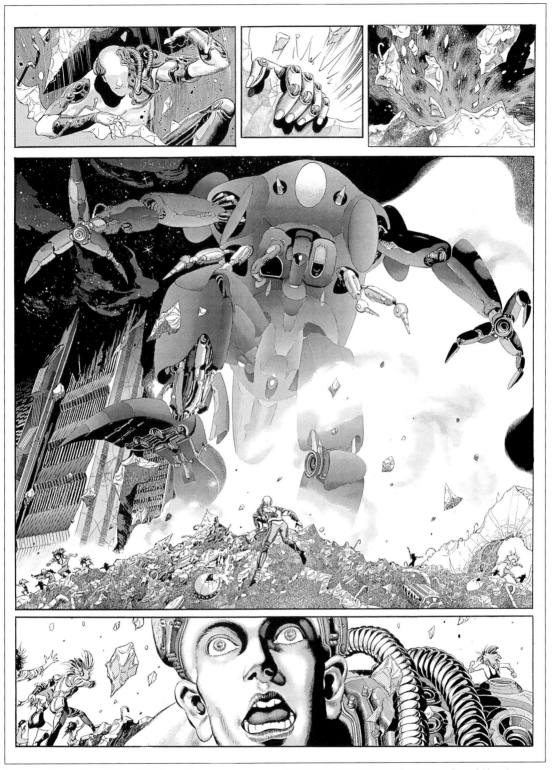

Apocalyptic images from Pale Saint: This wordless manga appeared in *Louise,* Hiroki's solo collection of illustrations and comics, published in 1995. This book served as a showcase for the kind of manga he longed to do—but could find no steady market for—utilizing laborious illustration techniques in each panel. Note the masterful use of Screen-Tone.
© Hiroki Mafuyu / Shincho-Sha

— In creating a manga story, do you begin with a script, a *name*—or do you just begin with an image and let a story develop from that?

I begin with an image. A good image. Something that you can't put into words. I have a 9B pencil, a dark one, and I scribble on a croquis, and from that picture there's an image that comes back to me. I start from there, and when it is a manga, I search for a story there. That's the way I do it.

— So it always comes from that scribble—and not from dreams, reading, movies, or other inspirations?

There are many inspirations that I get from those things, but I am not moved to draw. They may come to a head inside me, and I may remember that and enjoy it, but I don't get to the act of drawing from there. There may be ideas that persist that I write down, and I may look at those notes when I start working on a manga and they may come together in an idea for a story. But there is always something that is incomplete, that I have to study further.

— From what you have shown us of the steps in your current manga, it seems that the story evolves as you draw *names*, make notes, and redraw the images in a back-and-forth process.

I don't really understand the process myself. I have to try many things in order to get closer and start to see the real image.

— Besides making manga by hand, you also work on the computer. How does digital technology affect this process of making a manga story?

One of the obstacles in using digital is getting past just trying to duplicate analog (hand-drawing). My current thinking is that there must be art that can only be done in digital. There are many people who think they are doing this. But it's not simply scanning an underdrawing and coloring it digitally. Or—from the opposite way—drawing digitally, printing it out, and coloring it by hand. True digital art will be beyond these hybrids. Also, what Asamiya Kia-sensei said is really true—that you get tired of watching something digital in three seconds, but you can keep watching something done in analog for an hour. Even if you think it's stimulating and good, you can't look at

(digital art) for a long time. When I teach, I sometimes bring in a printout of my digital art. The students love seeing them, but when I bring artwork that I did by hand, they'll look at it much longer.

— When you use the computer to do manga, at what stage does the art go into the computer? Do you do line art (an underdrawing) with a pencil or pen and scan it in, or do you draw the images directly into the computer using a tablet?

The last manga I did ("Apples, Part 1") was a test case, so I tried everything. For some pages, I scanned a drawing and painted it with software, and there were other pages that I did from beginning to end digitally. I've used the computer on the current

manga, too (*Moon Child*). I put the rough sketch of a complicated scene into the computer and adjusted the size or cut and pasted the characters or flopped it. I made them look from right to left or made it larger and brought elements forward. Those things can easily be done on a computer. When you do it by hand, you have to erase it and do it all over again. But the computer is good for those things.

— What do you like best about using the computer?

Artists still haven't used the full possibilities of the computer. Maybe only about 10 percent so far. There are still a lot of sleeping treasures inside. I have an idea and the next time I do manga on a computer, I want to follow

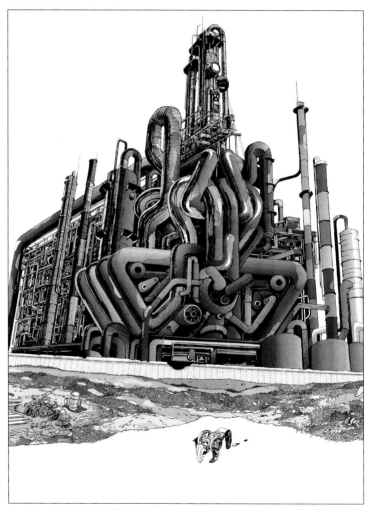

Image from "Ashes to Ashes," a short manga story set in the near future, also published in *Louise*. A catastrophic HIV epidemic has forced survivors to protect themselves by wearing biohazard suits. In the course of the story, the distinction between human and machine becomes blurred.
© Hiroki Mafuyu / Shincho-Sha

The name determines the worldview: Called in Japanese *name, conte,* or "picture continuity" (and in English "thumbnails" or "storyboards"), these first, loose drawings help Hiroki finalize not only the story, but—more important—what his imaginary world will look like. The drawings here are the third step in a process that started with scribbles, followed by a rudimentary name [inset] with little more than stick figures and text. These names are for *Moon Child,* appearing in this book on page 234 to 244.

it through. I can't tell you the specifics, but it's something abstract using the computer—there's a certain abstractness that can only be done on the computer. If I put this idea in analog, it's like ink blurring and getting fuzzy. I would like to make manga with an abstract expression that can only be done by computers.

— Is there anything about the computer that you do not like?

There's no original art. When you work by hand, even if it is drawn on tissue paper, it's still a three-dimensional treasure. But when it comes to the computer, it's only data or a printout. [It's sad that] there's no original art.

— You mentioned influences of Miyaya-sensei and Neal Adams when you first started. At the beginning of your career were there other inspirations—from manga or other arts?

There are many, but if it's Japanese manga artists I think it's Shirato Sanpei and Tsuge Yoshiharu.

— Are there any new ones today?

Not recently. But it's lonely that there aren't. Sometimes I get inspiration outside of manga. For example, I said that I liked David Silvian's CD jacket. I now look for anything I like. It doesn't have to be a certain genre or art form.

— Are there themes in your work?

The theme of *Moon Child* is that it's only a matter of time before people will be born in space . . . 50 years, 100 years, it may not take that long. I have tremendous interest in that. They may show us a totally different concept. I think I will keep drawing illustrations and manga in this theme.

— What is your favorite medium? Pen and ink? Colored ink? Computer? Or what is the easiest way to draw?

The best way to draw without any pressure and with the feeling of a child is drawing in pencil and then coloring it lightly. I am happy when I do that. My students at the vocational school

try to use mechanical pencils. I always get angry at them and say "If you keep using those things you will never be able to draw well. Use regular pencils!" What you learn from using a real pencil is huge.

— In terms of storytelling and design, are there any dos and don'ts you stick by? Any rules?

Maybe I do have . . . if not a rule, then a ritual or a ceremony. When I start, I come up with the image, but the inspiration fades. When I try to go with that image alone, I can't continue drawing. But something has come to life . . . it's as if I have conceived, so I have to nurture that new life. So I go out and go around to bookstores and Western bookstores and CD shops and buy something, even if it doesn't mean anything. When it's a CD, I choose a theme song. [Laughs.] I search for a sound that supports my image. And when I determine the sound, it goes smoothly. When the music doesn't work anymore, I have to go out and buy another one.

— Is making manga similar to making music?

After a song is written, a singer and background musicians must be found. It can be very hard and risky when they record it. There might be people who make music as a routine, but if it's music that they care about, they won't make it that way. I think good music is made through trial and error. Likewise, manga can be made by getting an idea, working on storyboards, penciling, drawing the characters, inking them, drawing the background, etc.

But that's not what I'm interested in. In the manga industry or in the music industry, there are many things that make a smooth-flowing production, but those are not the things I like. So I guess the art that speaks to me, whether it's manga or music, comes out of a great struggle.

— Do you work at home? What's a typical day for you?

The only place that I can concentrate is at my work desk. There is no typical day. I work until my eyes get tired and I can't see . . . about 10 hours a day.

— How many days a week?

I work every day. Teaching at the vocational school once a week is a break, but besides that, I sit down in front of my desk and work. When I'm busy and make a promise to meet a friend, it is fun at that moment, but it makes me feel pressured when it comes close. [Laughs.] So after teaching, I make that a day not to draw, so I go out to drink or meet friends. Also, when I finish a job and deliver it, I take a day off.

— How long does it take to do a page?

If I were to really say how long it takes me, I might not get any more manga work. [Laughs.] It takes me a long time, probably about a week to do one page.

— That is similar to the pace of some other artists I know of. Francois Schuiten, the Belgian BD artist, told me it takes him a week to do a page.

In the Japanese manga industry, that won't do. People draw weekly stories here. I drew for a commercial magazine until I was 30. If I drew like I wanted I missed the deadlines and couldn' t make a living. If I tried to make the deadlines, I wasn't satisfied with my work. So I started doing illustration work while I did manga, and in that way I was able to be free. Without that side business, it was impossible to do manga in my style. So I'm more of an independent type—I can't work within the limitations of a commercial manga artist. My emotional support were the artists of Europe and America. There's stuff out there that obviously takes time.

— It seems that your approach to manga might be better appreciated in Europe or America.

Yes, but it should also be done in Japan.

— Are there any of your works that you are unhappy with?

There are many—especially after the first two, and the period that began four years later when I started doing manga at age 22. I drew manga based on other people's stories and spent my 20s unsatisfied. After I turned 30 and started doing manga while doing illustration, the amount of manga I did decreased dramatically, but people began to take notice of that work from then on. [lLaughs.]

© Hiroki Mafuyu / Bijutsu Shuppan-Sha

Images from "Lovers, Take 1," in *Etiquette of Violence*. © Hiroki Mafuyu / Asahi Sonorama

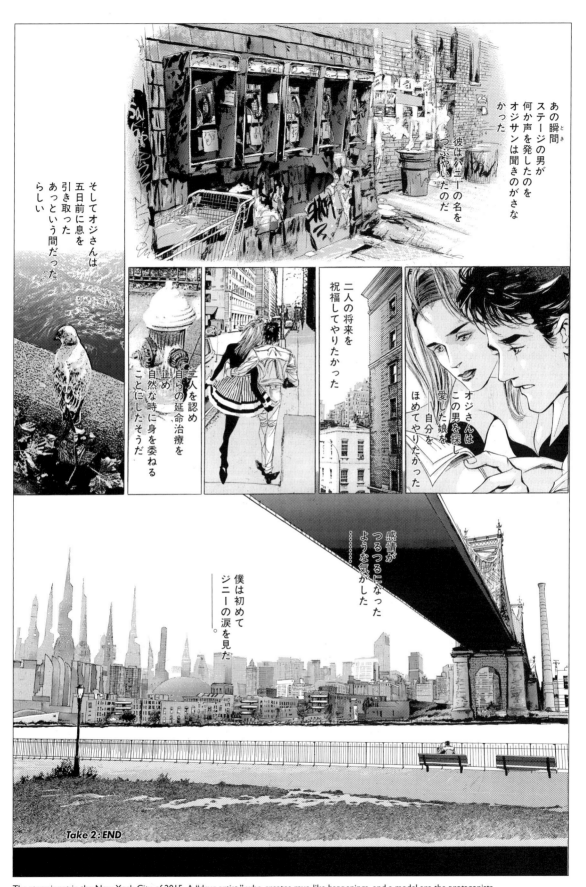

Take 2 : END

The story is set in the New York City of 2015. A "drug artist," who creates rave-like happenings, and a model are the protagonists.
Like many of Hiroki's manga, the plot seems little more than an excuse for the drawings—but they are exceptionally exquisite drawings.

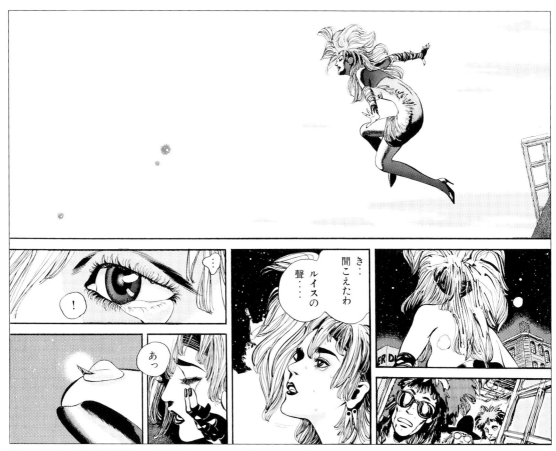

き…
聞こえたわ
ルイスの
聲……

The conclusion of "Calling": The psychic link between a man and a woman enables her to help him survive a critical operation—she actually heals him with her tears.
© Hiroki Mafuyu / Bijutsu Shuppan-Sha

The beginning of Moon Child: This is one of the very first concept sketches for *Moon Child,* Hiroki's new manga that appears in its entirety for the first time in this book. Contrast the downcast, crucifix-like figure here with the ascending figure on the last page of the finished manga.

— Someone said they will forget how long it took you to do something . . . they won't forget if it was good.

When I became an adult I realized that *Garo* and *COM* were minor publications (in terms of circulation). But to me as a child they were very important. I still think that way, even though I am now a creator and would wish for a big audience for my works. But the most important thing is to make something that will be remembered in someone's heart.

— What are your favorite manga or comics by other artists— Japanese, European, Asian, or American?

Enki Bilal (a French BD artist). When my creative drive goes down, I look at his work to bring it up.

— What advice would you give to any aspiring manga artists?

Don't think about whether it is commercial or not, or if you can make a

living or not, or if it will be accepted or not, just do what you want to do and draw until the end. Then something will begin. That's what I always think. Nothing can make you happier than seeing what comes out of that.

— Is there anything you would like to say to your fans outside of Japan or inside Japan?

Whether it's manga or illustration, if someone sees my work and enjoys it, that makes me happy. Even if it is just as entertainment. I also wanted to thank you. Because of this book, I had a chance to do a manga again. Thank you for this opportunity to do something I really love.

— It was your appearance in Manga Supa Tekunikku Koza that inspired this book. It almost seemed as if, in the story "Calling" that you did for that book, you were calling out . . . and you reached me with that message. Thank you very much.

LIST OF WORKS

Manga appearances:
- *Manga Supa Tekunikku Koza,* Bijutsu Shuppan-Sha, 1988
- *Error,* Vol. 00 Preview issue, Bijutsu Shuppan-Sha, 2000
- *Error,* Vol. 02, Bijutsu Shuppan-Sha, 2000

Illustration work:
- *SF Magazine,* November issue, Hayakawa-Shobo, 1991
- *Aoki Kage no Lilis* (authored by Kikuchi Hideyuki), Chuo-Kouronsha, 1995, 1998
- *Falling Angel (Midnight Blue)* (by Nancy A. Collins), Hayakawa Shobo, 1997
- *SF Magazine,* March issue, Hayakawa-Shobo, 2002
- *Vampire Junction* (S.P. Somtow and Kaneko Hiroshi), Sogen Suiri Bunko

Major works:
- *Louise,* Shincho-sha, 1995
- *Louise on CD-ROM,* Shincho-Sha, 1997
- *Etiquette of Violence,* Asahi Sonorama, 2000

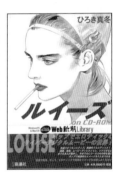

CHECK OUT

Top three:
- *Louise,* available online from Shincho-Sha: http://webshincho.com/
- *Etiquette of Violence,* available online from Asahi Sonorama: http://www.asahisonorama.co.jp
- *Error,* Vol. 00 Preview issue, which includes the story "Apples," available online from Bijutsu Shuppan-Sha: http://www.bijutsu.co.jp/comickers/

Web site:
- Hiroki Mafuyu's official Web site http://hirokimafuyu.com

Japanese manga artists you might like, if you like Hiroki Mafuyu:
- Hoshino Yukinobu
- Kamijo Atsushi
- Koike Keiichi
- Miyaya Kazuhiko

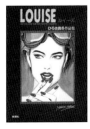

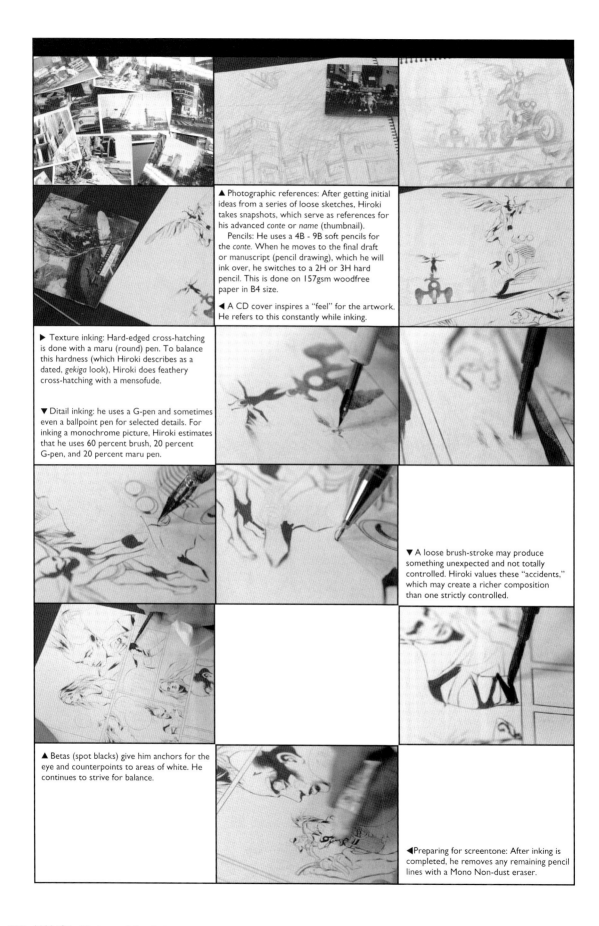

▲ Photographic references: After getting initial ideas from a series of loose sketches, Hiroki takes snapshots, which serve as references for his advanced *conte* or *name* (thumbnail).

Pencils: He uses a 4B - 9B soft pencils for the *conte*. When he moves to the final draft or manuscript (pencil drawing), which he will ink over, he switches to a 2H or 3H hard pencil. This is done on 157gsm woodfree paper in B4 size.

◀ A CD cover inspires a "feel" for the artwork. He refers to this constantly while inking.

▶ Texture inking: Hard-edged cross-hatching is done with a maru (round) pen. To balance this hardness (which Hiroki describes as a dated, *gekiga* look), Hiroki does feathery cross-hatching with a mensofude.

▼ Ditail inking: he uses a G-pen and sometimes even a ballpoint pen for selected details. For inking a monochrome picture, Hiroki estimates that he uses 60 percent brush, 20 percent G-pen, and 20 percent maru pen.

▼ A loose brush-stroke may produce something unexpected and not totally controlled. Hiroki values these "accidents," which may create a richer composition than one strictly controlled.

▲ Betas (spot blacks) give him anchors for the eye and counterpoints to areas of white. He continues to strive for balance.

◀ Preparing for screentone: After inking is completed, he removes any remaining pencil lines with a Mono Non-dust eraser.

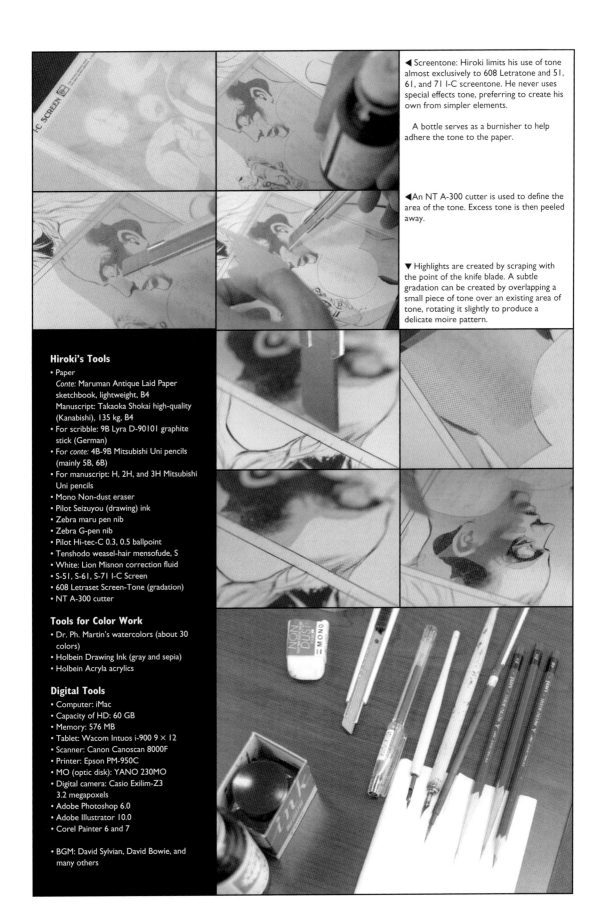

◀ Screentone: Hiroki limits his use of tone almost exclusively to 608 Letratone and 51, 61, and 71 I-C screentone. He never uses special effects tone, preferring to create his own from simpler elements.

A bottle serves as a burnisher to help adhere the tone to the paper.

◀ An NT A-300 cutter is used to define the area of the tone. Excess tone is then peeled away.

▼ Highlights are created by scraping with the point of the knife blade. A subtle gradation can be created by overlapping a small piece of tone over an existing area of tone, rotating it slightly to produce a delicate moire pattern.

Hiroki's Tools

- Paper
 Conte: Maruman Antique Laid Paper sketchbook, lightweight, B4
 Manuscript: Takaoka Shokai high-quality (Kanabishi), 135 kg, B4
- For scribble: 9B Lyra D-90101 graphite stick (German)
- For *conte:* 4B-9B Mitsubishi Uni pencils (mainly 5B, 6B)
- For manuscript: H, 2H, and 3H Mitsubishi Uni pencils
- Mono Non-dust eraser
- Pilot Seizuyou (drawing) ink
- Zebra maru pen nib
- Zebra G-pen nib
- Pilot Hi-tec-C 0.3, 0.5 ballpoint
- Tenshodo weasel-hair mensofude, S
- White: Lion Misnon correction fluid
- S-51, S-61, S-71 I-C Screen
- 608 Letraset Screen-Tone (gradation)
- NT A-300 cutter

Tools for Color Work

- Dr. Ph. Martin's watercolors (about 30 colors)
- Holbein Drawing Ink (gray and sepia)
- Holbein Acryla acrylics

Digital Tools

- Computer: iMac
- Capacity of HD: 60 GB
- Memory: 576 MB
- Tablet: Wacom Intuos i-900 9 × 12
- Scanner: Canon Canoscan 8000F
- Printer: Epson PM-950C
- MO (optic disk): YANO 230MO
- Digital camera: Casio Exilim-Z3 3.2 megapoxels
- Adobe Photoshop 6.0
- Adobe Illustrator 10.0
- Corel Painter 6 and 7

- BGM: David Sylvian, David Bowie, and many others

Introduction to *Moon Child* — How This Manga Came to Be

You hold in your hands a rare jewel. It's a treasure that Hiroki Mafuyu unearthed, carefully brushing away the white surface of the page, scratching away its blankness with his maru pen, to reveal what was buried in the pulp. It's one of the manga that he sneaks in, from time to time, between illustration commissions.

The story is like a dream memory that evokes a feeling. There's an outsider, born on the moon and exiled to Earth. Does she long to join those in the passing stargate? Is she forbidden to live there because of her outsider status? But the outcast has gifts beyond understanding.

I met Hiroki Mafuyu near the train station at Kunitachi in the late summer of 2003. I recognized him from a photo, taken some 15 years earlier, that had appeared in a manga technique book. Over coffee, I told him how I had first seen his work in a book not unlike this one, and had become an instant admirer of his art. My assistant and Hiroki spoke at great length, filling me in from time to time. My assistant knew what to say; there was no need to slow down the exchange with continuous translation. My assistant told him I was doing a book that would give those outside Japan a hint of what manga could contain. I nervously waited, hoping that Hiroki would agree to an interview. Then came the bombshell: Hiroki had proposed doing a 10-page story for my book! I was astonished, but accepted his generous offer instantly.

The premise of the story, alluded to above, is common in Hiroki's manga. Indeed, the theme that outsiders can have special abilities is common in folklore and tales told in every culture, in every art form. It is a fitting metaphor for the artists in this book, who are visionaries living outside the "normal," mundane existence of the rest of us—the masters of the elseworld of Japanese comics.

Tsuki no Musume (Moon Child 2055) begins on page 244 and reads from right to left, ending on the page opposite.

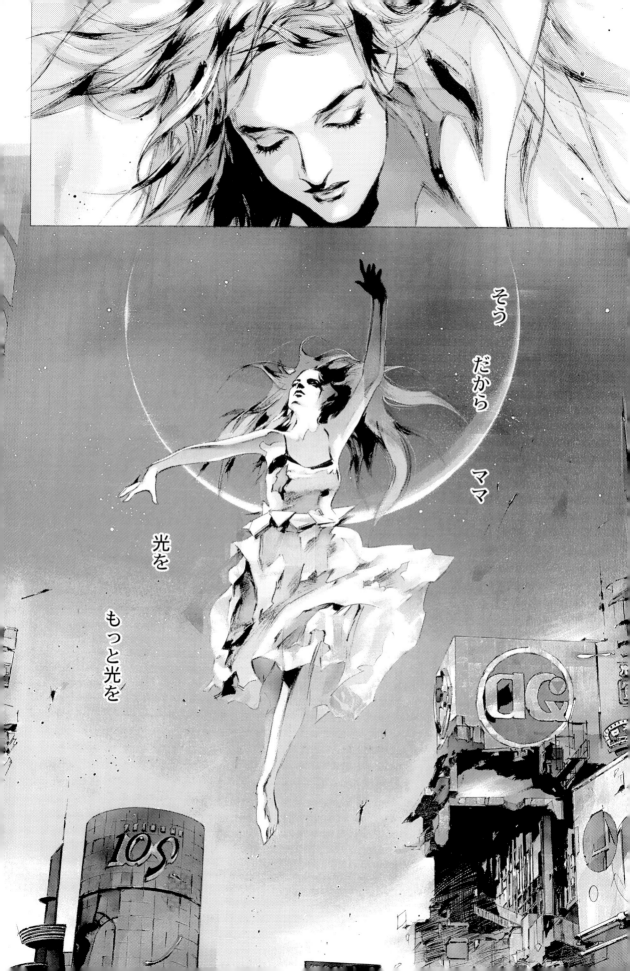

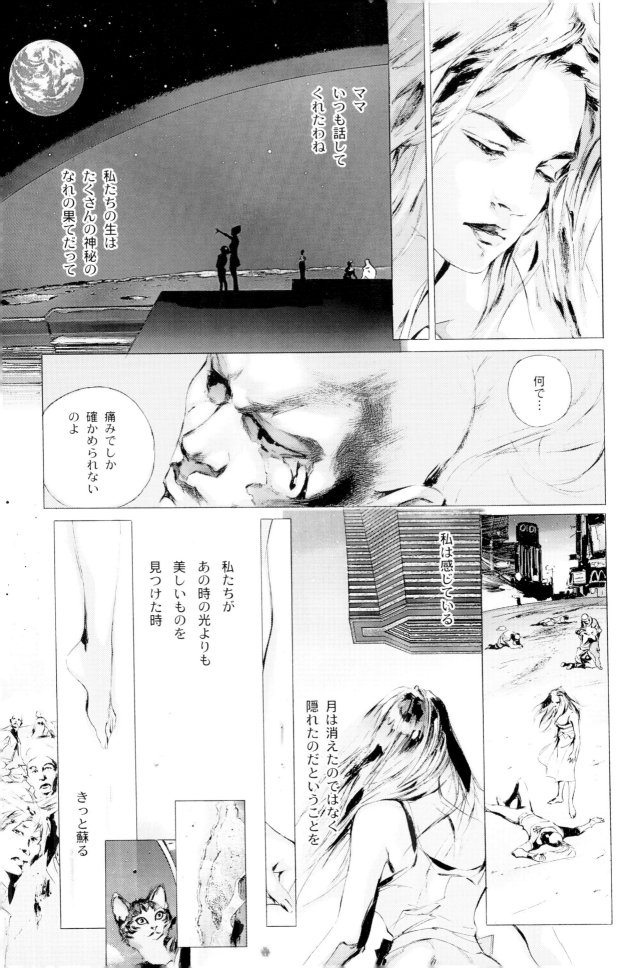

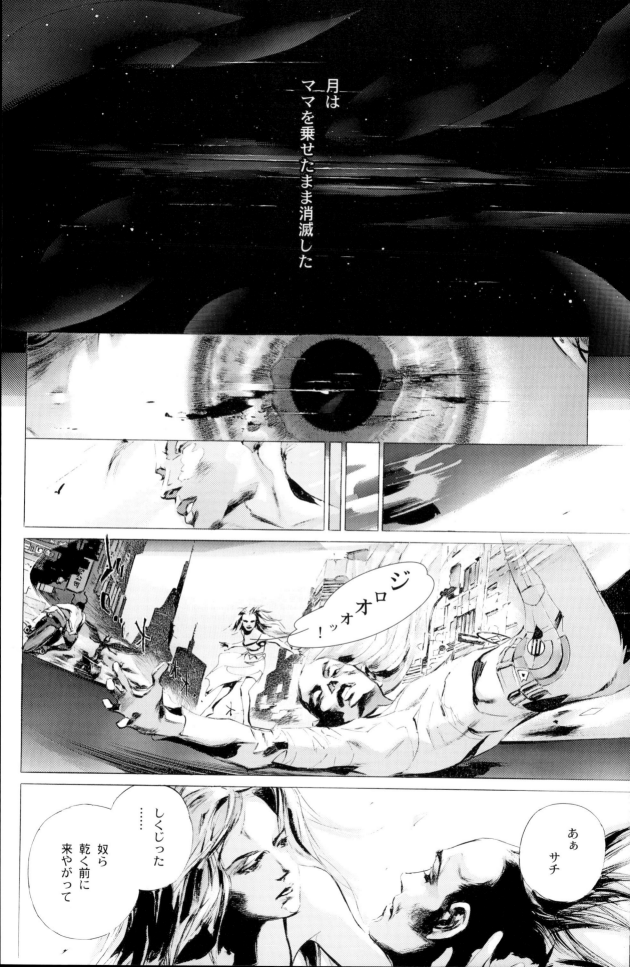

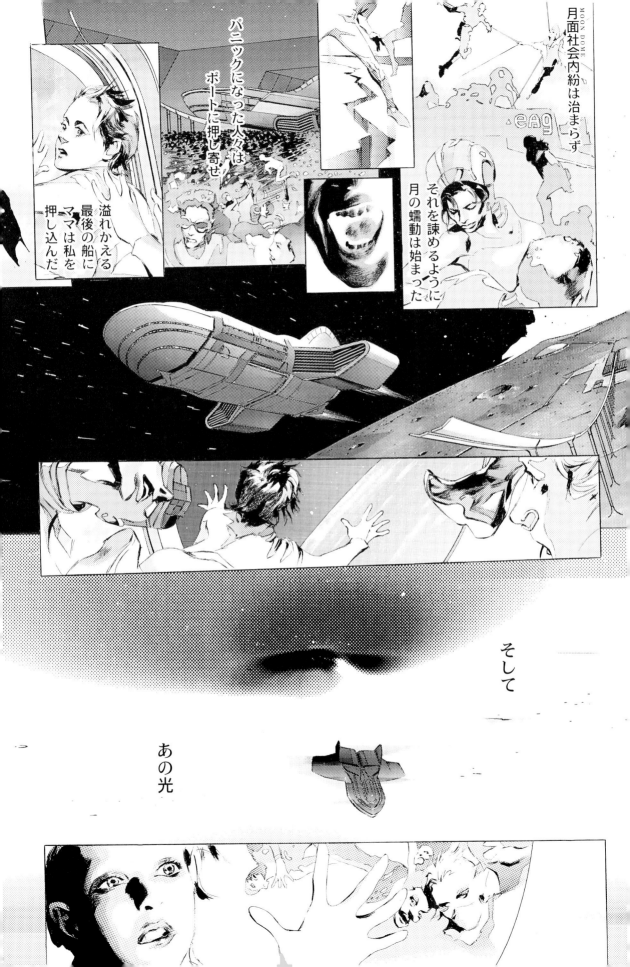

月面社会内紛は治まらず

それを諌めるように月の蠕動は始まった

パニックになった人々はボートに押し寄せ

溢れかえる最後の船にママは私を押し込んだ

そして

あの光

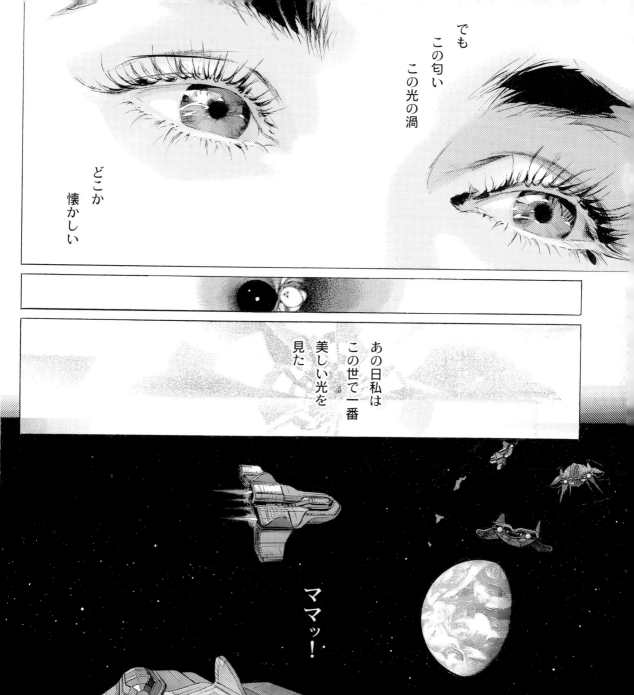

でも
この匂い
この光の渦

どこか
懐かしい

あの日私は
この世で一番
美しい光を
見た

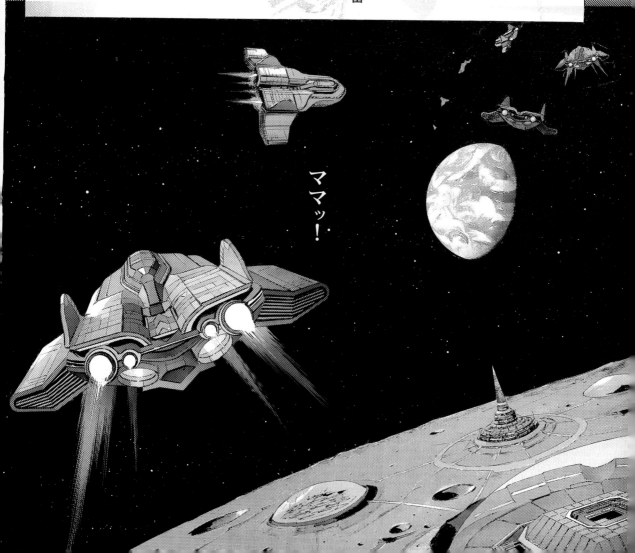

ママッ!

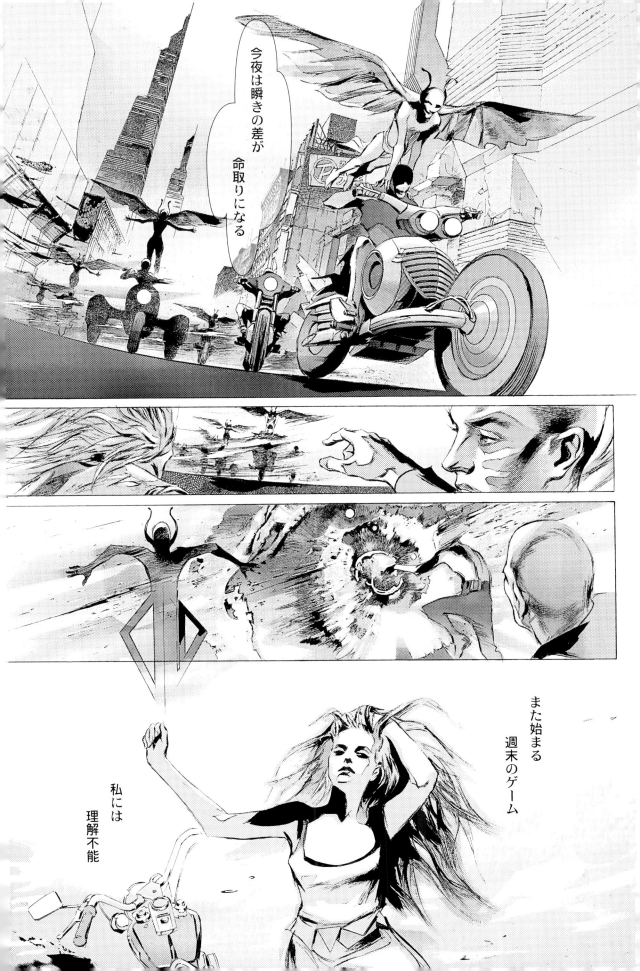

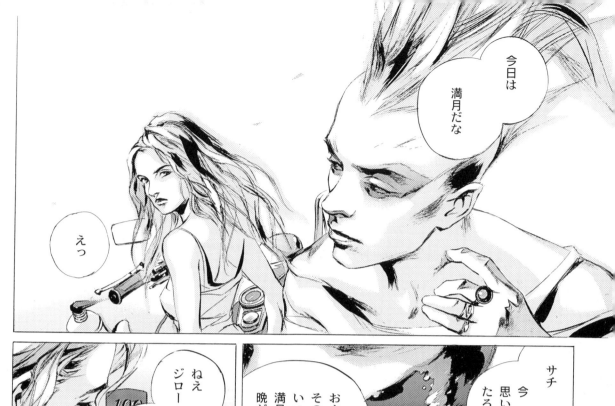

今日は満月だな

えっ

サチ

今　昔を思い出してたろ

ねえジロー

なんで今日はアクリルなの？

おまえがそのモードの時いつも満月画像の晩だ……

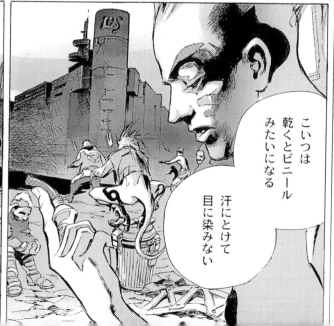

こいつは乾くとビニールみたいになる

汗にとけて目に染みない

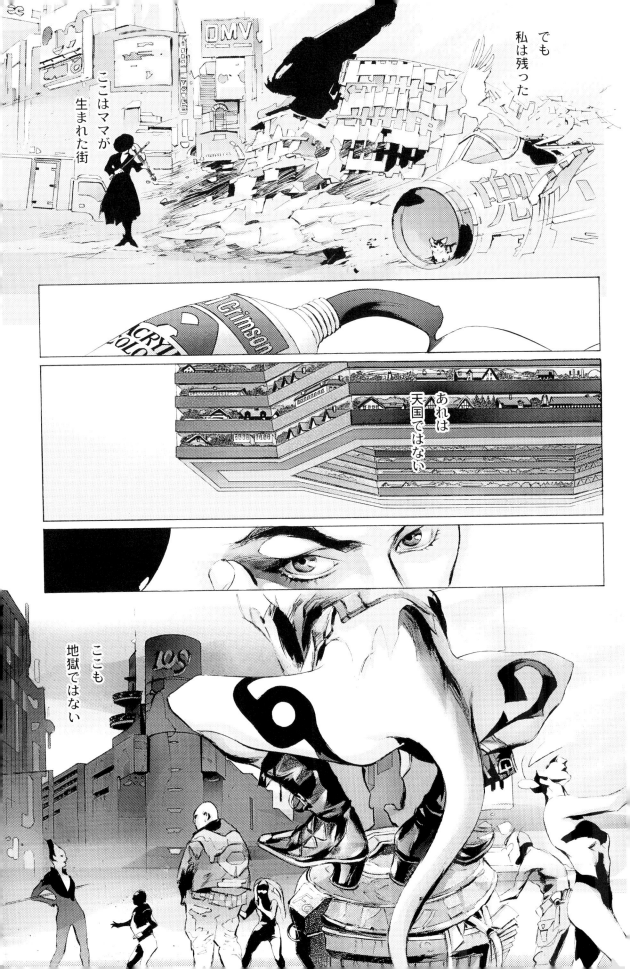

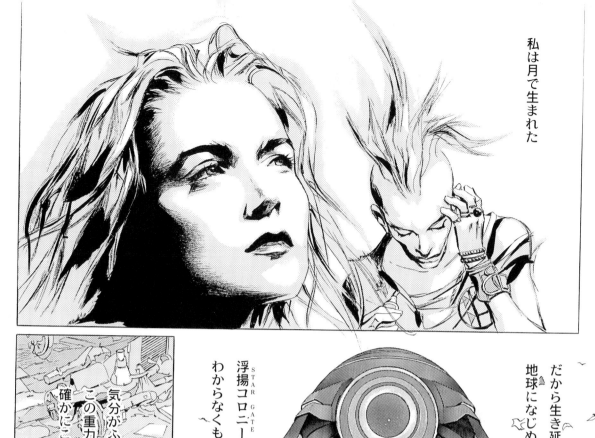

私は月で生まれた

だから生き延びた月帰国子女たちが
地球になじめず

浮揚コロニー_{STAR GATE}を造った気持ちは
わからなくもない

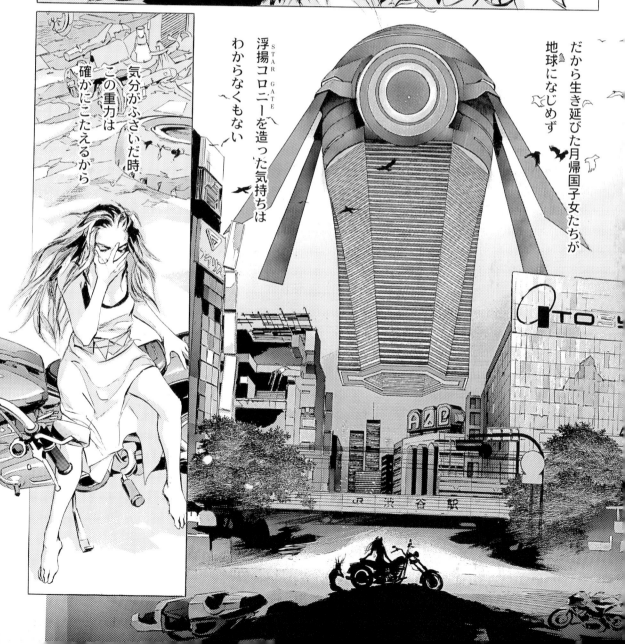

気分がふさいだ時
この重力は
確かにこたえるから

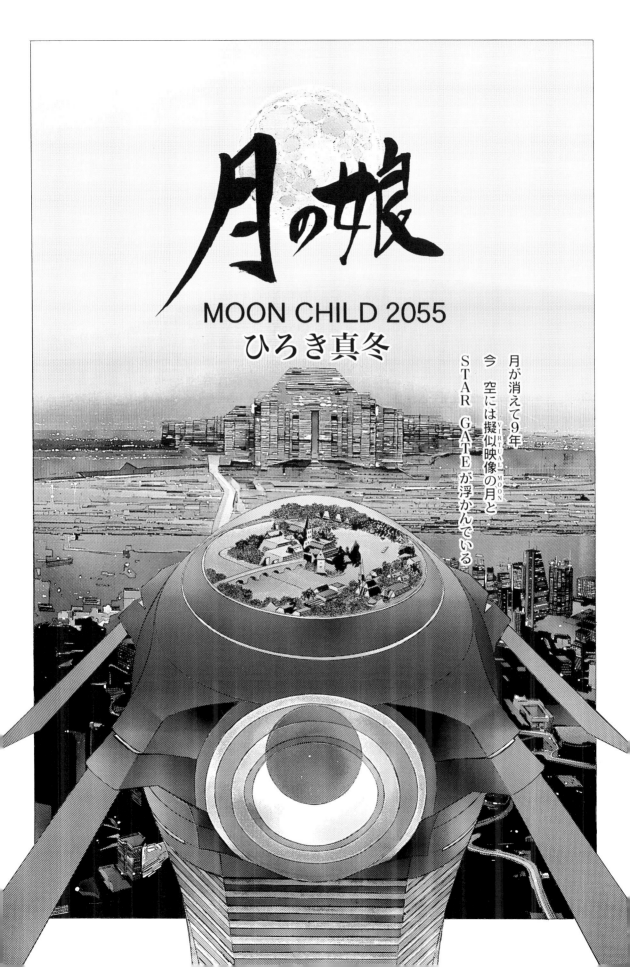

月の娘

MOON CHILD 2055

ひろき真冬

月が消えて9年
今　空には擬似映像の月と
STAR GATE が浮かんでいる

Glossary

Adams, Neal: An American comics artist whose work in the late '60s and early '70s revolutionized the standards for comic book art in the U.S. Adams used ad agency and illustration techniques, photo reference, and dynamic layouts to create a level of realism that had previously appeared only in the comic-strip work of artists such as Stan Drake and Alex Raymond.

alternative comics: A wide range of Western comic books and graphic novels created independently of large corporate publishers. These comics have appeared since about 1980, in the wake of the underground comix movement of the late '60s and early '70s. These works present an alternative to the formulaic genre comics that dominate the U.S. comic book industry (such as superhero-themed products). Alternative comics are often the product of a single creator, published in small numbers for specialized audiences, with material that a more general readership would find obscure or offensive.

Angouleme: The "Cannes" festival of European comics (bande dessinee) held annually at the end of January in western France.

anime: Term for animated film in Japan. The word originated in France, as a reference to imported Japanese animation. Anime are often adaptations of stories or series that first appeared in manga form.

artboard: Western term for the final drawing for a comics story, done on a medium-weight paper. The board is designed to take ink without smudging or running. Bristol Board is a common brand. Standard size is 15 inches by 11 inches (including bleed area and gutter). Western artboards are larger than the equivalent Japanese manga drawing surface, which is called a *manuscript*.

bande dessinee: French term meaning literally "strip drawings," roughly equivalent to the U.S. term *comic strips* (but without the implication of humorous content); the French and Belgian term for comics. Bande dessinee are hardbound in format and often have a highly developed illustrative aesthetic. Their appearance in both Japan and the U.S. in the '70s influenced many comics and manga artists.

beta: Japanese term for spot black. Areas on a comics drawing or page of solid black.

Bilal, Enki A European bande dessinee artist (he is a Czechoslovakian expatriate living in Paris). His style is similar to that of Jean Giraud, employing extensive cross-hatching.

bishonen: Japanese for "beautiful boy." *Bishonen* are found in all types of manga and anime. They are sometimes effeminate, but can also be quite masculine. *Bishonen* are the focus in "boys' love" manga, an extremely popular genre among normal heterosexual teenage and twenty something Japanese women.

boys' love: Also known by the acronym "BL." A genre of manga for women featuring romantic love between male characters.
The relationships range from platonic to overtly sexual, and the treatment may range from implied to explicit. These homoerotic titles are enjoyed by a great number of women in Japan. There is no equivalent to boys' love in the world of Western comic books.

butoh: A dance form born in post–World War II Japan, with both nihilistic and life-affirming elements, symbols of death and eroticism.

character chart: (See *kyara hyou*.)

COM: A magazine with which Tezuka Osamu was heavily involved, published between 1967 and 1972. COM was intended to be a gateway to success for new young cartoonists, and encouraged noncommercial and more serious, artistic works.

Comiket: A Japanese contraction of the English words "comic" and "market." Comiket is Japan's largest biannual gathering of manga sellers and buyers in Tokyo. Held at the Tokyo Big Sight Convention Center, crowds estimated at 500,000 show up for the three-day event. Over 10,000 creators and publishers of doujinshi sell their wares at Comiket, but you can also find vendors selling postcards, posters, trading cards, and other manga- and anime-related items. Game developers also have a large presence, selling the very latest in anime computer games.

concentration lines: (See *shuchu-sen*.)

conte: (See *e-conte, name*.)

continuity: (See e-conte, name.)

copytone: Screentone that can be used with a copy machine to imprint customized patterns on the tone sheet, which is then used like commercially manufactured tone.

cross-hatching: (See *kake ami*.)

daihon: Japanese word for "script" or "scenario".

doujinshi: Self-published books or booklets of manga or any of a broad range of subjects related to manga and anime. Also, unofficial amateur manga based upon successful, well-established manga or anime series. *Doujinshi* range in quality from crude black-and-white pamphlets numbering a few pages to beautifully produced volumes that dazzle the eye. Incredibly talented artists create *doujinshi*, and many successful manga-ka got their start in *doujinshi* circles. Some doujinshi venture into explicit adult themes and for this reason, some artists—though self-

published—disavow a connection with *doujinshi*. Large Japanese publishing houses generally look the other way and ignore the small print runs of *doujinshi* publishers, which never amount to more that a few thousand copies. The *doujinshi* market in Japan is conservatively estimated to be an $800 million industry.

doujinshi circle: A group of *doujinshi* artists working together to produce anthologies or collaborative stories of amateur manga.

draft: Preliminary version of a manga story, after the *name* or *e-conte*, but before the final manuscript. A parallel in English might be the relationship of a sketch to a final drawing.

e-conte: Japanese term loosely translated as "storyboard" or "thumbnails." The term is an amalgam of *e* (pronounced as a short "eh"), Japanese for picture, and *conte*, the French word for "story." This is a rough preliminary version of a manga story, usually done at a smaller size, which serves as a blueprint for the final story or manuscript. Some manga artists call this a *name*, *conte*, or continuity.

ero manga: Erotic comics for men.

ero-guro: A contraction of "erotic grotesque." Manga that flourished in Japan in the late '70s, combining sex and violence in an extreme form.

etching: Scraping Screentone with the blade of a cutter to create highlights.

fude pen: Literally "brush" pen, cartridge pen with a brushlike tip, which simulates traditional brushes that must be dipped in ink.

G-pen: Pen nib used most commonly by manga artists in Japan; wider than the maru pen; capable of drawing lines of varying widths.

Garo: Avant-garde experimental manga magazine, published from 1964 to 2002. *Garo* never paid artists, but provided a forum for their work. Other alternative magazines appeared in the '90s such as *Comic Cue*, *Erotics,* and *EroticsF*. When it ceased publication, many of Garo's editors went to *AX* magazine.

gekiga: Literally "dramatic pictures," originally referred to manga with realistic pictures and narratives that emerged from rental manga in the late '50s. Now refers to manga with more gritty stories, usually for men in their late 20s and 30s.

Giraud, Jean (aka Moebius): A dominant figure in French bande dessinee. Hallmarks of the Moebius style are shading with intricate combinations of fine lines and original expressions of texture. In Japan, he is known for the strong influence he has

had on Otomo Katsuhiro. Moebius was also very influential with an entire generation of American comics artists.

Gothic Lolita: A look in fashion and manga combining a "little girl" appearance with stark Goth fashions and accessories.

gradation tone: Screentone in which there is a shade shift from light to dark.

graphic novel: A stand-alone story in comics form, published as a book. Will Eisner's *A Contract with God*, published in 1978, gets the credit for being the first graphic novel, though it was not actually the first long-form graphic story nor the first use of the phrase. It was, however, the first marriage of the term, which appeared on the cover, and the intent of "serious" comics in book form. Over the past 26 years the meaning of the phrase has only gotten hazier and less satisfying. Japanese manga, superhero collections, nonfiction, autobiography—all of these are "graphic novels," a term that now applies to any square-bound book with a story told in comics format. Eisner himself disliked the phrase and preferred "graphic literature" or "graphic story."

Hagio Moto: Female manga-ka who made her debut in 1969 with *Ruru to Mimi* (*Lulu and Mimi*). One of the most famous shojo-manga-ka in history and the one who virtually invented "boys' love" manga. She is considered by many to be the female version of Tezuka Osamu. She's also part of the "Magnificent 24-Year Group," women artists born in Showa 24 (1949), who revolutionized the *shojo* genre, by introducing issues of gender and sexuality.

Heavy Metal magazine: First magazine to publish European comics in the U.S., beginning in 1977. Pre-Reagan, pre–politically correct last gasp of the counterculture revolution, it featured translations of *Metal Hurlant* material, the French magazine which was a forum for Moebius, Schuiten, and others. *Heavy Metal* today, after several editorial changes, is a pale shadow of the original.

Hi no Tori: Manga work by Tezuka Osamu, whose title is translated as *Phoenix*. An epic story spanning centuries, Tezuka considered it his life's defining work. It was originally serialized in *COM*.

ink wash: (See *sui boku ga*.)

Ishinomori Shotaro: Manga-ka who made his debut in 1955, and one of the pioneers of its modern form. His first work was published while he was still in high school. He studied under Tezuka Osamu and was enormously productive. He created *Kamen Raida* (*Masked Rider*) and *Cyborg 009*. His *Manga Nihon-no-Rekishi* (*A Manga History of Japan*) can be found in many Japanese school libraries.

josei: Manga, for women ages 18–37, featuring romance and relationships, not as sexually explicit as *redikomi* ("ladies' comics").

kake ami: Cross-hatching; patterns of intersecting lines used to create shades or texture in a pen-and-ink drawing.

Kamui Den (*Legend of Kamui*): Influential manga story by Shirato Sanpei of a ninja in feudal Japan, which ran in *Garo* from September 1964 to July 1971. With a theme of class struggle, it was popular with student activists of the time.

Kurosawa Akira: Japanese film director, famous for *Rashoman*, *Shichinin no Samurai* (*Seven Samurai*), and *Ran*, whose work influenced many Western filmmakers.

kyara hyou: Literally "character chart" or "character setting." A drawing of a protagonist in a manga story, with notes about her or his personality and role in the story.

manga: In 1814 the famous Japanese artist Hokusai created a book of black-and-white sketches that he called manga ("involuntary sketches"). In recent Japanese history the word has come to describe illustrated books of black-and-white ink drawings that tell a story. "Graphic novel" would be the closest translation for *manga*, though they are not at all like novels in the Western sense, nor are they comparable to Western comic books. Popular story manga in their current form began in the late '40s with artists such as Tezuka Osamu. Manga cover a wide range of topics, from fantasy and adventure to sports and cooking. Manga magazines, *tankobons*, and related books account for 40 percent of all publishing in Japan.

manga-ka: Japanese word for manga artist. The word is gender neutral and can refer to a male or female artist. Many of Japan's most famous manga-ka are women. CLAMP, Takeuchi Naoko (Sailor Moon), and Takahashi Rumiko (Ranma 1/2) are but a few examples.

manuscript: Japanese term for the page on which a manga story is drawn. Standard size in Japan is B4, with a printing size of 220×310 mm ($8\frac{5}{8} \times 12\frac{1}{4}$ inches) and drawing frame of 180 \times 270 mm ($7\frac{1}{8} \times 10\frac{5}{8}$ inches). Japanese manuscripts are smaller than the equivalent Western comics drawing surface, which is called an *artboard*.

maru pen: Crow quill pen nib. Literally "round" pen, a thin pen that must be dipped in ink, used for uniform fine lines and detail work, requiring more skill than a G-pen.

McCloud, Scott: American comics artist and a leading popular scholar of comics as a distinct literary and artistic medium. He created a lighthearted science fiction/superhero comic book series, *Zot!*, in 1984, which became a cult classic. He is best known as a comics theorist, following the publication in 1993 of *Understanding Comics*, a wide-ranging exploration of the definition, history, vocabulary, and methods of the medium of comics, itself done in comics form. As the most ambitious book on the subject to date, it sparked considerable discussion among comics creators and readers, and is now widely considered one of the definitive works about the medium of comics. He followed in 2000 with the more controversial *Reinventing Comics* (also in comics form), in which he outlined twelve revolutions that he argued would be keys to the growth and success of comics as a popular and artistic medium.

mensofude: Literally "face brush," a thin brush used for detail work, especially facial features.

Mignola, Mike: American comics artist who started his career publishing comics in fanzine *The Comic Reader* at age nineteen in 1981. In 1983 he was employed as an inker by Marvel Comics, where he worked on series such as *Daredevil* and *The Defenders*. In 1993, he drew the artwork for *Dracula* and *Aliens: Salvation*. In the mid-1990s, he created an original series, *Hellboy*, that allowed him to display the full range of his talent.

moe: A term in Japanese anime and manga culture denoting the strongest expression of one's favorites or the current hottest trends.

Moebius: (See Giraud, Jean.)

moire: Wavy pattern produced by overlaying sheets of Screentone.

monochrome: Having one color or only shades of gray.

muzan-e: "Atrocity prints," a 19th-century genre of woodblock printing devoted to depictions of crimes and violent themes; a source of inspiration for some contemporary ero-guro manga artists.

Nagai Go: One of the most important innovators in Japanese manga. He introduced eroticism in children's comics and developed the concept of transforming giant robots (Mazinger, Goldorak), an idea that has been used in countless television series. His manga series *Harenchi Gakuen* (*Shameless School*) appeared from 1968 to 1972 in Shonen Jump. The manga broke various taboos, dealing with subjects such as voyeurism and sex. The series ended dramatically: During a massacre all the characters died. Later Nagai created Devilman, a hero who fought hordes of demons.

name: Japanese term for "storyboard", a rough blueprint for a manga story. This term varies from artist to artist. Some artists'

names consist only of words, with a few sketches. Others are panels with word balloons and dialogue only, while still others are rough versions of the story with both words and images. Synonyms can be *conte*, *e-conte* and *continuity*.

nib: Metal pen tip.

otaku: This word can have a very negative meaning, depending on the context. In Japanese society it is widely understood to mean an antisocial misfit devoted to popular culture. But in the international anime community the word has evolved into a slang reference meaning "obsessed fan." Serious Western devotees of anime and manga proudly call themselves *otaku*.

Otomo Katsuhiro: Manga artist and anime director; creator of the *Akira* manga, the dystopian futuristic sci-fi fantasy, which became an equally groundbreaking anime. Otomo, influenced by bande dessinee (especially Moebius), started a revolution in clean-line realism in *seinen* manga in the early '80s, and was one of the first manga-ka to draw Japanese people with more Asian-like features.

Ozu Yasujiro: Japanese movie director, known for quiet films about ordinary people, such as *Tokyo Monogatari* (*Tokyo Story*).

penholder: Handle of a pen into which pen nibs can be inserted.

penning: Japanese term for inking.

picture continuity: (see *e-conte*, *name*.)

PULP **magazine:** First English-language publication to run the kind of manga that make comics a mass medium for ordinary adults in Japan, from dynamic action narratives to avant-garde experiments. It was published from December 1997 to August 2002. Despite critical acclaim, *PULP* had low sales, resulting in its demise. *PULP* offered readers a Japanese comics contrast to both the superhero genre that typifies American comics and the stereotypical "anime-esque" manga often offered to U.S. readers, by introducing sophisticated manga series such as *Bakune Young*, *Banana Fish*, *Dance Till Tomorrow*, *Even a Monkey Can Draw Manga*, *Short Cuts*, and *Uzumaki*.

redikomi: A contraction of "ladies' comics," meaning erotic comics for women. These manga are created specifically for women over 20 and for "office ladies" (women who work office jobs). Ladies comics are filled with stories about dating, romance, and sex—and are sometimes quite explicit.

Schuiten, François: A dominant figure in Belgian bande dessinee. The son of two architects, he studied at the Saint-Luc Institute. François collaborated with his brother Luc on the

series *Terres Creuses* (*The Hollow Grounds*), which was published in the legendary *Pilote* magazine. He later transferred to the more adult *Metal Hurlant* magazine. In 1980, together with Benoit Peeters, he created the series *Cites Obscures* (translated into English as *Cities of the Fantastic*), in which his love of architecture is magnificently visible. His work has received many awards, notably the prestigious Prix d'Angouleme.

Screentone: Patterns on transparent film with an adhesive backing that are affixed to drawings to create textures; Zipatone.

seinen: A Japanese word meaning "young man," that refers to manga and anime that targets young adult males ages 18 to 25. The stories in *seinen* works appeal to university students and those in the working world, and typically deal with the issues of adulthood.

sensei: The formal, polite honorific used when addressing someone who is an accomplished professional, meaning "master" or "teacher." Doctors, teachers, professors, scientists, and other specialists are addressed in this way. It is also used for gifted individuals in the arts, including manga artists.

sharp pencil: Japanese term for mechanical pencil.

shojo: The Japanese word for "girl." Shojo also defines manga and anime titles that are specifically created for teenage girls. These works often have very complex stories and character interaction. Romantic and plot-driven *shojo* works also attract large numbers of male fans.

shonen: The Japanese word for "boy." Shonen also defines manga and anime titles that are specifically created for teenage boys. These works are often filled with lots of action, fantasy adventure, and giant robots.

shonen-ai: Japanese words literally meaning "boys' love." However, this term is not used in Japan interchangeably with "boys' love" manga. In Japan, *shonen-ai* has become associated with depictions of relationships involving underage boys. "Boys' love" stories, by contrast, involve relationships of mutual consent. In the West, confusingly, *shonen-ai* usually refers to nonexplicit male-male love stories.

shuchu-sen: The Japanese word for "concentration lines," an expressive device used by many manga artists. They can direct a reader's attention, create an emotional effect, or suggest movement in a manga story. They are sometimes called "speed lines" in English.

Sienkiewicz, Bill: American comics and visual artist best known for his distinctively stylistic work on various comic books, notably Marvel Comics' *Elektra*. Sienkiewicz often utilizes oil

painting, collage, mimeograph, and other methods generally uncommon in comic books.

Spiegelman, Art: American comics artist who joined the underground comix movement in 1968. In 1980, he founded the magazine *Raw*, where he published important American talents such as Chris Ware, Dan Clowes, and David Mazzucchelli, together with non-American artists including Jacques Tardi, Joost Swarte, and Tsuge Yoshiharu. Spiegelman's autobiographical comics work, *Maus*, begun in 1972, was based on the experiences of his parents as concentration camp survivors. *Maus* won the Pulitzer Prize in 1992. Spiegelman has been of great importance for the reappraisal of the comics medium as an adult art form. His recent *In the Shadow of No Towers* is a response to the events of 9/11.

spot black: (See beta.)

storyboard: (See *e-conte*.)

sui boku ga: "Ink wash art." Art produced with india ink mixed with water to create shades of gray.

tablet: A digital device combining a drawing tablet with a stylus, enabling pressure-sensitive input into a computer when using drawing, painting, or photo retouching software.

tankobon: A book format in which manga are compiled after successful serialized runs in magazines. *Tankobon* means "separate volume," and these softcover books contain five to eleven story installments. *Tankobons* are usually printed on high-quality paper with black ink, whereas the larger-format monthly serial magazines are produced less expensively with colored ink on newsprint.

technical pen: A cartridge pen good for inking lines of uniform thickness.

Tezuka Osamu: Tezuka is considered the father of modern story manga and anime and is so revered in Japan that a museum has been built to house his creations. In 1963, Tezuka created his *Tetsuwan Atomu* (literally, "atom with iron arms"), which later that same year premiered on U.S. television as *Astro Boy*. Tezuka created the very first full-color animation, a television series called *Jungle Taitei* (*Jungle Emperor*).

thumbnail: (See *e-conte*.)

tone: (See Screentone.)

touch: Japanese term for the expressive quality of a line; the variation in line width to create accents.

Tsuge Yoshiharu: Legendary underground manga artist with a cult following, who gained fame in the pages of *Garo* magazine beginning in 1965. Tsuge wrote travel stories, stories inspired by dreams, and autobiographical stories, published mainly in the 1970s and 1980s. One of his most famous works is titled *Nejishiki* (*Screw Style*).

ukiyo-e: This school of art developed in the late 1670s and went on to become one of Japan's most well-known artistic styles. *Ukiyo-e* means "floating world pictures," and its aesthetics are concerned with the transient, fleeting aspects of life. *Ukiyo-e* woodblock prints became very fashionable in Europe in the late 1800s, and eventually directly influenced the Impressionist painters. The sensibilities of *ukiyo-e* resonate in contemporary manga and anime.

underdrawing: The pencil drawing that will be inked over to create the finished art on a comics artboard or a manga manuscript.

Wertham, Frederic: A German-American psychiatrist and crusading author who protested the purportedly harmful effects of comic books on the development of children. His best-known book was *Seduction of the Innocent* (1954), which led to a U.S. congressional inquiry into the comic book industry, as well as the creation of the Comics Code, which emasculated American comics at the height of their circulation, at the very time that manga were beginning an unprecedented period of growth in Japan.

yaoi: In Japan, this term refers to the most explicit male-male material for women, usually *doujinshi*. In the West, it usually means explicit "boys' love" material, but is sometimes used to mean any "boys' love" manga.

References and Recommended Reading

Books

Allison, Anne: "Permitted & Prohibited Desires: Mothers, Comics, and Censorship in Japan," West View Press, Boulder, Colorado, 1996.

Bijutsu Shuppan-Sha (ed.): "Manga Supa Tekunikku Koza" ("Super Manga Technique Seminar"), Bijutsu Shuppan-Sha, Tokyo, 1988.

—: "Manga Kiso Tekunikku Koza" ("Seminar on Basic Manga Techniques"), Bijutsu Shuppan-Sha, Tokyo, 1989.

—: "Manga Oyo Tekunikku Koza" ("Seminar on Manga Application Techniques"), Bijutsu Shuppan-Sha, Tokyo, 1990.

—: "Manga Tekunikku Koza Sukurinton Hyakka" ("Manga Technique Seminar: Screentone Encyclopedia"), Bijutsu Shuppan-Sha, Tokyo, 1996.

—: "Manga Sutato Apo Gaido Pan & Inku" ("Manga Start-up Guide: Pen & Ink"), Bijutsu Shuppan-Sha, Tokyo, 2000.

—: "Irasuto Sutato Apo Gaido Kara Inku" ("Illustration Start-up Guide: Color Ink"), Bijutsu Shuppan-Sha, Tokyo, 2001.

—: "Irasuto Sutato Apo Gaido Kara Maka" ("Illustration Startup Guide: Color Marker"), Bijutsu Shuppan-Sha, Tokyo, 2001.

Campbell, Eddie: "Alec: How to Be an Artist," Eddie Campbell Comics, Paddington, Australia, 2001.

DesignEXchange Company Limited (eds.): "Japanese Comickers," Harper Design International, New York, 2003.

Drazen, Patrick: "Anime Explosion!," Stone Bridge Press, Berkeley, 2003.

Eisner, Will: "Comics & Sequential Art," Poor House Press, Tamarac, Florida, 1985.

—: "Shop Talk," Dark Horse Comics, Inc., Milwaukie, Oregon, 2001.

Glickman, Adam (ed.): "Sake Jock," Fantagraphics, Seattle, 1995.

Gravett, Paul: "Manga: Sixty Years of Japanese Comics," Laurence King Publishing in association with Harper Design International, New York, 2004.

Horn, Maurice (ed.): "The World Encyclopedia of Comics," Chelsea House Publishers, New York, 1976; updated edition 1998.

Janson, Klaus: "The DC Comics Guide to Inking Comics," Watson-Guptill Publications, New York, 2003.

—: "The DC Comics Guide to Pencilling Comics," Watson-Guptill Publications, New York, 2002.

Kawade Shobo Shinsha (ed.): "J Comics: Best 145," Kawade Shobo Shinsha, Tokyo, 1999.

Kinsella, Sharon: "Adult Manga: Culture & Power in Contemporary Japanese Culture," University of Hawaii Press, Honolulu, Hawaii, 2000.

Komori Hironori (ed.): "How-to Art Vol. 1: Basic Lesson," Kadokawa Shoten, Tokyo, 1994.

—: "How-to Art Vol. 2: Mixed Media Lesson," Kadokawa Shoten, Tokyo, 1995.

Koyama Unkaku: "How to Draw Manga: Super Tone Techniques," Graphic-sha Publishing Co., Tokyo, 2000.

Lu, Alvin (ed.): "Fresh Pulp: Dispatches from the Japanese Pop Culture Front" (1997–2000), Viz Communications, San Francisco, 1999.

McCarthy, Helen: "Hayao Miyazaki, Master of Japanese Animation," Stone Bridge Press, Berkeley, 1999.

McCloud, Scott: "Understanding Comics: The Invisible Art," Kitchen Sink for Harper Perennial, New York, 1993.

—: "Reinventing Comics," Harper Perennial, New York, 2000.

Media Factory (ed.): "Comic Link," Media Factory, Tokyo, 1998.

Mizuno Hiroshi (ed.): "How-to Art Vol. 3: Mixed Media Lesson II," Kadokawa Shoten, Tokyo, 2000.

Nagamoto Haruno: "Draw Your Own Manga," Coade and Kodansha International, Tokyo, 2003.

Napier, Susan J.: "Anime from Akira to Princess Mononoke," Palgrave, New York, 2001.

Narita, Hyoe (ed.): "Secret Comics Japan: Underground Comics Now," Viz Communications, San Francisco, 2000.

Nyberg, Amy Kiste: "Seal of Approval: The History of the Comics Code," University Press of Mississippi, Jackson, Mississippi, 1998.

Ohta (ed.): "Digital Manga Production," Ohta Publishing Co., Tokyo, 2001.

Quigley, Kevin (ed.): "Comics Underground Japan," Blast Books, New York, 1996.

Robbins, Trina: "A Century of Women Cartoonists," Kitchen Sink Press, Northampton, Massachusetts, 1993.

Robbins, Trina, and Catherine Yronwode: "Women and the Comics," Eclipse Books, Forestville, California, 1985.

Roman, Annette (ed.): "Japan Edge: The Insider's Guide to Japanese Pop Subculture," Viz Communications, San Francisco, 1999.

Sabin, Roger: "Comics, Comix & Graphic Novels," Phaidon Press, London, 1996.

Salisbury, Mark: "Artists on Comic Art," Titan Books, London, 1996.

Schodt, Frederik L.: "Manga! Manga! The World of Japanese Comics," Kodansha International, Tokyo, 1983.

—: "Dreamland Japan: Writings on Modern Manga," Stone Bridge Press, Berkeley, 1996.

Society for the Study of Manga Techniques (ed.): "How to Draw Manga Volume 1: Compiling Characters," Graphic-sha Publishing Co., Tokyo, 1996.

—: "How to Draw Manga Volume 2: Compiling Techniques," Graphic-sha Publishing Co., Tokyo, 2000.

—: "How to Draw Manga Volume 3: Compiling Application and Practice," Graphic-sha Publishing Co., Tokyo, 2000.

—: "How to Draw Manga Special: Colored Original Drawing," Graphic-sha Publishing Co., Tokyo, 1997.

Talon, Durwin S.: "Panel Discussions: Design in Sequential Art Storytelling," TwoMorrows Publishing, Raleigh, 2002.

Toudo Ryo: "How to Draw Manga: Pen & Tone Techniques," Graphic-sha Publishing Co., Tokyo, 2003.

Tufte, Edward R.: "The Visual Display of Quantitative Information," Graphics Press, Cheshire, Connecticut, 1983.

—: "Envisioning Information," Graphics Press, Cheshire, Connecticut, 1990.

—: "Visual Explanations: Images and Quantities, Evidence and Narrative," Graphics Press, Cheshire, Connecticut, 1997.

Wani (ed.): "Ten Who Made Manga," Wani Publishing Co., Tokyo, 2002.

Wiater, Stanley, and Stephen R. Bissette: "Comic Book Rebels: Conversations with the Creators of the New Comics," Donald I. Fine, New York, 1993.

Magazines and Journals

The Comics Journal, Fantagraphics, Seattle; www.tcj.com

Comickers, Bijutsu Shuppan-Sha, Tokyo; www.bijutsu.co.jp

International Journal of Comic Art, John Lent, Drexel Hill; www.ijoca.com

9eme Art, Editions de l'An 2/Centre National de la Bande Dessinee et de l'Image, Angouleme; www.editionsdelan2 and www.cnbdi.fr

New Type USA, New Type USA, Inc., Houston; www.newtypeusa.com

Special feature editions of magazines:

"Comic Box: Manga 1993–1994," Expanded June/July edition of *Comic Box Jr.*, July 1994.

"Manga Sokessan: 1994–1995" ("Settling of Accounts for Manga: 1994–1995"), *Comic Box*, vol. 99, no. 7., July 1995.

No longer published but still available as back issues:

Amazing Heroes, Animerica, Mangajin, Manga Max, Pulp

Web Sites

Japanese-Language Manga & Art Book Publishers:

Akita Shoten—www.akitashoten.co.jp

Bijutsu Shuppan-Sha—www.bijutsu.co.jp

Kodansha—www.kodansha.co.jp

Seirinkogeisha—www.seirinkogeisha.com

Shodensha—www.shodensha.co.jp

Shogakukan—www.shogakukan.co.jp

Shueisha—www.shueisha.co.jp

Japanese Publishers with English-Language Pages:

Kodansha—www.KodanClub.com (catalogue, previews and story synopses)

Shogakukan—www.shogakukan.co.jp/english/htm/m_manga.html (A–Z by author and title)

English-Language Manga Publishers:

ADV—www.advmanga.com

Blast Books—www.blastbooks.com

Broccoli Books—www.broccolibooks.com

ComicsOne—www.comicsone.com

CPM Press—www.centralparkmedia.com

Creation Books—www.creationbooks.com

Dark Horse Comics—www.darkhorse.com

DC Comics—www.dccomics.com

Del Rey Books—www.randomhouse/delrey/manga

DH Publishing—www.dhp-online.com

Graphicsha—www.graphicsha.co.jp (How to books)

ibooks—www.komikwerks.com

Kodansha International—www.advmanga.com

Last Gasp—www.thejapanpage.com

Ponent Mon—www.ponentmon.com

TokyoPop—www.tokyopop.com

Viz Media, LLC—www.viz.com

Information Sites and Links:

www.anipike.com (massive list of manga and anime links)

www.artistic-inks.net

www.bigcomics.shogakukan.co.jp/title/k_s.html (scanned pages of Shogakukan manga)

www.brainyencyclopedia.com/ (entries on comics artists)

comics.cool.ne.jp/link/eofficial.html (List of shojo links)

comics.shogakukan.co.jp/ikkipara/comics/ (page for *Ikki*, Shogakukan's magazine for semi-experimental manga)

www.callenreese.com/magazine70.html (historic site on women's manga magazines in the 1960s, 1970s, and 1980s)

www.comiketservice.com/11w-e.htm (comiket *doujinshi* order site)

en.tezuka.co.jp/tomm/contents/project_ex/no09/cat01.html

en.wikipedia.org/wiki/Main_Page (many encyclopedia-like articles on comics and manga)

fact-index.com/c/co/comic_book.html (History of comics.)

www.lambiek.net/artists/index.htm. (A–Z of world comics authors)

www.littleprojecta.com/words/Garo_interview.html

www.manganetto.com/link/linkzassi (list of manga sites)

www.marmax.com/menaut.htm (list of titles with thumbs of covers)

www.matt-thorn.com (insight and essays on *shojo*, *redikomi*, and other manga from Matt Thorn)

myhome.naver.com/fischer/ (translation of Comic Link 50 top manga determined by Japanese readers in 1998)

www.s-book.com/plsql/sbc_janHSv2?jcode=02&lpc=1

sv.shodensha.co.jp/fc/ (shodensha manga for contemporary twenty-something women)

users.skynet.be/mangaguide/ (A–Z of manga authors)

www.student.kuleuven.ac.be/~m8107966/terminology.html (multilanguage terminology used in comics)

www.theblackmoon.com/Gloss/agloss.html (glossary of manga and anime terms)

www.tinami.com/list

www.tky.hut.fi/~otakut/anime/manga

yj.shueisha.co.jp/ (Young Jump site for boys)

youngyou.shueisha.co.jp/02comics/list/ (*Young You* magazine site for women, with thumbs of *tankobon* covers)

Creators' Web Sites

Asamiya Kia—www.tron.co.jp

CLAMP—www.clamp-net.com

Egawa Tatsuya—homepage3.nifty.com/egawa-tatuya/

Hiroki Mafuyu—hirokimafuyu.com/

Inoue Takehiko—www.itplanning.co.jp

Maruo Suehiro—www.maruojigoku.com/

Nagai Go—www.d-world.jp

Okano Reiko—www.najanaja.co.jp

Takaya Miou—www1.linkclub.or.jp/~miou/

Tezuka Osamu—www.tezuka.co.jp

Credits

Copyright information for Introduction Materials.

All illustrations are copyright their respective copyright holders and are reproduced for journalistic and historic purposes. Copyright credits for the introduction are listed by page number. Creators' names may be followed by those of the publishers who originally published their works.

The publisher should be notified of any omission or error so that it can be rectified in any future edition.

p. 8 & 9:
Art by Melissa DeJesus/© 2004 TokyoPop Inc.; © Frederik L. Schodt/ Stone Bridge Press.; © Bijutsu Shuppan-Sha, Ltd.; © Mark Salisbury/ Titan Publishing.

pp. 10 & 11:
The Japanese Manga Timeline chart was created by *Comickers* magazine, Bijutsu Shuppan-sha.

pp. 12 & 13:
Pyramid graphic is © Scott McCloud / Harper Perennial (All copyrights to properties in the pyramid graphic are held by the creators unless otherwise noted.)

#9 © Lorenzo Mattoti / Editions Albin Michel S.A.

11, 27, 79, 80 © Furuya Usamaru / Seirindo / Ohta Comics

#13 © Field Newspaper Syndicate

#20 Batman © DC Comics (Batman created by Bob Kane)

#23 © Cherkas and Hancock

#29½ Polly and Her Pals © Newspapers Features Syndicate Inc.

#32 © Asamiya Kia / Akita Shoten

#33 © Munoz and Sampayo

#34 © Takaya Miou / Taiyo Tosho

#35 Dick Tracy © Chicago Tribune-New York News Syndicate

#36 Darkseid © DC Comics

#45 © Koike and Kojima

#47 © Okano Reiko / Scholar / Heibonsha

#48 Corto Maltese © Casterman, Paris-Tourmai

#57 Popeye © King Features Syndicate

#58 Krazy Kat © International Feature Service Inc.

#59b © Hiroki Mafuyu / Shincho-Sha

#60 X-Men © Marvel Entertainment Group Inc. (X-Men created by Lee and Kirby)

#61 © Taniguchi Jiro/Kodansha Ltd.

#63 X-Men © Marvel Entertainment Group Inc.

#64 Superman © DC Comics Inc. (Superman created by Jerry Siegel and Joe Schuster)

#65 © Tsuno Yuko / Seirindo

#66 © Egawa Tatsuya / Shogakukan

#70 © CLAMP/Kodansha Ltd.

#72 Bringing Up Father © International Feature Service Inc.

#73 Peanuts © United Features Syndicate Inc.

#83 © Maruo Suehiro

#85 The Vision © Marvel Entertainment Group Inc.

#90 Superboy © DC Comics Inc.

#91 Plastic Man © DC Comics Inc.

#92 Omaha the Cat Dancer © Waller and Worley

#93 Elfquest © WaRP Graphics

#94 Veronica © Archie Comics

#95 Little Orphan Annie © Chicago Tribune-New York News Syndicate

#96 TinTin © Editions Casterman

#97 Mickey Mouse © Walt Disney Productions

#99b © Inoue Takehiko / I.T. Planning Inc.

#99c © Sakurazawa Erica / Shodensha Publishing Co. Ltd.

#101 Captain Easy © NEA Service Inc.

#104 Alley Oop © NEA Service Inc.

#108 Pogo © Selby Kelly

#109 Hans and Fritz © King Features Syndicate Inc.

#110 Mutt and Jeff © McNaught Syndicate Inc.

#111 Hi and Lois © King Features Syndicate Inc.

#112 Astroboy © Tezuka Productions

#113 Scrooge McDuck © Walt Disney Productions

#114 Barnaby © Field Newspaper Syndicate Inc.

#115 Felix the Cat © Newspaper Feature Service

#116 Asterix © Dargaud Editeur

Acknowledgments

Everyone I talked to at the very beginning said this is a book would be impossible to do. It has become a team project involving partners across oceans, cultures, and the Internet, because each loved what we were doing together and believed that this was an important story to tell. It is not possible to express my gratitude in words, but here is an attempt to give credit to some of those who made the impossible possible. I offer my deepest appreciation…

First of all, to the artists: Asamiya Kia, CLAMP (Igarashi Satsuki, Ohkawa Ageha, Mokona, and Nekoi Tsubaki), Egawa Tatsuya, Furuya Usamaru, Hiroki Mafuyu, Inoue Takehiko, Maruo Suehiro, Okano Reiko, Sakurazawa Erica, Takaya Miou, Taniguchi Jiro, and Tsuno Yuko. As different as you all are from each other, as unmatched as each of your visions, you are all truly masters. My respect and admiration for your work continues to grow.

And to their publishers, editors, and personal staff: Akita Shoten, Asahi Sonorama, East Press, Futabasha, Gentosha, Hakusensha, Hayakawa Shobo, Heibonsha, Kadokawa Shoten, Kawade Shoten Shinsha, Kodansha, Magazine House, One Two Magazine, Scholar, Seirindo, Seirinkogeisha, Shincho-Sha, Shinshokan, Shodensha, Shogakukan, Shueisha, Taiyo Tosho, Blast Books, Central Park Media, Creation Books, DC Comics, Fanfare/Ponent Mon, Gutsoon!, ibooks, Marvel Comics, TokyoPop, and Viz Communications; Hoya Kenichi, Ooe Kazuhiro, Segawa Keiichi, Watanabe Shinnosuke, and Yoshida Rou; Imai Mamiko and Yano Naoe.

To Bijutsu Shuppan-Sha, especially Mizukoshi Hiroshi, for taking such an extraordinary chance with a gaijin author. To Matsumoto Shigetoshi, for helping to arrange that first meeting. And to all the folks at Harper Design International.

To my direct partners: Sugisawa Yoshifumi, my advisor and friend, and Yamamoto Keiko, my long-suffering and patient editor at Bijutsu Shuppan-Sha. To Yanagi Akihide, my chief coordinator and interpreter/translator, my eyes, ears, and hands in Japan; you are my hero. To Komanoya Rico and Sasaki Akehiro, who were indispensable and thoroughly professional.

To the giants on whose shoulders I stood: Frederik L. Schodt, Susan J. Napier, Sharon Kinsella, Paul Gravette, and Patrick Drazen.

For crucial contacts, to: Abe Jin, the Asian and Middle Eastern Languages Department at Western Michigan University, Washio Yukiko, C.B. Cebulski, Shiratori Chikao, Hara Kiyoto, Ichikawa Kunio, the Kalamazoo-Numazu Sister City organizations, especially Bob Hall, Nakamura Fusako, and Hara Norio, Helen McCarthy, Minari Mami, Daniel Mishkin, Uemetsu Shinobu, and Yanagisawa Mitsuaki.

To my translators, interpreters, research assistants, photographers, and designer: Itasaka Atsuko, David and Mika Karashima, Kojima Katsunori, Nakada Hazuki, Onuki Yukiko, Sakurai Tadahisa, Pam Shebest, Shimizu Masako, Daniel Shulman, Suzuki yo-yo, Taga Hitoshi, Wendy Walser, Watabe Ryoji, Yamakawa Yohei, and Zenki Megumi.

To artists, editors and scholars who didn't appear in this book due to space limitations, but who nonetheless filled in gaps in my understanding and shared their work and thoughts with me. To the wonderful artists of Manga Japan, especially Satonaka Machiko, Baron Yoshimoto, Inuki Kanako, Yaguchi Takao, Hino Hideshi, Big Joe, and Manga Japan's representative, Hara Takao. To the incredibly talented and knowledgable Fukuyama Yoji, Hayashi Tetsuo, Iezaki Haruo, and Ikeda Takashi.

To professionals who gave me encouragement: Amano Masanao, Bill Baker, David Baker, Paul Benjamin, Colleen Doran, Marc R. Hairston, Andy Helfer, Jennifer Lantagne, Frenchy Lunning and the Minneapolis College of Art & Design, Trina Robbins, Jeremy Ross, Barbara Schulz, Chris Staros, Jim Valentino, and Anthony Wahl.

To Scott McCloud and Harper Perennial for the use of the comics art styles pyramid. To Adam Warren and DC Comics for the use of the "Roxy" artwork.

To my employers George Arwady and Rebecca Pierce, who granted leaves of absence and special arrangements for me to pursue a passion outside of my newspaper job.

To family, friends, and co-workers who cheered me up, gave me advice, training, feedback, and support, and put up with long absences: Randi Rae Arnold, Jill Baker, Mark Bugnaski, Shawano Cleary, Rick Cristofaro, Mark Donnelly, Katie Englert, Clayton Hardiman, Bill Hein, Elspeth Hetrick, Kim Hetrick, Matthew Jackobowski, Richard Jordan, Danielle Kronk, Keith Lehmann, Tom Minehart, Jean Morack, Linda Odette, Scott and Suzy Rosema, Chad Stevens, Bob Thompson, and Lynn Turner.

Finally, to those I have no doubt inadvertently omitted, my sincerest apologies and heartfelt thanks.

About the Author:

Timothy R. Lehmann is a journalist, artist, designer, photographer, and
art director and has won awards in journalism, design, and graphics.
He is an expert in comics and Manga, and regularly lectures on Manga
creation and anime.